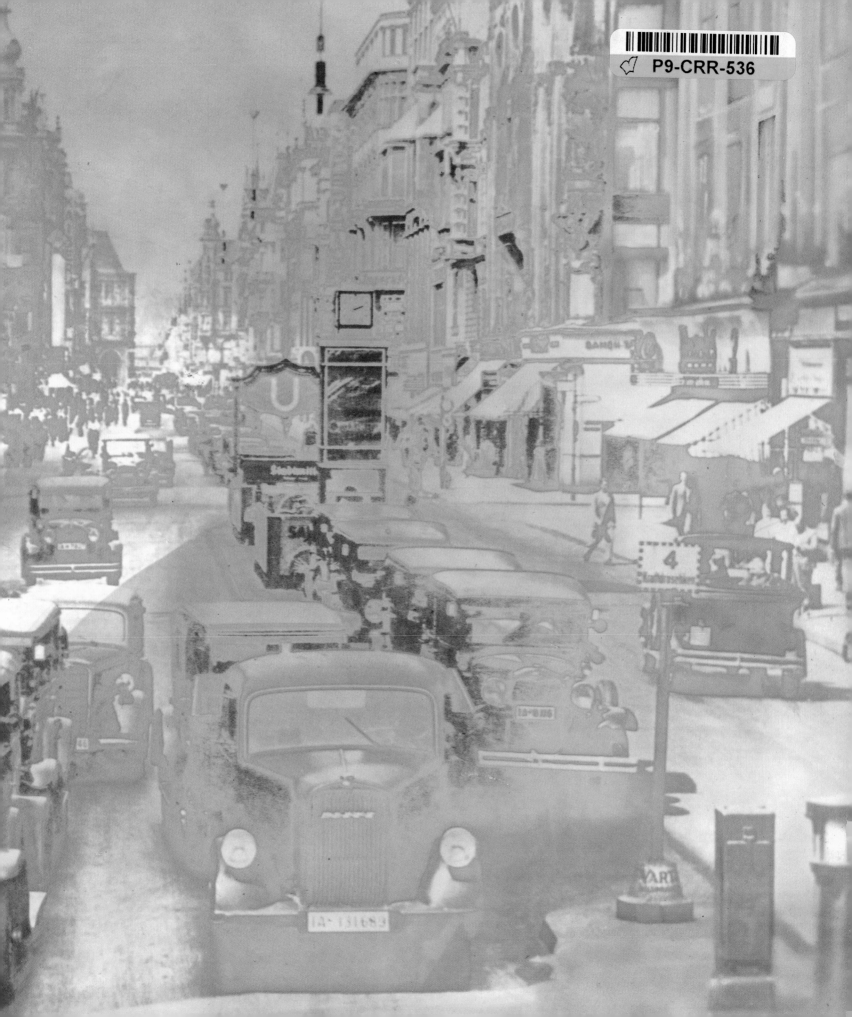

Bärbel Schrader/Jürgen Schebera

The "GOLDEN" TWENTIES

Art and Literature in the Weimar Republic

Yale University Press

New Haven and London
1988

First published in the
German Democratic Republic
by Edition Leipzig 1987

This English language edition
© 1988 by Yale University Press

Design: Eveline Cange
Production: Druckerei Fortschritt Erfurt
Printed in the German Democratic Republic

ISBN 0-300-04144-6
LC 87-50845

Translated from the German
by Katherine Vanovitch

Contents

Introduction

Between 1918 and 1933, Germany experienced fifteen years of political and intellectual turbulence which came to an abrupt end with the emergence of Nazi dictatorship. The period has entered history as the Weimar Republic.

The arts blossomed and bore a rich harvest of books and magazines, operas and plays, paintings and buildings which have won a place in international culture. But above all the output of the thriving entertainments industry lent that age its aura of nostalgic mystique, expressed in our notion of the "Golden" Twenties. Of course, this image will not stand close scrutiny. For one thing, it does not apply to the entire period, as it was only between 1924 and 1929 that Germany was relatively free of crisis, and for another, it belies the reality of life in the Weimar state.

And yet we have decided to call our book *The "Golden" Twenties*, retaining the epithet in quotation marks. Our purpose in doing so is to question the mystique and show what was really happening on the cultural scene: the outstanding artistic accomplishments alongside the mass production of trash and reactionary jingoism; the striking aesthetic experiments side by side with routine perfectionism; the influence of the Soviet avant-garde and at the same time the full-scale imitation of the mass entertainment industry of the capitalist United States of America. The culture of the Weimar Republic was the phenomenon of extremes rubbing shoulders, where Alfred Döblin and Hedwig Courths-Mahler, Kurt Weill and Franz Lehár, *Kuhle Wampe* and the *Leuthen Chorale* made their impact simultaneously.

We are, above all, interested in the historical constellation which permitted these various developments and—the reverse of the coin—the reasons why the ideas of progressive artists and intellectuals could not be asserted, such that a kind of mental perversion took root after 1933.

Even today we have no clear explanation for these occurences, but any researcher concerned with the subject can now draw on a wealth of studies conducted in recent years by historians and specialists in art and literature.

It is clearly impossible to consider the political and the cultural development of the Weimar Republic in isolation, and it is equally impossible to paint a picture of the contradictory whole without contemplating the highly diverse facets of the contemporary cultural landscape. In order to present an accurate account, it is essential to look back on the years 1917/18 and to look forward to the events of 1933.

We were also tempted by the opportunity to produce an attractive illustrated volume in which the text is supplemented by an abundance of previously little-known photographs and documents, so that many of the works of art described can also be conveyed visually. We hope that the reader will not merely take pleasure in browsing through this cross-section of art and culture in the Weimar Republic and discovering much that is new, but will also acquire a deeper understanding of an age which, as a result of its artistic achievements, has left its mark in so many ways on our own times.

War and Revolution

**1918—The Kaiser goes,
the Generals stay behind**

On 15 April 1918 Germany's children had another day off school. The German troops had scored their last tactical success at Armentières. The schools held their obligatory victory celebrations: undernourished children, rationed to only a tenth of their actual food needs since the turnip winter of 1916/17, enthusiastically sang "Hail to thee in victor's laurels! Hail to thee, Kaiser!" to the tune of "God Save the Queen". For all the hunger, warweariness and longing for peace which marked Germany's internal situation during the fifth year of the conflict, the Prussian Culture Minister's decree of early 1915 was still having its "patriotic" effect. It stipulated that every time a victory was reported from the front the next day should be spent in celebration without lessons. If a victory report arrived during lessons, they were to be stopped immediately, and after celebrating the children were to be allowed home. What young boy or girl could fail to support "our brave soldiers at the front" and "our glorious Kaiser" wholeheartedly.

Unfortunately, there had not been much occasion since 1916 to make use of this "beneficent" arrangement. The German forces were bogged down in east and west alike. Dispatches about the war of the trenches and the reciprocal depletion of stores on the Western front were reduced to the terse formulation "All quiet!" It meant, in fact, that one German soldier in every fourteen was dying. 1,936,897 men aged sixteen to sixty fell in this war; hundreds of thousands went missing; 4.2 million were wounded or crippled.

Their wives and mothers, who had been obliged since 1916 to take over the men's jobs in the armaments industry, in commerce, communications and services, went into mourning and dyed their old clothes black, assuming

they had any that were not black already. There were few new clothes to be bought, or at least few who could afford them. Since 1915 it had been unlawful to produce cotton fabrics for civilian purposes, so special shops sprang up where people could exchange their old clothes for different ones, or acquire new rags on coupons. The skirts and dresses in the fashion magazines grew shorter and narrower from one year to the next, and the tunic was the height of elegance. Substitute materials did a roaring trade. Wooden shoes and paper clothes and drapery stole the show at the Leipzig Wartime Fair in August 1917, their major virtue being that they did not require polishing or washing, for grease and soap were in extremely short supply.

All essential goods were only available on coupon, and it was hard enough to obtain the meagre rations to which the cards entitled their holders. By 1917 the weekly acquisitions of a city-dweller amounted to almost two kilos of bread, three pounds of potatoes or turnips, 250 grams of meat, 180 grams of sugar, 80 grams of butter and half an egg. In Berlin fat rations had been cut to 50 grams of butter, the difference being made up by 30 grams of margarine, and during 1918 weekly bread rations in the city fell to one kilogram.

In 1918 agriculture produced half its pre-war output. All industry was geared to the war effort, and raw materials were becoming scarcer. Crude iron production was down to 61 per cent of the 1913 figure, coal-mining stood at 83 per cent, and there was less than 40 per cent of the lead, tin, copper and other metals available.

Once the bells and organ pipes had been confiscated from the churches, and the tin lids removed from tavern beer tankards, copper roofs and bronze statues followed them into the furnace. Coins were melted down, replaced by paper money, and pots and pans from the kitchen cupboard met the same fate. Once the law on "Auxiliary Service to the Fatherland", which Deputy War Minister General Groener let it be made known was "nothing but the extension, continuation and logical development of

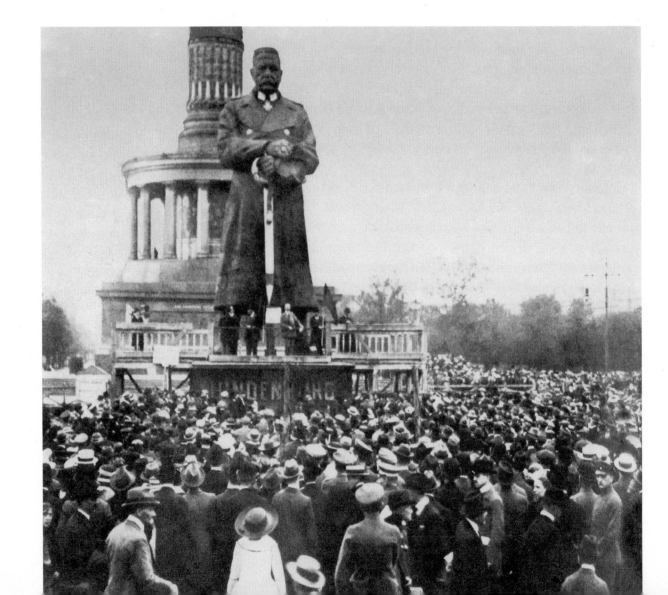

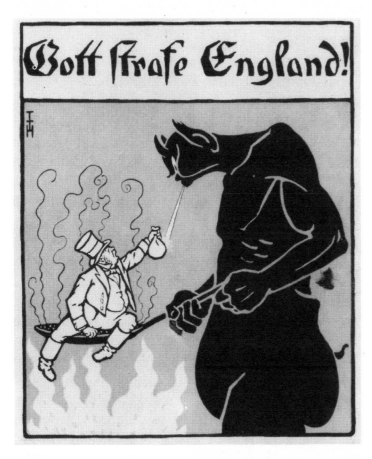

Thomas Theodor Heine's cover design for the pamphlet "God Punish England", published in 1917, is typical of the chauvinistic hysteria which was still raging as the First World War entered its fourth year.

Left:
The "Iron Hindenburg" next to the Victory Column in Berlin was not dismantled until the end of 1919. In June it had served as the venue for a protest rally against the Treaty of Versailles.

universal conscription"[1], came into force on 5 December 1916, every citizen aged between sixteen and sixty was called up for war service, and the long arm of the state reached out for any property which could be utilized for the war effort.

Cutbacks and economies were not so rigorously imposed when it came to strengthening the backbone of the already anaemic fatherland by means of war propaganda in order to extract even more effort. Iron nails were still available for the "Iron Hindenburg", a monumental wooden statue on Berlin's Königsplatz. Every nail hammered into the wooden flesh of the Chief of Staff testified to another donation to finance the equipment of the armed forces. The money poured in just as fast as it did in the rapid succession of government campaigns to sell public war bonds. It was not the war-profiteers, lining their pockets by supplying the army, who made sure that the donations ran into millions of Marks even in 1918, but the clerks, the small tradesmen and also many workers, who offered their last pennies. The big publicity campaigns were aimed at them, and the psychological impact had been well calculated. The soldier in the trenches appealing for war credits in sprawling newspaper advertisements, or on bills posted on pillars and in shop windows otherwise empty, reminded people of their own fathers, husbands and sons, stretching out their hands for help from the front.

In spite of the material deprivation, the theatres played to full houses. There were some courageous productions of plays by Expressionists such as Walter Hasenclever, Georg Kaiser and Reinhard Goering, which were frequently only shown to a private audience in order to ward off the censor. They heralded peace and friendship among men, thus concurring with the growing desire for peace experienced by their spectators. But the basic repertoire, which came under the aegis of the War Ministry, was dominated by ethnic romance, military buffoonery and raucous comedy, designed to counter depression at home and at the front. One such project was the patriotic play *Der deutsche Schmied* (The German Smith), penned by a literary major called von Lauff, which was staged at the Schumann Circus in Berlin in 1917. Henny Porten was among the cast. Like other stars of the silent screen, she was intended as a crowd-puller, just as in all the patriotic and military films churned out non-stop by a growing number of private film companies during the first two years of the war as a result of their box-office success. But the popular interest in war films dropped off rapidly after the failure of the Schlieffen Plan, which had promised a lightning victory for the German troops in December 1914, the sobering end to the Verdun offensive in 1916, the sterility of unlimited submarine warfare, and the third attempt by the supreme command in 1917 to stake

all on victory. The German film industry switched to sensation and comedy. Detective Stuart Webbs replaced the screen heroes in battle dress—not that this detracted in any way from the hostile slogan "God curse England!" The cinema had not turned neutral, but had simply changed its function: the film became a lucrative tranquillizer which banished those everyday cares for a few brief hours. 25 German film companies participated in the propaganda business in 1914. By 1918 that number had risen to 130.

There were about 1,850 daily newspapers in the German Reich, and they constituted the most important propaganda tool of all because they were exposed to the most direct influence from the War Ministry. Along with the publishing companies, they were responsible, not only for the mass circulation of daily news complete with exhortations to "hold out" and "pull through", but also for sizeable editions of rosy war reports and books about heroic deeds at the front, which were mostly read by young people. No new publishing companies were permitted for the duration of the war. Illegal writings were hunted down mercilessly. The Social Democratic and liberal press were subjected to severe censorship by the War Press Office, which prohibited more and more as the war drew to a close. Even so, many an anti-war poem and many a book with little regard for the patriotic spirit slipped through the censor's tight net, and audacious anti-war magazines, such as *Die Aktion* in Berlin and *Der Ziegelbrenner* in Munich, appeared in clever camouflage. These were read by left-wing bourgeois intellectuals and by young anarchists, who felt an allegiance to the Independent Social Democratic Party (USPD) and the Spartacus group. In January 1918, these forces within the labour movement, which had already channelled the hunger demonstrations of 1916 into a broad strike campaign, scored their first major success with a strike in the Berlin munitions factories followed by mass political strikes in the Ruhr, Saxony, Upper Silesia and a number of coastal towns. The revolutionary movement grew in Germany under the influence of the October Revolution in Russia. Spartacus's call to form workers' and soldiers' councils took the form of strike demands. Military suppression of the strikes merely postponed the rapid spread of revolutionary activity in Germany.

The Supreme Command cherished quite different hopes of the Russian Revolution. It was they who had advised the German government to allow Lenin to cross Germany in a sealed railway carriage on 10 April 1917 so that he could reach Russia via Stockholm. On 17 April the head of German Defence in Stockholm had cabled to Berlin: "Lenin's entry into Russia successful. He is working entirely as planned."[2] What the Supreme Command hoped was that the Bolsheviks would topple the Kerensky government—it was assumed beyond doubt that they would put an end to the war with Germany. And everything hinged on just that, for the armed forces serving on the Eastern Front were urgently needed in the west, where the situation was threatening to take a turn for the worse now that the United States was entering the war. The Spring Offensive in the west was Germany's last trump card.

Once more the wartime propaganda machinery swung into action. At the instigation of Ludendorff, who had headed the Supreme Command with Hindenburg since August 1916 and was virtually exercising a military dictatorship in Germany in alliance with the monopolies, the Universum Film AG (Ufa) was founded in Berlin in December 1917. It was, in fact, a government-financed enterprise disguised as a joint-stock company, and it received 25 million gold Marks in starting capital to resurrect the war film. Ludendorff, whose "Picture and Film Office" had already been supervising film distribution at the front and at home, monitoring the German film companies and allocating material to film-makers since the beginning of the year, offered the royal War Ministry a revealing justification for this measure: "The war has demonstrated the outstanding power of picture and film as a tool to enlighten and influence. Unfortunately, our enemies have taken such thorough advantage of the superiority which they have in this field that we have suffered considerable damage. Nor will film lose its tremendous importance as a tool of political and military influence as long as the war continues. For this very reason it is absolutely essential to a happy resolution of the war that film should make the

deepest possible impact wherever German influence is still feasible."[3]

But it was not only in the various cultural fields that the military took the driving seat, using men of straw as a public front. In preparation for the Spring Offensive, propaganda as a whole was taken out of the government's hands, while the independent press offices and other associations, which were so difficult to keep under control, lost their rights altogether. The "Home Service Headquarters", specially set up for the purpose in February 1918, assumed the task of "total centralization of all institutions, organizations, etc. engaged in war propaganda".[4] It included the Social Policy Office, the United Associations Information Centre, the League of German Academics and Artists, and the Study Commission for Organization Abroad, which was represented on the new body by, among others, Theodor Heuss. Everybody soon agreed that phrases like "German honour" and "German glory" were no longer going to achieve much. More tangible aims were needed, and the Treaty of Brest-Litovsk, signed on 3 March 1918, was an answer to their prayers. The peace terms enforced, which deprived Russia of its wheatfields in the Ukraine, its oil deposits in the south and almost all its coal and iron industry, were viewed in Germany as a victory, and the bells rang out to celebrate. The message of the secret memos from the monopolies to the Supreme Command had long been crystal clear, although Germany's true war aims—economic exploitation of territories to be conquered in the east and of the French ore deposits; conquest of Belgium and northern France to give Germany control over the Channel and possession of the Belgian and French ports—had never been stated in public. But after Brest-Litovsk it seemed that the time was right to dangle further expansionist aims in front of the population in order to boost enthusiasm for the Spring Offensive. There was a gratifying response. Max Bewer, a Dresden poet, had a jingoistic warning printed:

O fatherland, remember this,
As Entente spleen engulfs thee:
"The God who made the iron to grow
Made men to be born free". . .

And yet in fifty years from now
No iron shall grow in Germany,
Not on the Rhine, nor by the Saar,
In Silesia nor in Saxony.
Even Krupp had to look abroad
To make his furnace roar.
Germany was forced to buy
Two-fifths of all her ore. . . .
(. . .)
Our foes had crushed us long ago
And slavery been our fate,
Had we not fetched from France the ore
For which our factories wait.
It nestles in the crevices
Of Longwy and Briey.
Let us thank God we found it there
And now it's ours to stay!
For if our enemies should choose
To sell us no more ore,
Then German mills will idle stand,
Though we should win the war. . .
Hold fast that anvil, Germany,
To forge your destiny;
We must have iron to bring our land
Peace with prosperity! . . .[5]

But by the time the Supreme Command had promised "final victory" for the fourth time, most of the population could no longer be roused, even by such effusiveness. Stefan Zweig describes the mood of the times in his memoirs: "A bitter distrust gradually began to grip the population—distrust of money, which was losing more and more of its value, distrust of the Generals, the officers, the diplomats, distrust of every public statement by the government and General Staff, distrust of the newspapers and their news, distrust of the very war itself and its necessity."[6]

The picture was no different at the front. Desertion and mutiny were already common on the Western Front when the troops arrived from the Eastern Front with their tales of fraternization between the Russian and German soldiers since the armistice in December. In contrast to the origi-

nal plan, large units had been kept behind in the east to secure the occupied territories and maintain the black-out on information about the developments in Russia. However, the revolutionary mood took hold and spread. When the Bolsheviks published their first official statement, the Decree on Peace, many reacted in a similar manner to Oskar Maria Graf on hearing the news that the October Revolution had begun: "I felt an electric charge rush through me. I leapt up and stared at the words (. . .) 'Good Lord!' I gasped. 'Good Lord! The revolution! Revolution!' I forgot all else. 'The revolution is beginning! All over the world! It will all be quite, quite different!' said I, as if in a trance. 'The new age is dawning!'"[7]

On 21 March 1918, 3.5 million soldiers opened the offensive on the Western Front. By 6 April they had advanced so far, at the cost of 240,000 lives, that the promised success seemed to be within grasp. But this grand prelude petered out once more into trench warfare. Henceforth none of the operations was more than partially successful. When the Allies began their counter-offensive in July, the fate of the German forces was sealed. They retreated on 8 August. On 11 August Kaiser William II announced: "I realize we must take stock. The war must be ended."[8]

The Supreme Command feverishly began its attempts to save face. On 4 September it issued an ordinance against the dissemination of false rumours. The word "defeat" was now punishable. Responsibility for the imminent armistice and peace negotiations with the Allies, which would inevitably impose even harsher conditions on Germany than those laid down in US President Wilson's 14-point Peace Plan of January 1918, was handed over to a new "Truce Government". The Kaiser proclaimed himself a democrat, not only because Wilson, the sole candidate as an intermediary in the negotiations with France and England, had declared that he would only talk to parliamentary governments, but also because it was crucial to prevent revolution in Germany.

Under the new Chancellor of the Reich, Prince Max von Baden, Philipp Scheidemann, a loyal supporter of the monarchy who shared the chairmanship of the Social Democratic Party (SPD) on an equal footing with Friedrich Ebert, entered the government as a permanent secretary. He was joined by Gustav Bauer, Deputy Chairman of the General Commission of German Trade Unions, who had already made it abundantly plain that he was utterly opposed to mass political strikes. Even though the SPD had lost almost half its members since 1914, it was still the largest working-class party in Germany, and now it was to join the trade unions in forging an alliance with the Catholic Centre Party, the Conservatives, the National Liberals and above all the Generals, in order to save the monarchy. It was to topple that very monarchy that former members of the SPD and many young bourgeois artists and intellectuals had founded the USPD in April 1917. The Spartacus group, whose leaders Karl Liebknecht and Rosa Luxemburg were still in prison, worked within the USPD, and this group decided on 7 October at its Reich Conference in Berlin to adopt a programme for people's revolution in Germany.

In the meantime, Hindenburg was mustering all the available forces to hold his position in the west, even though the Front was being forced back daily with enormous casualties under the Allied attack. But why, after all, had Ludendorff ensured himself a complete monopoly on the manipulation of opinion among the German public and at the front by uniting all military and political propaganda institutions into a single "Central Agency for the Publicity and Information Service at Home and Abroad" on 29 August 1918? While efforts to secure a truce were already under way, he had his front man Deutelmoser draw up some "Guidelines for Information Work in the Homeland": "As our enemy desires no peace for which we do not pay with our servitude, we must fight on. We must and we can! We have sufficient reserves of troops, war equipment, raw materials and other aids indispensable to the war leadership to be in a position to continue resisting the enemy victoriously."[9]

There were still many in Germany who cherished such hopes and would not accept the disaster which defeat implied. Even a poet like Richard Dehmel, at fifty-five already wounded several times, was willing to return to battle, and the passion of despair drove him to write: "Everything is at stake. We still hope that our enemies will hon-

our our goodwill, but if they compel us into desperate combat, then we shall require a thorough review. The only men who should go to the front are those who would truly rather die than live to see a shameful peace. There are too many out there fighting against their will. Give them permission to go home; there is enough work for everyone behind the front. Let none look askance at them; many have good reasons. But if anyone has bad reasons, he is the last person to entrust with a post where only the courage to die born of a sense of honour can still decide the outcome. The time is past when the trenches should have been relegated to penal institutions. Let no one protest that after a week the front would be too poorly defended; a hundred brave men are stronger on their own than in the company of a thousand lily-livers. Let the Supreme Command place its confidence in the people!"[10]

Towards the end of October, those "good reasons" provoked countless politically aware soldiers to put a stop of their own to the senseless mass deaths caused by Ludendorff's policy of "sticking it out". An everyday occurrence at the front is described by Jacob Bourlanger, a worker from the Ruhr, in his recollections: "In 1918, in October, they wanted to send us into action again, this time against the Americans. We said: 'We won't fall in this time! If they put us down here, we won't march with them.' So when they put us down and we were supposed to march to the front, the whole platoon of Rhinelanders did a left about turn. A group of about 30 of us marched to the next station, deserted. Then we went back to Cologne. I was in Cologne on 8 November."[11]

That was the first day of the Revolution in Cologne, after naval ratings had sparked the process off with their mutiny in Kiel on 4 November. Within a few days, the Revolution had spread right across Germany. Workers' and soldiers' councils were set up everywhere. The Bavarian monarchy fell on 7 November, and a republic was proclaimed. On 8 November Chancellor Prince Max von Baden sent a telegram to the Kaiser at army headquarters in Spa, where William II had been keeping a low profile since 29 October, asking him to step down. Party Chairman Friedrich Ebert had given an ultimatum that, if this demand was not met, the SPD would not continue to offer its assist-

ance in preventing the Revolution led by the Spartacus group and large sections of the USPD. "If the Kaiser does not abdicate," Ebert told the Chancellor, "then the social revolution is inevitable. But I do not want it, indeed, I hate and despise it."[12] In view of this counter-revolutionary government alliance, the general strike planned by Spartacus and the USPD for 11 November was brought forward. It was on 11 November, when workers called their general strike, that the Revolution began in the last bastion of the Hohenzollern dynasty. All access routes to Berlin had already been sealed off by government troops during the previous few days. In the morning the workers demonstrated in columns which marched from barracks to barracks, fraternizing with the soldiers. By noon the Palace, the Police Headquarters, the prisons and government buildings, and telegraph and newspaper offices were in the hands of the revolutionaries. Towards 12 o'clock, even though he had not yet received William's consent, Max von Baden announced that the Kaiser had abdicated and he appointed Friedrich Ebert as the new Chancellor of the Reich. The next day William II crossed the Dutch border to safety.

Towards 2 p.m., while Ebert was still negotiating about how to form a government according to the monarchal constitution, Philipp Scheidemann proclaimed a "German republic" from a window of the Reichstag. Speed was of the essence, for Scheidemann had heard that Liebknecht was on his way to the Palace at the head of a huge demonstration. Liebknecht reached his destination at about 4 p.m. and proclaimed a "free socialist republic" in front of a cheering crowd.

The Spartacists' revolutionary programme, backed up by Liebknecht's own tremendous popularity, posed a serious danger to the plans of the "government socialists". In spite of the official announcement, it had not been the influenza epidemic now spreading through Berlin and across Germany which prompted His Majesty, for the sake of his royal health, to disappear to Spa on 29 October: he had been obliged to witness thousands of Berlin workers cheering Liebknecht on 23 October after the latter's release from prison. Even General "Hold-On-Lads" Ludendorff had seen what was coming and quickly re-

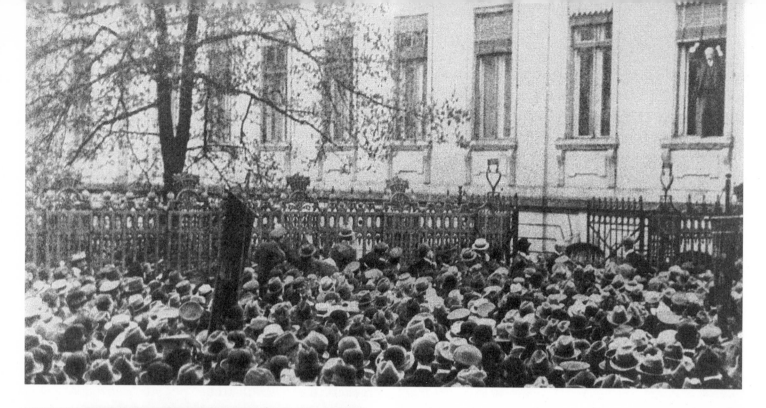

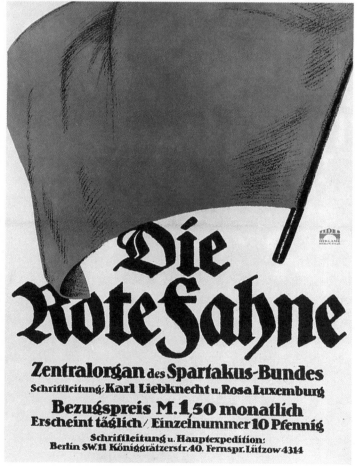

At about two o'clock in the afternoon on 9 November 1918, Philipp Scheidemann (SPD) proclaimed the "German Republic" from a window in the Reichstag. Two hours later, from a balcony of the Kaiser's Berlin Palace, Karl Liebknecht declared a "free socialist Republic".

Alfred Stiller's poster advertising the Spartacus newspaper in late 1918. Museum für Deutsche Geschichte, Berlin

Right:
Bavarian Prime Minister Kurt Eisner, seen here addressing the Reich Conference of federal state government representatives at the Chancellor's Palace in Berlin in November 1918, was assassinated in Munich on 21 February 1919.

signed from Imperial service on 26 October. Things had to move fast if the Social Democratic workers were to be stopped from following Liebknecht as well. Unlike Spartacus, the SPD had a well-oiled party machine which swung into action when the workers' and soldiers' councils were set up, to ensure that loyal party men were installed in the key positions. Within a few hours, the SPD's own rotary presses were printing the decrees signed by Ebert for mass distribution in the form of special editions or posters. The phrase "peace and order" was used to create the impression among workers and soldiers that the Revolution had already prevailed and that they held power in their hands. Spartacus published a pamphlet listing 14 revolu-

tionary demands which would now have to be met if the struggle was to prove victorious, as had been done in Russia; but compared with the propaganda facilities enjoyed by the SPD, their resources at that crucial point were meagre.

On the evening of 9 November, the world seemed to be turning as usual for those readers of the *Berliner Lokal-Anzeiger* who started their newspaper from the back. There was something for every taste in the Guide to Berlin's 35 theatres in the week to come, from *Wallenstein* at the Königliches Schauspielhaus to *Graf Habenichts* at the Wallner, from *Othello* at the Königliche Oper to *Prinzenliebe* at the National-Theater. A detective agency with the promising name of "Zukunft" (Future) was offering conscientious observation and investigation. There was a positive write-up of a new book about the air force, *Die Luftwaffe 1918*, which was full of original photos. Only football fans had to swallow the bitter pill that the Crown Prince matches scheduled for Sunday 10 November had been called off owing to the unsettled situation. "Whether the matches will be postponed until a later date or cancelled altogether is not yet clear. We must wait and see how things develop."[13] But those who started their news-

paper on the front page did not need to wait any longer. As from this edition, the *Berliner Lokal-Anzeiger*, which belonged to the big Scherl press company, had been renamed *Die Rote Fahne* (The Red Flag), at least for two days. Spartacus had occupied the office, but they had only had time to reset the first page before the second evening edition went out. It was headlined "Berlin beneath the red flag" and contained the Spartacists' reports about the first day of the Revolution in Berlin, the day which, after the Russian October, was to usher in the world revolution. This first militant newspaper to be published officially by Spartacus was passed quickly from hand to hand, and from 18 November it appeared as an independent daily which was also distributed outside Berlin. The next morning the new paper even appeared in the prohibited zone which Germany occupied along the Eastern Front, as Walter Oehme reports: "The first rumours that a republic had been proclaimed in Berlin trickled through on 10 November, and soon the *Rote Fahne* edition of the *Lokal-Anzeiger* arrived. Even during the revolution, the German Reichspost operated with mathematical precision, delivering the *Rote Fahne* to every reader of the *Lokal-Anzeiger*."[14]

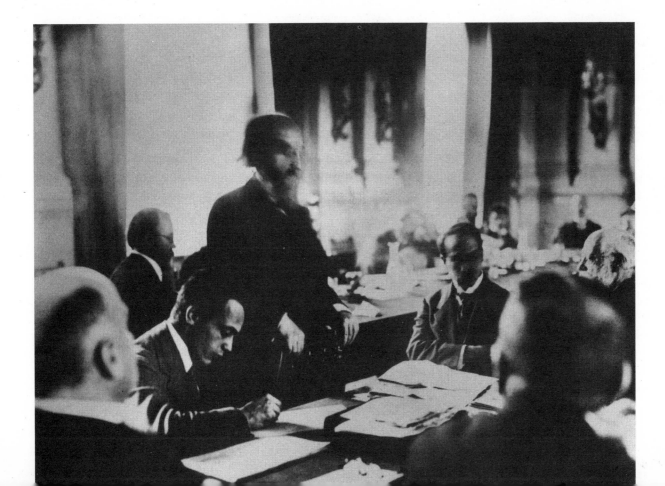

Bremen and Munich—
The *Räterepubliken* and
the intellectuals

From the end of November onwards, the bourgeois and Social Democratic press was full of vindictive attacks on the Spartacus League. That was the name which the revolutionaries in the Spartacus group had taken when they constituted themselves as an independent propaganda organization within the USPD on 11 November 1918. They stepped up their campaign for a dictatorship of soviets, or local revolutionary councils, in Germany. They were joined in this by many other left-wing forces, notably the International Communists of Germany, a group based in Bremen and Hamburg and led by Johann Knief and Paul Frölich. The left held firm control over the workers' and soldiers' councils in quite a few towns, including Bremen, Brunswick, Düsseldorf, Mühlheim, Hanau and Gotha, where they were able to consolidate their positions of power. Workers' and peasants' councils had even been set up subsequently in a number of agricultural areas, declaring war on the reactionary Junkers, the landed aristocracy. The *Rote Fahne* was published autonomously in all major towns. The International Communists sold their *Arbeiterpolitik* in many coastal towns, and in Bremen Johann Knief also edited the daily newspaper *Der Kommunist*. Both soon had offices in Dresden and elsewhere. The need for a united, militant revolutionary party was quickly recognized by all concerned as a result of the common struggle being waged by the left, which had been extremely successful in towns such as Bremen. That party was founded in Berlin on 30 December as the Communist Party of Germany (KPD). Its Central Committee included Karl Liebknecht, Rosa Luxemburg, Wilhelm Pieck and others from the Spartacus League alongside Paul Frölich of the International Communists and the left-wing trade unionist Paul Lange.

The right wing forged a strong alliance to oppose the movement for councils and the coalescence of left-wing forces in the Communist Party. A flood of leaflets, posters and pamphlets depicted the gory spectre of Bolshevism. They prophesied war and devastation, unemployment and misery, servitude, bloody dictatorship and "Judaistic" rule to all who gave credence to the Spartacists and their "unpatriotic machinations". A "General Secretariat for the Study and Combat of Bolshevism" was set up to devise a constant flow of increasingly effective arguments to suit every political taste. The newly-formed bourgeois parties merged on 1 December into the "Anti-Bolshevist League". Financed by the big industrialists and the banks, with a million Marks from the "Curatorium for the Reconstruction of the German Economy", the German Democratic Party and the old, conservative Centre Party, the new Bavarian People's Party, the German National Party and the German People's Party lined up with the SPD and the Generals in a co-ordinated campaign against the workers' and soldiers' councils. The German Democratic Party was backed by industrial magnates Borsig, Siemens, Bosch, Rathenau and banker Hjalmar Schacht. Its public profile was fashioned by well-known intellectuals, such as Theodor Wolff, chief editor of the *Berliner Tageblatt*. Matthias Erzberger ruled the Centre Party. The German Nationals were a combination of Junkers and top brass loyal to the Kaiser. Hugo Stinnes and Gustav Stresemann represented the German People's Party.

In early December, the military attempted to remove the workers' and soldiers' councils in a number of towns which were not controlled by the SPD, but the enterprise failed. On 6 December, they planned to make an example of the Executive Council of workers' and soldiers' councils in Berlin, whose members were arrested by the Gardekorps with the consent of Otto Wels (SPD), the city's military commander. But such was the pressure of mass demonstrations over the next two days that the council representatives had to be freed again. The military suffered their biggest defeat on 24 December, when an attack on the People's Navy Division was thwarted by revolutionary sailors and workers in Berlin, and followed by mass protests throughout Germany. Thereupon the USPD's representatives left the "Revolutionary Government" and the Council of People's Deputies, which until that point had been composed of three men from the SPD, Ebert, Scheidemann and Landsberg, and three from the USPD, Haase, Dittmann and Barth.

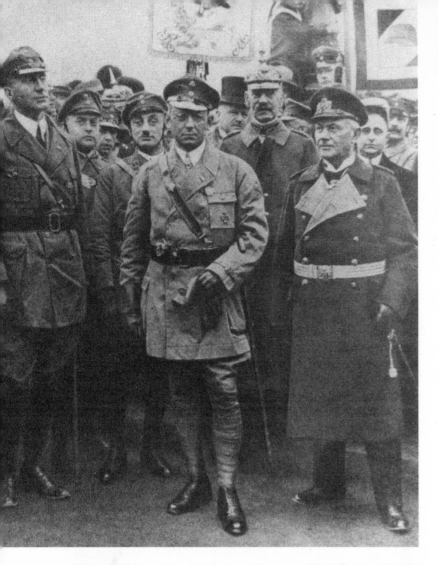

This group photo shows the faces of German militarism at the 6th Stahlhelm Conference at Magdeburg in 1925: Franz Seldte (centre), the leader of the Stahlhelm, and Admiral Scheer (right).

Stinnes, Ernst Borsig and Carl Friedrich von Siemens, donated 500 million Marks to an "Anti-Bolshevist Fund". The money went to the bourgeois parties and the SPD, to the "Association to Combat Bolshevism", to the Frei-korps recruitment offices, to the alternative movement for citizens' councils and the bourgeois self-defence organizations, and to the student employment offices at Germany's deeply reactionary universities. The electoral campaign for a National Assembly, aimed at establishing a bourgeois democratic republic in Germany, had entered its final stage.

On 30 November Franz Pfemfert published an article in his literary magazine *Die Aktion* entitled "National Assembly is Counter-Revolution". He warned the many artists and intellectuals who were his readers exactly what to expect from this National Assembly, which was being extolled repeatedly by Ebert and Scheidemann as the legitimate road to revolutionary power for the working-class masses: "We know now that the various executives of the military dictatorship had ordered soldiers' councils to be set up after this truly democratic form of government had developed clearly underground. The military tyrants believed (and still believe!) that they can stifle liberty by dressing their drill puppets (or capitalist mercenaries) in a revolutionary cloak. (. . .) The German people have been lied to systematically for four years. Even if we were to return all the rotary presses this very day to their rightful owners, the people, a year would be too short to enlighten every mind.

"We are in favour of real democracy, of true, complete rule by the people. We do not want capitalist dictatorship, the dictatorship of a single minority, restored. We do not want 95 per cent of the community bending to the brutal will of five per cent. And because we want to achieve true democracy it is our duty to muster all we can to prevent the counter-revolution. The National Assembly planned by the capitalists would guarantee the old tyranny. We confront this tyranny with democracy: the organization of the workers' and soldiers' councils."[15]

The tone of Pfemfert's article shows that he was in complete agreement with the programme put out by revolutionaries like Karl Liebknecht and Rosa Luxemburg,

The right flexed its muscles with the aim of stamping out the council movement once and for all. Ebert summoned fellow SPD member Gustav Noske from Kiel to Berlin and put him in charge of defence of the Council of People's Commissars. Right-wing bourgeois newspapers vied with one another in a campaign to recruit volunteers to form anti-Bolshevist associations. The Stahlhelm, an organization of former frontline soldiers founded in Magdeburg on 13 November by Franz Seldte, the soda water manufacturer and eventually Hitler's Labour Minister, played a vociferous part in the barrage of anti-Bolshevist propaganda. In early January 1919 a number of Germany's industrial and banking tycoons, notably Hugo

which was drawing increasing support from workers all over Germany. More and more artists and intellectuals were also sympathetic to the ideas of Spartacus and were joining the struggle for the councils. But this commitment rarely entailed a political decision in favour of dictatorship by council of the proletariat. More often than not, their understanding of free self-determination for the people in a society based on councils was coloured by a whole range of Utopian views. The generation of young artists who had been born of Expressionist art and literature before and during the war rejected revolutionary force in favour of their principle of non-violence: man's love for man was their bourgeois alternative to revolutionary democracy, and instead of the demands of a revolutionary programme for struggle they called for the immediate introduction of a classless community. Accordingly, the plethora of revolutionary demands which intellectuals published in endless manifestos was quite chaotic. The list was usually headed by socialization of the press and abolition of censorship. This, at least, was a response to experience with the imperialist mass media during the war. There followed a hotch-potch which ranged from nationalization of the banks to "freedom for sexual life", from dissolution of the army and the abolition of military service to economic recognition of the artistic professions and a reform of the education system. Basically there was no attempt at a critique of the political texts published by Spartacus or of Marxism in general. The artists were swayed quite simply by a consistent campaign on the part of Spartacus and the International Communists for power to the councils and against the moribund monarchy. That was enough to prompt writers and theatre workers such as Bernhard Kellermann, Paul Zech, Oskar Kanehl, Bertolt Brecht, Erwin Piscator, Franz Jung, Edwin Hoernle, Karl Schnog and Friedrich Wolf to work with the workers' and soldiers' councils as delegates or elected representatives. A Council of Intellectual Workers, presided over by journalist Kurt Hiller, was founded in Berlin with political pretensions to offer the revolution intellectual leadership. Many, often very well-known names, joined it for a while, including writers Anette Kolb and Kasimir Edschmid, painter Ludwig Meidner, politician Helene Stöcker, journalist

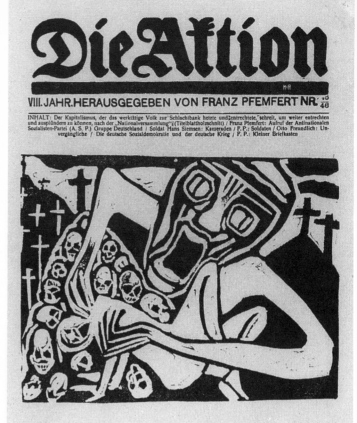

This woodcut for the title page of Franz Pfemfert's *Die Aktion* on 16 November 1918 illustrates the artist's rejection of the proposed National Assembly as a capitalist ruse.

Right:
In January 1919 Liebknecht's supporters rallied in the Palace Park, Berlin, in support of the revolutionary Volksmarine. Wilhelm Pieck was one of the speakers.

Arthur Holitscher and *Weltbühne* editor Siegfried Jacobsohn, sexologist Magnus Hirschfeld, architect Bruno Taut and actor Alexander Moissi. Heinrich Mann set up a Political Council of Intellectual Workers in Munich. Intellectual councils sprang up in Dresden, Hamburg, Leipzig, Darmstadt, Breslau, Hanover, Magdeburg, Marburg, Stuttgart and many other towns. In April 1919, when most of these autonomous artists' councils had already bitten the dust, Hermann Sinsheimer attempted to form a Reich League of Intellectual Workers in Munich.

The first Reich Congress of Councils met in Berlin from 16 to 21 December 1918 to decide between a National Assembly and a *Räterepublik* (republic of workers' and soldiers' councils). During the delegate elections which preceded the Congress, the SPD loyalists had been able to use their influence once again. Almost all the delegates mandated by the soldiers' councils, where it was easier to install officers and NCOs in key positions on the grounds of better "education" and greater eloquence, were faithful champions of bourgeois parliamentary democracy. The workers' councils called for more caution. The most important aim was to keep out as many Spartacus supporters as possible. This plan worked: after lengthy speeches and discussions, 291 SPD delegates, 90 from the USPD, including ten Spartacists, and, to crown this mockery, 25 council delegates from the German Democratic Party, came forward to cast their votes. Rosa Luxemburg and Karl Liebknecht were cleverly deprived of their mandates. The outcome was a decision in favour of the National Assembly by 344 votes to 98. The Council of People's Deputies was given legislative and executive powers to prepare for elections, and the Executive Council was replaced by a Central Council composed of SPD members which in any case possessed no authority at all.

On 4 January, two weeks before the election date, the Prussian government set the scenario for a decisive blow to the Communist Party, which had given way to extreme left-wing pressure and refused to stand for the National Assembly. The fear was that this stance would provoke a boycott on the part of the electorate, jeopardizing the Social Democrats' hopes of achieving power with an absolute majority. Ebert's government threw down the gauntlet to the Berlin masses, who were in revolutionary mood, by dismissing the city's Police Commissioner, Emil Eichhorn of the USPD. A revolutionary council consisting of 33 representatives from the KPD, the USPD, the People's Navy Division, the Berlin Garrison and other forces called on the workers to take arms and topple Ebert and Scheidemann. Gustav Noske, who had in his own words taken on the role of "bloodhound", saw his great moment arrive. He assumed command over the government troops and volunteer units which had taken up position around Berlin, and a wave of white terror was let loose upon Berlin from 9 to 14 January. Intellectuals joined the barricades around the newspaper offices and helped workers occupy the headquarters of *Vorwärts* and the press companies Scherl, Mosse and Ullstein, but by 15 January resistance had been quelled even in the outlying districts and the hunt for Spartacists' heads had begun. On the evening of 16 January a group of officers had their photographs taken at a party. Just the day before they had murdered Karl Liebknecht and Rosa Luxemburg.

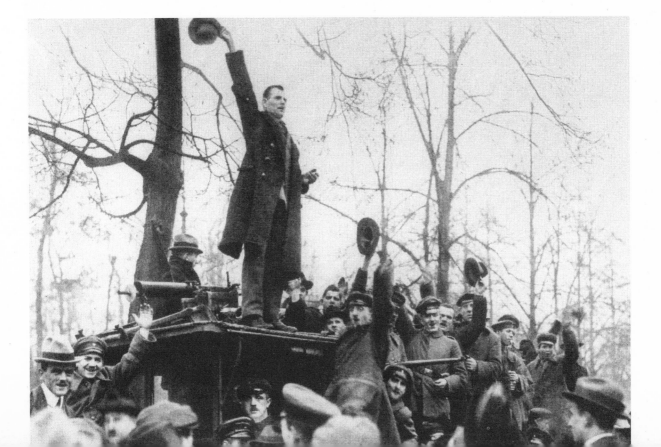

By the time of the fights on the streets of Berlin, there had been a wave of striking and demonstrating in the Ruhr, Thuringia, Saxony, Württemberg and Upper Silesia. In some cases counter-revolutionary forces were disarmed after costly battles, but incidents like this lacked co-ordination. The mass of workers either did not turn out in support of the revolutionary forces, or else did not really understand how to achieve victory. One initiative, however, stands apart from all the others for resolutely pursuing its aims. On 10 January the workers of Bremen, led by Johann Knief, established a *Räterepublik* in their city:

"Residents of Bremen!
Our history has been decided! Not wishing to be swept along in the suicidal collapse of the capitalist economic order, the working people of Bremen, the revolutionary proletariat, have taken their destiny into their own hands!

Bremen is now under military law!
All economic and political power is in the hands of the proletarian people's government.

Bremen is an autonomous socialist republic.
The Senate has been dissolved!"[16]

A Council of People's Commissars from the KPD, USPD and soldiers' council had taken power. Batallions of workers enforced the measures required to re-organize the economy and improve food supplies, assumed the authority of the police and disarmed all troops stationed in the town. Artist Curt Stoermer, a member of the workers' and soldiers' council in the Osterholz district, took charge of censoring the bourgeois press. The boot was on the other foot. Bremen's workers had learnt the painful way from their own bourgeois Senate and its police force how to protect their powers.

Another member of the workers' and soldiers' council in Osterholz was the painter and architect Heinrich Vogeler, known throughout Germany for his *art nouveau*. Now, approaching fifty years of age, he helped to organize the fight and the propaganda for the *Räterepublik* of Bremen. Johann Knief entrusted him with the task of explaining the developments to the local farmers and locating produce which should have been released for public consumption. Vogeler's house, Barkenhoff, in the artists' colony at Worpswede became a meeting place for the People's Commissars. The intellectuals in Worpswede, including Curt Stoermer, and later playwrights Reinhard Goering and Friedrich Wolf and painter Karl Jacob Hirsch, took their political inspiration from the left-wing extremism of the Bremen communists, and their views were accordingly emotional and radical. Vogeler set up a workers' commune at Barkenhoff, consisting of persecuted revolutionaries, artists and craftsmen, which was to be an em-

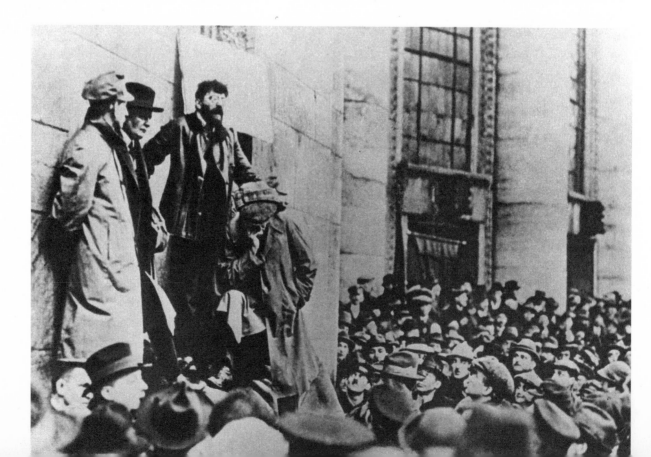

Writer Ernst Toller, Chairman of the USPD in Bavaria, was in charge of organizing a "Red Army" during the Bavarian *Räterepublik*. He was sentenced to five years' imprisonment as a "ringleader", and spent the years 1919 to 1924 in the fortress of Niederschönenfeld, where he wrote, amongst other things, the collection of poems *Das Schwalbenbuch* (Book of Swallows).

Gustav Landauer, the prose and essay writer, was one of the brains behind the *Räterepublik* in Munich. He was murdered by counter-revolutionary troops on 2 May 1919.

Left:
Poet Erich Mühsam addresses a mass meeting during the *Räterepublik* of 1919 in Munich. After the Republic was crushed by Noske's forces he spent seven years in prison. Mühsam was to be one of the Nazis' first victims: they murdered him in Oranienburg concentration camp in 1934.

bryo of communist society. He gave talks and published pamphlets throughout Germany publicizing this experiment in instant classless communism, yet, inevitably, it foundered due to internal quarrels and lack of money. In 1923 Vogeler gave Barkenhoff to Red Aid for use as a children's home. The commune outlived the *Räterepublik* of Bremen by several years however the bourgeois parliamentary Republic which emerged from the national elections of 19 January sent the Gerstenberg Division to win back its bastion at Bremen. On 4 February the resident middle classes returned peacefully to the cinemas to enjoy the latest box office hit, *Die Lieblingsfrau des Maha-radscha* (The Maharajah's Favourite Wife). Two true Communists were to evolve out of the intellectuals at the Worpswede Commune: Heinrich Vogeler and Friedrich Wolf.

In April the writers of Munich continued where the painters of Bremen had left off in February. On 21 February the student and officer Count Arco-Valley had assassinated the Bavarian Prime Minister Kurt Eisner (USPD). Munich was in uproar, for Eisner had been very popular with the workers. Admittedly, as an advocate of non-violent means, he was not a tremendously vigorous politician, but at least he was loyal to the working class. The intellectuals also cherished a considerable respect for this journalist and sensitive thinker. His Eisner Evenings had been well attended even before the revolution in Munich. He was often forgiven for being rather wishy-washy on major issues which needed decision, because of his choice of the young writer Ernst Toller as adjutant and his willingness to put his signature to a number of appeals from the artistic community. When Eisner was murdered the city held its breath for several days as thousands of demonstrators of all complexions took to the streets. After his death the Central Council of workers' and soldiers' councils, a mixture of SPD, USPD and the Bavarian Farmers' League, assumed the reins of government. The deputies who had already been elected to the Bavarian Parliament had taken flight. Parliament did not meet again until mid-March, when it chose a new government led by Social Democrat Johannes Hoffmann. However, the Central Council did not relinquish its governmental position. Hoffmann helplessly accepted this "double rule" and bided his time. In March, Socialists and Communists in Hungary proclaimed the Hungarian *Räterepublik*. One of the political measures they took was to nationalize theatres and publishing companies. Georg Lukács, the philosopher and literary theoretician, was appointed Minister of Education and named writers Béla Balázs and Julius Hay as his assistants. The Hungarian example added more weight to growing demands in Munich for a *Räterepublik*, and only the Communists warned against such a move. On 6 April, after the towns of Würzburg, Regensburg, Ansbach, Passau, Fürth and Augsburg had taken steps

towards proclaiming *Räterepubliken*, a revolutionary Central Council was constituted, with the Social Democrat Ernst Niekisch, who had been sent to Munich from Augsburg, in the chair. He held talks with Ernst Toller, as Chairman of the Bavarian USPD, other SPD forces, the Farmers' League and the anarchists led by Erich Mühsam and Gustav Landauer and then, the next morning, declared the first Bavarian *Räterepublik*. The Hoffmann government fled to Bamberg. Not a single shot had been fired. 7 April was declared a public holiday and celebrated forthwith. The only symbols of victory were the posters bearing the proclamation and the red flag over the Wittelsbach Palais.

The Council's first decision was to socialize the press, then to arm the workers and set up a Red Army; these were followed by measures to alleviate the dire housing situation and ensure food supplies. The people who set out to implement these policies had almost no experience to draw on. Ernst Niekisch stepped down on 8 April and was replaced as Chairman of the Central Council by Ernst Toller. Thus one writer succeeded another. He was supported in his work by Ret Marut as head of the Council's Press Department, Gustav Landauer, the People's Commissar for ideological work, education, science and art, and Erich Mühsam, whom few could match as a tireless campaigner for the cause. In fact, beyond propaganda the Central Council had no authority. Meanwhile Hoffmann was mustering forces in Bamberg. Sections of the Munich Garrison, which had not been disarmed, mutinied against the *Räterepublik* on 13 April. At this point the KPD took a hand in the struggle, and Paul Frölich and Frida Rubiner were sent to back up Eugen Leviné, who had been dispatched to Munich by his party on 15 March to take over as editor of the local *Rote Fahne*. A Campaign Council of KPD, USPD and SPD members was chosen and adopted a Communist programme of action. An Executive Council headed by Leviné took over executive powers from the old Central Council. Toller was given the task of organizing the Red Army, and sailor Rudolf Eglhofer was appointed supreme commander. The Executive Council introduced measures to disarm the government troops in Munich, replace civil servants, install factory councils to monitor their workplaces, and nationalize the banks. The second *Räterepublik* was born and was equipping itself for defence against the approaching government troops. All eyes were on Munich. The intellectuals had also set up a campaign council of their own which had been fighting for political aims and revolutionary art since November 1918 in association with the anarchist groups around Mühsam and Landauer. Some unusual decisions were taken against the background of turbulent events. Once the Munich press had been banned completely from 13 April, the only newspaper to appear was the information bulletin put out by the Executive Council of Factory and Soldiers' Councils, which carried the following Appeal on 15 April:

''Revolutionary artists

The Campaign Council of Revolutionary Artists herewith declares that it shall be regarded as the sole representative of the artistic community in the town of Munich and all Bavaria. It is founded on communist principles and recognizes the dictatorship of the proletariat as the true and only way of implementing the proletarian *Räterepublik* and communism.

Bethge, Georg Kaiser, Titus Tautz, Schrimpf, Pilartz, Scheffler, Schiner, Burschell, Sachs, Coeln, Wolfenstein, Wolf-Ferrari, Lorrain, Trautner et al.''[17]

Many more of Munich's artists and writers might have been added, but few of them fully appreciated the principles at stake in this declaration. The Reichswehr troops and voluntary units requested by Noske had already begun to encircle Munich. Toller and Eglhofer had an army of 15,000 with which to confront the 79,000 soldiers under the command of the Hoffmann government. By 1 May Munich and its environs were engulfed in battle. A thousand perished as red soldiers and civilians alike were massacred. Once the *Räterepublik* had been crushed, another 5,000 faced trial. Those leaders who were captured in the early days—Gustav Landauer, Eugen Leviné and Rudolf Eglhofer—fell prey, either at once or in prison, to lynchings by the white forces. Mühsam had been taken prisoner by government forces during the coup on 13

April and sent to northern Bavaria. He was subsequently sentenced to 15 years' imprisonment. Toller was arrested on 4 June and spent five years in the fortress at Niederschönenfeld. Others to receive gaol sentences were the publisher Bachmair, who commanded the Red Army artillery, writer Albert Daudistel, who headed the commission to aid political refugees, Frida Rubiner, Ernst Niekisch and writer Rudolf Hartig.

Ret Marut, the editor of *Der Ziegelbrenner* and future novelist B. Traven, whose true identity remained a secret for many years, escaped detention. When the *Räterepublik* of Munich fell, the majority of Germany's artistic community buried their hopes for a world without classes or violence. For most of them the revolution was over. But they did not renounce their sympathy with the workers, who had toppled the monarchy and dared to attempt revolutionary change. The events of Munich and the lessons it taught were a recurrent theme in the German arts over the next few years. Revolution became the new preoccupation of artists and writers. Along with its *Räterepublik*, Munich lost its status as the centre of revolutionary and avant-garde art in Germany. Even bourgeois artists betrayed a mournful nostalgia for their city's former significance when they came to write their memoirs: ''Munich, named a 'Capua of Minds' by the socialist leader August Bebel even before the war, had long enough been the place where one spent the day feeling sleepy and the night wide awake. In case that sounds too much like moralizing or maybe an excuse, let me add that Munich was also a town of young people and what were after all a more relaxed type of German values, where a person counted for something beyond his success or failure and found encouragement and consolation in many forms. In that respect this southerly, pleasure-loving city was really quite un-German, in an age and under a regime which were only too rigorous in pursuing and forgetting their purposes.''[18]

In spite of Thomas Mann, in spite of Lion Feuchtwanger, in spite of a Münchner Theater which set the pace in Germany with its premières, in spite of its prestigious art galleries, its wealth of journals and publishing houses and its sophisticated music, once the fate of Germany's November Revolution had been sealed in Munich, anyone who sought influence and respect in the arts, anyone who wanted to make a name for themselves and an impact on the world had only one choice of residence: Berlin.

The birth of Greater Berlin, metropolis of the arts

Since early May 1919, the Magistrat of Berlin, which was its ruling council, the Town Assembly and the citizens' committees had been hammering out a project first placed on the agenda fifty years previously. A number of draft laws were discussed until, on 27 April 1920, the constituent Prussian Provincial Assembly passed legislation which was to unite eight urban parishes, 59 rural parishes and 27 estates into a single community. The law came into force on 1 October that year. The seat of the old Prussian monarchy, covering an area of just 6,570 hectares, became Greater Berlin, the second largest city in the world after Los Angeles with its new surface area of 87,810 hectares. Over four million people were living in Greater Berlin in 1925. When the Town Assembly met in July 1920, its President and oldest member Pfannkuch declared in his enthusiasm: ''We have done it at last! The overwhelming majority of the population in the economic territory of Greater Berlin have seen their deepest wish realized, the united community is now a fact of law! The path was clear when we swept away Wilhelminian rule. The puppets in the Berlin Prefecture have been driven out. The freest of electoral laws constitute the firmest foundation on which rests the right to self-administration of our united community. (. . .) Unfortunately we are living in abnormal conditions. The war years destroyed a treasure worth thousands of millions, and labour, which alone creates value, has lost millions of busy hands. A considerable proportion of the people are deprived of all necessities. We are suffering from a shortage of adequate food, clothing and housing; we are being utterly crushed by a gigantic burden of debt.

''If the people of the united community of Berlin, in these sad circumstances, courageously tackle the reconstruc-

tion of economic life in the knowledge that only the most diligent work, coupled with tenacious endurance, can accomplish the task they have begun, then anyone must be bound to display great respect for their activity."[19]

The foundation of Greater Berlin was not in itself an ambitious undertaking for the new Republican government of the Reich. The city, with its extreme polarization in politics, economic life and the arts, posed a permanent challenge and was hard to keep in check. On the one hand, it was a centre of conservative forces inspired by the "spirit of Potsdam", the reactionary influence of Prussian military bureaucracy, while on the other, it was a key bastion of the revolutionary movement in Germany. The views of Berlin's business community tended to range from liberal anti-monarchism to left liberalism. The entrepreneurs had drawn their economic power from the commercial boom and the millions paid in reparations by France after the Franco-Prussian War in the early 1870s. Now that this state of affairs had been reversed by the Treaty of Versailles and the demand for German reparations, they were exploiting the end of the monarchy to develop Berlin as an independent economic territory and to assume control over the city's political future. When the draft legislation on Greater Berlin was first debated, it did not even look as though the Kaiser's former residence would become the capital of the new Republican Reich. At the elections to the Town Assembly on 23 February 1920, the USPD had won 47 seats and the SPD 46. The bourgeois parties only managed to obtain 51 mandates between them. Besides, there was a deal of disquiet in the city, even amid bourgeois circles, after the murder of Karl Liebknecht and Rosa Luxemburg.

The mood was too dangerous for the coalition government of SPD, German Democrats and Centre Party which had emerged from the National Assembly to proceed comfortably with drawing up a Constitution and laws for the new Republic. Given the situation in Berlin, they had moved to the peace and quiet of Weimar in early February. Ebert himself had carefully chosen the little town for the great mission of the future Republic, as Walter Oehme narrates in his first-hand account: "He had been negotiating with Noske and the military for days. They kept coming back to the question of which town would be easiest to defend against any actions by the revolutionary workers. The conference hall was hung with maps of Central Germany. The word Weimar cropped up more and more frequently. The officers used the maps to demonstrate that the forests of Thuringia provided a strategic position which would make it easy to prevent any demonstrations from marching in."[20] The National Assembly formed for its first meeting in Weimar's theatre on 6 February 1919, protected by the eminent stone figures of Goethe and Schiller as well as Noske's notably flesh-and-blood security forces outside the entrance. Ebert's election as President of the Reich consoled him for his party's overall set-back. Contrary to the expectations of the SPD leaders, the National Assembly elections had left them with only 163 mandates, instead of the absolute majority they had wanted. The USPD had picked up 22 seats. The bourgeois parties, meanwhile, had amassed 228 seats, of which the Centre had 91 and the German Democrats 75. The latter, however, were unable to make use of their absolute majority as the entire process was untenable without the right-wing SPD leadership. The Democrats made use of the SPD so that they could leave "working-class leaders" to the dirty job of completing the counter-revolution, leaving their own hands untied for the pursual of "bourgeois democracy". The Monarchists, on the other hand, had political reasons for preferring not to collaborate openly with the pro-Republican Democrats: their voters felt just as bitterly ashamed about the transition from Imperial Reich to Republic and the embarrassing retreat of this apparently quite incompetent Parliament before a confrontation with the "reds" as they did about their Kaiser's flight to Holland.

The new government enacted laws on socialization, which it never put into practice but which served at the time as a sedative, and, on 31 July, the Constitution of the Weimar Republic. At least the setting was worthy, for the fittings from the sessional chamber at the Berlin Reichstag had been ferried to Weimar for the purpose. Tucked away at a safe distance in their government offices in a stately home belonging to the local dukes, with a telephone and a specially created airborne postal service

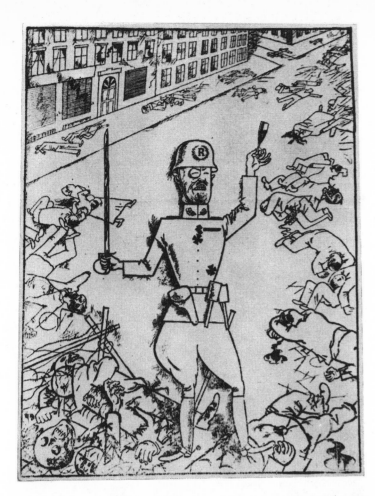

George Grosz's cartoon for the title page of *Die Pleite*, published by Malik, in April 1919 was inscribed with the comment: "Your health, Noske! The proletariat has been disarmed!" His caustic pen and political marksmanship made Grosz a merciless chronicler of the Weimar years. His hatred of the German military was especially vitriolic.

between Berlin and Weimar, they supervised Noske's "cleaning up campaigns" in the Reich's former capital, now under siege: these included the defeat of the general strike during the fighting in March, the attempt to wipe out the sailors of the People's Navy Division, the destruction of the editorial offices and printroom at the *Rote Fahne*, and the rounding up of Spartacists. With 1,200 dead in Berlin and thousands more arrested, the new Parliament decided that the coast was clear enough to move back into the Reichstag in late August. The city itself had made an offer and removed the last traces of the soldiers who, only weeks before, had filled the corridors and rooms of the now deserted colossus. In May the pest controllers

entered the building and placed it under quarantine for delousing.

The government's return did not change much in the city. Its political, economic and cultural standing was dependent less on the favours of national government than on the policies of the city fathers, and they were moved above all by the money which flowed into the municipal treasury from Berlin's industry.

Even before the First World War, Berlin had liked to compare itself with New York, London and Paris. It was the youngest industrial centre, and since the early seventies, after Bismarck had united the Reich, had enjoyed reputation for possessing Germany's greatest potential for technological progress. Mechanical engineering in Berlin, based on the firms Borsig and Schwartzkopff, had become a focus for the metal-processing industry. The town's electrical industry, led by big companies such as Siemens, Bergmann and Emil Rathenau's Deutsche Edison-Gesellschaft, later AEG, not only monopolized the market in Germany, but also exerted a decisive influence on the international market, sometimes in close collaboration with American companies. Then, in 1919, the dominant Berlin firms merged to form Osram, which monopolized the German lighting industry. The textile trade which had been the lynchpin of the Berlin economy in the last century made room for a modern clothing industry. Thanks to this technological progress, a considerable scientific potential was concentrated in Berlin, enabling Berlin University and the Technical College to become pace-setting establishments within Germany.

At the same time, there had been a tremendous influx of labour before and after the turn of the century, densely packed into a relatively small space, and this made Berlin one of the key centres of the working-class movement. In 1875 the capital of the German Reich had a population of about 900,000. By 1900 it had risen to 2.7 million. As a result of this rapid population growth there was such a boom in trade, communications and construction that the face of the old royal seat changed dramatically. Just a few hundred yards from the Kaiser's Stadtschloss and all the grand accompanying buildings which Schinkel had built for earlier monarchs, cheap tenements began

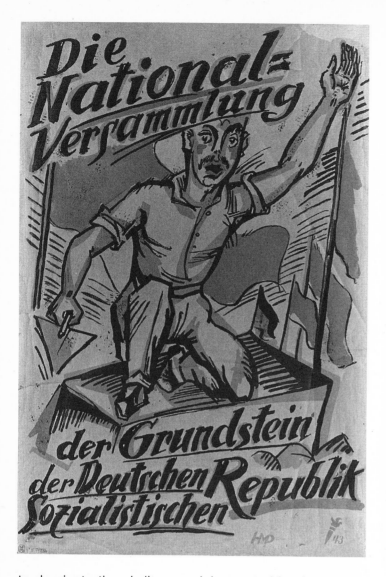

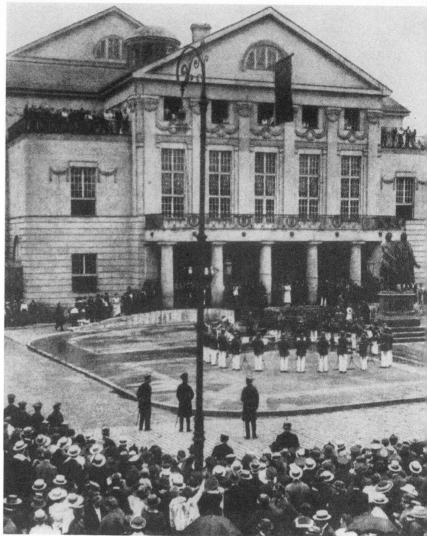

to dominate the skyline, crudely erected by the speculators as Berlin's housing shortage became more and more acute. The houses, which grew darker and darker the further away they were from the street, were aligned in regimental rows. Thousands of traders and artisans had their shops, restaurants, workshops and haulage carts here in the cellars and backyards. In 1916 there were 25,000 flats with no heating facilities at all and another 400,000 with only one warm room, squashed together in the centre of town and the outlying districts to the north, north-east and south-east, and it was here that 40 per cent of the population, mostly workers, found dwellings. By contrast, luxury homes, shopping boulevards, pleasure-grounds and spacious villas mushroomed on the

In clear contrast to Pfemfert's express rejection of the National Assembly, Max Pechstein lent complete support to this proposal, which he saw as the "cornerstone of the German socialist Republic". Poster, 1919. Museum für Deutsche Geschichte, Berlin

While Friedrich Ebert was sworn in as President of the Reich on 6 February 1919 at the Deutsches Nationaltheater in Weimar by the deputies of the National Assembly, the Maerckersches Landesjäger-korps Military Band played brisk march music outside at the feet of Goethe and Schiller.

Right:
After the National Assembly had voted for the Weimar Constitution on 30 July 1919 it officially entered force on 11 August 1919 when it was signed by Ebert and the members of the Reich Ministry in the Thuringian health resort of Schwarzburg near Weimar. Article 48 gave the President emergency powers from the outset, enabling him to curtail the rights of the elected Parliament drastically and impose his own will. The document is now in the GDR's Central State Archive in Potsdam.

western side of the town. Expensive hotels and restaurants followed. Germany's first big department stores were built in Berlin. An urban petty bourgeoisie and a well-heeled middle class took root and flourished within wholesale commerce and the retail trade and around the factories and crafts. Berlin was indeed the only town in Germany which could compare with the great cities of Western Europe as a modern, capitalist capital harbouring extremely blatant social contradictions.

The epithet "modern" became the hallmark of quality for the cultural phenomena which were born of this industrial expansion. Other cities, such as Dresden, Leipzig, Frankfurt am Main, and even the great towns of the Hanseatic past—Hamburg, Bremen and Lübeck—all of which enjoyed a notable economic significance, had developed without losing their sense of tranquility and deep-rooted tradition, but in Berlin little had remained of these things since the turn of the century. The population explosion had turned the city into a veritable breeding ground for an arts industry motivated by profit alone.

One of the most lucrative and effective institutions was the Berlin press. Just before the end of the last century,

Berlin and its suburbs already had at least 834 newspapers and magazines, 36 of them daily. Some of them were published by the big newspaper companies Mosse, Ullstein and Scherl, which consolidated their dominant position during the twenties to become giant corporations. They had laid the foundations for this expansion before the war.

Even at that time, Scherl was already printing his *Berliner Lokal-Anzeiger* on the most up-to-date American high-speed presses and rotary machines. Correspondents all over the world used the telegraph to send in the latest reports. Press offices, local branches and sales representatives were established. Competition between the big companies spread into a new area when agencies opened to deal in news, making substantial profits for themselves and at the same time offering the smaller newspapers a chance to survive. The Wolffsches Telegrafenbüro, half-owned by the government, headed the field. The big dailies were not merely a source of topical international news, but also offered special services, attracting an increasingly broader circle of readers. The newspaper was an indispensable aid and companion to the city-dweller, thanks to its advertisements, play and book reviews, sports reports, and a whole range of small ads, from flats for sale and jobs vacant to stock market reports and cinema and theatre listings. From a technological point of view, the newspaper world of Imperial Germany was already prepared for the media explosion which followed the Revolution.

With the printing industry expanding in Berlin, it was clear by 1900 that mass literature marketed very well. Alongside a modest number of publishing houses which defended the true interests of art, placing their activities in the service of their writers and catering for the literary tastes of the liberal bourgeoisie, such as S. Fischer or Schuster und Loeffler, the publishers of mass literature did a roaring trade. Some of them provided cheap editions of good literature, but the trend was rather for trash and entertainment along the lines of the American penny dreadfuls, whose authors simply supplied the goods for business-minded editors. It was here that war literature was to find a niche.

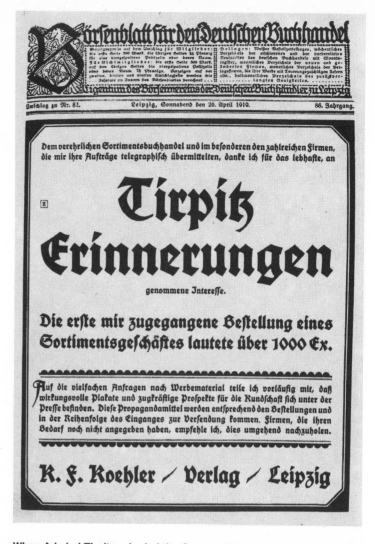

When Admiral Tirpitz, who led the German U-boat campaign in the First World War, published his blatantly nationalistic memoirs in 1919 they were an instant bestseller. Over 100,000 copies had been printed by 1930. This trade advertisement was placed in the *Börsenblatt* on 26 April 1919.

Right:
Max Liebermann, President of the Prussian Academy of Arts in Berlin, opens an exhibition in spring 1921. To the right, holding a brochure, Gustav Böss, Lord Mayor of Greater Berlin.

Quite apart from the demand for tenements, many architects were attracted to Berlin as an industrial town. There was an aura of thoroughly modern construction which was created by the offices, stations, factories, big department stores and theatres, such as the Volksbühne and the conversion of the Schumann Circus into Max Reinhardt's Big Playhouse, begun at the height of the war.

No other town in Germany could lay claim to so many architects of repute as Berlin, with Hans Poelzig, Peter Behrens, Bruno Taut, Bruno Paul and Erich Mendelsohn. The others, the hordes who plastered the desolate façades of the tenement blocks with a gamut of prefabricated stucco elements and obscured the real cultural contributions with a clutter of buildings, remained anonymous.

The visual arts in Berlin evolved within the same antithesis between lucrative kitsch on the one hand and lucrative art on the other. Alongside the great favourites such as Menzel, Corinth, Slevogt and Liebermann, a whole army of painters were kept employed by daubing canvases for the petty-bourgeois living-room, a form of commodity production which found a partial outlet via the department stores. Between the great Berlin art exhibitions staged by the Prussian Academy, the Secession and the Juryless Artists on the one hand, and art for mass consumption on the other, there developed the private galleries which brought the most modern art to Berlin. Paul Cassirer, the patron of Impressionists; Herwarth Walden's *Sturm* Gallery, which kept its doors open to Expressionists of all countries even during the war; the Galerie Flechtheim with its Matisse and Picasso exhibitions, and Goldschmidt und Wollerstein, the art salon which introduced the artists of the Dresden *Brücke* and Oskar Kokoschka to art lovers in Berlin: all of them appealed to a broad bourgeois public.

The theatre was the most notable example of heterogeneity in Berlin's cultural life. There was direct confrontation between the monarchist tradition cultivated in the royal Schauspiel- und Opernhaus, the entertainment industry with its operetta, variety, cabaret, out-of-town theatres and night clubs, and the modern stage. There were 30 theatres playing every night in Berlin at the be-

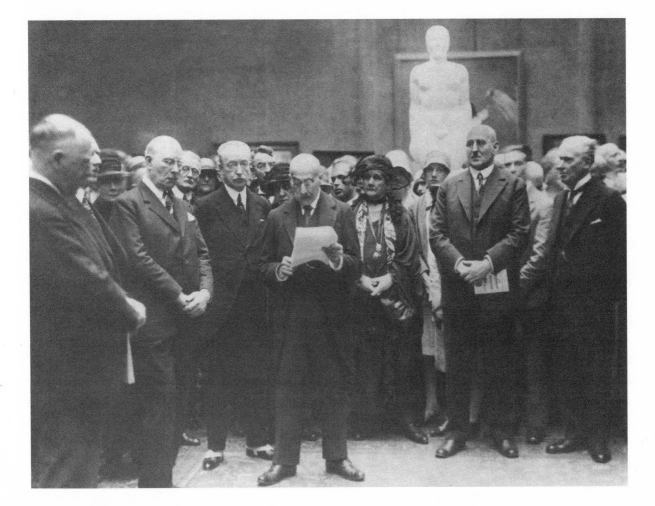

ginning of the century. Almost all of them were geared to a fairly regular audience, formulated their own, independent repertoire, and yet shared in the discoveries and appeal of other theatres. Nowhere in Germany was theatre so competitive and nowhere did it pose such a challenge to the imagination of great producers and to the performance of great actors as in Berlin. When Herbert Jhering arrived in Berlin in 1907, it was the theatre which made a decisive impact on him, as it did on many others: "It was soon evident that Berlin's theatres differed in all important regards from those which I had seen in Hanover and Munich, or indeed was later to see in Vienna. (. . .) In Berlin, the stage was a respiratory organ for the city, a part of its very body, as necessary as streets, underground trains, houses, restaurants, as necessary as the River Spree, Lake Wannsee or the Grunewald, as necessary as work, factories and Potsdam, necessary, and so, like them, taken for granted. It was not for special occasions, nor for the learned few, it was neither a carnival nor an object of snobbery. It was everyday life, but this everyday life was excited, charged, alert, clever, rousing. Anything that turned flabby was quickly cast out, and whatever promised to stimulate was taken up. Taken up? No, more than that: sucked in, strengthened, championed, asserted. (. . .) Berlin's progressive spirit asserted itself everywhere."[21]

A curious nostalgia took hold of Berlin's conservative forces after 1918, a yearning to see the return, not only of the Kaiser, but of Berlin culture as it had been in its heyday. Berlin had been a moderate town before the war, for all its progressive spirit, and the trends had been set by an intellectual community of liberal, nationalist inclinations. Now, in the eyes of the conservatives, the city stood on the brink of chaos, toppling between Americanism and Bolshevism. But under the auspices of the Republic, it was the left-liberal intellectuals, many of whom had close links with the working-class movement, who formed alignments and promoted those elements which had been decried under the Kaiser as "modernity" at its most extreme. The first move came from the theatre when Leopold Jessner, an Expressionist and Social Democrat, was invested almost symbolically with the position of Intendant at the former Royal—now State—Schauspielhaus.

Berlin was already preparing during the years of inflation to become the scene of great experiments in modern European art as the city's contradictions increased. Its big industrialists were converting to peace-time production, having pocketed millions as a result of the war. At a single stroke of the pen, the legislation constituting Greater Berlin handed them a centrally controlled market which absorbed 50 per cent of their entire output. The town itself was now an economic enterprise vulnerable to monopoly where it was worth making extravagant investments. New banks and commercial districts sprang up, with luxury hotels for a busy tourist industry; the way was smoothed for pleasure-grounds and shopping centres. The cultural industry which had sprouted before 1914 was a mere sapling compared to what was to happen now. There were signs of the boom to come even during the inflation period. When Carl Zuckmayer came to Berlin in 1921 he witnessed the city on the eve of its golden dreams: "Berlin in the early twenties was flash, it reeked of chypre, make-up remover and bad petrol, it had lost the splendour of its Imperial and grand-bourgeois era and only later was it launched to its dazzling, hectic zenith.

'Why cry when you part?
There's another waiting at the next corner,'

urged the most popular hit, which could be heard ostentatiously blaring from every *Diele* (that is what they called the little bars peddling entertainment found on every street corner); people trembled hysterically when the latest exchange rate for dollars was announced and shot themselves in the head after the first row with their girlfriend.

"Nevertheless, one could already sense that incomparable intensity, a hint of that turbulent upswing which in a few years was to make Berlin the most interesting, exciting city in Europe. (. . .) Berlin tasted of the future, and that made people prepared to accept the filth and the cold."[22] Most of the population of Berlin did not share the euphoria of intellectuals like Zuckmayer. The workers and lesser tradespeople were at the mercy of the filth and cold. There was nothing in their everyday lives to suggest the flavour of the future.

The new productive ethos—
Expressionism en route to Weimar

No sooner had the November Revolution begun than a generation of Expressionist playwrights, who had always been defamed under William II as wayward young men, took the German stage by storm. Although some Expressionists had broken through the iron curtain in 1917, as the theatres wearied of their dutiful repertoires packed with patriotic appeals for endurance, it would be an exaggeration to talk of success and acknowledgement. It was usually the younger drama advisers and producers who smuggled these plays in among the obligatory classics, comedies and hymns to heroism, as audacious, marginal experiments for hungry culture-lovers to relish. In late 1916, for example, there was a production in Königsberg of *Die Temperierten* (The Moderates) by the theatre critic Emil Faktor, and in early 1918 the same town was treated to *Ein König Esther* (A King Esther) by his colleague Max Brod. Adam Kuckhoff staged his own play *Der Deutsche von Bayencourt* (The German from Bayencourt), a plea for peace and friendship with France, at the Neues Theater in Frankfurt am Main, where he was engaged as adviser, actor and producer. Twenty years later, when he was actively involved in the anti-fascist resistance to Hitler, Kuckhoff used the same title for his most famous novel. Soon afterwards he fell into Nazi hands and was executed. *Der Einsame* (The Lonely Poet), a play about the death of mankind, was first performed in Düsseldorf in 1917. Its author, Hanns Johst, was eventually to be President of Hitler's Reich Chamber of Writing and to achieve inglorious fame for his drama *Schlageter* in 1933, when he succeeded Heinrich Mann at the Academy. Walter Hasenclever's *Ein Geschlecht* (One Race) was staged in Dresden in late 1916. Hasenclever and Franz Werfel, whose plays *Troerinnen* (Women of Troy) and *Der Besuch aus Elysium* (The Elysian Visitor) had their premières in Berlin, were two of Expressionism's most prominent playwrights.

But there was really only one who had made a name for himself at a range of theatres before the November Revolution, and that was Georg Kaiser, who invested his great dramatic talents in over seventy plays during the course of his lifetime. Almost all of them were a success. Kaiser was also the only one to respond to the current situation with a prolific assortment of works. *Die Koralle* (The Coral) and *Von morgens bis mitternachts* (From Morn till Midnight) ran in Munich in 1917; *Die Sorina* (Sorina) in Berlin; *Rektor Kleist* (Rector Kleist) in Königsberg; the one-act plays *Claudius*, *Friedrich und Anna* (Frederick and Anne) and *Don Juan* and the grotesque comedy *Der Zentaur* (The Centaur) in Frankfurt am Main. *Gas*, an aggressive drama which by this time was able to make a topical revolutionary impact, was also given its première there on 28 November 1918. It was a plea for the mass of humanity to liberate themselves from the constrictions of capitalist industry, formulated in terms of an Expressionist Utopia, a world of love and brotherhood.

The Expressionist movement had begun in Germany around 1910. Theatre historian Siegfried Melchinger describes it as the "German chapter" in a "world revolution of artistic theatre" and continues: "Amid the premonitions of war, the younger generation of around 1910 came to realize that political measures or social criticism would no longer suffice to prevent the disaster. The only salvation lay in the transformation of all humanity. When so many died on the battlefields of the war, this idea was galvanized into action: the writers became revolutionaries and formed an alliance with the politicians who were pressing for revolution. This 'transformation' from a self-oriented profession of belief to missionary preaching was the theme of many Expressionist plays."[23] Admittedly, few of these writers evolved beyond the evangelizing of all-embracing brotherly ideals or a state based on the good sense of a spiritual élite, and few recognized the need for organized political struggle.

Expressionism's artistic revolt was by no means confined to drama and the stage. In fact, it originated in painting, where young German artists, stimulated by Cézanne, Van Gogh and Matisse, were searching for new forms of expression. They identified with the philosophy of Heinrich Mann, who had published an essay, *Geist und Tat* (Spirit and Deed) in 1910, calling on artists to be politically active.

Naturalism, with its meticulous descriptions of the squalid world around, had long since been discarded as dismal. Impressionism, the momentary impression internalized and thrust cursorily onto canvas, dissolved into the harmless, transparent colours of atmospheric scenes devoid of all reality. The younger generation rebelled against all this, asserting a new claim on art. They called their art expressive, and it was a sheer screaming protest against all the old conventions poured forth in the loudest colours and in wild ecstatic forms. The young poets and playwrights took up the cry. They were ready and determined to defy their world with brush and paint or pen and ink. Ernst Ludwig Kirchner, Erich Heckel and Karl Schmidt-Rottluff had already founded the Dresden artists' group known as *Die Brücke* before 1910. The *Neue Künstler-Vereinigung* was set up in Munich in 1909, and it was from this association that the *Blauer Reiter* emerged in 1911, a grouping which included Vassily Kandinsky, Franz Marc, Paul Klee, August Macke, Alfred Kubin, Heinrich Campendonk and eventually Lyonel Feininger. They felt an affinity with the French Expressionists, *Les Fauves* (or "wild beasts") and their leader Matisse. In 1912 Franz Marc declared: "In our era of great struggle for the new art we are fighting 'wild', without organization, against an old, organized power. The struggle appears uneven, but in spiritual matters it is never the quantity, but the strength of ideas which wins."[24]

In 1910, at around the same time as the *Neue Sezession* with Max Pechstein, Georg Tappert and Arthur Segal, the Expressionist literary magazine *Der Sturm* began publication in Berlin, with Herwarth Walden as editor. In the poet August Stramm he found a champion of verbal Expressionist art, gaining a considerable influence over the generation of young poets such as Johannes R. Becher.

Franz Pfemfert's *Aktion* carried similar weight, differing from *Der Sturm* by dint of its radical politics. This became Germany's leading anti-war magazine alongside Schickele's *Weisse Blätter*, published from exile in Switzerland. It was *Aktion* which printed Ludwig Rubiner's appeal to the younger generation of writers for political commitment in their work and fraternity with the working masses. There

was also a regular column of "Verse from the Battlefield" which carried the anti-war poetry of Yvan Goll, Max Herrmann-Neisse, Carl Einstein, Rudolf Hartig and Carl Otten. The magazine soon found space for lithographs and woodcuts by visual artists. Meanwhile *Der Sturm* developed a happy blend of art and literature to become one of Europe's leading art journals.

Grammar school student Joseph Würth founded his publishing enterprise *Die Dachstube* in Darmstadt in 1915. He printed his magazine on a manual press installed in his parents' attic, and was immediately supplied with visual material by young artists from the town. Carlo Mierendorff and other friends sent literary contributions from the field, and Expressionist writers like Kasimir Edschmid and Max Krell, who had already established their reputations, assisted the young publisher with advice and pieces of their own.

Wieland Herzfelde was not much older than Würth when he began publishing his journal *Neue Jugend* in Berlin in 1916, a foretaste of his future publishing house Malik. The aim of the periodical was to print works by young writers, intellectuals, artists and musicians. "We shall take up the cause of all those who encounter the opposition and incomprehension of the public," announced the editor's statement, "but above all the youngest among them, who have not yet found a place in the literature of our day."[25]

There were only scattered examples, during the last years of the war, of Expressionist artists making emotive declarations of their commitment to revolution, immersing themselves in the mass of working people, articulating a conscious pride in their role as artistic workers leading manual labour through the gates to a new world with a new culture for the human race. The word "revolution" had been on everyone's lips, but nobody knew quite what it meant. So when they actually witnessed revolution in November 1918, there was inevitably an exuberant eruption of declarations which, for a brief while at least, lent Expressionism the appearance of a united, revolutionary political movement. The first spontaneous statements were published in manifesto form by a torrent of magazines devoted to championing Expressionism. All of them bore

1 Max Beckmann painted *Die Nacht* (Night) in 1918/19. The artist seems to have turned his flashlight on the mood in Germany during the first post-war winter. *Das Kunstblatt* wrote: "It is as if all the horrors of that homicidal war had been distilled into one essence, and the storm of violence, brutality and crime rages on, as this family is attacked by a murderous gang, in apocalyptic pursuit of those blood-stained years." Kunstsammlung Nordrhein-Westfalen, Düsseldorf

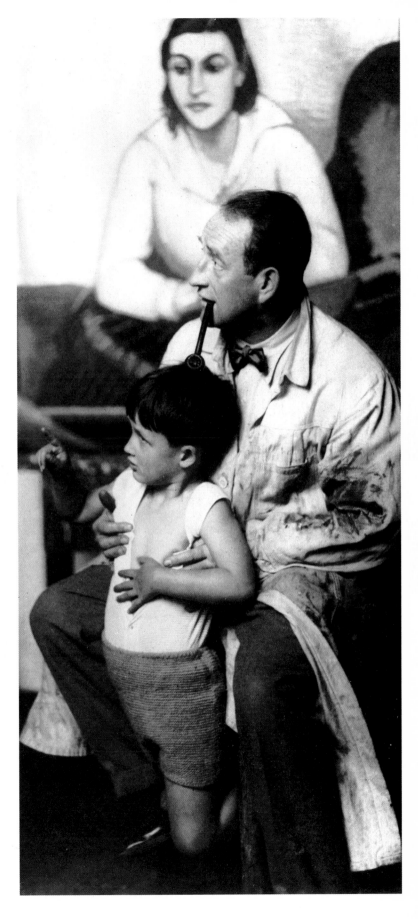

Left:
2 Artist Max Pechstein was an unswerving advocate of the German Republic. In January 1919, Pechstein, Ludwig Meidner and Johannes R. Becher published the manifesto *An alle Künstler* (To All Artists). This threw down the gauntlet to "moth-eaten Imperial art" and articulated the Expressionist plea for "justice, liberty and love"—Cover by Max Pechstein

3 Max Pechstein and his son in his Berlin studio in 1931. A portrait of the painter's wife hangs in the background.

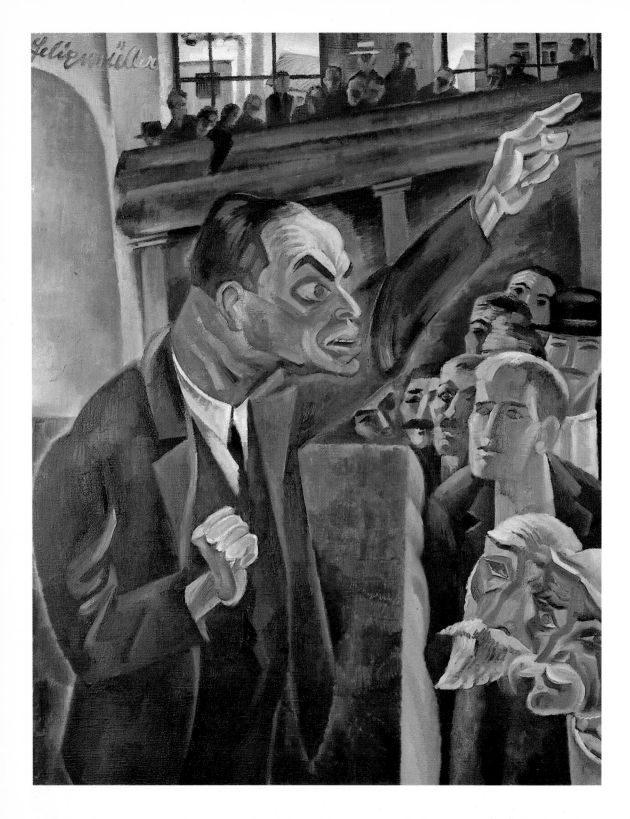

4 Conrad Felixmüller was one of the founders of the Dresden Secessionists *Gruppe 1919*. *Otto Rühle spricht* (Otto Rühle Speaks), painted in 1920, depicts the radical left-winger and co-founder of the Spartacus League when he was serving on Dresden Workers' and Soldiers' Council in 1919. Rühle later joined the SPD, where he pressed for educational reform. Staatliche Museen zu Berlin, Nationalgalerie/Otto-Nagel-Haus

5 Paul Klee, who worked with the Weimar Bauhaus from 1920, was Germany's most prominent Constructivist painter. The water colour *Betroffener Ort* (Location Hit), painted in 1922, might illustrate Klee's declaration of 1920, in which he wrote: "Art does not reproduce what is visible, but makes visible. By its very nature, an illustration leads simply and quite rightly into the temptation of abstraction." Kunstmuseum Bern, Paul Klee Stiftung

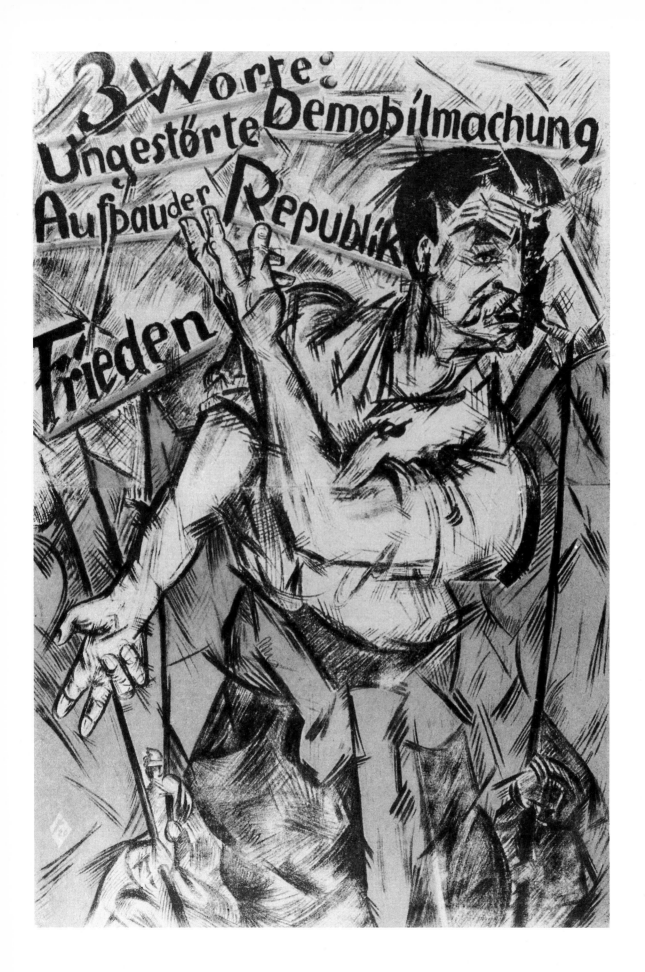

10 Expressionism in 1919: the set for Robert Wiene's film *Das Kabinett des Dr. Caligari* (The Cabinet of Dr Caligari), designed by Hermann Warm, Walter Röhrig and Walter Reimann, projected a completely artificial world. The photo shows Caligari's medium Cesare (Conrad Veidt) on the roofs of the town as he carries off a young woman.

11 The Expressionists had a predilection for woodcuts. *Aufschrei* (Cry)
by Karl Jakob Hirsch appeared in the magazine *Der schwarze Turm* in
1920.

HEFT 1

Veröffentlichung

der

NOVEMBER
GRUPPE

HERAUSGEGEBEN VON
H. S. v. HEISTER &
R. HAUSMANN

PAUL STEEGEMANN
VERLAG

HANNOVER

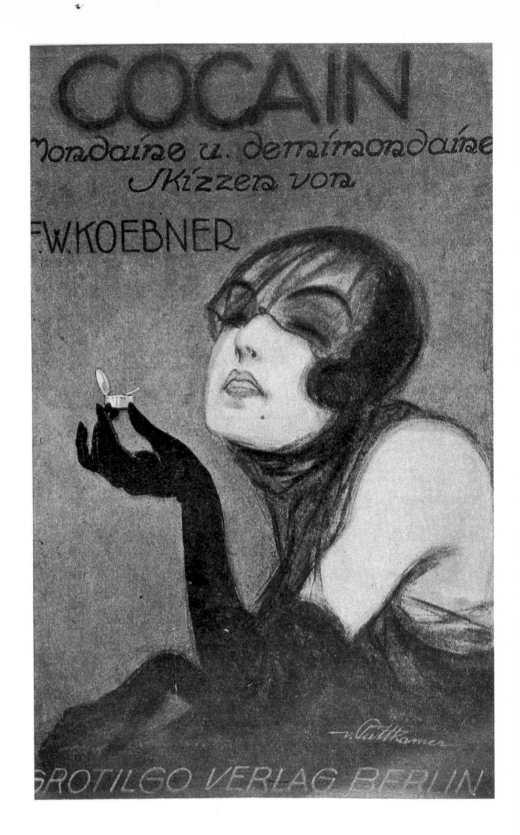

COCAIN

Mondaine u. demimondaine
Skizzen von

F.W. KOEBNER

GROTILGO VERLAG BERLIN

12 The *Novembergruppe*, formed in Berlin at the end of 1918, was the most important association of artists in the early post-war years. Four issues of their magazine *NG* were printed in Hanover in 1920, but then stopped. The Dada movement in Hanover also gravitated towards publisher Paul Steegemann.

13 Morals loosened in German cities in the immediate post-war years. Once police censorship had been lifted, ill-disguised pornography blossomed in literature and cinemas. Prostitutes and drug-pushers did a roaring trade in sleazy nightclubs. This cover page for these "sketches of worldly and promiscuous ways" published in 1920 is typical of the period.

Berlin,
halt ein!
Befinne Dich.
Dein Tänzer
ift
der Tod.

DIE PROSTITUTION II.TEIL
SOZIAL HYGIENISCHES FILMWERK, UNTER
MITARBEIT von DR. MAGNUS HIRSCHFELD.

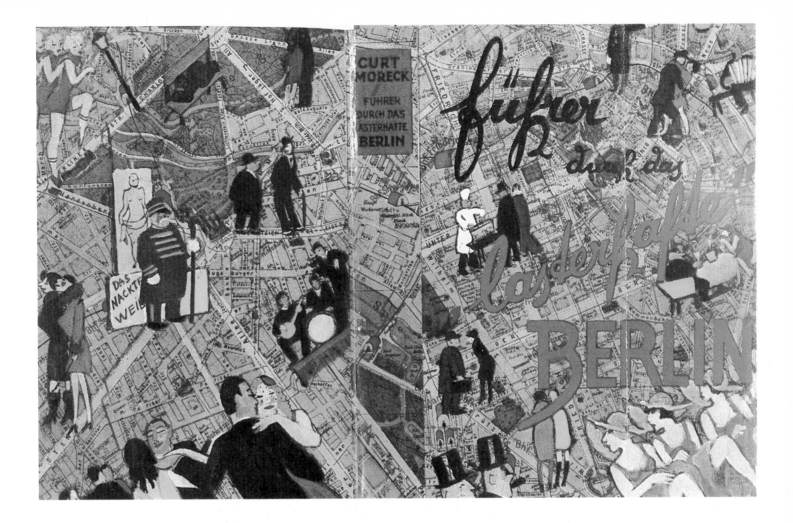

Left:

14 This bill was posted all over Berlin in 1921 to warn the population about the dangers of venereal disease. The urgent tone of the wording, "Berlin, stop and think! You are dancing with Death!" is a vivid indication of the feverish, unhealthy mood which characterized the inflation period.

15 These advertisers sought to give their silent blue movie of 1920 a scientific veneer by mentioning sexologist Magnus Hirschfeld. It seemed a good gimmick to boost ticket sales, as the Institute for Sexual Research, which Dr Hirschfeld had opened in 1919, was a highly controversial issue.

16 "City vice" fed an entire industry until the early thirties. This guide to Berlin printed in 1930 boasts about it on the cover.

Following page:

17 Laszlo Moholy-Nagy painted *Brücken* (Bridges) in 1920. It was the year he arrived in Berlin from Budapest and came into brief contact with the Dadaists. His own painting was influenced by Kasimir Malevich's Constructivism. In 1923 Moholy-Nagy joined Bauhaus, for which he contributed typographical works, photography and stage sets. Saarland-Museum, Saarbrücken

names which advertised their principles, their rebellion, their will to transform the world: *Das Tribunal* (The Tribunal), *Der Revolutionär* (The Revolutionary), *Kräfte* (Forces), *Die Rote Erde* (Red Earth), *Der Sturmreiter* (Stormrider), *Der Schrey* (The Cry), *Die Rettung* (Salvation) and so forth.

The stage, like the press, was still a key centre of the campaign. Not only did Expressionist drama conquer the existing theatres, but many young producers and drama advisers also moved out of the traditional establishments and set up houses of their own, with the intention of playing messianic Expressionist works solely for the working-class. Rudolf Leonhard and Karlheinz Martin founded the *Tribüne* in Berlin, which opened with Hasenclever's *Der Retter* (The Saviour) and *Die Entscheidung* (The Decision) and went on to stage a play by Ernst Toller, *Die Wandlung* (The Transformation), for the first time. Toller soon became one of Germany's most frequently produced Expressionist dramatists. *Masse Mensch* (Mass Man) and *Die Maschinenstürmer* (The Machine Breakers) found their way into the repertoire of important theatres. The première of *Hinkemann* in Dresden unleashed a massive political scandal in the theatre in 1923 as a result of reactionary provocation. Leonhard and Martin were soon to leave the *Tribüne* in protest because the company players and managers refused to perform for striking metalworkers in Berlin who had put in a request. It was evident from this episode, if not before, just how far removed Expressionist revolution, with its absolute faith in transformation and salvation, actually was from the revolutionary issues being fought out in contemporary class struggles.

There was a similar situation in the visual arts. Painters, sculptors and architects met in Berlin on 3 December 1918 to constitute an association which was to unite Expressionist artists throughout Germany under a single banner. Thus the *Novembergruppe* was born, and all through the years of the Weimar Republic it remained the only big organization in Germany which adhered to its Expressionist programme and even drew musicians and writers into its ranks. The draft manifesto declared: ''We stand on the fertile soil of revolution. Our slogan is Liberty, Equality, Fraternity! (. . .) We bestow our immaculate love on young, free Germany, from which we rise to fight with courage and without inhibition, drawing on all the forces at our disposal, against reaction and the obsolete past.''[26] But most members were unable to accept these principles. An opposition even formed within the *Novembergruppe*, with Otto Dix, George Grosz, Rudolf Schlichter, Raoul Hausmann, Hannah Höch and Georg Scholz among its number. They demanded an uncompromising decision to pursue revolutionary political art in the service of the working community, while the majority of members, among them founders Georg Tappert, César Klein, Moritz Melzer, Rudolf Belling and Max Pechstein, had long been preoccupied with the propagation and implementation of their own aesthetic concept of Expressionism as avant-garde art, a strategy which was bringing them great success. There were similar contradictions within the Working Council for Art, founded in 1919, and the young artists' associations set up in other towns, such as *Sezession Gruppe 1919* in Dresden, where Conrad Felixmüller and Otto Dix defended their political aims for art against a purely aesthetic tendency, and the *Neue Sezession Gruppe 1919 des Jungen Rheinland* based in Düsseldorf, where Otto Griebel and Otto Pankok adopted the proletarian position. The revolutionary momentum was preserved at the Bauhaus, the new art college for functional construction which Walter Gropius founded in Weimar in 1919, funded in part by the government. As far as groups of artists in Magdeburg, Bielefeld and Karlsruhe were concerned, the revolution had been accomplished with the end of the war, and there were many more Expressionists who felt the same way. They welcomed the new Weimar state, for at last they were no longer denied public recognition for their profession. The art historian Jost Hermand, who coined the phrase ''ethos of new productivity'' as a fundamental characterization of Expressionist revolt at its incipience and throughout its war-time development, describes the many-faceted contradictions within the movement thus: ''There is a problematical magnificence about the all-embracing pretensions with which the manifestos and pamphlets of this tendency demand a new 'openness towards the universal' from the bourgeois order now doomed to extinction, and this culminates not infrequent-

ly in the postulate that all human relations require total renewal. (. . .) And so alongside these directly political tendencies we find a series of spiritually idealistic, purely cynical, anarchistic or unorthodox religious currents which even overlap with them to some extent, since older ideologies dating from the world of art styles around 1900 are sometimes so powerful that the Expressionist impulse is only able to assert itself by means of a grotesque restyle. That is why the revolutionary embryo in this movement is constantly in danger of toppling from specifics into human, Utopian, even megalomaniac generalities."[27]

On 25 May 1919 *Das Junge Deutschland*, an experimental stage set up at Max Reinhardt's theatre in 1917, which saw itself as a forum for Expressionist drama and produced Reinhard Goering's rebellious anti-war play *Die Seeschlacht* (The Sea Battle) in March 1918 in the middle of Ludendorff's Spring Offensive, put on two works by Oskar Kokoschka, *Der brennende Dornbusch* (The Burning Bush) and *Hiob* (Job). Kokoschka, already a well-known painter but still undiscovered as a writer, produced the plays himself. The Kammerspiele auditorium was packed. The première, where the audience protested loudly at the utter incomprehensibility of the action on stage, was a fully-fledged theatre scandal. Even Alfred Kerr, the famous theatre critic whose sophisticated and sharp-sighted judgements bore the authority of a court of law, was obliged to confess that he, for once, was flummoxed. He hunted in desperation to find the meaning of the plot, using terms such as "mystosketch" and "E.T.A. Hoffmann in paint". Yet unlike the booing spectators, Kerr discovered something which ultimately helped to explain the triumphant advance of Expressionist theatre in the early Weimar years: "Anyone who saw the Bush spectacle can have no doubts that the painter took his work seriously. This was painting conceived especially for the boards. Here is a producer of plays who is simply without his equal. Even spoken sound has been musically graduated to the last detail. Yes, even in the polish he gives to verbal sound Kokoschka (. . .) remains unparallelled to this day. It is as if he has composed an oratorio without music and with almost no words."[28]

Carricaturist Karl Arnold captured the atmosphere of the post-war years in so many of his drawings. *Friedrichstrasse*, his sarcastic portrayal of one of the flourishing pleasure-grounds in the German capital, dates from 1921.

Right:
The Bar. Drawing by Ludwig Meidner, 1919.

Once Expressionism had taken hold of the theatre, completely new aesthetic standards held sway. The Expressionists no longer placed the stage in the service of drama, but regarded theatre as a synthetic work of art consisting of literary text, the actor's verbal and body language, painting, architecture and music, with all these elements merging into one another. Words were composed like language, sets constructed like architectural formations, the text was a material for processing like any other. In Kokoschka's production, this new idea of theatre

had simply found early, one-sided expression as a vital visual idiom from the point of view of a painter.

Then in December 1919 Leopold Jessner exploited the full potential of this revolution in Thespian art with his maiden production, Schiller's *Wilhelm Tell* (William Tell) at the Staatliches Schauspielhaus. The stage was hung with black drapes and before them stood nothing but a sober giant staircase where the actors—the best in Berlin with Albert Bassermann and a very young Fritz Kortner in the lead parts—demonstrated what Jessner called Theatre of Convictions: highly expressive political stageplay free of all decorative accoutrement. The political standpoint inherent in Schiller's drama was powerfully accentuated and bore a clear relation to the present by nature of the performance. The old classic had been transfigured into a magnificent, topical liberation drama. Jessner inspired all the great producers who followed him in the Weimar Republic with his radical tailoring of a classical work and his provocative, new, functional stage setting. His audacious scaffolding entered theatrical history as Jessner Stairs. There were countless imitations at almost all German theatres over the next few years. The Expressionist stage became as fashionable as Free Dance, which Emile Jacques-Dalcroze had helped to found in Germany in 1911 at the Hellerau School of Rhythm, Music and Physical Instruction. Expressionist painting and sculpture also became the fashion and took their place at major art exhibitions on an equal footing with the works of Max Liebermann.

But even though Expressionism was now a popular affectation and, as Kasimir Edschmid observed sarcastically in 1920, the spinsters of Kötzschenbroda, Ulm and Gnesen now gave vent to their unappreciated German melancholy in abstract landscapes and triangulated visions, rather than the old-fashioned bolsters and carvings, it was not everyone who forgot that the formal idiom of Expressionism had not evolved from any quest for modern originality but that this revolution in art had been born as an aesthetic consequence of artists' rebellion against the bourgeois world of the Imperial Reich and its war. Even so, the revolutionary momentum dissipated as they came to terms with the Republic. Many Expressionists retreated completely and bade farewell to the hopes they had once cherished for those November days. This was particularly the case among writers, who had made a notable impact as Expressionists. René Schickele, editor of the *Weisse Blätter*, was one example, and another was Kasimir Edschmid, who remarked in 1920 on the state of the art: "The orators, painters, writers, producers, sculptors of this young community are busy working, and what lies behind them surely has nothing to add. Perhaps in ten years another generation will come, perhaps attacking ours with tomahawks, perhaps with a most depressing Nazarenerity. We shall take no notice of either, carry on along our road, do our deeds."[29]

Edschmid was proved wrong. It was men of his own generation who were already founding the National Socialist German Workers' Party (NSDAP) with their "tomahawks" while he wrote those sentences.

The poet and playwright Walter Hasenclever was a leading exponent of Expressionism in literature. In his book *Der politische Dichter* (The Political Writer), published in 1919, he called for a "politicization of the intellect". In 1914 his play *Der Sohn* (The Son) raised the issue of the generation conflict, which was to become a frequent theme in the twenties. The photo shows Hasenclever disguised as a woman at a fancy-dress ball for artists in 1921.

Ernst Toller's drama *Hinkemann* was the story of a castrated war invalid which depicted the fate of a generation of soldiers who had returned from the front. The photo was taken at the première in Dresden's Schauspielhaus in 1924. Paul Wiecke was the producer.

Like Herwarth Walden, editor of *Der Sturm*, Franz Pfemfert was responsible for a number of other cultural initiatives in conjunction with his magazine. Exhibitions and readings were held at his bookshop, the Aktions-Buchhandlung. Conrad Felixmüller's advertisement for the shop was printed regularly in *Die Aktion*.

Otto Dix, poster for an exhibition by *Gruppe 1919*, Dresden 1920. Staatliche Kunstsammlungen Dresden, Kupferstichkabinett

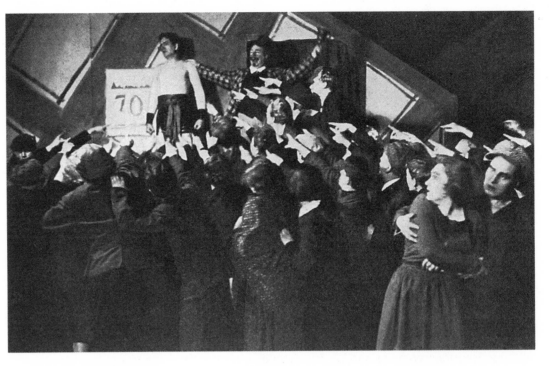

"In this building the German people granted themselves, through their National Assembly, their Weimar Constitution of 11 August 1919." Memorial plaque on the Deutsches Nationaltheater, Weimar, bronze relief by Walter Gropius, 1919.

IN DIESEM HAUSE GAB SICH
DAS DEUTSCHE VOLK DURCH
SEINE NATIONALVERSAMMLUNG
DIE WEIMARER VERFASSUNG
VOM 11. AUGUST 1919

Inflation

**"Help! Here comes Dada!"—
The great affront**

1920: Bobbed hair was just coming into fashion for women. Mothers flung up their hands in horror at the sight of their daughters' shorn necks. In January the music shops were selling "Tiger Rag", the first jazz record to arrive in Germany. The Kaiser was in Holland writing his memoirs. His supreme commander Hindenburg appeared in Berlin to answer a committee of investigation: the Entente had insisted that war criminals be brought to justice. Berlin's monarchists celebrated his return in triumphal procession. Ludendorff was back, too, and on the Sunday before Advent, when the dead are traditionally remembered, he had staged a big funerary rally for the "victorious" German army at the Theater des Westens. A foreign correspondent of the *Berliner Tageblatt* cabled news of the German Crown Prince from Copenhagen: "The Europa Press office reports: The *Berlingske Tidende* correspondent visited the former German Crown Prince on the island of Wieringen. According to the Danish journalist the Crown Prince is also busy writing his memoirs. The Crown Prince spoke very bitterly of Ludendorff and his General Staff. In the opinion of the Crown Prince Ludendorff was a talented, excellent general for a short campaign but totally inadequate for a long war. During the interview the Crown Prince admitted that he had never been popular in Germany, but he denied having wanted the war. He had simply ensured that Germany was armed for it. In conclusion he said: 'I do not want people to judge me particularly intelligent, but I am certainly not degenerate, as certain French, English and American newspapers claim. And if I were, how could I possibly have declared war with the entire world against us.'"[30]

The *Rote Fahne* of 4 March 1920 carried a detailed article warning of a "creeping Ludendorff coup". The warn-

ing was repeated on 12 March. At five o'clock on the morning of 13 March the Ehrhardt Brigade entered Berlin. The citizens' militia sent to defend the Republic instead welcomed these heroes of the Baltic Army who had painted white swastikas on their helmets and tanks. Noske implored General Seeckt to dispatch army troops to fight for the Republic, but neither he nor any of the other Generals had any such intention. The short campaign, at which Ludendorff was allegedly so talented, was the result of long-armed preparations. The Reichswehr was supposed to eliminate the Republic and establish a military dictatorship in Germany. By 6 o'clock Germany had a new government. The Chancellor of the Reich was Wolfgang Kapp, a leader of the German Fatherland Party which he had founded during the war together with Admiral Tirpitz, and which counted the writer Ludwig Thoma among its members. The coup had been organized by General Lüttwitz, who was rewarded with the post of Defence Minister. It was a job he had demanded in the ultimatum which he had sent Ebert on 10 March, in which he also called for a boycott of the paragraph in the Treaty of Versailles which sought to reduce the German army to 100,000 men. The Entente had already postponed the deadline for its demands until 10 July 1920 because Ebert had managed to convince them that he needed his entire army to ward off the threat posed by Bolshevism. Now that army was turning on him. The government fled to Dresden and then, on 15 March, to Stuttgart. The workers had put down their tools well before they received the call for a general strike. In the other parts of Germany, where the Generals, commanders, German National People's Party (DNVP) and German People's Party (DVP) had also switched allegiance to Kapp, the USPD, SPD, trade unions and KPD nevertheless immediately issued a joint call in many cases for resistance to the coup. They were united in their determination to defend this actually unsatisfactory Republic against a military assault with every means available, for it was a question of salvaging the achievements of the November Revolution, however meagre they had been.

The Baltic forces boasted about their anti-Republican symbols in a song:

Hakenkreuz am Stahlhelm,
schwarz-weiss-rotes Band—
Die Brigade Ehrhardt
werden wir genannt.
(Our helmets bear the swastika,
Our sash is black, white and red.
They call us the Ehrhardt Brigade.)

The workers responded with their own version, which everyone had learnt by the evening:

Hakenkreuz am Stahlhelm,
schwarz-weiss-roter Lump—
die Brigade Ehrhardt
schlagen wir in Klump.
(Their helmets bear the swastika,
We're going to smash the Ehrhardt Brigade to pulp.)[31]

From 15 to 17 March the Weimar Republic witnessed the tremendous potential force of the united German working class. Every wheel ceased turning as twelve million workers went on general strike. Even the bourgeois government parties trembled at the sight of this mass action, and the Democrats began negotiating with the dictators. The strike evolved into armed struggle. The Red Ruhr Army was constituted out of 100,000 armed workers in the Rhineland. Action councils all over Germany organized the resistance to Kapp. Once again Germany was a hair's breadth away from being a *Räterepublik*. Kapp fled to Sweden on 17 March and Lüttwitz resigned. The old government was restored to its former dignity and rushed to stifle the general strike. Ebert and all his men turned up in Berlin again on 20 March.

The armed conflict between workers and forces of the Reichswehr which erupted in all major towns in Germany

The Dresden artist Otto Griebel was a champion of committed Tendentious Art. He joined the KPD in 1919 and was a co-founder in 1929 of the Association of Revolutionary German Artists (ARBKD). His pencil drawing *Ein Stück Europäischer Kulturaufschnitt (Made in Germany)* (A Slice of European Cultural Ham, Made in Germany) dates from 1922. It is interesting to compare this drawing with Hannah Höch's collage *Schnitt mit dem Küchenmesser. . .* (Ill. 18), whose title similarly expresses a metaphorical intention to offer a cross-section. Museum für Deutsche Geschichte, Berlin

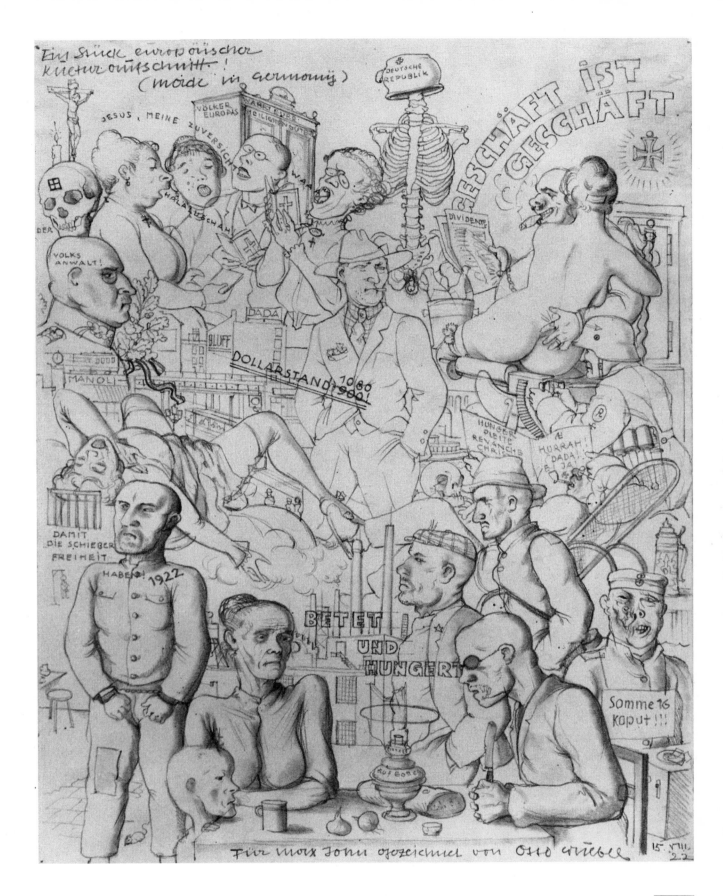

during the Kapp Putsch also hit Dresden. Barricades were erected right alongside the Zwinger Palace. On 15 March a shot ricocheted through a window of the art gallery and landed in Rubens's painting of Bathsheba bathing. The next day the Dresden newspapers and advertisement columns carried a letter of protest from Oskar Kokoschka, who had just been appointed Professor at the Dresden Academy:

"I implore all those, be they radicals of the left, the right or the centre, who propose in the future to substantiate their political theories by means of gunbattles to refrain henceforth from conducting these warlike manoeuvres outside the Zwinger Art Gallery and to transfer them to the exercise grounds on the Heath where human culture is not endangered. (. . .) No doubt the German people will later discover more happiness and meaning from the sight of the paintings thus saved than in all the views of to-day's politicizing Germans put together. I dare not hope to prevail with my counter-proposal, which is that, as in Classical times, feuds in the German Republic be fought out in future in duels between political leaders, possibly at the circus, rendered more impressive by the Homeric cursing of the parties which follow them. That would be more harmless and less confusing than the methods currently employed.

Oskar Kokoschka
Professor at the Academy
of Fine Arts in Dresden."[32]

Over 40 newspapers in Germany printed this appeal, and two Berlin artists used the occasion to defend their own revolutionary aims for art and launch a vehement attack on the prominent Expressionist painter. The assailants were two Dadaists, George Grosz and John Heartfield. They published an article in *Der Gegner* entitled "The Knave of Art", by whom they meant Kokoschka. It provoked a long-drawn-out debate between Expressionists and bourgeois humanists, and even the KPD and USPD newspapers chimed in. The issue at stake was the function played by the cultural heritage in the arts of the German Republic. As far as Grosz and Heartfield were con-

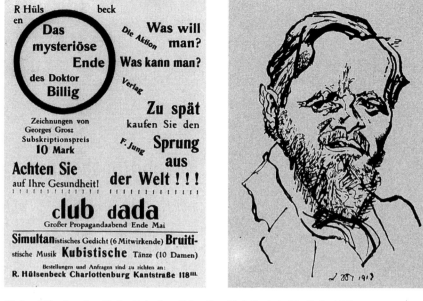

Richard Huelsenbeck's leaflet advertising the Club Dada in Berlin is a typical example of Dadaist typography.

Oberdada Baader (Top Dada Baader). Portrait drawn by Ludwig Meidner, 1919.

cerned, the matter was decided: neither the heritage nor anything which followed had any function whatsoever any more. Their battlecry was "Down with art!" And by that they meant everything which helped to justify bourgeois claims on culture and the bourgeois sense of value. The only thing which was to be permitted any validity was a new art for the proletariat, totally freed from all tradition. Dadaism, the bourgeois bogey, had come to haunt Germany and intended to take the Revolution seriously.

Dadaism appeared in Germany during the war, conquering Berlin as its first bastion. The cultural personalities close to Wieland Herzfelde's Malik publishing house (his brother John Heartfield, George Grosz, Erwin Piscator, Walter Mehring, Carl Einstein), and to the magazine *Die freie Strasse* published by writer and economist Franz Jung (Raoul Hausmann, Hannah Höch, the Russian painter and musician Yefim Golyshev, dancer Gerhard Preiss, and architect Johannes Baader) were all fascinated by the idea which Richard Huelsenbeck brought to Berlin from the Cabaret Voltaire in Zurich. The Cabaret Voltaire had been set up by German emigrés from the arts community who had taken the rebellious

step, rather than continuing to tinker with art that nobody wanted, of "taking the mickey" out of their bourgeois audience and shocking their desire for pleasantry and entertainment with products of pure nonsense.

What was neither more nor less than an aesthetic affront in Zurich was taken up in Berlin by politically minded artists. On 15 February 1919 a newspaper called *Jedermann sein eigner Fussball* (Each to his own football) appeared in the German capital. It was published by Malik and introduced everything which the Dadaists lampooned with their caustic wit, with laughter and scorn and at the same time with deadly earnest: it declared battle on the forces that had unleashed the war, on the betrayal of the Revolution by means of the National Assembly, on the organizers of white terror in Berlin, on those who slandered the Russian Revolution, on the Church, the military and the Junkers, and on the bourgeois arts institutions. The content was an out-and-out political challenge dressed up to play upon the selective tastes of a bourgeois readership. The appeal of the title page was every bit as effective as it might be in a well-designed bourgeois newspaper. Indeed, this "fortnightly illustrated periodical" far excelled the sophisticated presentation of even the Ullstein empire's *Berliner Illustrirte Zeitung*. The name, cushioned in black, was emblazoned on pale yellow paper which Herzfelde had acquired from a merchant as leftover stock. Here once again, this time beautifully ordered, was the bewildering typography, the lines set at all angles in different faces, which Herzfelde and Heartfield had used for their *Neue Jugend*, now banned, in anticipation of Dada magazine layouts in 1919/20. Gothic typefaces predominated, lending the whole an upper-crust flair. But what did those banner headlines say? "Competition! Find the Most Beautiful Man!" Underneath, splayed out as if a dancing class belle had adorned her ballroom fan with photographs of her suitors, were the portraits of the new government leaders in dignified pose. The struts of the fan bore the pillars of this "society"—Ludendorff in his General's uniform, Matthias Erzberger and Gustav Noske. Caption: "German Male Beauty 1". This was followed by the beginning of the lead story, which cut across the page: "Socialization of party funds. A demand to pre-

vent the universal custom of electoral fraud." The other pages were all a match for the first. The irony, satire and revolutionary stance were merely blunter, more direct, with no holds barred. Wieland Herzfelde, Walter Mehring and Mynona (the writer and philosopher Dr Salomo Friedlaender) wrote the articles. George Grosz established his reputation as an outstanding caricaturist with a bitter satire on the secular power of the Church. Heartfield took charge of the design, and the front-cover picture was his first major political photomontage. The censors banned the journal for ever before it even reached the official distribution network, after Herzfelde and Heartfield had persuaded Robert Barthe & Co., a highly reputable and expensive firm producing books and art reproductions, to print their order on credit. Malik's Dadaists simply loaded all 7,600 copies on the back of a pony and trap complete with brass band and set off amid great hullabaloo through the centre of the city, with each of the authors praising his own contributions at the top of his voice. By the time the police took a hand almost every copy had been sold. A law suit against Walter Mehring ended in acquittal thanks, in part, to a testimony from Gottfried Benn. Mehring had printed his poem *Der Coitus im Dreimäderlhaus* (Coitus in the House of the Three Girls) in the football magazine and had been taken to court for contempt of the Reichswehr and dissemination of immoral literature, as a result of its attacks on the monarchy, Reinhardt's Baltic troops and the "People's Deputies" Ebert and Noske. These quarrels with the Public Prosecutor were to pursue authors and artists working with Malik throughout the Weimar period.

The football magazine illustrates the specific approach to artistic affrontery which the Dadaists adopted in Berlin, and countless more episodes were to follow in a similar vein during the next few years. Some of the incidents were quite spectacular, as when the gravestone designer Johannes Baader attended a Sunday sermon by the former Court cleric Dryander in a packed Berlin Cathedral, shouted "We don't give a shit for Jesus Christ!" and launched into a speech about the dishonesty of the appointed clergy in the war. He caused an even greater furore on 16 June 1919 when he turned up at a session of

the National Assembly in Weimar, identifying himself as "Top Dada" and "President of the Planet" and showering the deputies from the public gallery with a Dadaist leaflet which contained a great deal of nonsense and the proposal: "Are the German people willing to give the Top Dada a free hand? If the referendum is affirmative, Baader will provide order, peace, liberty and bread."[33] He demanded at the top of his voice that the government should hand over its business to the Dadaists. Many were also shocked by the Dada soirées held amid a blaze of prior publicity at high-class galleries on the Kurfürstendamm. The public responded as usual to the expensive invitations printed on handmade paper and paid a hefty entrance fee, only to witness a contest between a typewriter and a sewing machine. Huelsenbeck and Hausmann were the performers; one was typing a constant stream of pages at breakneck speed, while the other sewed an endless funeral ribbon. George Grosz was the referee and attacked the viewers with unconcealed derision. Sometimes the public were invited to pay twice the usual entrance fee and then simply treated to the explanation that the organizers just wanted to have a look at all the silly people who were prepared to fork out twice the money. Quite often members of the public began fighting each other while the performers watched passively from the stage. But nevertheless the masses always swarmed to these events. After all, one never knew . . . And indeed, there was meaning and method to the nonsense that the Dadaists pounded at their Berlin arts establishment.

Dadaism had been born in Zurich because artists rejected in despair the impact which the war had made on cultural developments in Europe. All Zurich's Dadaists had their roots in Expressionism, which they had experienced as the start of a uniquely creative international avant-garde movement in the 20th-century arts. Hans Arp, Hugo Ball and Richard Huelsenbeck, the Germans among the Dadaists of Zurich, had emigrated to Switzerland when the war broke out because they could not reconcile their basic sense of belonging to an international vanguard with the sudden need to regard their artistic friends abroad as political enemies. Watching the trenches from the sidelines, they were particularly sensitive in their

reactions to the xenophobia which was being whipped up in all the countries involved, to the destruction of human life, the brutalization of emotions and the vandalization of cultural treasures. To them the war signified the end of bourgeois culture, and through this belligerence the Imperial Reich and the bourgeois class forfeited their one-time claims to leadership for ever. Their premonitions of doom, or as the art historian Eberhard Roters put it, this "bourgeois desperation which leads to sociocritical irrationalism"[34], encouraged them to hold up a mirror to the bourgeois class in which they could observe their own doom, and to perfect the chaos of war by subverting and destroying those artistic values and experiences which still survived. They borrowed their tools for making the crisis visible from Italian Futurism, notably its exponent Filippo Tommaso Marinetti, but without sharing his nationalism and the affirmation of war which was eventually to evolve from his artistic theory. What appealed to them was the

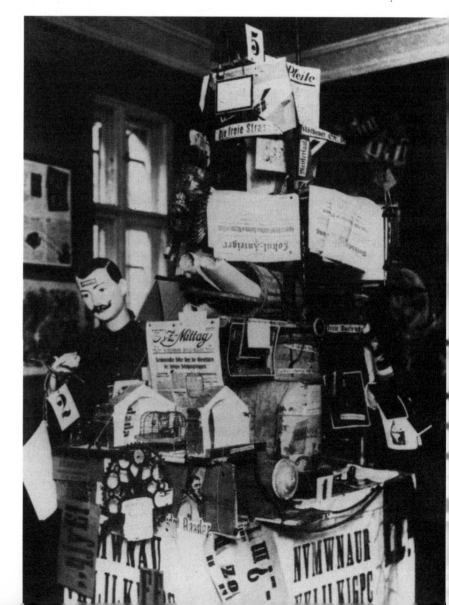

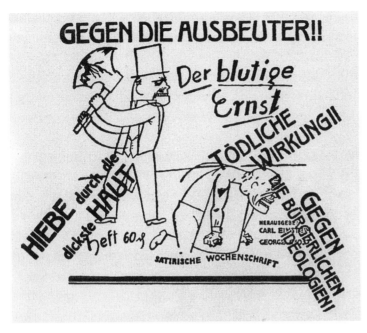

In 1919 Carl Einstein and George Grosz published Nos. 3 to 6 of the satirical weekly *Der blutige Ernst* with the Berlin publishing company Trianon. Advertisement by George Grosz, 1919.

John Heartfield's commentary on the fork, "I do not consider this to be a staircase, but a fork," was a confrontation with the "interpretations" of many art critics. A page from the magazine *Der dada*, No. 3, 1920.

Left:
At the top of this assemblage, which pulled in the viewers at the Berlin Dada Fair, we see the titles of Berlin's two political Dada magazines, *Die Pleite* and *Die freie Strasse*. Johannes Baader, *Das Plasto-Dio-Dada-Drama "Deutschlands Grösse und Untergang"* (The Plasto-Dio-Dada-Drama "Germany's Splendour and Fall"), 1920.

new perspective on nature as the purely objective world, a kind of scientific access route to life and humanity via which the Futurists hoped to break through to the origins of existence by dividing everything up into "atoms". Reducing language to sound patterns, music to noises, painting to geometric forms, all of which existed side by side with equal status according to the simultaneity principle, offered the Zurich Dadaists an experimental opportunity to pose a radical challenge to the bourgeois experience of art and, at the same time, to attempt a new beginning free of all tradition. There was not much to separate scandalizing the middle classes in this case from avant-garde art, and, for all the urge to destroy and pro-

test, it was artistic creativity which governed the movement. The Cabaret Voltaire functioned exactly like any conventional arts institution. The material foundations of bourgeois culture in Zurich were never shaken.

In Berlin the picture was quite different. True enough, the intellectuals associated with Herzfelde's publishing house Malik and with Franz Jung's *Die freie Strasse* had joined together to form their Club Dada, but that was only intended as a pastiche of closed arts associations and the whole club mentality. There were no statutes, no set programmes and none of the other accoutrements. The aim of the Berlin Dadaists was not merely to wreck establishment art itself, but also to undermine and infiltrate its or-

ganization. They did not need their own galleries to make themselves heard, but took possession of what was already available with a cocky self-assurance. After all, where better to rout the enemy than in his own home? Berlin's Dadaists were children of the Revolution. Just as the Spartacists had occupied the *Lokal-Anzeiger* on 9 November, so they intended to occupy the network of arts distribution. Just as the armed struggle had taken to the streets, so they carried their cultural revolution onto the streets. Everything they did was part of an unbridled campaign of action, and their goal was ruthless involvement in current political events. It was here, of course, that the Dadaists faced their greatest challenge. Amid all the strikes, mass demonstrations and street battles, they had no desire to sit idly by while the bourgeois forces, backed up by the SPD's right-wing leaders, secured their restoration and regained the power they had almost lost. One of the most bitter blows they suffered was seeing Expressionism, the movement which had given birth to them, sucked into this restoration process. That was why they turned their political rebellion against everything which smacked of what Hausmann called the "Weimar philosophy". Their artistic rebellion was an experimental rejection of their own Expressionist past. The last thing Dadaism wanted, in their eyes, was the founding of a new artistic school. Instead it was an attempt to cast off styles and schools of any kind in favour of creative, active involvement in the social issues of the day. In his *Dadaistisches Manifest* (Dadaist Manifesto), drafted in Berlin before the Revolution itself in April 1918, Huelsenbeck wrote: "The greatest art will be that which presents the thousandfold problems of its time in the context of a consciousness, which shows that it has erupted from the explosions of the past few weeks, which scrabbles time after time beneath the rubble of the previous day to piece together its members. The best and most outrageous artists will be those who gather up their bodily shreds hourly from the confused cataracts of life, gasping with the intellect of the age, bleeding from their hands and hearts."[35]

None of the Berlin Dadaists had followed the revolutionary Expressionist vogue that November and, in a fit of enthusiasm, suddenly discovered their proletarian identity.

They all recognized how irrational such declarations were. They were more inclined to sense the challenge to their political responsibility as creative artists. Most of them sought a path in this direction and experimented with ways of placing art in the service of the Revolution. The illustrated magazine *Die Pleite*, which appeared twice monthly after *Jedermann sein eigner Fussball* had been banned, became a clearly comprehensible tool for those forces within Dada who had either joined the KPD or identified in their political convictions with the Communist struggle. Herzfelde, Heartfield, Grosz, Mehring and Einstein proved to be keen-sighted political journalists, and once again it was George Grosz who gave the paper its biting satirical edge with his illustrations. There was absolutely no Dadaist tomfoolery about this. And in spite of the Dada typography and nonsensical slogans, the political thrust was also clear to see in Grosz and Einstein's magazine *Der blutige Ernst* and in three issues of the journal *Dada* which appeared in Berlin with the collaboration of Hausmann and Baader. *Der Gegner*, published by Herzfelde together with Julian Gumperz, who had come to Berlin from Halle, was from the outset an extremely objective, politically oriented art magazine amid all the Dada action. It was here that the debate about revolutionary art for the proletariat was articulated most clearly.

Alfred Kerr describes a Dada Evening in Berlin: "The basic idea seems good: Clowning about with a philosophy behind it. Everything under the sun parodied. One might call the movement 'I-don't-give-a-damnism'.

But the performance was shaky. If this be madness, there should be far more method in it."[36]

And it certainly was hard for outsiders to define what might be called Dadaism's artistic method in Germany, and notably in Berlin. Key contradictions and arguments were not long in rearing their heads, even among the Dadaists themselves. Futurist influence in the capital was not confined to Dada. Bruitist poems, concoctions of verbal fragments and sound pictures, were written and read aloud here, too. Simultaneous recitations, when ten poems were spoken at once, were delivered in Berlin just as in Zurich, Cologne or Hanover. Berlin was also treated to its share of collages made of scraps of newspaper and

all kinds of broken utensils. But one specifically decisive feature was the manner in which environmental impressions of the technical metropolis combined with political movements to provoke a revolution in the artistic media and their potential. The Futurist rejection of figurative painting and sketching from nature emerged as a reaction against the inroads which photography had been continuing to make into the field of art. Now Berlin's Dadaists, led by Heartfield, Grosz, Hausmann and Hannah Höch, produced a blend of photography and the abstract, Futurist collage principle in painting. They utilized the new technical potential of photography as an authentic reproduction of reality to create new forms of artistic expression. Factual material replaced the paintbrush. That was how photomontage, which John Heartfield subsequently developed into an autonomous political art genre, came to originate in Berlin.

How could the arts remain unaffected by the myriad of city impressions, the posters, newspapers, leaflets, advertisements, street peddlars, barking merchants and papersellers, the hectic, day-to-day confluence of human beings, and the atrophy of language in slogans and signs, for these were reality! Huelsenbeck had written in his *Dadaistisches Manifest*: "For the first time Dadaism is not responding aesthetically to life when it shreds all slogans about ethics, culture and inwardness, which are merely cloaks for frail muscles, into its components.

The BRUITIST poem
depicts a tram as it is, the essence of the tram with the yawn of old man Schulze and the screech of the breaks.

The SIMULTANEOUS poem
teaches the sense of all things whirling about one another, while Herr Schulze is reading the Balkan Express crosses the bridge at Niš, a pig squeals in Nuttke the slaughterer's cellar. (. . .) Dada is the international expression of this age, the great faction of art movements, the artistic reflexion of all these offensives, peace conferences, vegetable market tussles, dinners at the Esplanade etc. etc. Dada seeks the use of
new material in painting."[37]

Although there is much here that has been borrowed from Futurism and sets its sights on innovations which derive from a new understanding of art, the Berlin Dadaists were concerned with more than predominantly experimental games using new opportunities. They wanted their artistic media to be politically effective and to intervene directly in the conflicts of the day.

Walter Mehring, for example, who was soon to open his Political Cabaret in Berlin, wrote poems and chansons which drew on the metaphors of a posterwriter's idiom to achieve political meaning. The poem *Berlin simultan* (Berlin Simultaneously), the "First Real Dada Musical Hall Song", ran:

"Das Volk steht auf! Die Fahnen raus!
Bis früh um fünfe kleine Maus!
Im Ufafilm
Hoch Kaiser Wil'm,
Die Reaktion flaggt schon am Dom,
Mit Hakenkreuz und Blauzeuggas,
Monokel kontra Hakennas'
Auf zum Pogrom
Beim Hippodrom!
Is alles Scheibe—
Bleibt mir vom Leibe—
Mit Wahljeschrei
Und Putsch
Eins zwei drei
Rrrutsch
 mir den Puckel lang"[38]

"The people arise! Hoist the flags!
See you in the morning sweetheart!
In the Ufa film
Up Kaiser Bill,
Reactionaries by Cathedral waving flags,
With swastikas and blue gas,
Monocles versus hooked noses
Start the pogrom
at the Hippodrome!
What a load of crack—
Get off my back—

With electoral cheers
and coup
One two three
Whooooops
 down my hump"

The first exhibition of Dadaist painting and sculpture went on show in May 1919 at Neumann's Graphisches Kabinett on the Kurfürstendamm, but it attracted little attention by comparison with what followed in 1920. In July of that year, Berlin's Dadaists opened their first big International Dada Fair at the Galerie Burchard. An enormous banner bearing the message "Dada fights side by side with the revolutionary proletariat" stretched right across the three exhibition rooms. Beneath that declaration there was free rein for everything currently ascribed to international Dada. The figure of a Reichswehr officer with a pig's head was suspended from the ceiling. Tatlin's machine art was extolled under the rubric "Dada is dead". Parodies of the Old Masters were hung between collages and photomontages which illustrated the multifarious jumble of city life, and these were interspersed with Otto Dix's *Kriegskrüppel* (War Cripples) and the drawings from George Grosz's folder *Gott mit uns* (God with Us). "If drawings could kill, the Prussian military would definitely be dead. (Anyway drawings can kill.)"[39], wrote Kurt Tucholsky of Grosz in his review of the exhibition. The Dada Fair sparked off some extremely heated reactions amongst the general public, including the inevitable court case for insulting the Reichswehr. It was the death knell for the Dada movement in Berlin.

In 1925 Grosz and Herzfelde wrote an essay called *Die Kunst ist in Gefahr* (Art Is in Danger) summarizing their experience with Dadaism, which they defended as being the "only art movement of substance in Germany" since the war and pre-war years, as it condensed "all art's isms into a little studio debate the day before yesterday". Dadaism, they continued, "was the bawling, scornfully laughing escape from a narrow, supercilious and overvalued milieu which floated in the air between the classes and knew no jot of responsibility for the life of the community. At the time we saw the insane products of the ruling social order and burst out laughing. We could not yet see that there was a system behind the insanity.

"The approaching Revolution gradually enabled us to recognize that system. There was no more cause for laughter, for there were more important problems than those of art; if it was to carry on having any meaning at all, it would have to be subordinate to those problems. Some of us Dadaists were lost in the void in which we found ourselves when we outgrew the cliché about art, mostly those in Switzerland and France who witnessed the social upheavals of the last decade more from the vantage point of their newspaper. We others, however, perceived a new great task: partisan art in the service of the revolutionary cause."[40]

The international Dadaist movement which put itself on display at the Berlin Fair did not join Herzfelde and Grosz on this road from Dada towards socialist art. One of the Zurich Dadaists, the Rumanian Tristan Tzara, ambitiously devoted himself to organizing Dada as an international art movement from his base in Paris, and for a short while he was successful. The Dadaist revolution in materials was conflated with incipient Surrealism in the work of artists such as Picabia, Breton, Duchamp and Ray. Thanks to his commitment and persuasive enthusiasm, Tzara managed to unite these artists in a Parisian Dada movement until it was totally submerged by Surrealism in 1923. There was another pocket of Dada in Holland, where Otto van Rees and Paul Citroen drew their inspiration from Paris and the two other centres of Dada in Germany. Hans Arp had left Zurich in early 1919 for Cologne, where he worked in close contact with Max Ernst and Theodor Baargeld. They initiated a Dada group which included Angelika Hoerle, Anton and Martha Räderscheidt, and Franz Wilhelm Seiwert. Max Ernst became their champion, but under Tzara's influence he soon had one eye on Paris and his interest moved towards Surrealism. By the time the Dada journal *Die Schammade* began publication in Cologne in 1920, only Baargeld and Hoerle played a part. The others formed the Dada group *stupid* in autumn 1920, but it soon disintegrated. Seiwert, whose origins were in the Anarchist movement, turned to anarcho-syndicalism, which had pitched its artistic camp in Berlin amid the ad-

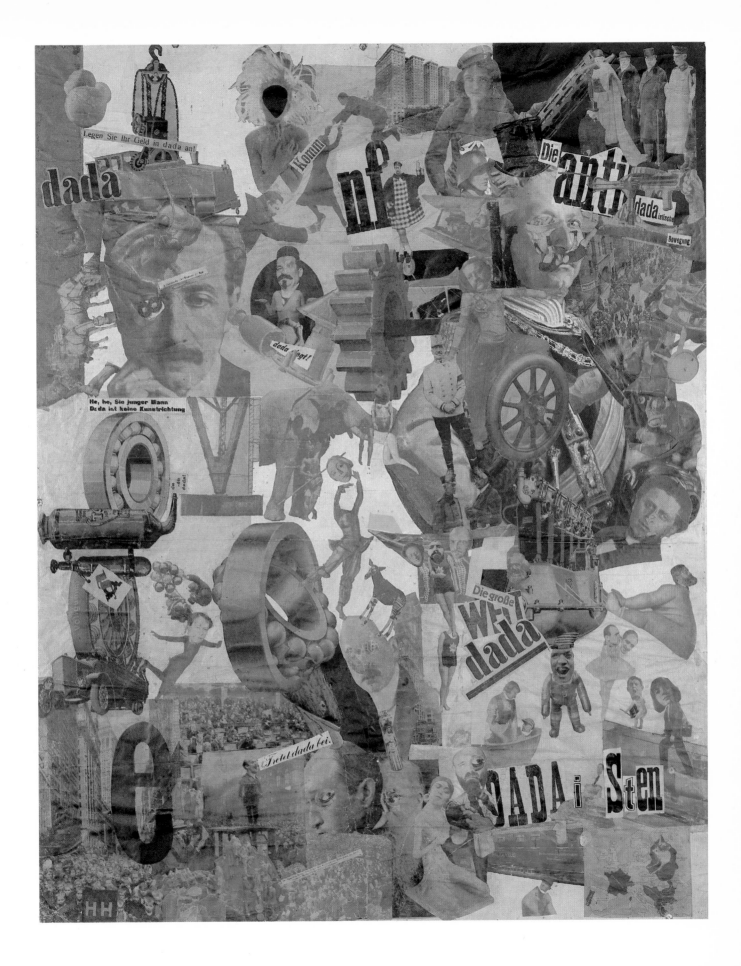

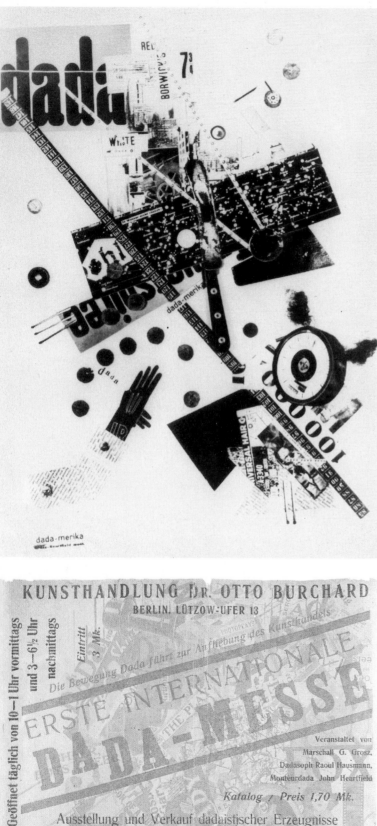

18 Hannah Höch's *Schnitt mit dem Küchenmesser Dada durch die erste Weimarer Bierbauch-Kulturepoche Deutschlands* (The Kitchen Knife Dada Slices through Germany's First Era of Weimar Beergut Culture) was a 114 × 90 cm montage of photos and textual snippets. She produced it in 1919, and it bore all the signs of the more political Dadaism put out by the group around Franz Jung's magazine *Die freie Strasse*. The aim was not simply an affront to the arts in general, but also an "intervention" in contemporary events. The top right-hand corner depicts the barons and top brass, with Hindenburg's head clearly visible, as an "anti-Dadaist movement". Below, the faces of Radek, Baader, Marx and Lenin are identified as "great dadas". Bottom left are photos of mass demonstrations in New York and Berlin with the caption "Join dada!" Staatliche Museen Preussischer Kulturbesitz, Berlin (West), Nationalgalerie

19 In 1919 George Grosz and John Heartfield began to make collages out of photographs mounted on Grosz's drawings. *Dada-merika*, signed "Grosz-Heartfield mont.", was one of them. Today this collage has been lost, and the reproduction is taken from the catalogue of the First International Dada Fair held in Berlin in 1920.

20 John Heartfield and George Grosz made this poster for this Dada Fair in Berlin. Hausmann, Höch, Baader, Herzfelde, Grosz and Heartfield, leading names in Dada in Berlin, gathered for the opening on 5 June 1920 at Burchard's art shop. The Fair ran for a good month and was described as "Bolshevism" by the *Neue Preussische Kreuz-Zeitung* in its edition of 3 July. This must certainly have been the most inappropriate of many possible labels!

Right:
21 The editor of the magazine *Der dada* was Raoul Hausmann. The first two issues were published by Freie Strasse Publishers, and the Dada Department of Wieland Herzfelde's publishing company Malik brought out No. 3 in April 1920. John Heartfield designed the cover. The collage mentions prominent Dada artists in Berlin: Hausmann, Baader and Grosz.

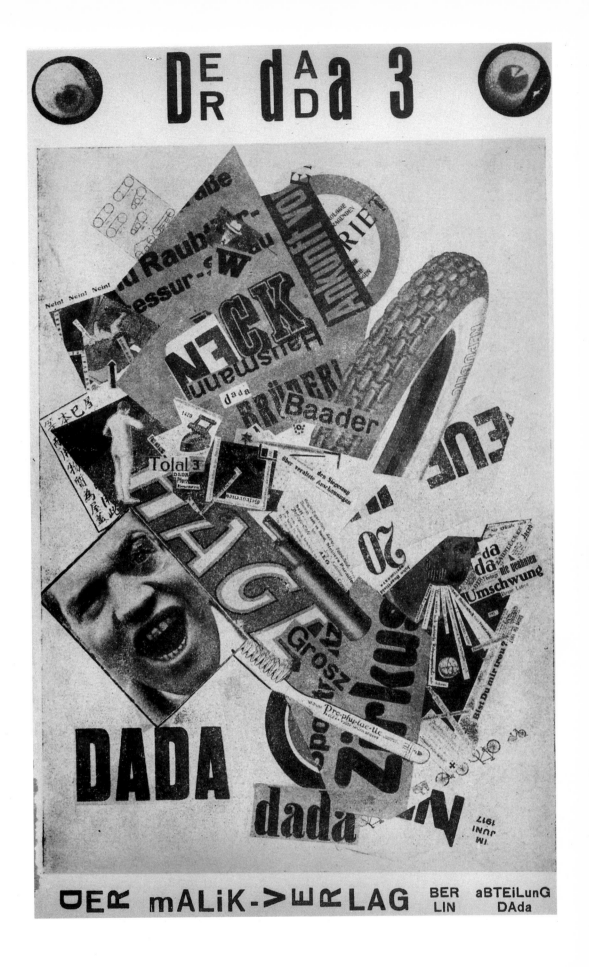

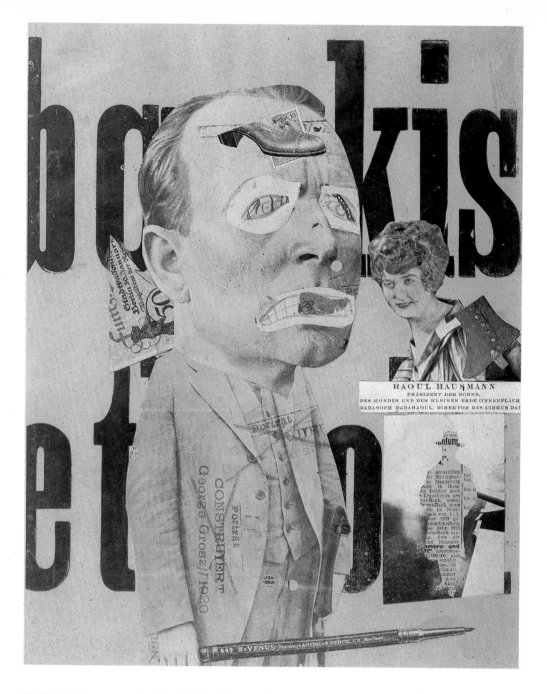

22 Raoul Hausmann, *Der Kunstkritiker* (The Art Critic). Collage 1919.
Tate Gallery, London

Right:
23 Georg Scholz's collage painting *Industriebauern* (Industrial Peas-
ants), dated 1920, contains elements of Surrealism and Dada. The painter
was a KPD member and a close friend of Dix and Grosz. At the time of this
work he was a committed Verist, later an advocate of New Objectivity, and
by the end of the twenties was to be found among the "Asso" artists. *In-
dustriebauern* illustrates the militancy, religious bigotry and reactionary
fug of a wealthy farming household, which technical progress and also
an itinerant preacher of the old mould penetrate from outside. It is *Das
Gesicht der herrschenden Klasse* (The Face of the Ruling Class), as Grosz
named a collection of his own drawings in 1921, in a quite different, yet
equally fascinating artistic style. Von der Heydt Museum, Wuppertal

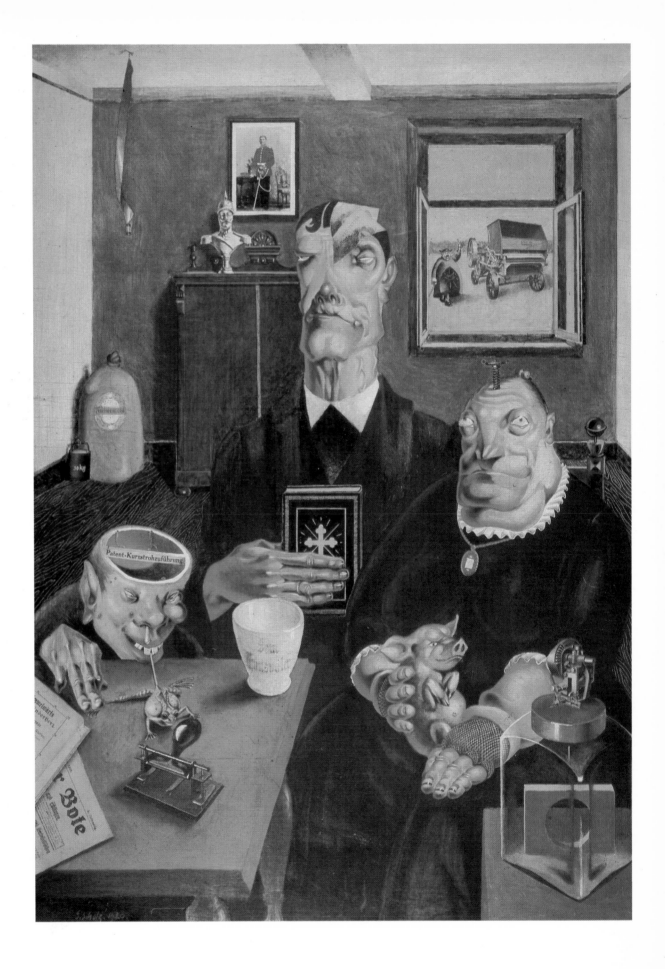

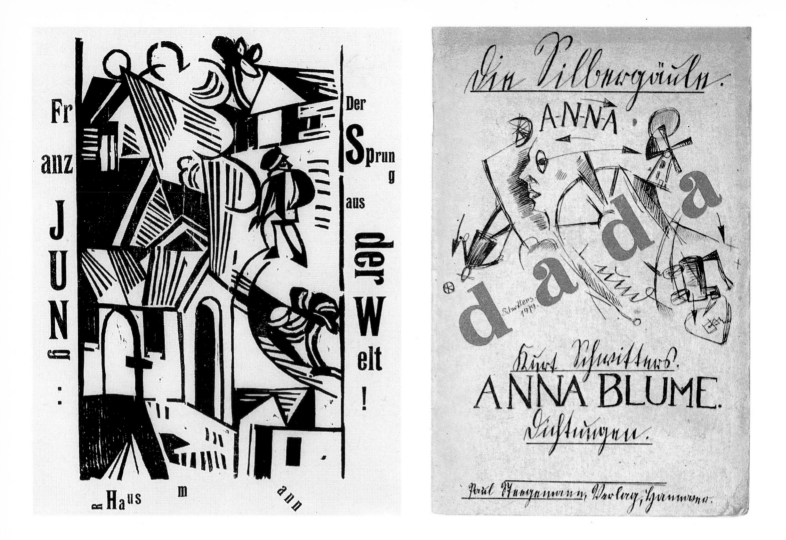

24 Franz Jung's *Der Sprung aus der Welt* (Leap from the World) was published by the Club Dada in Berlin in 1920. The title page shows a woodcut by Raoul Hausmann.

25 *Anna Blume*, a collection of texts by Kurt Schwitters, appeared in Hanover in 1919 and became the symbol of Dada poetry. Schwitters wrote in his Epilogue: "I have a lot to thank Anna Blume for. I have even more to thank *Sturm* for. *Sturm* was first to publish my best poems and to publish a collection of my Merz pictures. Greetings to Herwarth Walden!"

Right:
26 George Grosz's *Musketier Helmhake* went on display at a Berlin workers' art exhibition in 1921. It was presented to the public standing on a simple wooden bench, and other works were mounted using similarly primitive means. Such were the difficult beginnings of proletarian art in the Weimar Republic.

Following page:
27 Like the word "Merz", which he used to denote a number of his pictures and poems, Kurt Schwitters cut the letters "Kots", a homophone for "puke", at random from a newspaper headline. The collage *Kotsbild*, which refers again to Anna Blume, dates from 1920 and is an example of the pure affrontery encountered in Dada. Kunstmuseum, Hanover

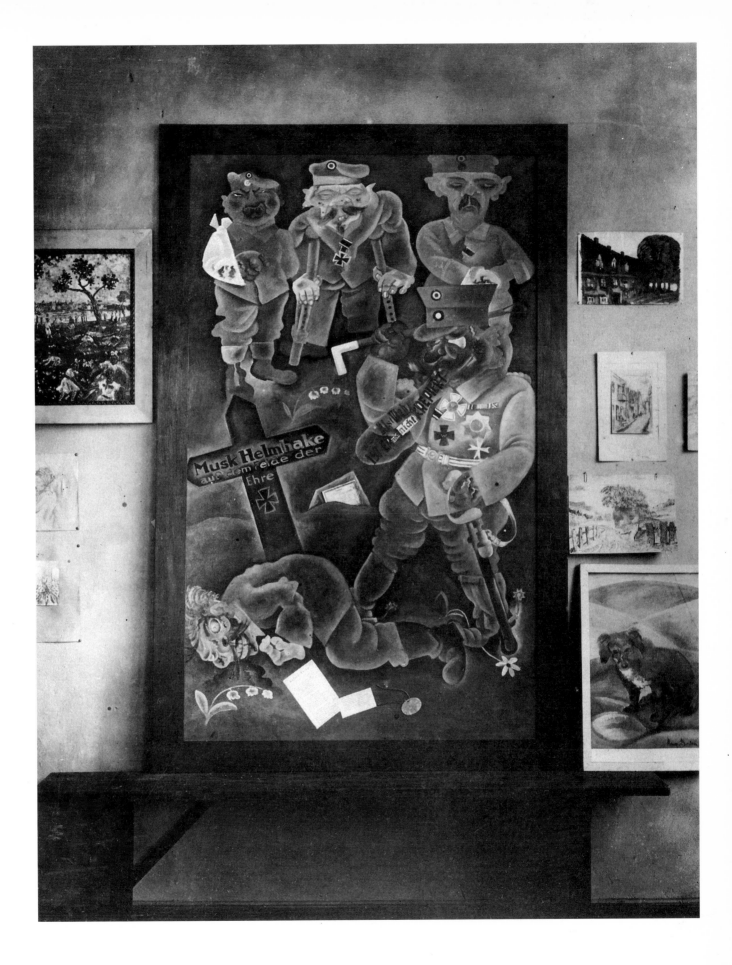

herents of Franz Pfemfert's *Aktion*. Pfemfert had been an outstanding wartime journalist and a passionate defender of Karl Liebknecht and Rosa Luxemburg, but after the Munich *Räterepublik*, when the Revolution had finally failed, he had thrown in his lot with the Anarchist splinter party, the KAPD, founded in 1920 by former members of the internal KPD opposition and active for only a brief period.

It was a long time before people stopped talking about Kurt Schwitters and his one-man Dada show in Hanover. The painter and writer compiled his own Dada programme, which he called "Merz", a word invented at random, just as "Dada" had once been—even though quarrels about its etymology have never ceased, from the days of the Zurich Dadaists until our own. Schwitters had caused a considerable stir with his prose work *Anna Blume*, which still betrayed heavy leanings towards the Expressionist writings of the *Sturm* circle. When Dada fell apart in Berlin, he became the latterday *spiritus rector* of Raoul Hausmann and Hannah Höch, who maintained their allegiance to Dadaism. They undertook joint tours to Dresden, Leipzig and Czechoslovakia and above all worked closely with the Dutch Dadaists associated with the magazine *De Stijl*. But the most important project was always Schwitters's own magazine *Merz*, which followed Herwarth Walden's *Sturm* by setting up its own Merz Theatre. Just as Max Ernst in Cologne had argued for an aesthetic creed based on dilettantism, so Schwitters was a kind of founding father of what today would be called a "happening", the staging of artistic acts which not only scandalize the audience, but aim to set them in motion as art is dissolved into pure play. Dada Hanover owed its longer survival in part, too, to publisher Paul Steegemann, who kept his company and his magazine *Der Marstall* open to the Dadaists, particularly their literary products. Kurt Schwitters himself, and along with him Hans Arp, Walter Serner and Mynona, an author of grotesqueries who was close to Dada, contributed to Steegemann's special series *Die Silbergäule* (Silver Steeds), beautifully designed books which have preserved Dada's rapidly obsolescent output until today. Richard Huelsenbeck, who took the non-art slogans seriously and became a ship's doctor when the movement crumbled in Berlin, wrote an early history of Dadaism, *en avant Dada*, which appeared in this series in 1920. A young Czech called Melchior Vischer wrote the only Dada novel, *Sekunde durch Hirn* (Seconds through Brain), which Steegemann also published. The Bremen literary critic Victor Klages, whom Steegemann had asked to review the book, dismissed it as "rubbish" and addressed a few sarcastic comments to the publisher: "If meaning and intention have any part at all to play in Dadaism, then in my view they must be political. The 'often repeated rubbish', which Mr Vischer himself quotes, is perhaps supposed to be something rather like the literary avant-garde of communism; the idea is to make the public meshuga in order to trample all over them. Are you laughing? Do you protest? Fine, then you are magicking the carpet from under the feet—assuming at a pinch that there still was any carpet—of all your favourite writers. (. . .) Your company also publishes people like Heinrich Mann, Carl Hauptmann, Kurt Martens, Klabund, Otto Flake and Kasimir Edschmid. I hope that you, Mr publisher, will not take a tumble too, but will make use of a parachute that drops you gently on the shores of central European good sense."[41]

In one respect Victor Klages was proved right: Dada never became an independent art movement.

"Make way for the worker!"— Art for the proletariat

On 28 June 1919 German government representatives signed and sealed the peace conditions imposed by the Entente at Versailles. The Scheidemann government had resigned on 19 June under the burden of this responsibility, for the terms of peace were such that they would drive the country to the brink of economic disaster. The main aim of the Versailles Treaty was to eliminate Germany as a rival on the world market. Alsace-Lorraine, Upper Silesia and Western Prussia had been sacrificed, which meant the loss of major resources of iron ore, hard coal and agricultural land. In statistics that amounted to 75 per cent of Germany's ore extraction, 28 per cent of its black coal, and 17 per cent of its potatoes and grain. Over and above

that Germany was to pay up to a quarter of its manufacturing output and much of its farm produce to the victorious powers. The Entente also acquired all major trading vessels, a quarter of the fishing fleet and one in five inland craft. It was not only the industrial magnates, the military, the bourgeoisie and the Junkers who protested against this Treaty: the workers also objected to these burdens, for in the long run it would be they who shouldered them. On the other hand, the working masses could see the justice of terms such as the reduction of the army to 100,000 men, the dissolution of the General Staff, repeal of national conscription, the ban on heavy weaponry and the extradition of war criminals. But in the years which followed those were the very conditions which were not strictly observed. In April 1921 the Entente Commission fixed their demands for financial reparations at 132,000 million gold Marks and assured themselves of 26 per cent of Germany's export revenue. By establishing that Germany bore sole blame for the war, and insisting that Germany's government representatives sign this clause in the Treaty, the Entente found a justification for these extraordinarily harsh conditions.

The war, the post-war crisis and the effects of the Versailles peace terms were the main causes of the inflation which began in Germany in 1920. Unemployment, hunger and price rises took hold. By 1 May 1920 food prices had already escalated by comparison with July 1914:

margarine	from 1.60 Marks per kilo to	37.50 Marks
dripping	from 1.32 Marks per kilo to	39.00 Marks
butter	from 2.72 Marks per kilo to	45.00 Marks
wheat flour	from 0.40 Marks per kilo to	2.80 Marks
potatoes	from 0.04 Marks per kilo to	0.80 Marks
bread	from 0.23 Marks per kilo to	2.37 Marks[42]

These prices only applied to set rations per head of population, but most of these were in inadequate supply. Food consumption was really regulated by the black market, but most people earned too little to afford the prices demanded. At this point it was still possible to keep a clear account of the figures, but in the months which followed Marks lost any meaning and inflation could only be re-

Stramme, junge Kerls

Turner, Jungmannen, Wandervögel und wer sonst noch Lust zum Soldatenleben hat, ob gedient oder ungedient, werden bei der

Geb.-M.-G.-Abtlg. 229 in Billmenau bei Kattern (Kreis Breslau)

eingestellt. Ihr habt am 7. März unsern strammen Durchmarsch durch Breslau gesehen. Kommt und zieht unsern grünen Rock an!

Einstellung unter den bekannten Grenzschutzbedingungen. Auch Fahrer, Handwerker und Musiker werden eingestellt. Auf Anforderung wird Ausweis für Fahrkarte gesandt.

Paulssen, Lt. d. R. u. Abt.-Führer.

The remilitarization of Germany began just a few months after the First World War was over. From the summer of 1919 it continued "in secret", as it was prohibited under the Treaty of Versailles. Most of the outlawed military units re-formed many miles away from the capital, beyond the gaze of the international community. The *Schlesische Zeitung* of Breslau carried this recruiting notice on 8 March 1919.

Right:
When inflation began to rocket in winter 1920, everyone was talking about the daily increases in food prices. The theatres were obliged to keep pace: the Schlossparktheater announced that it would sell its cheapest seats for the price of two eggs and its most expensive for the price of a pound of butter.

corded by conversion into Dollars. In terms of Marks, the average German was becoming a millionaire or billionaire by the day. When inflation reached its peak in the autumn of 1923, a million-Mark bank note would not even buy a slice of bread.

Street peddling flourished all over Germany from 1920 onwards and the pawn shops were doing a roaring trade. Anyone who still had anything left to sell took it on to the pavement and stood out in that respect at least from the

hordes of war-wounded beggars. Hans Ostwald, a chronicler of Germany's inflation years, describes the street merchant's trade: "Lots of them have 'made something of themselves', have managed to buy a little cart and open a proper business. In many a bustling street they stand in rows along the kerb, advertising their wares with varying degrees of hoarseness: roll upon roll of textiles, gentlemen's trousers, the very best brands of chocolate, fruit, kippers, sausage and bacon, fresh fish, especially herring —and above all books: 'Any book just 20 Pfennigs, any book only a Mark.' And for every few hundred carts scattered across the city on every corner where customers with an appetite for reading and money in their pockets are likely to come past, there are carts which offer well-bound classics and work of the best literature at bargain prices. The booksellers are only the lessees or employees of entrepreneurs who supply a fair number of these carts from leftover stock or wholesale lots, thus helping to meet the demand for books which has grown rapidly due to the war and the restless times."[43]

What did people read? Classics lined the shelves of every decent bourgeois living room. The authors that their owners really preferred reading were Rilke, Rudolf Stratz, Jakob Wassermann and the irrepressible Ludwig Ganghofer, or occasionally Thomas or Heinrich Mann. Another bestseller was Oswald Spengler's *Der Untergang des Abendlandes* (The Decline of the West). A series of war memoirs, books which gave a particular impetus to the nationalist vogue, began in September 1920 with Ernst Jünger's *In Stahlgewittern* (Storms of Steel). They fell on fertile soil during the inflation years and in the wake of what they called "peace with shame", the Treaty of Versailles. In 1922 the magazine *Das literarische Echo* conducted a poll in the public libraries to find the most widely read authors. The results showed Rudolf Herzog, Ludwig Ganghofer, Hermann Löns and Gustav Frenssen. To some extent these writers also had a following among the working-class, but it was limited. There was a movement of working-class culture in Germany that was rich in traditions, from workers' poetry and autobiography

to experiments in drama and the important Volksbühne project, a scheme run by Social Democrats to draw workers into the theatre. As a result, the working class had its own network of literature and art, and there was a relative autonomy to trends in working-class demand for culture, which serializations and reviews in the proletarian press went a considerable way towards meeting.

Although the Social Democrats were heavily criticized for allowing the working-class cultural movement to sink into reformism, a process which began soon after the turn of the century, the experience that had been gained was to prove a crucial factor in the development of proletarian art after the Revolution. It also explains the notable commitment of bourgeois intellectuals who, after 1918, regarded proletarian culture as the only lasting, viable alternative for the future.

On 1 August 1920, Leipzig Cycle Track became the scene of a huge proletarian production. A cast of 900 workers from Leipzig factories under producer Josef von Fielitz of the Leipzig Schauspielhaus acted out the story of the Spartacus Revolt in Rome to an audience of 50,000. The *Leipziger Volkszeitung* of 2 August commented: "As dramatic art the production deserves the highest approbation, for such a combination of participants has never before been witnessed in Germany on this scale. (...) It is only too easy to understand why organized workers should show such particular interest in this performance—slaves in rebellion against their oppressors. That applied to cast and audience alike. The murky night sky was yet another boon to the production. Generously structured scenes were illuminated by the pools from two floodlights, keeping every spectator in suspense till the end with a lively plot and heightened drama."[44]

These mass performances were repeated each summer until 1924 during Leipzig's Festival of Trade Unions. 1,800 people took part in a production of *Der Arme Konrad* (Poor Konrad) in 1921. Texts by Toller were used as a basis for the last two productions. Compared with many other experiments in proletarian theatre in Germany, the Leipzig projects were comparatively one-sided affairs, as they simply exploited the mass presence on stage in order to foster proletarian mass consciousness.

Independent proletarian companies mushroomed throughout Germany in 1920. They were usually started up by professionals from the theatre who were sympathetic to or members of a working-class party and chose this way to make their political contribution. Breaking with the commercial stage was often the only opportunity they had of realizing their theatrical aims, which on the whole were oriented towards politically committed theatre in the wake of the Revolution and provoked by the crisis-ridden years of inflation. The Neue Bühne opened in early 1920 in a pub near Munich's main station. It was organized along co-operative lines, with every member—most of them workers—investing 20 Marks in the enterprise. The manager was Eugen Felber, and Oskar Maria Graf was the dramatic adviser. This theatre, however, was modelled on the Social Democrats' Volksbühne and saw its role primarily as educational. The repertoire ranged from the classics via comedies to Gorki's *Night Asylum* and Emil Rosenow's *Kater Lampe* (The Cat Bunny). The young Expressionists were also played: Herbert Kranz, Rudolf Leonhard and Ulrich Steindorff. The workers gathered in the public house were treated to Georg Kaiser's *Von morgens bis mitternachts* (From Morn till Midnight), with Alexander Granach in the lead role. Oskar Maria Graf later wrote of this working-class theatre: "Without being markedly political, the Neue Bühne did nevertheless fulfil a political purpose. (...) After all the defeats of recent years, here at last was something which seemed successfully to be strengthening the confidence the comrades had lost and their extinguished optimism. That was the great thing about this little workers' theatre."[45]

The actor Josef Gärtner had been a member of the Action Committee set up by the *Räterepublik* of Würzburg in 1919. When this republic, whose fate was closely linked to that of Munich, was crushed, he was sentenced to eighteen months in prison and released in late 1920.

When Walther Rathenau was assassinated in Berlin in July 1922 the masses took to the streets in protest. The staff of the publishers Malik can be seen here amongst the demonstrators carrying banners they had painted themselves. The company's first annual appeared in 1924 bearing the title *Platz dem Arbeiter!* (Make Way for the Worker!). The editor was Julian Gumperz and the illustrator John Heartfield.

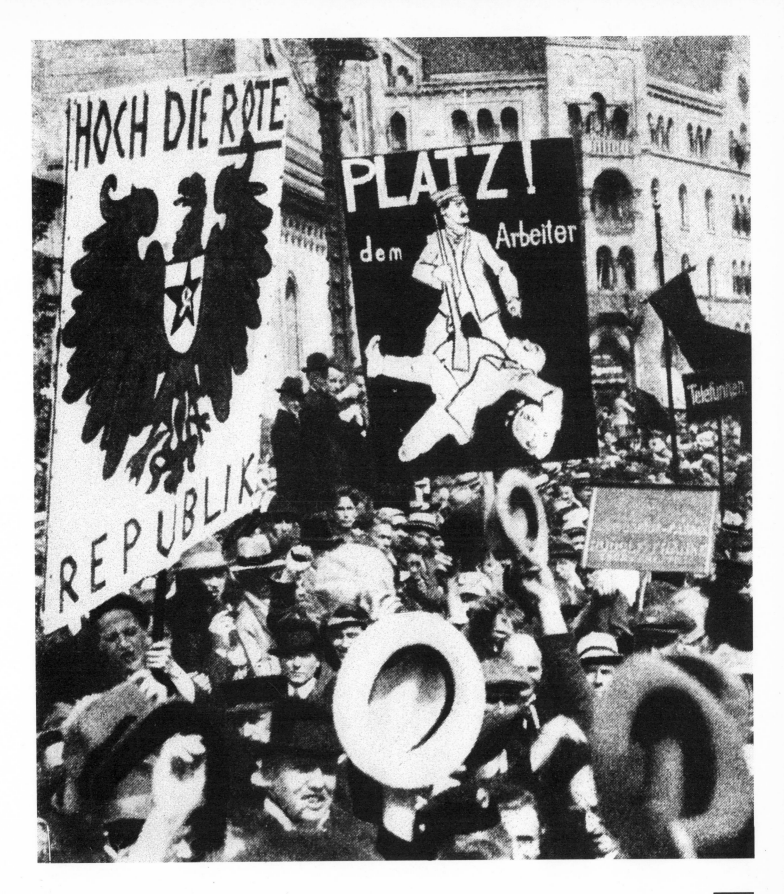

He was taken on by the Stadttheater in Nuremberg, where he eventually founded his *Proletarische Tribüne*. Most of the actors were amateurs and came from the labour movement.

The repertoire included Erich Mühsam's *Judas*, Karl August Wittfogel's *Rote Soldaten* (Red Soldiers), Gorki's *Enemies* and Bruno Schönlank's *Erlösung* (Redemption). From 1922 the plays were selected from publications by Malik, which ran a series of twelve revolutionary stage plays by new authors between 1921 and 1923. These works, by Franz Jung, Erich Mühsam, Upton Sinclair, Karl August Wittfogel, Xaver, Felix Gasbarra, became the standard repertoire for proletarian theatres in Germany.

In October 1920 Erwin Piscator and Hermann Schüller opened their Proletarian Theatre for the "revolutionary workers of Greater Berlin". It had been preceded by the Proletarian Theatre set up within the framework of the League of Proletarian Culture, founded in Berlin in 1919 by Rudolf Leonhard and Karlheinz Martin, who had left the *Tribüne*, together with Ludwig Rubiner, Arthur Holitscher and Alfons Goldschmidt. But this theatre closed down again after its first performance of Herbert Kranz's *Freiheit* (Freedom) due to lack of money and organizational support. Piscator and Schüller were not only more systematic about organizing their enterprise; they also had an unambiguous political programme, being the first proletarian company of this kind to do so. A paragraph which appeared in the press in 1920 announced: "We received the following notice from a publicity office for the 'Proletarian Theatre' in Halensee, Berlin: 'A committee of revolutionary workers of Greater Berlin is being constituted in support of a proletarian theatre which is to be set up as a propaganda company for the revolutionary workers of Greater Berlin. (. . .) The committee invites all organizations committed to the dictatorship of the proletariat to attend its second meeting, where the programme and statutes are due to be discussed.''[46] A stage aimed at disseminating communist ideas was something quite new, and there had certainly never been a body of drama which might serve its goals. But the process was set in motion by Piscator and Schüller's Proletarian Theatre. The company made their debut in Kliem's Ballroom in Berlin on the an-niversary of the October Revolution with three plays: Wittfogel's *Der Krüppel* (The Cripple), Ladislaus Sas's *Vor dem Tore* (At the Gate) and Lajos Barta's *Russlands Tag* (Great Day for Russia). All three plays had been revised and updated by the company of amateurs and young professional actors, adopting a stance on the urgent social problems and political events of the day: the plight of the war wounded in inflationary Germany, the problem of unemployment and solidarity with Soviet Russia, which had been invaded by the Polish army in April 1920 in a campaign backed by Wrangel's White Guard. *Russlands Tag* had been written in a few days especially for the Proletarian Theatre as part of a broad wave of solidarity which was gripping even bourgeois circles in Germany with its slogan "Hands Off Soviet Russia!" In May the trade unions, SPD, KPD and USPD had drawn up a joint document for the first time ever, calling for the obstruction of arms supplies which the Entente was sending the Polish army via Germany for use against the Russians. Accordingly, the production at the Proletarian Theatre met with enduring success, and not solely because it was highly relevant to current political developments, but also thanks to its artistic potential, which began to reveal how dynamic Piscator was to prove as a producer. The next four productions met with similar success: Gorki's *Enemies*, Upton Sinclair's *Prince Hagen*, and Franz Jung's *Die Kanaker* (The Kanakas) and *Wie lange noch?* (How Much Longer?). The company had no regular theatre, performing instead in pubs, schools and even occasionally in factories. Its tremendous appeal was due in part to the fact that it really was a grass-roots project, not an isolated cultural institution, and that it addressed all proletarian organizations without distinction. The strongest support came from the radical left-wing trade union organizations and Anarchist groups who had factory branches, something that the big workers' parties had not yet managed to achieve. This must at least partially explain why Piscator's own party, the KPD, did not show much sympathy for his project. Although the *Rote Fahne* published fairly appreciative reviews of its productions, financial and organizational backing for the theatre was barely forthcoming. With the authorities also repeatedly withholding its licence it was

eventually forced to give up. This had been the first attempt at borrowing and adapting Soviet Russian experience of proletarian culture and letting it bear fruit in Germany. Looking back in 1929, Piscator wrote: "Theatre had conquered a leading position among the means of propaganda available to the proletarian movement. It had been incorporated into the channels of expression used by the revolutionary movement just as had the press and Parliament. But as a result theatre as a cultural institution had altered its function. Once again it was fulfilling a purpose which lay in the social sphere. After a long fossilization which had isolated it from the forces of its time, it was once more a factor in live developments."[47] The *Review Roter Rummel* (Red Fairground), which was put together on commission from the KPD for the 1924 Reichstag elections, demonstrated the political power of this theatre. The big *Review Trotz alledem* (For All That), a theatrical event for Berlin which was staged in the Grosses Schauspielhaus to mark the opening of the KPD Congress in 1925, ran for many more performances and was hailed by the liberal bourgeois press.

By this time theatre, and cultural work in general, was an undisputed component of KPD campaigning and policy. The party had held a Reich Education Conference in 1922, where it adopted principles for education work. These included a demand for propaganda with mass appeal that would win broad sections of people for the class struggle. Theatre, cinema and literature were ascribed an important role in this process, which included involving working-class youth in the creative arts and drawing on the arts to liven up political events and celebrations. The demand was based on the broad proletarian cultural movement which had already been working in this direction. The daily newspapers published by the Communist Party had set up cultural departments in 1919, and the KPD itself had been developing as a mass party since December 1920, when it merged with the left wing of the USPD. All these factors contributed to a major cultural offensive. Communist intellectuals such as Edwin Hoernle wrote texts, sketches and plays. Hoernle's one-act drama *Arbeiter, Bauern und Spartakus* (Workers, Peasants and Spartacus), which argued for an alliance between workers and peasants, was printed in the Young Communists' *Hammer und Sichel* and acted by numerous youth branches at events they had organized. Choruses rehearsed revolutionary poems by Johannes R. Becher and Oskar Kanehl. The KPD set up a national chorus in Berlin in summer 1922, and this merged in 1923 with the Proletarian Travelling Theatre, one of many ensembles to emerge from bourgeois, Social Democrat and even Anarchist associations of ramblers and nature lovers. The chorus had 60 members and was entrusted in 1923 to the leadership of Gustav von Wangenheim, then still a hopeful young actor with Reinhardt. Wangenheim built the choral recitation of poetry into a new kind of stage performance by compiling an appropriate script, *Chor der Arbeit* (Chorus of Labour), a combination of solo and group pieces. This was a move towards breaking up the purely recitative form into scenes without relinquishing the suggestive power of mass delivery. It paved the way for agitprop, which began to take root in 1924.

Attempts to forge a proletarian culture were not confined to the theatre. They spread to literature, where Franz Jung proved to be an outstanding writer. Apart from his plays for proletarian theatre he wrote short stories and novels which appeared not only with Malik, but also in the daily press of the proletarian movement, where they numbered among the most gripping serializations. In his novels *Die rote Woche* (Red Week), *Arbeitsfriede* (Labour Peace) and *Die Eroberung der Maschinen* (How the Machines Were Won) and his short stories *Joe Frank illustriert die Welt* (Joe Frank Illustrates the World) and *Proletarier* (Proletarians), Jung not only drew his characters from the life and struggles of the working-class, but also found a narrative mode which bore the clear stamp of community, solidarity and a revolutionary attunement with the masses. In much of his prose the reader is no longer confronted with the destiny of an individual proletarian designed to provoke identification, but with a literary method which constructs a collective hero. Observations of individual traits and behaviour are assigned symptomatically to groups of people, often nameless, who are depicted in relation to a specific social context. They face their antagonists as "strikers" or "prisoners". Jung's narrative style

was no less suggestive than conventional characterization. Its aim was to convey the social matrix of individual experience within a community. His books were extremely popular with proletarian readers. Proletarian poetry made a similar appeal.

Meanwhile a cultural crisis seemed to be gripping young bourgeois democrats. The fashion for oriental life and thought, its philosophy, literature and culture, which had been shared by many European intellectuals before the war and had left its mark on German literature in the earlier works of Alfred Döblin, Hermann Hesse, Klabund and Lion Feuchtwanger, now re-appeared as a form of escapism.

It reached its peak in the summer of 1921, when the Indian poet and philosopher Rabindranath Tagore gave a lecture tour in Germany and was granted an enthusiastic welcome in all the university towns. In the years which followed, the writings of Tagore were compulsory reading for bourgeois youth all over Germany.

It was not until the autumn of 1923, when the post-war revolutionary crisis was over and the economy had begun to stabilize, that a ''new lease of life'' swept through the bourgeoisie, luring Tagore's disciples back into political reality, but by now it was becoming increasingly difficult to avoid the choice between left and right. On the one side was a broad proletarian cultural movement with considerable mass influence, and on the other the nationalist forces in the process of alignment. Many bourgeois intellectuals shunned the pressure for a clear-cut decision. They did not really take the right wing seriously, nor yet felt able at that stage to join forces with the proletariat, which implied commitment to a revolutionary alternative. The majority still believed that they could carry on down the middle road.

The "Golden" Twenties

"Lo, the chimney smoketh!"— Stabilization

Inflation reached its peak in autumn 1923. The children on the streets of Berlin were chanting:

> "Eins, zwei, drei, vier, fünf Millionen
> Meine Mutter, die kauft Bohnen.
> Zehn Milliarden kost' das Pfund,
> Und ohne Speck!
> Du bist weg."

> (One, two, three, four and five million.
> Mummy's gone to buy some beans.
> A pound of beans costs ten thousand million
> Without bacon—
> And out you go!)

The million-Mark banknotes which trickled through their owners' hands were replaced by thousand-million-Mark notes and finally, in October, people began counting in billions. The official exchange rate in Berlin rocketed from 320,000 million Marks to a Dollar on 2 November 1923, to 680,000 million Marks on 7 November, a billion Marks on 11 November and no less than 4.2 billion Marks to a Dollar on 20 November. But quite apart from the disastrous consequences which this entailed for the population at large, the German economy was becoming less and less competitive, so that the financiers and industrialists pressurized the Reich government to take appropriate action against the drop in currency rates. On 1 November 1923 the Minister of Finance, Luther, issued a Decree on the Establishment of a German Security Bank, whose Rentenmark was introduced as Germany's new currency. On 22 November it was linked in value to the gold Mark and fixed to the Dollar at an exchange rate of 1:4.2. This was an acknowledgement of the Dollar rate of one to 4.2 bil-

lion, the new Rentenmark being worth one billion former Marks. This administrative measure put an end to the spiralling inflation which had lasted over two years. It was not concern for the people which had prompted this action, but basically concern for the interests of Germany's industrial and finance capital, and this was reflected in personal appointments. On 16 November 1923 Hjalmar Schacht, the director of a leading bank, was named Commissioner of Reich Currency, and shortly afterwards President of the Reich Bank.

The exchange of money proceeded apace, and within five days of 22 November, 300 million Rentenmarks were in circulation. The currency stabilized, which helped the government to consolidate its state power and the German economy to recover from the severe damage caused by the war and reparations.

Wilhelm Marx, the leader of the Centre Party, formed a Cabinet on 1 December 1923 which introduced various emergency measures, thoroughly approved by the industrial community to the detriment of working people, and aimed at securing stabilization. Sixty-three Emergency Laws were enacted in order to reduce wages and salaries, cut unemployment benefit and pensions, and raise taxes for the mass of workers. At the same time there was tax relief for the wealthy. General Seeckt, the commander of the Reichswehr, wrote in early January 1924: "Restoring the German economy will lead to bitter struggle between employers and workers."[48]

Even at this early stage in developments it was obvious with whom the big industrialists would be reckoning in this struggle. They provided substantial sums of money for both the paramilitary organizations (the 400,000-strong Stahlhelm, the 200,000-strong Jungdeutscher Orden, the 100,000-strong Werwolf and countless smaller associations) and the populist right-wing political alliance which comprised the German National People's Party (DNVP) and the National Socialist German Workers' Party (NSDAP).

In September 1923 Hugo Stinnes, a German coal and steel magnate, had cast all doubts about the political future to the wind. The United States' Ambassador to Germany, Houghton, cabled a report to his government:

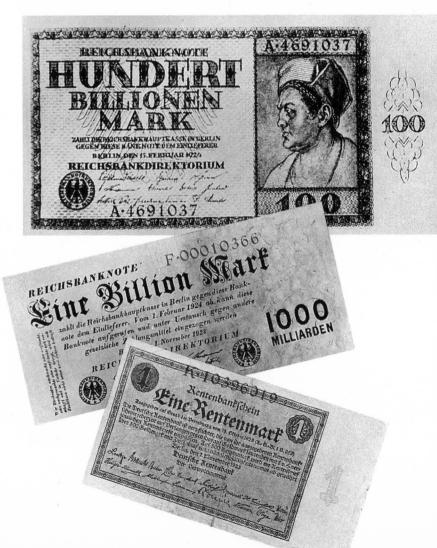

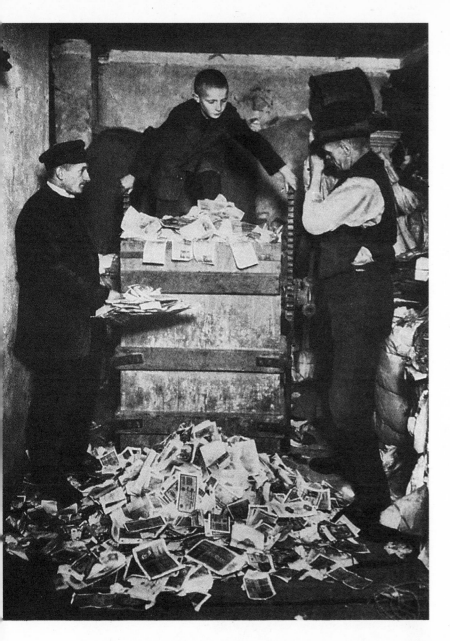

Banknotes were bought up by the week for recycling with the other wastepaper, while new ones were issued with dizzying values. Photo taken May 1923.

Left:
The price index published during the last week of inflation in Germany from 16 to 22 November 1923 shows that a postcard stamp cost 40,000 million Marks, a cubic meter of water 210,000 million Marks and a hundredweight of household coal almost two billion Marks.

The last banknotes for denominations over 1,000 million Marks were printed in October 1923 towards the end of the inflation period. The new Rentenmark, dated 1 November 1923, was issued on 22 November.

"Stinnes came Sunday afternoon. He . . . talked about Germany's economy, which he said had hit rock bottom. Factories and workshops are lying idle. However the German labour force has to work harder and longer hours . . . He is, however, convinced that the German labour force will not accept the necessity for this and will have to be forced. For this reason, he said, a dictator must be found, equipped with the power to do whatever necessary. Such a man . . . exists. A big movement launched from Bavaria . . . is close at hand. I asked him how close—and he told me maybe three or four weeks away."[49] (Re-translated from the German.)

A remarkable document! Hugo Stinnes was sticking his neck out further than most reactionaries in Germany. In fact, when Adolf Hitler burst into the Bürgerbräu beer cellar in Munich on the evening of 8 November 1923 with a handful of his stormtroopers to proclaim a "national revolution" and declare a joint "Reich government" with Ludendorff, the Bavarian government responded the next morning by sending in the police against the Nazi demonstrators. Hitler was arrested several days later and sentenced to a short spell in prison which he never even completed. In May 1924 the first fascist deputies entered the Reichstag, and the alliance between the DNVP and NSDAP had notched up 1.9 million votes.

Once the currency revision had been achieved, the next important step towards facilitating economic stabilization was to amend the schedule of reparations which Germany was obliged to pay the victorious powers of the First World War. Part VII of the Treaty of Versailles signed in 1919 gave Germany 30 years to make compensation and provided for a commission to draw up the details. The payment of reparations had considerably debilitated Germany's economic potential in the five years up to 1923. As the ruling circles in the United States and Britain were sharp to recognize, this policy of sanctions and impoverishment would have to be modified, otherwise it would spark off a revolutionary situation in Germany which would weaken and threaten capitalism throughout Europe. Nobody wanted that. Quite the reverse: the country had enormous economic potential which could be exploited to strategic and political advantage.

The Dawes Plan, named after the American banker and Vice-President of the United States, Charles G. Dawes, who helped to draft it, was introduced in 1924. It revised the terms of reparation by leaving the full value and timing of the German payments open and merely demanding that Germany should pay 1,000 million gold Marks during the first year (1924/25) with an annual increment in the years to follow. The money to make these payments should be raised primarily out of taxes and excise.

This plan offered large-scale industry in Germany the very best conditions to develop. The Reich Federation of German Industry (RDI) gave it warm approval, and only a week after the Dawes report had been published the Reich government accepted the plan, which came into force on 1 September 1924 after ratification by the Reichstag.

The men who bore the major blame for the First World War were not those who now bore the brunt of the compensation. Instead, the working people of Germany were now required to contribute additional taxes. As a result in part of this ongoing reparation debt, the incipient stabilization in Germany was to be temporary and sporadic, in other words only relative, and sooner or later it would be followed by new economic and political crises.

In 1924 Kurt Tucholsky wrote his poem *Wo bleiben deine Steuern—?* (What's Happened to Your Tax?), which summed up the situation accurately:

"Wenn einer keine Arbeit hat,
 ist kein Geld da.
Wenn einer schuftet und wird nicht satt,
 ist kein Geld da.
Aber für Reichswehroffiziere
und für andere hohe Tiere,
für Obereisenbahndirektoren
und schwarze Reichswehrformationen,
für den Heimatdienst in der Heimat Berlin
und für abgetakelte Monarchien—
 dafür ist Geld da.
Wenn ein Kumpel Blut aus der Lunge spuckt,
 ist kein Geld da.
Wenn der Schlafbursche bei den Wirten zuguckt,
 ist kein Geld da.

Aber für Anschlussreisen nach Wien,
für die notleidenden Industrien,
für die Landwirtschaft, die hungert,
für jeden Uniformierten, der lungert,
und für Marinekreuzer und Geistlichkeiten
und für tausend Überflüssigkeiten—
da gibts Zaster, Pinke, Moneten, Kies.
 Von deinen Steuern.
 Dafür ist Geld da."[50]

(If someone hasn't got a job,
 there's no money.
If someone sweats and his tummy rumbles,
 there's no money.
But for officers of the Reichswehr
and other Very Important Persons,
for Directors of the Railway Board
and Reichswehr divisions in black,
for service to the country at home in Berlin
and laid off monarchs—
 there's money.
When a miner coughs blood from his lung,
 there's no money.
When the lodger watches his landlord eat,
 there's no money.
But for business trips to our cousins in Vienna,
for industries which are in a bad way,
for our starving agriculture,
for every loafer in uniform,
for battleships and men of the Cross,
and for a thousand little luxuries—
there's brass, spondulics, shekels and dough.
 From your taxes.
There's money for that.)

And now the money was flowing back into Germany from abroad. Investments were forthcoming, and so were loans for German industry—almost 27,000 million Marks' worth between 1924 and 1930—as the returns looked promising. The German economy recovered with relative speed, reaching pre-war levels of industrial output by 1927, two years earlier than victorious Britain! The grow-

ing concentration of industry and capital facilitated this process. Joint-stock companies and powerful groups were in control of entire productive industries, for state monopoly capitalism was taking shape in Germany, too. Modern technology in the field of electronics and chemicals saw the rise of "new" names that were to join the traditional giants of coal, steel and heavy engineering as major factors in the structure of power.

IG-Farben was founded in late 1925 on share capital worth over 1,000 million Reichsmarks (the currency which replaced the provisional Rentenmark in 1925). It was a group company with 78 subsidiaries. Before long IG-Farben held substantial control of chemicals production in Germany. Karl Duisberg, the Chairman of the Board, took over the chairmanship of the Reich Confederation of Industry at the same time in 1925. The Vereinigte Stahlwerke AG, which united Germany's seven biggest steel manufacturers with the Ruhr companies dominating crude iron production, was founded in early 1926 and asserted similar control. Thyssen, Krupp, Kirdorf and Vögler headed this coal and steel lobby in pressurizing for arms production, as maximum profits could only be obtained from large-scale manufacture.

Just how concentrated German industry was becoming is clear from the table below, which shows what percentage of overall production in selected branches of the economy was accounted for by the big companies in 1928:

Potash mining	98.3
Mining and mining industries	97.3
Paint and dye industry	96.3
Lignite extraction	94.5
Hard coal extraction	90.1
Electricals	86.9
Metalworking	85.0[51]

Egon Erwin Kisch wrote a vivid account of life in Leverkusen, a major centre of IG-Farben, in his book *Das giftige Königreich am Rhein* (The Poisonous Kingdom on the Rhine), published in 1927: "There are white shirts hanging out of the windows or on washing lines to dry, just like anywhere else. But here the visitor will notice blue, green and purple spots on the laundry. Enlightenment is not long in coming: the skin of the people working in IG's alizarin block at Leverkusen is impregnated by the dye and at night or on Sundays some of the absorbed pigment is sweated out through the pores onto sheets and clothing, after which it is impossible to remove the famous colouring.

"It is not only his washing line which tells you which factory a dyeworker is from. The colour of his face also shows whether he is an 'Indian' and handles brown dyes, or a 'green woodpecker'. During a single evening in Leverkusen you can shake blue hands, green hands, red hands . . .

"It is most regrettable for those concerned that these chemicals designed to dye textiles should actually demonstrate their durability on the skins of live human beings, but it is not so bad as the vapours which enter the lungs when the dyes are boiled, and not so dangerous as the lead poisoning, the arsenical hydrogen gases in the lithopone unit which often cause mental illness, the vitriolic burns and eye wounds in the shop where the zinc sludge is mixed, the chlorine which also eats away at the brain cells.

"But if chance is kind, the chemicals are not: most of the workers in 'Yammerkusen' are distressingly pale and emaciated. Even the young girls who pack the dye powders and make the films and photographic paper have sacrificed all the youth from their eyes and cheeks to the poison or the eternal darkness."[52]

The big companies exerted their influence on the Weimar state apparatus in a number of ways. "On major points of economic, home and foreign policy, the state merely carried out the agendas which the employer associations compiled in their memos (e. g. the memo from the Confederation of German Industry on German Economic and Financial Policy in late 1925)."[53]

The growing concentration was accompanied by far-reaching changes in the mode of production. German industry followed the example of the United States in rationalizing and automating labour processes. Assembly lines and piece rates were introduced. Research and development were expanded, permitting technical innovations

and updated technologies to be adopted rapidly. Productivity lurched ahead, and between 1924 and 1929 the annual rate of increase averaged no less than 40 per cent. The biggest factor in this was the intensified exploitation of working people, many of whom toiled for ten hours a day.

In addition, unemployment hovered around the two million mark from 1924 to 1929, and those affected were obliged to live in inhuman conditions.

These class antagonisms should be borne in mind when considering the tremendous advances that were taking place in science, technology and art. There were many in Germany for whom the twenties were not as "golden" as parlance might lead us to believe. If bourgeois circles all over Germany revelled in the "new mood of the times", the jobless were lucky even to read about it in the newspaper.

This new lease of life flowed from two main sources. The end to inflation and the post-war crisis created an impression that the new Republic had drawn significantly closer to realizing its bourgeois democratic ideals. Few shared Kurt Tucholsky's ability to note that the Republic was still being nourished by the same militaristic soil, that justice still depended on class, and that as far as political and economic progress was concerned:

"Republik oder Kaiserreiche—
's ist immer das gleiche, immer das gleiche."[54]

(Republic or Imperial Reich—
nothing changes, nothing changes.)

The second reason for this articulation of a "new age" was an objective one: life in the twenties was being overwhelmed by technology at a breathtaking speed, comparable only with the era of the first industrial revolution in the 19th century. This process was spurred on partly by products and influences from industry in the United States which crossed the Atlantic to Europe, and partly, in fact primarily, by the whirlwind advances in Germany's own science and technology.

Universities and research establishments in Germany were working more closely with modern research and development units in industrial concerns in order to convert theoretical findings into useful productive methods. Two examples serve as illustrations:

In 1918 Fritz Haber devised the first ever industrial process for producing ammonia at the Kaiser Wilhelm Institute of Physical Chemistry in Berlin. In 1925 Fritz Haber and Carl Bosch, one day to become Chairman of the Board and Administrative Council of IG-Farben, used this initial discovery to develop a process in the company laboratories for producing artificial fertilizer. By the end of 1925 IG-Farben's Leuna plant had already gone into large-scale production, soon becoming the world's major nitrogen producer.

Friedrich Bergius at Berlin's Kaiser Wilhelm University had begun working on the high-pressure hydrogenation of coal in 1913. Again it was IG-Farben which managed to incorporate Bergius into its in-house research, enabling it to launch large-scale production of industrial oils and petrols in 1926 and, just a few years later, of synthetic rubber and synthetic substances from coal and chalk.

Thanks to these industrial process using domestic raw materials, Germany was able to become less dependent on raw material imports.

Given the level of civil technology at the time, none of these products, with the exception of the fertilizer, could be marketed in the kind of quantities which IG-Farben was now able to produce. Only if armament and war production were stepped up would they be able to make a profit from millions of litres of synthetic petrol and similar numbers of rubber tyres.

The development in electricals was just as rapid as in chemicals. A new company giant was born, the Allgemeine Elektricitäts-Gesellschaft, or AEG, which led the field in manufacturing the latest turbines, generators and motors and also electric cable and light bulbs. The telephone network in Germany expanded fast from 1922 onwards. In October 1923, the city of Leipzig opened the biggest automated telephone exchange in the Europe of the day. There was considerable pride in its claims to more than eleven kilometres of wire and seven million solderings. The technology of wire-less communication also proceeded apace. In 1924, for example, there was

great public interest in the first telephone conversation to be conducted from the Berlin-Hamburg Express. The first phototelegraph was more or less contemporaneous: Arthur Korn built it in Berlin in 1925.

Transportation, especially by air, made tremendous headway. The first civilian passenger craft, Hugo Junkers's non-braced aeroplane made entirely of metal, was designed in Dessau in 1919. Junkers opened a factory in the town where 73 of these planes were constructed in 1920, and the models were constantly updated in the years which followed. This was another productive sector where the potential for profit could not be fully exploited for civilian purposes.

The Zeppelin airships made in Friedrichshafen on Lake Constance by a team under Hugo Eckener were a sensation in Germany, and when they floated over German towns they were frequently greeted by celebrations. Eckener attracted as much limelight when he crossed the Atlantic in 1924 as did the American Charles Lindbergh in his single-engine aeroplane three years later.

The Zeppelins began ferrying passengers in 1926, but the service was stopped a good ten years later after the Lakehurst disaster, when a scheduled flight burst into flames in the United States.

Albert Einstein was often asked to participate in official functions alongside his scientific work. He is seen here opening the Berlin Radio Exhibition in 1930.

The Deutsche Lufthansa was fond of using prominent air passengers to advertise this new form of transport. The caption to this photo taken in 1930 reads: "Sigmund Freud, the well-known Viennese professor, boards a scheduled Deutsche Lufthansa flight at Tempelhof Airport in Berlin on the return journey to his home town."

The airline Deutsche Lufthansa was formed out of a merger between Junkers-Luftverkehr and Aero-Lloyd in 1926, and in the years until 1930 it established regular flights to the major European capitals. In 1931 passenger craft with up to 30 seats were flying from Berlin to London in the impressive time of four hours. Tempelhof Airport in Berlin was developed to become Europe's most modern air terminal. Air travel could not have succeeded without comparatively reliable weather forecasting, something achieved by the Berlin physicist Heinrich Ficker, notably as a result of his research into the stratosphere using balloons.

German research into physics was to prove revolutionary. Names like Albert Einstein, Max Planck and Werner

Heisenberg are symbolic of discoveries that pioneered a new approach to science.

When Einstein devised his special Theory of Relativity in 1905, he had already ushered in a new era of thinking in physics. He then went on to frame a completely new understanding of the nature of time and space in his general Theory of Relativity in 1917 and a follow-up theory in 1929, eventually absorbing previous theories about electricity and gravity into a Unified Field Theory and making an enormous impact on almost all areas of theoretical research in the natural sciences. Like Einstein, Max Planck also worked at the Kaiser Wilhelm Institute of Physics in Berlin. In 1918 he discovered the elementary particles that formed the basis for quantum mechanics and revolutionized theoretical physics from about 1924 onwards. Werner Heisenberg's research at Leipzig University from 1926 played an important part in the development of quantum mechanics as it sought to interpret the behaviour of an atom's electron shell. In 1932 Heisenberg discovered that the nucleus of an atom was composed of two elementary particles and could therefore be split. This was the beginning of nuclear research as such, and in 1938 Otto Hahn succeeded in splitting the atom for the first time.

Quantum physics and atomic theory led to advances in chemistry in the late twenties, with completely new areas of research being established. Macromolecular chemistry opened up new research into the structure of large organic molecules. Biochemistry was finally accepted as a science. Once the existence of enzymes, vitamins and hormones had been demonstrated by around 1924, it was possible to investigate how chemical processes were governed within an organism. This in turn influenced medicine, and chemical therapies gradually became more widespread. One important advance here was Gerhard Domagk's discovery in 1932 that sulphonamides could be used in the treatment of disease.

At that time, sexology and psychoanalysis were two completely new areas of research. Magnus Hirschfeld at the Berlin Institute of Sexual Research did much to pioneer a scientific approach to this important aspect of people's lives.

German laboratories produced countless inventions and technical improvements which one might cite to substantiate this picture of a scientific and technological boom, from the electric soldering iron to bullet-proof glass. Whereas only 2,200 German patents were registered with the Reich Patent Office in Berlin in 1919, by 1924 the number had soared to 56,000, twenty-five times as many.

16 Germans received a Nobel Prize for science in the years between 1918 and 1933. No other country has ever held such a dominant position in the scientific world, an achievement which testifies to the status of German research during the years of the Weimar Republic. Berlin was a leading centre of this activity, but it was by no means the sole scientific metropolis in Germany. There were major research establishments at the universities of Munich, Heidelberg, Göttingen and Leipzig.

Accelerating progress in new technological processes was one pillar of incipient modern mass production, and the other was the introduction of the latest American methods in industrial streamlining. Science played a role here, too, with the big companies commissioning research into the new fields of labour psychology, industrial hygiene and management studies.

There were radical changes in the organization and management of production, the aim being to achieve maximum intensification of the production processes. Industry was quick to set up two bodies designed to promote this trend, the German Industrial Standards Commission in 1917 and the Reich Science Curatorium in 1921, both of which studied American experience and proposed suitable measures for Germany. From 1923 onwards, production became increasingly standardized, encouraged by the process of industrial concentration. The latest branches of manufacturing, notably electronics and engineering, introduced assembly lines based on the American model. At the same time Refa, the Reich Commission for the Investigation of Labour Time, carried out time-and-motion studies that formed the framework for new wage systems.

The rate of rationalization in German industry advanced by leaps and bounds thanks to the production belt and the

new wage structure. But for millions of working people these very same measures meant an increased rate of exploitation, as their employers pushed them to the extremes of their physical ability. They experienced a sharp rise in monotony and coercion in their jobs.

"The demonic screen"—
From silence to sound

The Booklovers' Association published its anthology *Kunst und Technik* (Art and Technology) in 1930. Leo Kestenberg, a consultant in the Prussian Ministry of Culture and a major patron of contemporary music, contributed the Introduction, in which he reviewed the trends of recent years: "Technology is the driving force of the era. It exerts a decisive influence on the profile of the times. Most of the phenomena which occur in the economic, social and political process are derived from consequences of technological development . . .

"Art, the realm of the few; technology, the realm of all: how can these heterogeneous spheres forge an association? At first glance the question seems more than justified, for the truly great achievements of technical innovations have taken place without any reference to artistic considerations. Inevitably, the development of technology paid not the slightest heed to the fundamental concepts of aesthetics. Film, radio, the gramophone record all emerged at first as purely technical sensations . . .

"Once the pure pleasure sparked off by the technical invention had faded, there was an interest in the shape which these technical innovations might take, and only then did people remember art. That was the point at which art invaded technology.

"But we should also note that technology has invaded art. It is an invasion which has taken place over recent years with primitive force."[55]

Artists of all genres were fascinated and, indeed, influenced by the new technological media of the twenties, and began to work for them. Here, too, there was an evident concentration of forces from about 1924 onwards, and in that respect the process was not so very dissimilar from trends in German industry. The first of the new mass media after 1918 was the silent film. Although it had been invented in the previous century, it had led an obscure existence for almost twenty years as a mere fairground sensation. It was not until 1910 that the first, lengthier feature films were made and the first cinematographic theatres opened.

Berlin had a virtual monopoly on film-making in Germany. There were no studios outside the capital until the Munich workshops were built in the mid-twenties. In Berlin the primitive "glasshouses" of 1910 gave way after the First World War to efficient modern film studios, both in the centre of town (the ateliers by the Zoo) and in the outlying boroughs of Weissensee, Johannisthal and Neubabelsberg. The market was promising: for just a few pennies the public could buy an hour or two of entertainment and protection from the cold air of the post-war winter. This enabled business to grow and flourish from 1918.

There were already 2,280 cinemas in Germany by 1919, and by 1930 there were 3,500, with a million tickets sold daily. They ranged from the cheap nickelodeon to the luxurious picture palace. The region around the Kaiser Wilhelm Gedächtniskirche soon earned the name of "Berlin's Broadway", as a cluster of cinemas sprang up between Tauentzienstrasse and Kurfürstendamm—the Marmorhaus (1911), Capitol (1916), Gloria-Palast (1918), Ufa-Palast (1918) and the Rialto, which opened in 1919 with 3,000 seats as the biggest cinema in Germany.

Similar palaces were built in all major German towns from 1918. The market was crying out for films, and the studios churned them out on a conveyor belt: tear-jerkers, war films, thrillers and Westerns in the American style, nostalgic "Prussian" films by the score and—the latest genre in those post-war years—so-called sex education films, barely concealed exercises in pornography from the brothels and demi-monde which were released under the cloak of "medical advice". This trivial cinema was matched on the book market by penny dreadfuls, third-rate paperbacks of similar flavour which appeared by the dozen. All this had little to do with art. The reaction during 1919/20 was for more and more people to call for a complete ban on cinema in Germany. An official Church statement declared: "The cinema is one of the principal cen-

tres of the epidemic which is infecting and poisoning our nation daily."[56] The Centre Party politician Galleiske delivered more detailed arguments in October 1919: "Film leads the way into every area of criminal law; it shows us the forger in his workshop, it initiates us into the mysteries of poaching and cheating; it illustrates hypnosis in the service of crime, it strolls with the cinema-goer through the haunts of pimps and whores and, in the provocative—rather than educative—films which are currently so fashionable it introduces him to the company of white slavers and brothel owners, and ultimately sexual offenders."[57]

The protests grew so clamorous that the government began tightening up the censorship laws in 1921. The film censors applied tougher standards, but as time went on they functioned more and more as tools of political censorship.

While the welter of trashy films provoked a backlash of serious pressure for abolition of the cinema, in Berlin, art, to quote Kestenberg again, was invading technology. There had been isolated attempts at artistic films since 1910. *Der Student von Prag* (The Student of Prague) in 1913 and *Der Golem* (Golem) in 1914 were examples. In 1911 Kurt Pinthus had published a film script which illustrated the interest that the literary community was taking in the new medium. But the public paid little heed to such things, and they hardly exerted any influence on production.

The situation changed on 26 February 1920, when Robert Wiene's film *Das Kabinett des Dr. Caligari* (The Cabinet of Dr Caligari) had its première at the Marmorhaus. The German Expressionist silent film was born. "Not for years," wrote Kurt Tucholsky, "have I sat in the cinema so riveted as I was here. This film is something quite new."[58]

The newness lay in the totally artificial world of *Caligari*, the film's conscious detachment from reality, and the exaggerated Expressionist set constructed with the help of prominent painters and architects. There were also some significant contributions to the technique of film itself, such as the careful use of light and shadow, mirrors, camera movement, and acting geared primarily to the camera. By 1925 there had been several important works of Ex-

pressionist cinema, including Friedrich Wilhelm Murnau's *Nosferatu*, Paul Leni's *Das Wachsfigurenkabinett* (The Waxworks), Karl Grune's *Die Strasse* (The Street) and Fritz Lang's *Dr. Mabuse der Spieler* (Dr Mabuse the Gambler). The film historian Lotte H. Eisner has described "the magic of light and half-dark, the stylized fantasy in the *féerie de laboratoire*, the decorative Expressionism, the world of mirrors and shadows and the symphony of fear"[59] as valuable innovations for the medium.

While the formal components were so intriguing, however, the content of the films was sometimes dubious. Siegfried Kracauer, the writer and eminent film historian, wrote: "In these films the soul can only choose between tyranny and chaos, a desperate dilemma. For every attempt to cast off tyranny leads straight to chaos. As a result the film creates an all-pervasive mood of horror."[60]

Directors Lupu Pick and Friedrich Wilhelm Murnau made the transition from Expressionism to Realism in a series of films for esoteric consumption. The subject matter was drawn from everyday life, the characters were limited in number, and the unity of time, place and action was observed in realistic manner. Yet here again the protagonists were depicted in a hopeless situation, although this time they were not rebelling against tyrants, vampires and other superior enemies, but against the cruel laws of daily existence.

In Murnau's *Der letzte Mann* (The Last Man), a proud hotel porter ends up as a toilet attendant, in Lupu Pick's *Scherben* (Shattered Glass) a track inspector kills his daughter's seducer and then gives himself up to the law, and in Pick's *Sylvester* (New Year) the landlord of a small coffee-house takes his own life because he can no longer solve his problems.

All these films reflected the decline of the lower and middle strata of the bourgeoisie and also their determination not to admit that the decline was happening. Kracauer: "What choice did they have in this situation but to keep their eyes open for a new 'Fridericus' who would cast out the melancholy from their plush living-rooms?"[61]

Although this handful of "art films" are remembered as Germany's contribution to silent cinema before 1925, they probably account for no more than 40 films out of an

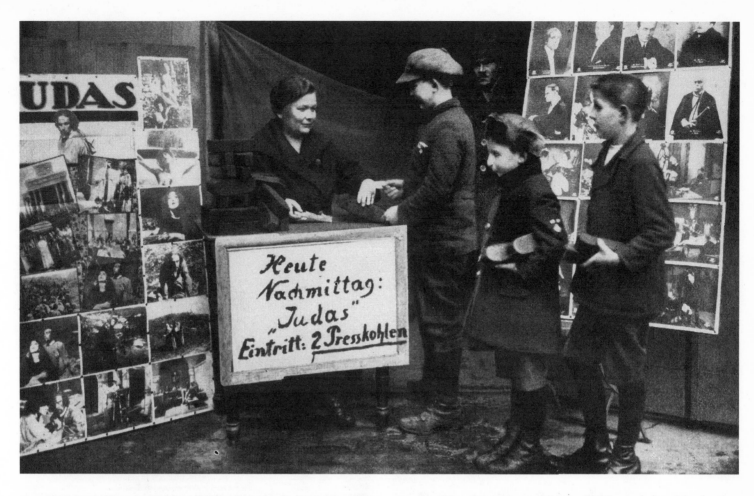

Even Berlin's cinemas resorted to self-help in the bitterly cold winter of 1919/20. Anyone who wanted to see the matinée showing of *Judas*, a Biblical melodrama, was expected to help with the heating.

overall production of more than a thousand. Avant-garde they may have been, but they were a drop in the ocean compared with the third-rate pictures that managed to pull in the masses by the million. Lotte H. Eisner again: "They had already been drowned in the flood of films with public appeal, the box-office attractions about the Rhine and the beautiful blue Danube, about the heart someone left in Heidelberg, the flag-waving films about Frederick the Great, Schill's heroic Prussian officers, the King's Grenadiers and the First World War."[62]

One popular theme of the silent movie was the city along with all its sunny and shady sides, although it was the shady sides which dominated. Leopold Jessner's and Paul Leni's *Hintertreppe* (Back Stairs), 1921, Karl Grune's *Die Strasse*, 1923, G.W. Pabst's *Die freudlose Gasse* (The Cheerless Alley), 1925, and Joe May's *Asphalt*, 1928, were melodramatic projections of an urban organism cast in the role of a vampire, which tore to pieces whoever it caught in its claws.

Murnau and Lang were the two outstanding directors of silent film in Germany. After *Der letzte Mann* turned out to be such an unexpected success, Murnau attempted screen versions of two literary works, *Tartuffe* (1925) and *Faust* (1926), with Emil Jannings in both title roles. But although the performances were impressive and the camerawork excellent, neither film achieved the intensity of *Der letzte Mann*.

The biggest problem lay in conveying the philosophical depth of Goethe's play without being able to use the text. As a last resort, Gerhart Hauptmann provided rhyming couplets for the title links. One American critic aptly remarked that the libretto to Gounod's opera was all that had been salvaged of the drama.

Left:
The extensive grounds at Ufa's Neubabelsberg Studios just outside Berlin left plenty of scope for monumental sets. Here against the pinewoods of Brandenburg's sandy plains Fritz Lang did the shooting for his *Nibelungen*. High up on the left is the director's chair and camera.

K. Umbehr's photomontage for the documentary film *Berlin—Symphonie einer Grossstadt,* 1925, used "roving reporter" Egon Erwin Kisch as the symbol of a hectic age.

Otto Hunte produced the designs for Fritz Lang's gigantic city in *Metropolis*, 1926. A new animation technique invented by Eugen Schüfftan was used to film the airships gliding between the skyscrapers.

Rocket researcher Professor Hermann Oberth was called in for advice in 1929 when the Babelsberg Studios built a moon rocket for Fritz Lang's last silent film *Die Frau im Mond*. Front right is the moon's surface as conceived by the Ufa set designers.

The shooting for *Metropolis* brought together cameraman Karl Freund (left), director Lang and, on the set, actors Willy Fritsch and Fritz Rasp.

After *Faust* Murnau was invited to Hollywood, and he pursued his career there successfully from 1927.

Fritz Lang had been highly successful with *Der müde Tod* (Weary Death), 1921, *Dr. Mabuse der Spieler*, 1922, and above all the two-part film *Die Nibelungen*, 1924. After that he decided to tackle an American-style "epic". *Metropolis* took two years to make from 1925 and was based on a scenario by Lang's wife Thea von Harbou, who had written many popular novels for Ullstein. The production costs amounted to over five million Marks, and 620,000 metres of film were shot for the finished picture of barely, 5,000 metres. These statistics were quite unlike anything Germany had known before.

Metropolis was a futuristic vision, a city built above and below the Earth. Below were the grey, faceless mass of worker slaves, and above the owners living in undescribable luxury. But the social potential in the plot was never exploited. In Thea von Harbou's story there was an uprising which ended in reconciliation between those down under and those on top. The son of the biggest capitalist married the woman who led the workers. A happy ending! This film more than any other of his silent movies betrays the poverty of Lang's genius. The often superb optical and formal inspirations stand out in stark contrast to the illogicalities of the plot. A review in the Berlin *Filmwoche* after the première rightly commented: "Your misfortune, distinguished Fritz Lang, is that the idea means nothing to you, only the image. You clutch at the tableau."[63]

The British novelist H. G. Wells, whose book *The Time Machine* had provided Thea von Harbou with some of her ideas for *Metropolis*, was rather more outspoken: "The film dishes up uncustomarily large portions of almost every conceivable folly, cliché, banality and confusion about technical progress in general, served with a sentimental sauce which is unique of its kind."[64]

One can only agree with the Polish film historian Jerzy Toeplitz when he concludes that after almost 60 years all that is left of *Metropolis* is "a sense of regret that such great technical opportunities were wasted on such pointless subject matter. And doubtless also a sense of wonder at the outstanding décor and the clever direction in many of the crowd scenes."[65]

Fritz Lang's last silent film was *Die Frau im Mond* (The Woman in the Moon) in 1929. Once more the director

And the Prussian films kept churning out: after the *Fridericus Rex* trilogy of 1926/27, with Otto Gebühr as the screen Frederick II, Queen Luise became a favourite theme. The 1931 version, directed by Carl Froelich, starred Henny Porten. The photograph well illustrates its sentimental mood.

Left:
Actress Lilian Harvey and composer Werner Richard Heymann (standing) were big names in early German sound films. The photo shows them on location in 1931 with the dome of Berlin Cathedral in the background.

drew on an ambitious piece of science fiction, a journey to the moon. He even persuaded rocket researcher Oberth to act as adviser for the flight scenes. But again the film suffered from Thea von Harbou's banal storyline, while Lang, for his part, again sacrificed psychological depth of character and a logical plot to superficial visual effects, although the lunar landscape constructed in Babelsberg was no match at all for the imaginative *Metropolis* set.

Once inflation was over, the film world was affected by the process of concentration. American capital eager for investments in Germany was an important factor. The Hollywood film giants had been flirting with the interesting market for cinema in Germany for some years. As the German currency stabilized, many film companies found

themselves in financial difficulties, and Hollywood seized its chance. In 1925 Universal, Paramount and Metro Goldwyn Mayer all bought substantial shares in Ufa and built up their Parufamet distributor to ensure that their films would be shown in Germany. Universal also purchased shares in Terra, a firm based in Berlin's Johannisthal, while MGM bought their way into Phoebus-Film.

As a result there was now strong competition from American pictures at German cinemas, and that provoked an even greater commercialization of German moviemaking. There was a slump in demand for artistic experiments: box-office success was all that mattered.

Ufa and Terra grew to become Germany's biggest film companies, and their share of annual output soon exceeded 20 per cent. In 1927 Alfred Hugenberg, the future Chairman of the German National People's Party, became President of the Ufa Board of Governors. Germany's biggest film company was now integrated into his reactionary media concern. Hugenberg had started building his press empire in 1916 out of a small newspaper office. By the mid-twenties it included the Scherl group, the Telegraphen-Union, Ufa and nationwide newspapers such as the nationalist *Tag*, and Hugenberg made skilful use of his strong foothold in the major mass media to disseminate his political aims.

Under Hugenberg's chairmanship Ufa began making a considerable number of chauvinistic nationalistic pictures from 1927. Some celebrated the glory and splendour of historical wars—*Königin Luise* (Queen Luise), 1927, or *Die elf Schillschen Offiziere* (Schill's Eleven Officers), 1927—and others paid undisguised homage to German soldiers in the First World War—*Emden*, 1927, or *U9 Weddingen*, 1927.

As the German cinema became increasingly commercial, many famous directors and actors accepted tempting offers from Hollywood and turned their backs on the Berlin studios for ever, or at least for many years. Thus the German film world lost directors Ernst Lubitsch, Friedrich Wilhelm Murnau, Ewald André Dupont (whose *Varieté* of 1925 had been one of the best realistic films) and Ludwig Berger, and actors of the stature of Pola Negri or Emil Jannings (who in fact returned to Berlin in 1930).

Few of the films to emerge from this scene bore any artistic merit, but a small cinema vanguard persisted in its work, influenced by silent Surrealist film from France and revolutionary film from Soviet Russia.

Russenfilm, as Alfred Kerr baptised the works of the Russians Eisenstein, Pudovkin and Vertov in 1927, found a following in Germany from 1926. This was partly due to Prometheus, a film production and distribution network set up by International Workers' Aid under its director Willi Münzenberg. A huge protest movement in 1926 reversed the film censors' decision after the première of *Battleship Potemkin* had been banned several times. From 1927 the premières of new *Russenfilme* were big events for cinema-goers all over Germany. Backed by the Association of Cinema-Lovers, Prometheus launched its big publicity campaigns from Berlin as the films went on release in many towns, often in the presence of directors Eisenstein and Pudovkin.

But the bold visual idiom, gripping montage and free-ranging camera which characterized the new Soviet cinema only influenced a few German productions outside the mainstream companies, such as Friedrich Zelnik's screen version of Gerhart Hauptmann's *Die Weber* (The Weavers), 1927, or Piel Jutzi's *Hunger in Waldenburg*, 1927, a proletarian feature film in documentary mode.

Walter Ruttmann's full-length documentary *Berlin—Symphonie einer Grossstadt* (Berlin—A City Symphony) made in 1926 showed clear leanings towards Dsiga Vertov's principles of montage. Ruttmann had pieced together imposing footage of Berlin as an industrial metropolis to a rhythm which was almost musical. Here, too, we find the fascination for city life and its hectic whirl of factories, traffic and machines. Ruttmann's montage sequences were often regarded as the incarnation of New Objectivity in the German cinema.

Hans Richter's "absolute" films were influenced by French Surrealist cinema. Richter began by playing with shapes—*Rhythmus 1921* (Rhythm 1921) to *Rhythmus 1925*—and later abandoned his hand-drawn material to make short films with the camera. The main theme of *Vormittagsspuk* (Morning Ghostwalk), 1928, is the dance of four bowler hats. That same year he made *Inflation*, a satire on the period from 1920 to 1923. Walter Ruttmann also made several "absolute" films which, like Richter's, were numbered in sequence (*Opus I* to *Opus III*).

Another avant-garde film-maker was Ernö Metzner, whose experimental work *Überfall* (Attack), 1929, contained a merciless portrayal of police weighing in on proletarians. The censors therefore banned it.

The *Zille-Filme* marked another step in the direction of realist cinema in Germany. They were made in the years from 1925 to 1927 and took their name from the artist Heinrich Zille, who had produced such brilliant paintings and drawings of the Berlin slums. The series began with Gerhard Lamprecht's *Die Verrufenen* (The Disreputable) in 1925, and the same director followed this up a year later with *Die Unehelichen* (The Illegitimate). Other films of this genre were Viktor Janson's *Die da unten* (Them Down There), 1926, and Walter Fein's *Die Gesunkenen* (Sunk Deep), 1927. While these films gave a realistic enough account of milieu, they still gave no indication of the causes and social conditions which lay behind the misery portrayed.

Two Prometheus productions as silent film was nearing its demise began to express the needs of German proletarian cinema. Leo Mittler's *Jenseits der Strasse* (Beyond the Street) and Piel Jutzi's *Mutter Krausens Fahrt ins Glück* (Ma Krause's Ticket to Paradise) were both made in 1929. Mittler's picture showed unemployment on the German screen for the first time, but the overall effect was melodramatic. Jutzi, on the other hand, had produced the first real counter-response to bourgeois German cinema. The story of the proletarian figure Ma Krause was shot exclusively on location in Berlin's working-class district of Wedding using authentic interiors, and went one step further than depicting poverty to pose the only possible answer: while Ma Krause attempts the only solution she knows by turning on the gas tap, her daughter Erna is already fighting for happiness at the side of a class-conscious worker. "It is not grey Wedding, but red Wedding which is crucial to this film," wrote *Die Rote Fahne*: "This is not a 'slum film' reeling off the projector, nor a 'ballad of poor folk', but a class-conscious film about the revolutionary proletariat in Wedding."[66]

Ich besitze seit drei Jahren eine Adlerschreibmaschine, aber ich habe nicht immer eine besessen. Als ich im Sommer 1925 den "Fröhlichen Weinberg" schrieb, war ich noch nicht einmal in der Lage, die Kosten für die Herstellung eines maschinegeschriebenen Exemplares aufzubringen, welches bekanntlich die Voraussetzung ist, dass die Arbeit eines unbekannten Autors überhaupt gelesen wird.Eine abgebaute Stenotypistin pumpte mir ihre alte Maschine.Die war in einem völlig unbrauchbaren Zustand. Die Umschaltung funktionierte nicht und man konnte keine grossen Buchstaben schreiben. Das "e" und das "r" waren dermassen zusammengewachsen, dass man sie nur gemeinsam aufs Papier brachte. Das "a" hatte eine sonderbare seitliche Ausbuchtung, an der man sich jedesmal den Finger blutig riss. Ich hatte von Maschineschreiben keine Ahnung und tippte mir nachts mühsam mit wörtlich blutigen Fingern mein Stück zusammen, das man dann, infolge der kleingeschriebenen Hauptwörter, zunächst für ein Gedicht von Stefan George hielt. Allerdings stellte sich bei genauerer Prüfung des Inhaltes der Irrtum bald heraus.

Kurzum: Von den ersten Tantièmen kaufte ich mir eine kleine "Adler". Mit der führe ich seitdem eine zärtliche und untrennbare Ehe. Ich schleppte sie durch ziemlich sämtliche Zollämter der alten Welt und demnächst wird sie wohl auch mit mir über den grossen Teich schwimmen. Ich habe erfahren, dass man auf ihr die verschiedensten Arten von Stücken schreiben kann: sogar solche, die dann von der Presse verrissen werden, der "Klein-Adler" ist das ganz egal. Mir zum Teil auch. Das heisst, offen gesagt, nur bis zu einem gewissen Grad.-

Auf meiner kleinen "Adler" habe ich den "Schinderhannes" geschrieben, die "Katharina Knie", meine sämtlichen Novellen, meinen demnächst erscheinenden ersten Roman, viele Gedichte, wenig Briefe, der Maschine ist alles wurscht, sie hält unentwegt durch, und ich vermute, dass sie es bis zum Endsieg so weiter treibt.

Carl Zuckmayer

Famous names provided publicity for the technical innovations of the twenties:

Previous page:
28 Pola Negri, star of the silent film, with the latest luxury Ford saloon on Unter den Linden in 1922.

29 In 1928 Carl Zuckmayer extolled the virtues of the Adler portable typewriter in the magazine *Die literarische Welt*.

Right:
30 Heinrich Zille, whose paintings and drawings of Berlin tenement life were so popular, was photographed with the electric microphone at a radio event in the capital in 1927.

31 Writer Thomas Mann demonstrates the Electrola gramophone at his Munich home in 1930.

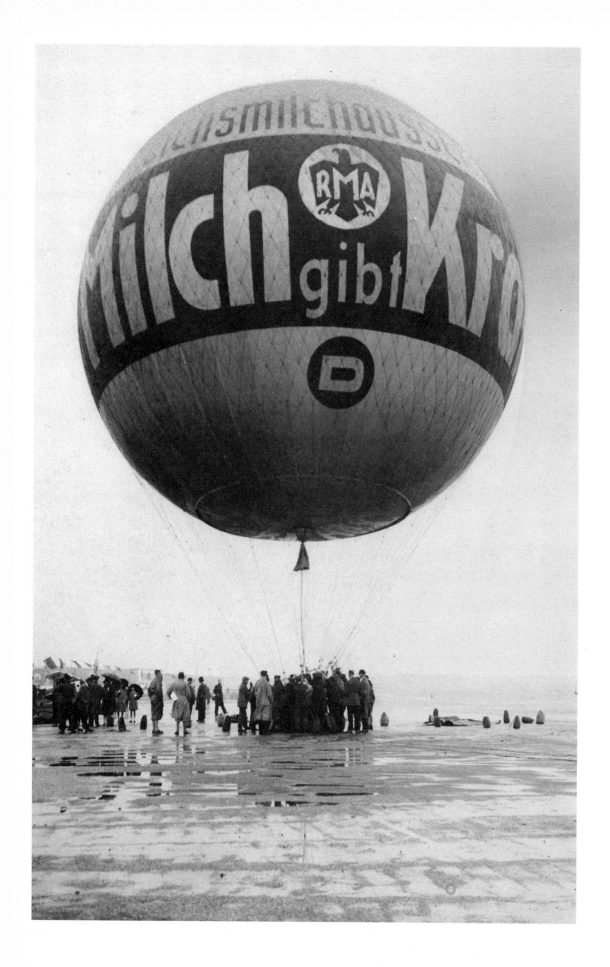

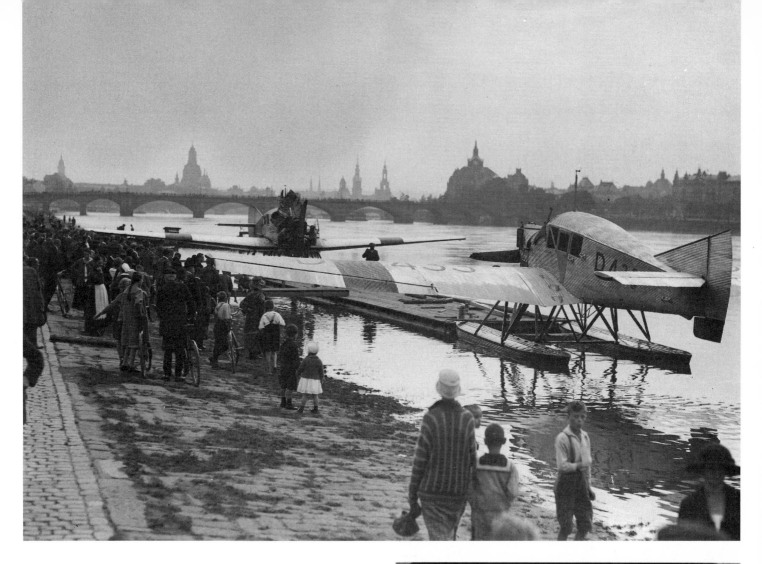

Left:
32 Even the captive balloon was a winner. This one advertising the Reich Milk Board attracted attention at the 1930 German Air Festival at Berlin's Tempelhof Airport.

33 Two Junkers F 13s on floats moored in readiness on the River Elbe in Dresden to mark the opening of passenger flights between Dresden and Hamburg in 1922.

34 When the airship "Graf Zeppelin" first crossed the Atlantic in late 1924, Captain Hugo Eckener cut a disc about his experiences.

EIN BILD VON DEUTSCHEM GLANZ
UND DEUTSCHER NOT
★
REGIE:
G. VON BOLVARY-ZAHN

RUTH CAREL · HELENE V. BOLVARY · ERNST DERNBURG
HEINRICH SEITZ · KARL WALTER MEYER · KARL POTT
RICHARD KOUTÉNSKY · ADOLF GREHL · GIDA VON LAZAR

URAUFFÜHRUNG: 6. MÄRZ 1925
S C H A U B U R G
KÖNIGGRÄTZER STRASSE 121
B A Y E R N - F I L M S

von Hanns Heinz Ewers
REGIE: HENRIK GALEEN
In den Hauptrollen:
Conrad Veidt, Agnes Esterhazy, Werner Krauss
Elizza la Porta
URAUFFUHRUNG
Montag, den 25. Oktober 1926
im CAPITOL
Sokal-Film-Verleih GmbH
BERLIN SW 48 · FRIEDRICHSTR. 246
Fernsprecher: Hasenheide 3081-82

Karlchen-Ensemble
1920

Left:
35/36 New film releases 1925/26. In this remake of *Der Student von Prag* (The Student of Prague), which originally starred Paul Wegener in 1913, Conrad Veidt took over the central role (below left). The director was Henrik Galeen, who wrote the script for *Nosferatu*. But with the exception of a few ambitious artistic productions like this, mass production dominated the screen as ever, with its share of nationalistic films glorifying war and the "German spirit" (top left). Director Geza von Bolvary was to become a master of entertainment and spectacle at the cinema.

37 *Caligari*: Erich Ludwig Stahl and Otto Arpke designed the poster when this silent Expressionist film was released in 1919.

38 *Caligari* was the exception. It was films like the *Karlchen* series which dominated the German cinemas that year. 15 films based on this character arrived on the market in 1919/20 alone. Oozing with patriotic sentimentality, smutty humour and old military chestnuts, they represented the lowest of the low in culture for mass consumption.

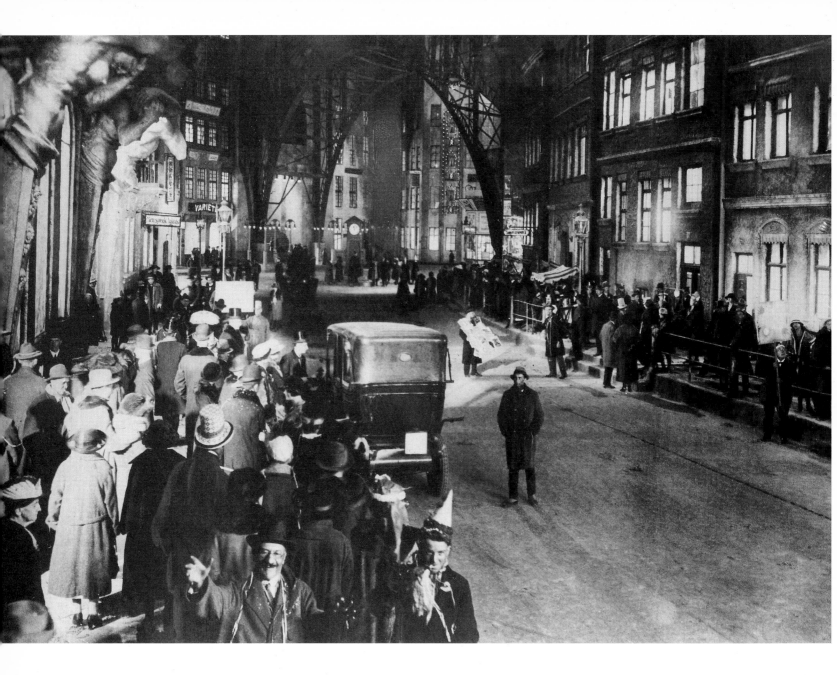

39 The temptations and dangers of the streets at night symbolized a whole series of "street films" from 1923 to 1928. This photo was taken during the shooting for Lupu Pick's film *Sylvester* (New Year) in 1923 and shows the studio set designed by Robert A. Dietrich.

Right:
40 Friedrich Wilhelm Murnau's *Nosferatu—Eine Symphonie des Grauens* (Nosferatu—A Symphony of Fear), made in 1922, paved the way for many vampire films to come, particularly in the United States of America. Max Schreck as Count Orlok.

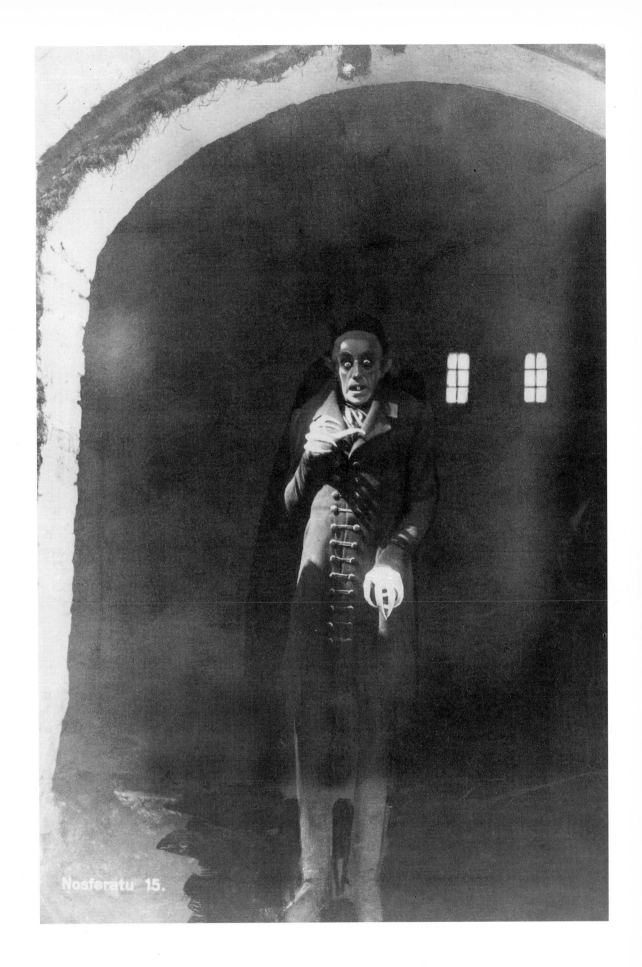

Nosferatu 15.

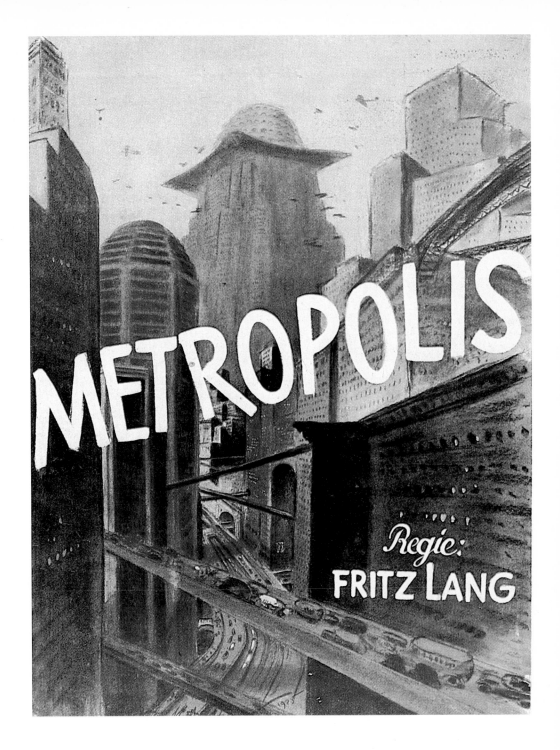

Left:
41 Fritz Lang and Thea von Harbou, seen here in 1927, were a husband-and-wife team who worked together for many years. Until 1933 she was a successful novelist with the publishers Ullstein, writing the scenarios for most of Lang's films. When the famous director emigrated, she left him and remained in Nazi Germany.

42 Willy Fritsch and Dita Parlo play the central roles in *Melodie des Herzens* (My Heart's Melody), the first German sound film made in 1929. "Every suggestion of a kitsch oleograph" (Lotte H. Eisner).

43 Fritz Lang's *Metropolis* was a breathtaking vision. Lang's direction exploited every optical effect created by set designers Otto Hunte, Erich Kettelhut and Karl Vollbrecht and cameramen Karl Freund and Günter Rittau to conjure up the Moloch of a city ruled by machines. Poster.

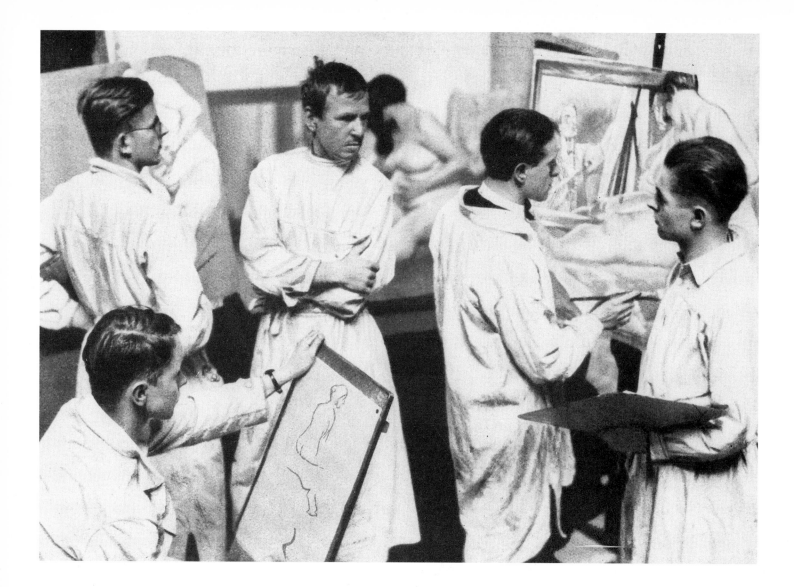

44　Otto Dix in 1930 working in his studio with pupils from the Dresden Academy of Fine Arts, where he taught from 1927 to 1933. The Nazis dismissed him on the usual grounds that his art was "degenerate".

Right:
45　Otto Dix painted this portrait of the famous gallery owner *Alfred Flechtheim* in 1926. In the mid-twenties he produced an inordinate number of portraits and self-portraits. Carl Einstein wrote: "Grosz, Dix and Schlichter shatter reality with pregnant objectivity, expose their era and force it to view itself with irony. Painting as an audacious gallows; observation as a tool of forceful attack." Staatliche Museen Preussischer Kulturbesitz Berlin (West), Nationalgalerie

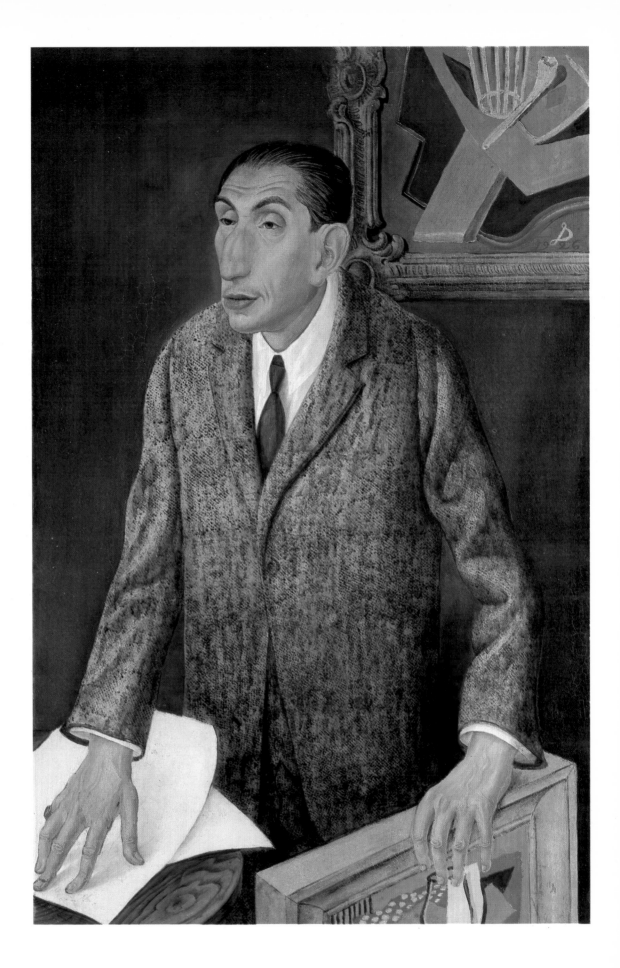

46 The artist Ludwig E. Ronig was an adherent of New Objectivity. His painting *Gliederpuppe* (Marionette), 1928, borrows directly from Italian surrealism, taking up Giorgio de Chirico's "manichino" theme of 1921. Ronig replaced the usual components of New Objectivity still life (guitar, fruit, withering leaves) with the doll, a direct symbol of transitory human life. Museum der Stadt Köln, Cologne, Museum Ludwig

Right:

47 Oskar Schlemmer was a Master at the Bauhaus, where he led the Theatre Workshop, from 1920 to 1929. In 1930 Nazi Minister Wilhelm Frick ordered his murals in the hallway of the Weimar Bauhaus to be white-washed over. Meanwhile Schlemmer was painting new murals for the Folkwang School in Essen. It was in this context that he painted his *Gruppe am Geländer I* (Group on Banister I) in 1930/31, demonstrating the influence on Constructivist art of the Functionalism which Schlemmer had witnessed and helped to evolve at the Bauhaus. Kunstsammlung Nordrhein-Westfalen, Düsseldorf

48 Georg Scholz moved over to New Objectivity in 1925. His painting
Bahnwärterhaus (Signal Box) adopts a theme which interested a number
of artists of this tendency: the level crossing as a junction in the broadest
sense of the word. This is where technology cuts into human life. The sig-
nalman himself must betray automatic precision, functioning like a
machine and responding exactly to the sound of the bell. The pessimism
which pervades this work is typical of New Objectivity painting. Kunst-
museum der Stadt Düsseldorf

While we are looking at Realist trends in German cinema towards the end of the silent era, there is one more film which deserves a mention. Five young directors and camera operators set up their Studio 29 in Berlin, where they made the semi-documentary feature *Menschen am Sonntag* (People on Sunday). The Studio manager was Moritz Seeler, who had first attracted attention in the avant-garde theatre company *Die junge Bühne* in the early twenties. He was joined by Eugen Schüfftan (who came up with some interesting inventions in the field of cartoon), Edgar G. Ulmer, Robert Siodmak, Billy Wilder and Fred Zinnemann. The last three later made their names as Hollywood directors.

Menschen am Sonntag tells the everyday tale of young people from Berlin on a Sunday excursion to Lake Nikolas. The main parts are all played by amateurs, and this unpretentious film displays precise attention to detail. It was, besides, more or less a farewell to silent pictures since it contained a few "talking" sequences. Sound was arriving to a flurry of fanfares.

Seven years had passed since the engineers Hans Vogt, Josef Engl and Joseph Masolle in Berlin had developed their light and sound technique in 1922, converting acoustic waves into optical signals which were copied onto the film strip alongside the image. The invention had been patented as the "Triergon" technique, meaning "the work of three". The first trial showings were at the Berlin Alhambra on the Kurfürstendamm in November 1922, and later on in other towns, too.

The response, however, was poor, for the German film industry was confronted with enormous financial problems and the new invention called for a complete conversion of both production studios and cinemas. Ufa bought the rights on the patent very cheaply, but stored it away in an archive. As the American film industry did not seem to be engaged in any similar pursuit—and the United States was, after all, the acknowledged pioneer of new techniques—Ufa did not find the decision difficult. Indeed, when the company faced a further financial crisis in 1926, it sold the patent rights to a group of Swiss financiers, who in turn made a profit out of selling it to 20th Century Fox, one of the Hollywood giants.

William Fox, the President of the enterprise, was the first to recognize the potential of the new process, and he pushed for introduction in the United States. The Warner Brothers picture *The Jazz Singer* opened the new era of cinema in 1927.

When Ludwig Klitzsch, Ufa's General Director, saw this film during his American tour in early 1928 and observed the tremendous impact it was making on the public, the die had been cast. Ufa spent a huge sum of money on buying back its sound patent, and Germany began re-equipping its studios and cinemas in 1929.

Ufa President Hugenberg had close links with the big electrical companies AEG and Siemens, who took a large slice of the new business. A newly founded company, Tobis-Klangfilm, shared the remainder: Tobis and AEG produced the new recording apparatus, while Ufa-Klangfilm and Siemens provided cinemas with their new projection equipment. Ufa's new sound studios, four big sheds in Babelsberg, were ready by early 1930. Terra and Emelka also switched production methods. The conversion from silence to sound consolidated Ufa's monopoly on the German film business. In 1931 the company had no fewer than 71 subsidiaries in the fields of production, distribution and presentation. 115 of Germany's biggest cinemas belonged to Ufa.

Sound films accounted for more and more of Germany's overall film output:

1929 183 feature films, 8 of them sound
1930 146 feature films, 101 of them sound
1931 159 feature films, 157 of them sound
1932 exclusively sound film production

The process of equipping cinemas with the new technology proceeded just as rapidly. The first 223 German cinemas were converted to sound in 1929, and by mid-1932 all 3,500 of them were in possession of the new apparatus. The electrical companies involved were delighted with the business, especially as they were able to export the new technology to several European countries which did not manufacture their own cinematic apparatus. The sound film camera put on the market by the Dresden firm Ernemann was the best in the world around 1930.

114

Drei
von der
STEMPEL
STELLE

**DREI GEHEN NICHT
UNTER!**

MANUS.: GEORG C. KLAREN u. F. A. REICHER
EIN FILM VON P. M. BÜNGER MIT
FRITZ KAMPERS, PAUL KEMP
AD. WOHLBRÜCK, EVEL. HOLT
MARG. KUPFER, FERD. v. ALTEN
REGIE: EUGEN THIELE
MUSIK: HUGO HIRSCH
PRODUKT. U. WELTVERTRIEB: PANZER-FILM
Täglich 5, 7 und 9.15 Uhr
MARMORHAUS
KURFÜRSTENDAMM 236
AB DIENSTAG TÄGLICH 5, 7, 9¹⁵

Marlene Dietrich left Berlin on the evening of 1 April 1930 to continue her career in Hollywood. She had just attended the première of her film *Der blaue Engel* before taking the train for Bremen, where she sailed for New York on 2 April.

Left:
Heinz Rühmann, in Wilhelm Thiele's popular musical *Die Drei von der Tankstelle*, illustrates the carefree (cellulose) world of 1930. This box-office success was countered the very same year by another film which parroted the title: *Drei von der Stempelstelle* (Three from the Labour Exchange), which was set against a background of unemployment and offered a much more accurate picture of reality.

Producer Erich Pommer (left) was another Ufa debutant who later made his name in Hollywood. He worked in the United States from 1926 to 1929 and returned there in 1933. Director Robert Siodmak (centre) and scriptwriter Robert Liebmann (right) went into exile in 1940, where Hollywood lapped them up as masters of suspense. The photo shows them at a production meeting in 1931 in Pommer's Ufa office.

But did this technological revolution in the cinema bring fresh artistic inspiration?

This was one area where art's "invasion" of technology proved somewhat tentative. At first film-makers were simply fascinated by the technical novelty of producing "talkies" and "musicals". The millions flocked at once to see the latter in particular, and to hear the music and even singing which flowed from the loudspeakers behind the screen in high-perfect synchronization, replacing the traditional cinema pianist or, in the big cinemas, the orchestra. 1930 witnessed a flood of conventional operettas, such as *Dich hab ich geliebt* (It Was You I Loved), *Zwei Herzen im Dreivierteltakt* (Two Hearts Beating Three/Four) and *Küss mich* (Kiss Me), in which songs and melodies by well-known composers were strung together by a meagre plot. Producer Erich Pommer developed these early Ufa offerings into a specific new form, the film operetta. *Melodie des Herzens* (My Heart's Melody), one of Germany's first sound films in 1929, was the first experiment

in the harmonious combination of image and sound. In 1930 Pommer made the Wilhelm Thiele films *Liebeswalzer* (Love Waltz) and *Die drei von der Tankstelle* (Three from the Petrol Station), followed in 1931 by the Erik Charell film *Der Kongress tanzt* (The Congress Dances). His film was a novel and successful approach to blending the elements of music, dialogue, song and dance into a cohesive whole. It also gave Ufa the chance to launch Lilian Harvey and Willy Fritsch as sweethearts in the American mould, and soon these new stars were luring the millions to the cinema. Hugenberg encouraged this trend in sound film to the best of his ability.

The first "talkies" tried, and at first failed, to imitate stage plays. When Georg Kaiser's successful play *Zwei Krawatten* (Two Ties) was released in its screen version, one critic wrote: "For anyone who has seen the play, this sound film is the strongest weapon there is against film."[67]

Richard Oswald's *Dreyfus*, 1930, and Piel Jutzi's film version of Döblin's novel *Berlin Alexanderplatz*, 1931, were early attempts at sound films with certain artistic aspirations, and both were geared entirely towards the actor, in both cases Heinrich George.

Robert Siodmak took credit for his dramatic use of the new sound element in the two films *Abschied* (Farewell) and *Voruntersuchung* (Preliminary Examination), which he made in 1930. He complemented the image with a novel, riveting mixture of language, sound effects and music.

The screen version of Heinrich Mann's novel *Professor Unrat*, made in 1930, was the first real landmark in German sound film, and it became an international success. Ufa had engaged the American director Josef von Sternberg, and Emil Jannings played the old grammar school teacher. But one vital factor in the film's success was the casting of a hitherto little-known actress, Marlene Dietrich, in the female lead. Friedrich Hollaender's lyrics brought her overnight fame in Germany and abroad as Lola-Lola.

Although Ufa had insisted on reducing the social criticism in the book quite substantially, Heinrich Mann gave the film his explicit endorsement. But there were contra-dictions. On the night of the première, Hugenberg's *Nachtausgabe* commented: "Ufa has managed to turn Heinrich Mann's disgraceful volume into a work of art!"[68] Yet when the film became such a big success, even internationally, nobody seemed to have any objections to using Heinrich Mann for publicity. Once again profit took priority over any political reservations.

After the première of *Der blaue Engel* (The Blue Angel), as the film was called, Sternberg and Marlene Dietrich left for the United States. The German cinema had lost another international star no sooner than she had been born.

After 1930 Ufa's politics made films like *Der blaue Engel* impossible. Until 1933 progressive films were only produced by small companies. Hugenberg and Klitzsch were steering Germany's biggest film enterprise uncompromisingly down the path of vogue entertainment and nationalism.

"At home I have a gramophone"— The triumph of the disc

Nowadays, if we play an old twenties shellac disc, with its modest volume amidst all the humming and crackling, and compare it with the modern long-playing record, we realize that technical progress has been much faster in this field than in radio or film. And yet until 1925, before radio began to establish itself as a mass medium, this fragile black plate was the only means of duplicating original voice and music.

The gramophone record, like silent film, had actually been invented in the late 19th century. The story began with Edison's phonograph and Emil Berliner's gramophone. These made it possible to record the natural tones of voice and music, whereas mechanical musical instruments such as the clockwork, music box and orchestrina, in which the melody was played by metal discs, cylinders or punched strips, could only produce the monotonous tinny quality of sound which was peculiar to their nature. Now sound waves were relayed through a cone onto a membrane which used a stylus to impose them on a wax matrix from which the shellac disc was then pressed.

The technique was first used commercially in 1910, when gramophone records and the horn-like gramophone player appeared on the market. An American trademark soon came to symbolize those early years, a dog listening attentively to the horn of this new gramophone: His Master's Voice. The same words appeared in German translation on the labels used by Deutsche Grammophon AG when they brought out their first records. Up until 1918 over two thirds of the output was accounted for by classical music. Record players were expensive and the sound quality left much to be desired. The gramophone was still a medium for connoisseurs and music experts. The earliest exhibit known today is a recording in 1910 of Beethoven's *Eroica* by Arthur Nikisch and the Berlin Philharmonic on no fewer than eight discs. With the records turning at 78 revolutions per minute, playing time was extremely limited, a problem which was not resolved until the early fifties with the introduction of the L.P. record.

What was particularly fascinating about this new medium was that it could reproduce the human voice. Recordings by the Italian tenor Enrico Caruso were among the "hits" of 1915. The record boom began in 1919. The demand for entertainment brought huge growth in turnover. The gramophone popularized both the latest dances—the One Step, Shimmy or Black Bottom—and songs by Claire Waldoff or shuffling groups like the Lincke and Kollo Schieber. *Fräulein, bitte, Woll'n Se Shimmy tanzen* (Dance the Shimmy With Me) and *Max, du hast das Schieben raus* (Max, You've Got the Hang of Shuffling) sold like hot cakes in 1921. And how did the hits reach the public? Simple: *Ich hab' zu Haus' ein Gramm', ein Gramm', ein Grammophon* (At Home I Have a Gram' a Gram' a Gramophone), as the record was called in 1922.

The breakthrough, however, came in 1925. That was when the gramophone became a true mass medium and record sales ran into six figures. Sound was improved decisively by the invention of the electric microphone. There was more shading in the recordings, volume improved and interference was reduced. Labels now boasted "remote" or "electric" recording, and the playing apparatus also became more compact. The big trumpet vanished and was replaced by the portable gramophone in a handy little box which could be taken on picnics. The hit-song business profited most from the innovations; now the Charleston was in.

The tonal quality of classical recordings also improved. With various microphones placed around the studio the different sections of the orchestra came into their own. Sceptics and even sworn enemies of the gramophone record were compelled to change their minds in the wake of the new electric recording technique. In 1921 the Belgian writer Maurice Maeterlinck had written angrily: "One might think that inferiority was in rebellion, that everything low was being systematically disseminated, accompanied by metallic laughter, in order to debase man and accelerate his madness." Only four years later Maeterlinck admitted: "Today I abjure my prejudice, my weapons, my bitterness. Today, thanks to new methods, thanks to the little twist of a finger with which the genius of our fellowmen lends the final touch to great, revolutionary discoveries, the human voice has been captured for ever as the most peculiar feature of the human being, as vital and vibrant as if it had been spoken from the mouth. And naturally, when I talk of voice, I also mean music, which ultimately is only voice which transgresses its limits."[69]

Electrical recording expanded the market and many record companies went into production from 1925, almost all of them based in Berlin. Deutsche Grammophon AG continued to lead the fields of classical music and opera with its label *Die Stimme seines Herrn*. Heinrich Schlusnus, Maria Cebotari, Erna Sack and Lotte Lehmann were the singers, Bruno Walter and Wilhelm Furtwängler conducted.

Carl Lindström became Germany's biggest record company with five labels: Electrola, Odeon, Parlophon, Gloria and Homocord. In 1928 they accounted for a third of the turnover from German record sales. They had a wide range on offer. Electrola issued classical music and operetta, with Richard Tauber the unrivalled star, while Odeon, Parlophon and Gloria covered hit songs and entertainment. In 1928 the Homocord label responded to the lucrative market for working-class music by recording proletarian choirs, marches for the characteristic shawm

and, from 1931, the first songs by Busch and Eisler. But Homocord also maintained its share of the hits: more than 500,000 copies of *Valencia* were released over the years!

Lindström soon had a monopoly on the manufacture of record players, too. Various models of the Electrola Gramophone, from the portable turntable to the record cabinet, dominated the expanding market.

Telefunken launched its own record company in 1926, with the two labels Telefunken and Ultraphon focussing for the most part on light music. Other successful names in this sector were Deutsche Chrystalate (Kristall label), Clausophon (Pallas, Patria, Adler-Elektro and Orchestrola labels) and Tempo (Tempo label). Standards varied. Alongside Germany's leading dance bands under Marek Weber, Jack Hylton and Béla Dajos and singers such as Richard Tauber and Fritzi Massary there was a flood of banal smooch, "humour" and the never-ending marches.

The Association of Record-Lovers was founded in 1925, enabling members to subscribe to discs from a number of companies at favourable prices. The club was an offshoot of the well-known and favoured Association of Book-Lovers.

Competition between the companies was extremely harsh. Exclusive contracts were signed with the top personalities ("Jack Hylton—only on Electrola!"), companies rushed to pocket the latest hit and vied for every success story. One example is typical of many: after the sensational première on 31 August 1928 and the ensuing saga of accolade for the *Dreigroschenoper* (Threepenny Opera) at the Theater am Schiffbauerdamm in Berlin, Homocord led the way into battle in 1929 with an orchestral recording of two numbers by Theo Mackeben and the Dreigroschenband. Orchestrola followed with a disc in Brecht's own voice, Parlophon cut a record with Harald Paulsen, who played Mackie Messer at the première. Telefunken joined the fray in 1930 with a selection on four records which included Lotte Lenya singing, Electrola replied with Carola Neher, then Orchestrola and Homocord each brought out a new song record. That made ten records from five companies within the space of a generous year.

Towards the close of 1929, as the world economic crisis was beginning, shares in the record industry fetched the best prices on the Berlin Stock Exchange with dividends reaching about 20 per cent. This was mostly due to the hit songs. Light entertainment set the tone for the gramophone medium. It is significant that no recordings were ever made of major avant-garde works in the music of the Weimar Republic such as Alban Berg's opera *Wozzeck*, while the fashionable products of the day, such as Krenek's opera *Jonny spielt auf* (Johnny Strikes up the Band) were marketed instantly.

The task of recording young writers was left to small, independent producers such as Artiphon-Record with its series of readings by Erich Kästner, Erich Weinert and others. Here and there special documentary issues appeared related to spectacular contemporary events. Shortly after the first transatlantic Zeppelin flight, for example, Deutsche Grammophon recorded pilot Hugo Ecke-

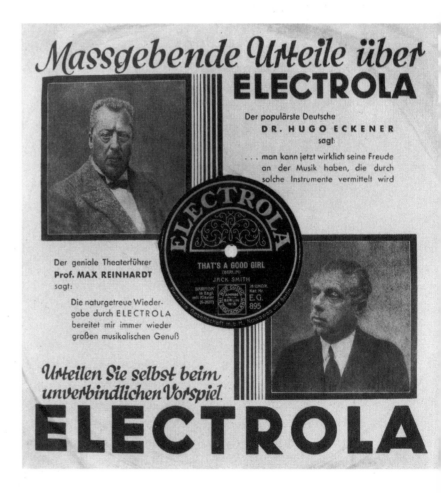

German gramophone company advertisement, 1922.

Left:
Famous personalities provide publicity on the Electrola record sleeve in 1925. This disc was one of the earliest American jazz and song recordings on the German market.

ner's account of the journey. American discs were also sold in Germany, especially the Columbia and Brunswick labels. From 1921 these brought the first authentic recordings of American jazz to Germany.

As political conflict intensified from 1928, a new dimension was added to the record industry. Proletarian cultural organizations published records with working-class music and popular works of revolutionary literature. One notable institution was the Versandhaus Arbeiter-Kult set up in 1929, which sold recordings of choirs and shawm marches as well as readings by the well-known reciter Alfred Beierle. Recordings by Weinert were also released.

The big political parties made greater use of records during electoral campaigns. Eminent politicians cut brief campaign speeches so that their voices would be heard in smaller towns missed out on their canvassing tours. It was all possible thanks to the gramophone.

Records were particularly valuable to radio. The new electrical recordings were borrowed to piece together musical transmissions, and that meant extra income for the record companies. Even more important to the broadcasters was that, in the absence of tape recorders, their own productions could be stored on gramophone discs, and today these offer a unique insight into intellectual and cultural developments in the Weimar Republic. The radio archives are treasure houses containing prominent studio guests from Max Liebermann or Selma Lagerlöf to Rabindranath Tagore, concerts, including a recording of *Lindberghflug* (Lindbergh's Flight) with words by Bert Brecht and music by Kurt Weill at the Berlin Philharmonia in 1930 under Hermann Scherchen, and the earliest drama productions, including a radio version of Döblin's *Berlin Alexanderplatz* dating from 1931 with Heinrich George as Franz Biberkopf.

The disc business also profited from the introduction of sound film around 1930. Only days or weeks after a new screen hit had been created, any cinema-goer could walk out of a shop with the song in the star's own voice and play it at home. Electrola even cut the discs with Marlene Dietrich before *Der blaue Engel* had its première, and within a few days they were a tremendous sales success. Marlene had long since arrived in Hollywood, but her songs *Ich bin von Kopf bis Fuss auf Liebe eingestellt* (Falling in Love Again) and *Nimm dich in acht vor blonden Frau'n* (Beware Blonde Women) stayed with the German public in the form of acoustic signals on black gramophone discs.

"This is Berlin on 400"—
Radio as a new mass medium

The 200 or so owners of the first crystal sets switched on in the evening hours of 29 October 1923 to hear the launching of "radio for public entertainment" in Germany. At precisely 8 p.m., the voice of an announcer was heard over the earphones: "This is the Berlin transmitter, Vox-Haus, Wavelength 400." There followed a live musical broadcast from the studio. One eye-witness later told the story: "Several minutes before it was due to begin the housewife placed the steel band on which the earphones were mounted over her hair. We watched her movements breathlessly. Simple though they were, to us they seemed so pregnant and meaningful, especially as her

expression now revealed that she was listening. And then she must have heard the first sounds, for the tenseness in her features grew and became so visibly heightened that even the gentleman of the house wriggled restlessly in his armchair. When the earphones were passed round in a circle—we stuck our heads together and listened in pairs with one ear each—we sat there in true astonishment. We could hear a human voice, and music. We gazed at the blue sparks with deep respect."[70]

Four years of intensive preparations had gone into that event. Hans Bredow had given the Berlin public their first experimental demonstration of radio broadcasting on 16 November 1919. Development was carried out under the aegis of the Reich Postal Ministry and the Reich Telegraphy Office, the latter having taken over the former radio unit of the Imperial army at Königs Wusterhausen near Berlin for trials. From 1920 there was close collaboration with the electricals company Telefunken in developing both efficient high-vacuum transmission tubes and manufacturable crystal sets for reception. By the end of 1922 technology was ripe for the introduction of radio in Germany. However, almost another year passed before the Government of the Reich repealed a ban on private reception that had been imposed for political reasons. At last, on 15 October 1923, the Funkstunde AG Berlin was founded, and a fortnight later it broadcast its first programme from a station in the attic of the Vox record company offices.

The radio medium developed at a breathtaking pace. The Funkstunde Berlin had not been in existence for a year before another eight regional radio companies were set up, each with its own transmission network. Radio could now be heard all over the Reich, from Bavaria to Schleswig-Holstein and from Thuringia to East Prussia. While the transmitters multiplied, improvements were made in reception technology. By late 1924 the crystal sets were already making way for tube receivers, the earphones were no longer necessary, and the sound quality from the amplifier had improved dramatically. That encouraged far more people to listen: the audience of 200 Berliners in October 1923 had grown to 100,000 a year later. By 1926 there were a million radios in Germany, by 1928 two million, by 1930 three million and by 1932 over four million. Statistics from Berlin record that in 1931 48 households out of a hundred in the capital possessed a wireless.

Unlike the film and record industries, which were based on private enterprise, radio in Germany fell under government control from the outset. The Postal Ministry was entirely responsible for broadcasting technology. Organizational matters and guidelines for programmers were decided by the Reich Radio Society, founded in Berlin on 15 May 1925, which included representatives from all the broadcasting institutions under the chairmanship of Hans Bredow, in his capacity as Commissioner of Radio under the Reich Minister for Post. Although both the Reich government and Germany's autonomous regional governments constantly claimed that the broadcasting associations were "non-partisan" and "politically independent", in practice things were different. The political parties increasingly recognized how effective radio could be as a mass medium, and the ruling bourgeois forces made growing use of the service to promote their own aims. When political struggles took a sharp turn in 1929, the year that radio was integrated into the frequent election campaigns, it was quite clear that this much-vaunted "non-partisan" approach was partisan to the teeth. Whereas the right-wing parties, and increasingly the NSDAP, had unrestricted access to the microphones in Berlin, Cologne and Hamburg, the SPD was granted much less transmission time for talks and election addresses. The KPD was excluded altogether from bourgeois radio as a result of arbitrary government decisions.

The pattern of broadcasting in those early years was not so very different from today. The service offered news and talks, but the lion's share of programme time went to light music. The radio also showed a highly creditworthy commitment to disseminating classical music. Now that the mass reproduction of music was technically feasible, outstanding performances of chamber music, symphonies, opera and even operetta could be heard in the listener's own living-room. This presented a real opportunity to extend music's appeal beyond the circle of connoisseurs and concert-goers.

VORTRAGSFOLGE
FÜR EIN
ERÖFFNUNGSKONZERT
am 29. X. 1923, abends 8—9 Uhr

1. Hier Sendestelle Berlin, Voxhaus, Welle 400
2. Kurze Mitteilung, daß die Berliner Sendestelle Voxhaus mit dem Unterhaltungsrundfunk beginnt
In dem heutigen Konzert wirken mit: Herr Kapellmeister Otto Urack, Herr Fritz Goldschmidt, Herr Kammersänger Alfred Wilde, Herr Konzertmeister Rudolf Deman, Frau Ursula Windt, Herr Alfred Richter vom Deutschen Opernhaus, Herr Konzertsänger Alfred Lieban — Zur Begleitung wird ein Steinwayflügel benutzt.

MUSIKFOLGE

1. Cello-Solo mit Klavierbegleitung „Andantino" von Kreisler, gespielt von Herrn Kapellmeister Otto Urack. Am Klavier: Herr Fritz Goldschmidt
2. Gesang-Solo mit Klavierbegleitung, Arie aus dem „Paulus", vorgetragen von Herrn Kammersänger Alfred Wilde. Am Klavier: Herr Kapellmeister Otto Urack.
3. Violin-Solo mit Klavierbegleitung. Langsamer Satz aus dem Violin-Konzert von Tschaikowsky, gespielt von Herrn Konzertmeister Rud. Deman. Am Klavier: Herr Kapellmeister Otto Urack
4. Gesang-Solo mit Klavierbegleitung, Arie der Dalila aus „Samson und Dalila", gesungen von Frau Ursula Windt. Am Klavier: Herr Kapellmeister Otto Urack
5. Voxplatte: „Hab' Mitleid", Zigeunerlied (S. Pawlowicz), gespielt von Herrn Konzertmeister Rudolf Deman (Violine), Herrn Kapellmeister Otto Urack (Cello), Herrn Max Saal (Klavier)
6. Voxplatte: „Daß nur für Dich mein Herz erbebt", aus Troubadour, gesungen von Herrn Kammersänger Alfred Piccaver
7. Klarinetten-Solo mit Klavierbegleitung. „Larghetto" von Mozart, vorgetragen von Herrn Alfred Richter vom Deutschen Opernhaus, Am Klavier: Herr Kapellmeister Otto Urack
8. Gesang-Solo mit Klavierbegleitung, „Der schlesische Zecher" von Reißiger, vorgetragen von Herrn Kammersänger Adolf Lieban. Am Klavier: Herr Kapellmeister Otto Urack
9. Cello-Solo mit Klavierbegleitung, „Träumerei" von Schumann, gespielt von Herrn Kapellmeister Otto Urack. Am Klavier: Herr Goldschmidt
10. Gesang-Solo mit Klavierbegleitung „Über Nacht" von Hugo Wolf, vorgetragen von Herrn Kammersänger Alfred Wilde. Am Klavier: Herr Kapellmeister Otto Urack
11. Violin-Solo mit Klavierbegleitung, „Menuett" von Beethoven, vorgetragen von Herrn Konzertmeister Rudolf Deman. Am Klavier: Herr Kapellmeister Otto Urack
12. Voxplatte: „Deutschland, Deutschland, über alles", gespielt vom Infanterie-Regiment III/9, Obermusikmeister Adolf Becker

Mitteilungen der Mithörer über Urteile usw. an Voxhaus, Berlin W 9, werden erbeten

Erstes Vortragsprogramm des deutschen Unterhaltungsfunkdienstes

This event marked a new era in the technology of mass communications: programme for the first broadcast in Germany to be attended by the public, Berlin, 29 October 1923.

After a few weeks of less-than-perfect studio concerts and records, the Funkstunde Berlin broadcast its first live transmission in January 1924: "On 18 January came the first attempt to record an entire work in the theatre, relay it to the Vox-Haus transmitter and broadcast it via the wireless. The Reich Office for Telegraphy was responsible for the technical side. The work was Lehár's *Frasquita* under the composer's own baton at the Thalia-Theater. Only one microphone was used, a desk dictation microphone, suspended over the upper stalls beneath the first circle. The amplifying equipment was rigged up in the Visitors' Box. The experiment was not a perfect success, and cannot have brought pure enjoyment to the listener, but the door had been opened to opera transmission, even if almost a year was to pass before the first real opera was actually transmitted. On 8 October 1924 *Die Zauberflöte* (The Magic Flute) was relayed from the Staatsoper in Berlin."[71]

By 1926 the Funkstunde Berlin alone had broadcast 32 operas from the Staatsoper in the capital, while the other broadcasting stations had hung their microphones in the opera houses of Dresden, Frankfurt am Main, Munich and other cities. At the same time, studios began preparing their own productions of radio opera.

The invention of the electric microphone in 1925 was an important step towards improving the sound quality of radio music, just as it was an advance for the record industry. Now symphony concerts could also be broadcast more frequently. MIRAG, the broadcasting association operating in Central Germany, had already set an example by founding its own symphony orchestra—today's Leipzig Radio Symphony Orchestra—in 1924, and other companies followed suit. Europe's leading conductors, instrumentalists and singers performed to the radio microphone. Conductor George Szell commented on radio work in 1926: "It is not so easy to analyse my first impressions in front of a microphone. My prime concern was the need to assess the very different accoustic relations, while the lack of an audience (and thus of instant reaction) meant exerting all one's energies many times over. However, I feel that this initial impression was less important than the lasting satisfaction which I have gained from radio music-making for almost two years now since becoming more closely familiar with the specific conditions."[72] The encouragement given to chamber music was notable, as the radio programme for Berlin illustrates: from 20 December 1923, when the Deman Quartet gave the first evening performance of Beethoven, Mozart and Haydn from the studio, until May 1926, the radio broadcast 105 recitals by quartets without soloists and 48 chamber music recitals with soloists. Several broadcasting stations showed a similar commitment to contemporary music.

Programme directors Ernst Hardt (Funkstunde Berlin), Hans Flesch (Südwestfunk Frankfurt am Main) and Alfred Szendrei (MIRAG) not only promoted transmissions of new music, but even offered commissions to composers such as Paul Hindemith and Kurt Weill. Germany's major annual festival of contemporary music, Kammermusik Baden-Baden, worked closely with Frankfurt's radio station from 1926 to 1929 and created a framework for new experiments in radio music and opera. In 1927 the Berlin School of Music set up its own experimental studio, where the various instruments and instrumental sections were tested accoustically, microphones were tried out in different positions amongst an orchestra, and new instruments and tonal effects were investigated to discover whether they were suitable for radio music. Paul Hindemith wrote experimental compositions for the studio. But in spite of these avant-garde initiatives, contemporary works only accounted for a small proportion of radio music.

Just as this new technological medium enabled music to make a mass appeal—and without posing any threat to live concert-going, as some sceptics temporarily feared—so, too, it was now possible to relay poetry through the ether into thousands of homes. The first reading was on 3 November 1923, when the actor Peter Ihle recited Heinrich Heine's *Seegespenst* (Sea Phantom) for the Funkstunde Berlin. On that occasion the poetry was only dressing for a programme of music, but from 1924 there were broadcasts devoted to literature, with writers themselves speaking on the air. Waldemar Bonsels set the ball rolling on 4 October 1924 with an extract from his *Biene Maja* (Maya the Bee). The classics alternated with contemporary writing; just as there was a regular slot on modern composers, so there was now another on modern authors, and in 1925/26 such eminent names as Thomas Mann, Leonhard Frank, Ernst Toller and Egon Erwin Kisch came to the microphone. In Berlin Alfred Kerr and Hermann Kasack were the presenters, and a lively portrait was compiled from conversations with the writer and readings, either by the author in person or by professional actors. Other literary programmes were also presented by critics and literary personalities. Stefan Grossmann, for example, gave a profile of Gerhart Hauptmann's work

which lasted several evenings, while Anton Kuh introduced Viennese poets and Lion Feuchtwanger talked about Sinclair Lewis. Other literary productions made use of skilful readers: Alfred Beierle with Russian prose, Ernst Hardt with the works of Hofmannsthal, Roda Roda and Hans Reimann with texts of their own.

For all these ventures radio drew on traditional forms and genres, simply adapting them to meet the needs of the medium; the radio play, on the other hand, was a new form of dramatic art conceived specifically for radio transmission. Alfred Braun (Funkstunde Berlin) and Walter Bischoff (Breslau) were the pioneers. Initial attempts at adapting stage plays for radio had begun in 1925/26. At first the biggest problems seemed to stem from superficial concerns, as the following example illustrates. With a gravity which sounds highly amusing today, Ernst Hardt explained his efforts to render Goethe's *Torquato Tasso* fit for radio in early 1926:

"Let us consider Virgil's lines:
 'So many wreaths adorn my marble bust;
 A leafy branch belongs where there is life.'

Goethe adds a stage direction: 'Alphons gesticulates to his sister. She takes the wreath from Virgil's bust and approaches Tasso. He retreats.' Then Leonore cries:

 'You would refuse? See whose hand bestows
 the noble e'ergreen crown of honour.'

At this point the author relies entirely on visual business to project a crucial development. In a radio production I make all these movements audible with the lines

 'So many wreaths adorn my marble bust,
 A leafy branch belongs where there is life.
 Dear sister, take it from the marble head
 And place it there upon that living brow.'

 Leonore:
 'Why do you draw back from the laurels, Tasso?

 Do you refuse? See whose hand bestows'
 etc.

And Goethe philologists listening in did not even notice my insertion."[73]

Pioneers of radio meet at the Press Ball, Berlin, 1932: left, Hans Bredow, Commissioner of Radio, in the centre, architect Hans Poelzig, who designed the Berlin Radio Tower site and the Funkhaus in Masurenallee, right, Friedrich Knöpfke, Director of the Berlin Funkstunde. It was not much later that the Nazis imposed heavy prison sentences on Bredow and Knöpfke at the "Radio Trial". Knöpfke committed suicide in his cell.

The radio encouraged contemporary music: Arnold Schönberg conducting his own works in the Funkstunde Studio, Berlin, 1929.

Radio publicity truck in a small town in 1927. The Reich Radio Association launched a campaign of leaflets and trial reception to introduce people to the new mass medium. The loudspeaker on the roof demonstrated how transmissions were picked up to anyone who cared to watch.

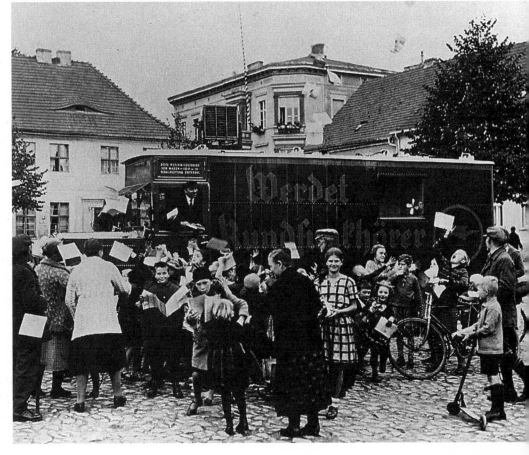

This was clearly not the way to establish an aesthetic code for radio drama. Tampering with the texts of stage plays would not suffice. Critic Kurt Pinthus was quite right to observe in 1927 that the genre was still in its embryonic phase. That year the Reich Radio Association ran a Radio Play Competition which attracted 1,177 entries. Seven of the manuscripts were purchased in all, including Rudolf Leonhard's *Der Wettlauf* (The Race), and it was when this work was broadcast from Breslau in April 1927 with an introduction by Walther Rilla that the modern radio play was really born. Here was the first successful mixture of text, sound and music to form an autonomous work of radio art. At about the same time Alfred Braun in Berlin made a radio version of Brecht's stage play *Mann ist Mann* (A Man's a Man), adapted by the playwright himself. The critics had nothing but praise for it. According to the magazine *Der deutsche Rundfunk* of 27 March 1927: "Altogether the impact was uncommonly gripping. It was a memorable evening for the development of the German radio play."

From 1928 the new genre was firmly entrenched as part of the regular service. Writers such as Arnold Zweig, Rudolf Leonhard, Alfred Döblin and Arnolt Bronnen encouraged the trend by adapting classical works (Bronnen's version of Kleist's *Michael Kohlhaas*) or writings of their own (Döblin's *Berlin Alexanderplatz*). Thanks substantially to the involvement of famous actors, the radio play soon gained in quality and popularity. It should be remembered that sound film had not yet arrived at the cinema!

Discussions and debates were another format specific to radio. Not only politicians and economists but also the arts community took the floor. Critic Alfred Kerr debated with Thomas Mann. Ernst Toller argued with Alfred Mühr about Piscator's Political Theatre. Hans J. Rehfisch met theologists to answer the question "Should God be portrayed on the stage?" Brecht, Hardt and Herbert Jhering discussed sociology in the arts.

There was a broad range of radio talks to meet the educational aims of the Reich Radio Association. The themes varied from foreign policy, via science for the lay listener, to advice. A new institution designed primarily for this purpose, the Deutsche Welle, was set up in January 1926.

Based in Königs Wusterhausen, it was the first German transmitter with a powerful long-wave frequency which could be heard all over the country. The studio compiled special education programmes, courses in languages and economics, schools broadcasts and all manner of lecture series. However, the "national education service" to which radio aspired remained everlastingly bourgeois in character and took no account of millions of working people. The most striking example of its attitude was the "workers' service". Every Saturday afternoon, from 1927 onwards, Deutsche Welle broadcast an hour's programme "for workers". In 1928 its aims were summed up by editor Richard Woldt thus: "The working-class is a mass phenomenon; topical problems relating to housing estates, co-operative organization and the psychology of the worker have been dealt with . . . We want to show workers themselves who listen to such talks how they should see themselves in relation to their society, their state and their people. We also want to provide middle-class listeners with insight which will enable them to understand the inner depths of the workers."[74] German workers did not receive much help with their fundamental problems from a "workers' service" like this. They were better advised to buy or make themselves a short-wave receiver, assuming they were able, and tune in to the German-language broadcasts from Radio Moscow or Radio Comintern, both of which were based in the Soviet Union.

Technical advances brought new opportunities for radio in the field of up-to-date information. Important political, cultural and sporting events could now be reported live thanks to the microphone and wireless transmission. From 1926 onwards it was rare to see a photograph of any bourgeois politician without a spherical radio microphone. Reporters were there to comment on the proceedings so that listeners felt that they themselves were first-hand witnesses. In July 1925 WERAG, the West German Radio AG, broadcast the first live sports commentary, a boat race from Münster. It was not long before the broadcasters introduced a regular weekend slot for major sporting events. The big sensation in 1927 was live transmission of the world title fight between Jack Dempsey and Alfred Tunney in New York. A reporter from Germany's south-

ern regional broadcasting station was there at the ringside and his report was relayed on short wave to Stuttgart, where it was fed into the German network. Sports commentary attracted large numbers of listeners to the regular broadcasts from football grounds or the big Six-Day Bicycle Race in Berlin.

Naturally enough, the radio covered every major political event, be it Stresemann's famous speech at the League of Nations in 1927 or government leaders addressing the Reichstag. Radio ferried its public directly to the scene of technological wonders, such as Hugo Eckener delivering a speech from the driving-seat of his Zeppelin airship during a long-distance flight in 1927, or the launch of the first rocket-engined car in 1928 after an interview with designer Fritz von Opel.

For those whose concern was aesthetics, radio was an extremely fascinating medium from around 1927, especially in relation to new sociological definitions of art's function. Two major issues were at stake: the first centred on radio as an "apparatus" (Brecht), and how it could best be utilized by the arts in their quest for radical change, given its bourgeois control. The second focused on how to make new art forms accessible to the growing millions of listeners. "The point now is education," as Brecht said.

That process called above all for radio experiments with new art forms and models. In practice the success was only partial. There was a broadcast of Friedrich Wolf's radio play about Rockefeller, *John D. erobert die Welt* (John D Conquers the World), a few radio experiments by Brecht and Weill such as *Der Lindberghflug* (Lindbergh's Flight) and *Das Berliner Requiem* (The Berlin Requiem), and some transmissions of new, socially-committed vocal music by Hanns Eisler, Wladimir Vogel and Stefan Wolpe. But those who were responsible for the "apparatus" sensed only too well that the new artistic experimenting by Brecht & Co. was inseparably linked to political aims. "True innovations attack foundations," Brecht had written in connexion with his opera *Mahagonny*, and the Reich Radio Association had no intention of letting anyone attack the foundations of Germany's bourgeois (and bar a few exceptions artistically conservative) broadcasting network. So it was that, apart from attempts by the avant-garde to establish a new radio art which only materialized only partially, radio remained a state-controlled enterprise, for all its commendable promotion of music and literature. Basically, of course, it was a tool of government policy, and from around 1928 onwards the conservative and reactionary elements in German broadcasting strengthened their hold.

"Münzenberg versus Hugenberg"— The press jungle

In June 1921, the magazine *Weltbühne* published a little parable by Hans Natonek:

"'I am the cow-hide,' said the cow-hide, as it stretched out on the grass where it had been laid to dry, feeling big. A newspaper the size of the *Times* rustled nearby, and that was no ordinary rag either.
'I am the cow-hide,' said the cow-hide, puffing itself up. 'There is nothing like me. I am even proverbial. What you can't do with a cow-hide is beyond the pale.'
A philosopher came by, kicked the newspaper away and said: 'What you can do with a newspaper you can't do with a cow-hide.' The newspaper was caught up by a gust of wind and soared into the air with a triumphant cackle. But the foolish cow-hide was ashamed and rolled itself up into a ball."[75]

It would be vain to attempt to survey the entire press jungle in the Weimar Republic. In 1927 alone there were over 4,000 periodical publications from daily newspapers to specialist journals. If we add the long list of magazines founded for a brief period only, particularly in the years from 1918 to 1923, some of which did not last for more than two issues, the total would rise to almost 5,000. The total circulation between 1918 and 1933 ran into thousands of millions.

There were some outstanding examples of journalism and also a huge number of mediocre papers. Investigating the extremely broad press spectrum helps to create a detailed picture of the political landscape in the Republic with all its parties and groupings. Every party in Germany had its own daily newspapers and magazines. The big na-

tional dailies were mostly printed in Berlin. These were *Die Deutsche Allgemeine Zeitung* and *Der Tag* (German National Party), *Der Reichsbote* (Christian National Party), *Völkischer Beobachter* (the Nazi paper based in Munich), *Germania* (Centre), *Vorwärts* (Social Democrats) and *Die Rote Fahne* (Communists). The parties also published regional newspapers in cities such as Berlin, Munich, Hamburg, Cologne and Leipzig. It is significant to note how the police and the law applied the freedom of the press guaranteed in the Weimar Constitution. They rarely, if ever, took action against nationalistic chauvinism from the right, such as the constant calls to re-arm Germany during the years when remilitarization was banned under the Treaty of Versailles, but the *Rote Fahne* was plagued by a stream of publication bans for "engaging in high treason". The authorities were particularly allergic when journalists writing for democratic bourgeois or left-wing newspapers criticized class justice in the Weimar Republic, usually responding with censorship and trial.

Three Berlin-based media companies, Ullstein, Mosse and Scherl, also published national periodicals. They had excellent staffing, their own modern printing facilities and smoothly functioning distribution networks. Ullstein, for example, carried its newspapers to various German cities by air. There were morning, lunchtime and evening papers. At Ullstein *Die Vossische Zeitung* (chief editor Georg Bernhard) and the *Berliner Morgenpost* opened the day, followed at noon by *B. Z. am Mittag* and in the evening by *Tempo*. Two Ullstein weeklies were among the most widely-read magazines in Germany: together the *Berliner Illustrirte Zeitung* and *Die grüne Post* were printed in editions of several hundred thousand. The monthlies *Uhu*, *Koralle* and *Die Dame* were popular in all bourgeois circles, while the more ambitious *Querschnitt* with its features on contemporary art was compulsory reading for intellectuals. Ehm Welk was on the cultural staff of the *Grüne Post* for several years, and the journalists Egon Jacobsohn, Monty Jakobs, Lothar Brieger, Max Osborn and Richard Katz also placed their brilliant pens in the service of Ullstein. Like all quality newspapers, the Ullstein press also drew on contributions from freelancers, ranging from Kurt Tucholsky to Egon Erwin Kisch. Mosse's biggest

daily was the morning paper *Berliner Tageblatt* (chief editor Theodor Wolff). Then came the *Berliner Volks-Zeitung* and the *8 Uhr-Abendblatt*. Alfred Kerr, Julius Bab, Rudolf Olden and Kurt Pinthus were all on the Mosse pay-roll.

Scherl published the early *Berlin am Morgen* and the late *Berliner Nachtausgabe*, as well as the monthly *Scherls Magazin*.

In 1921 another mammoth enterprise was launched alongside Ullstein, Mosse and Scherl amid the clamouring Berlin press (the capital city alone was treated to 45 morning newspapers, two midday newspapers and 14 evening newspapers). It was run by Willi Münzenberg on behalf of the KPD and International Workers' Aid (IAH). The newspapers, magazines and books published by Münzenberg were meticulously designed and contained clear political thinking. Such was their impact among the mass of working-class readers and even among bourgeois circles, particularly artists and intellectuals, that opponents spoke with abhorrence and supporters with affection of the "Münzenberg company".

First mention must go to the *Arbeiter-Illustrierte-Zeitung* (*A-I-Z*), which was as popular with working people all over the country as was Ullstein's *Berliner Illustrirte Zeitung* with its bourgeois readership. John Heartfield's photomontage played a big part in creating the unique *A-I-Z* flavour and combining politics with new art in an extremely effective manner. In 1931, when the *A-I-Z* was celebrating its tenth anniversary, Egon Erwin Kisch wrote: "My congratulations are inspired by the personal pleasure which it gives me to work on your staff. I do not need to tell German workers what the *A-I-Z* is all about; it shows them in words and pictures the world as it is and the road to a new one."[76]

Münzenberg's biggest daily was *Welt am Abend* (chief editor Bruno Frei). Other widely read magazines were *Der Rote Aufbau*, *Magazin für alle* and *Arbeiterbühne und Film*. All these periodicals contained articles by prominent socialist writers, such as Egon Erwin Kisch, Alfons Goldschmidt and Alfred Kurella, and contributions from famous left-liberal and socialist writers and artists from Heinrich Mann to Käthe Kollwitz and from Ludwig Renn to Anna Seghers.

In reviewing the Weimar press it would be inconceivable to pass over two dailies which spoke for the big bourgeoisie but did not belong to the powerful media giants. These were the *Frankfurter Zeitung* and the *Berliner Börsen-Courier*. They were financed by the world of capital, and this was reflected in their politics and in the extensive sections on the economy and stock exchange. Their supplements, however, were amongst the best in Germany. Herbert Jhering wrote for the *Börsen-Courier*, but the long list of contributors on the permanent pay-roll of the *Frankfurter Zeitung*, which also had a separate office in Berlin, was even more impressive. They included Friedrich Sieburg, a brilliant foreign correspondent who later worked for the Nazis, Siegfried Kracauer, Joseph Roth, Walter Benjamin, Ernst Bloch, René Schickele, Bernard von Brentano and Friedrich Torberg. When Roth later recalled the feuilleton team, he commented: "I sang my song in an orchestra, not as a solo performer."[77] Ernst Glaeser, Alfons Paquet and Anna Seghers also had spells with the *Frankfurter Zeitung*.

Two literary genres flourished in the feuilleton: the eye-witness account and art criticism. In 1926 *B. Z. am Mittag* paid Egon Erwin Kisch to spend several weeks touring Holland, while the *Frankfurter Zeitung* dispatched Joseph Roth to Poland and former Galicia the same year. Both journeys resulted in serialized accounts of the very best quality, accurate in their observations and assessments and skilfully penned in polished idiom. Of course, these writers attracted readers to the newspaper. Art criticism played a similar role. The newspaper feuilletons carried trenchant verdicts on plays, films, new books and exhibitions, usually the very next morning. Sometimes the battles between the critics made more interesting reading than the news of the work itself, as when Alfred Kerr, Herbert Jhering and Monty Jakobs argued about stage productions in the *Berliner Tageblatt*, the *Berliner Börsen-Courier* and the *Vossische Zeitung* or Max Osborn pronounced sentence on new exhibitions in "Auntie Voss", as the Ullstein paper was nicknamed.

These progressive but critical companions were just as much a part of the arts scene as the hordes of conservative reviewers with their vitriolic attacks from the right on all modern art. Friedrich Hussong of Hugenberg's *Tag* and Fritz Stege of the *Zeitschrift für Musik* were just two who championed a fascist "understanding of art" long before the Nazi dictatorship began.

Another indication of Berlin's special status as Germany's artistic metropolis was that the *Frankfurter Zeitung* was by no means the only newspaper based in another German city to employ a permanent Berlin correspondent. Some of the most penetrating assessments of music and opera in Berlin up until 1928 were written by Hans Heinz Stuckenschmidt for the *Thüringer Allgemeine Zeitung* in Erfurt.

A new type of press cartoon prospered in the feuilleton: sketched portraits, caricatured heads and sketched scenes. Rudolf Grossmann, Benedikt Dolbin, Max Oppenheimer (Mopp) and Rudolf Schlichter were past masters of this genre whose drawings appeared in Berlin papers. Another talented cartoonist was Emil Stumpp, whose "heads" were produced for the *Dortmunder Generalanzeiger*.

Does this picture contradict Natonek's parable about the cow-hide? The overwhelming majority of newspapers never achieved this quality and never aspired to the journalism of the progressive cultural schools. On the contrary, as Kurt Tucholsky reflected in 1928: "With a few exceptions the political and artistic horizons of these newspapers are far too narrow."[78]

Besides, the sophisticated critics' debates about Brecht, the finely composed comment on an exhibition of modern architecture, or the sociological analysis of a Murnau film were only ever read by minorities who were part of the Weimar arts community. Far too rarely did the progressive bourgeois journalists take any notice of the banal or, even worse, chauvinistic trash which flooded the bookshops and cinemas, and they certainly did not take it seriously. The quality newspapers wasted barely a word on the subject in the pages of their feuilletons. But if this mass culture was ignored in the periodicals described thus far, then the reactionary rags and the regimental journals of those paramilitary associations and groups which now numbered hundreds of thousands of members made up for the fact with a vengeance. They recommended

these "tales of heroism", "national drama", "films set in a great era" and monuments to war, and by introducing them to the public themselves became a factor in their mass appeal. At the same time these columns poured abuse on progressive and avant-garde art. From this point of view, therefore, the *Neue Preussische Kreuz-Zeitung* and the *Stahlhelm* are at least as interesting to read as the *Berliner Tageblatt*, and the feuilleton produced by the *Völkischer Beobachter* offers as much information about culture in the Weimar Republic as that in the *Frankfurter Zeitung*.

Before moving on from the dailies and illustrated weeklies it is worth pausing for a moment to consider the satirical publications, although they were few in number compared with the plethora of newspapers. The Munich-based *Simplizissimus* (chief editor Franz Schönberner) enjoyed the biggest circulation in the Reich as a whole. During the First World War it had descended into chauvinism with its tirades of "God punish England!", but after the hostilities it evolved as a moderate bourgeois magazine with well-known cartoonists such as Olaf Gulbransson, Karl Arnold and Eduard Thöny. A more concrete and challenging review of the political situation appeared in the left-wing satirical magazines *Der wahre Jacob*, *Der Knüppel* and *Lachen links*, which supported the SPD and KPD. The Nazis began publication of their own satirical weekly *Die Brennessel* in 1930. There were no bounds to its venomous attacks on Jews and Communists, a foretaste of the real horrors to come.

Several magazines devoted to politics and culture emerged as a significant forum of pugnacious democracy and committed journalism.

Two weeklies in particular were synonymous with left-liberal polemics, *Die Weltbühne* and *Das Tagebuch*, both in octavo, the former bright red and the latter sober green. The editors of *Die Weltbühne* were Siegfried Jacobsohn, followed by Kurt Tucholsky and then Carl von Ossietzky, while Stefan Grossmann held the reins at *Das Tagebuch*. Both were composed of articles on politics, economics and the arts, although *Das Tagebuch* devoted more space to economic issues. Whereas *Die Weltbühne* opted for an increasingly militant style of journalism, especially during the latter half of the Weimar Republic as it became clear that democracy was being eroded away, *Das Tagebuch* stuck to its more moderate stance. Among the personalities in literature, journalism, politics and academie who wrote for *Die Weltbühne* was Kurt Tucholsky under his five pseudonyms: Ignaz Wrobel, Peter Panter, Theobald Tiger, Kaspar Hauser and K.T. These contributors gave *Die Weltbühne* its distinct profile, and one which was more or less unique in the press jungle of the times. Obviously, both *Die Weltbühne* and *Das Tagebuch* were exposed to vitriolic observation and attack, particularly from reactionary quarters.

In conclusion, some mention should be made, in the context of cultural questions, of the arts journals, just one section of the vast realm of specialist periodicals. Naturally enough, literature, music, theatre, cinema and the fine arts all had their own magazines, a particularly large number of which were here today and gone tomorrow. The major permanent fixtures—again broadly speaking—were: in literature *Die neue Rundschau* (edited by Samuel Fischer and Oskar Bie), *Die literarische Welt* (editor Willy Haas), *Die neue Bücherschau* (editor Gerhart Pohl) and the journals produced by the SDS *(Der Schriftsteller)* and the BPRS *(Die Linkskurve)*; for the stage the national publications *Das Theater* and *Die Sonne*; on the music scene *Melos*, *Die Musik* and *Deutsche Tonkünstlerzeitung*; *Licht Bild Bühne* and *Filmkurier* for the screen and *Das Kunstblatt* in the field of fine arts.

Culture was one area in which many regional journals won respect throughout Germany as a whole, either thanks to the teams who produced them (such as the arts colleges in Dresden or Munich) or because they adopted an especially interesting approach, such as that of the theatre magazine *Der Scheinwerfer* based in Essen.

These journals provide a fairly comprehensive picture of developments in each of the arts, although once again they pay almost no attention whatsoever to the mass phenomena which were playing such a substantial role in moulding the consciousness of large numbers of people.

Paul Westheim, editor of Germany's leading art magazine *Das Kunstblatt*, was one of the most perspicacious and critical observers of contemporary art in the Weimar Republic. In Paris, where he lived in exile until 1939, he edited the oppositional magazine *Freie Kunst und Literatur*. From there he emigrated to Mexico. Chalk lithograph by Otto Dix, 1928. Galerie Nierendorf, Berlin (West)

Above:
Painter Max Oppenheimer (Mopp) was kept busy as a press cartoonist. The photo shows him sketching in his Berlin studio in 1927.

"An Ullstein book for every occasion"— From publishing literature to publishing for profit

The *Börsenblatt* was a daily bulletin for the German book trade which carried information about publications and order forms for stockists. If we open the edition of 10 November 1930, we find two full-page advertisements next to one another in what is surely a fascinating double spread: on the left-hand side the publishers Ernst Rowohlt in Berlin announce: "We have delivered—Robert Musil *Der Mann ohne Eigenschaften* (The Man without Qualities). First five thousand copies. Repeat orders requested." Meanwhile, across on the right, a publishing company called Bernhard Sporn of Zeulenroda in Thuringia declares: "Heroes of the World War Front. Clears a path for the truth! Every stockist can serve the nation by selling this book! We are now distributing the fiftieth thousand."

Or take another example. In December 1930 the Ullstein magazine *Der Querschnitt* carried a feature on "Tea with Hedwig Courths-Mahler". The queen of light fiction recounted with pride that her books had sold 22 million copies in Germany alone. At about the same time S. Fischer announced that their novel *Berlin Alexanderplatz* by Alfred Döblin was "an international success": "the 40,000th copy has just been printed!"

An analysis of literature in the Weimar Republic calls for more than paying homage to progressive writers and publishers who made an important contribution to the development of contemporary German literature in the twenties. These accomplishments must be placed in perspective against a general backcloth of banal and chauvinist mass products which dominated the book market in the Republic at all times—a perspective which is often forgotten. Historians today are influenced by the literary status of the works which date from that period, and not by the impact which they made at the time. Arnold Zweig's *Streit um den Sergeanten Grischa* (The Case of Sergeant Grischa) is now an international classic, but by 1932 it had barely sold 40,000 copies, while a volume like Werner Beumelburg's jingoistic war novel *Sperrfeuer um Deutschland* (Germany under Barrage) sold almost

200,000 copies. At 120,000 copies, Ludwig Renn's *Krieg* (War) was one of the few anti-war novels which topped the hundred thousand mark, but even that was far outstripped by, for example, Hans Grimm's expansionist treatise *Volk ohne Raum* (Nation without Space), which had sold 260,000 copies by 1932!

A constant stream of military works of every conceivable kind, some of them published by obscure little companies, appeared from 1919 onwards. All of them—the memoirs of generals and admirals who conducted the First World War (Tirpitz opened fire in late 1919), personal accounts, such as *Wir von der Infanterie* (We Infantry Men) and its ilk, tirades against Germany's "mortal enemies", tales of war both long and short—were intended to foster a spirit of "renewed German strength" among the people, with sales amounting to millions.

When the *Börsenblatt* celebrated its centenary in January 1933, shortly before the Weimar Republic was crushed, the best-sellers amongst this kind of literature held court among the advertisements in the hefty jubilee edition. They took proud stock of their record over the past 15 years. Stalling of Oldenburg boasted: "Pioneer of German renewal!", J. F. Lehmann of Munich: "Service to the German cause in a new era!", and Eugen Diederich of Jena: "The fight for Germany's renewal!"

And one more fact should not be ignored: by 30 January 1933 the Munich publishing company Franz Eher Nachfolger, which was eventually to become the Nazis' central publisher, had sold over a quarter of a million copies of Hitler's *Mein Kampf*.

Of all the mass media, then, it was the printed book which played the greatest part in rooting militaristic ideology more and more firmly in the minds of millions of Germans.

The works of Remarque or Thomas Mann paled into insignificance by comparison with either the trite novels of Courths-Mahler, Nathaly von Eschstruth and Karl May, or the abundant war propaganda, which posed by far the greater danger to the Republic's survival.

It was around this time, in 1931, that Kurt Tucholsky described the reasons why a young man portrayed in a vision fell mortal victim to war a second time: "Because,

young man, once a gentle green lamp shone, for example, in a book shop. It illuminated sheer mounds of war books, young man, which had been placed on display. . . and the book shop had won first prize for its patriotic window. . . And because your mother loved war, although all she knew of it was its flags, an entire industry was set up to oblige her, and there were many book-makers involved. No, not the ones from the race track, the ones which made literature. And publishers published it. . . The books stood there declaiming their ode to slaughter, their anthem of murder, the psalms of the gas grenades. That is why, young man."[79]

The two media giants Ullstein and Scherl set the tone in light fiction. Both of them published several series of novels in which new love stories, sentimental trash and thrillers of varying literary standards appeared by the month. Thea von Harbou and Vicki Baum led the field in this genre: Vicki Baum's *Menschen im Hotel* (Grand Hotel) was an international success. When Wilhelm Goldmann in Leipzig published the German translations of Edgar Wallace's detective stories from 1926 onwards, the company was soon notching up sales by the millions. Although that particular venture set certain literary standards, these were something that mass-produced light fiction generally preferred to dispense with. Bland and addictive literature was churned out on the assembly belt, from the tales of sleuth Nick Carter around 1920 to the "society novels" of Eufemia von Adlersfeld (who had penned some 90 works by 1926); from the novels by the above-mentioned ladies Courths-Mahler and von Eschstruth to the countless "ethnic romances" which proliferated in the wake of Ludwig Ganghofer's death at Tegernsee in 1920.

But there were also many companies whose publishers and editors possessed the enthusiasm and sensibility to nurture their writers and artists and foster a literature which is remembered today for its role in preserving the progressive traditions of the Weimar Republic. Some of these companies were already operating before the First World War, while others were founded later.

Samuel Fischer in Berlin and Anton Kippenberg in Leipzig established their companies, S. Fischer and Insel-Verlag, in the late 19th century. The former published

Karl May's Indian novels sold by the million in the Weimar Republic. He died in 1912, but the cult which surrounded him was thriving, as this photo of an Indian delegation from the United States visiting May's grave in Radebeul near Dresden demonstrates. The caption read: "Sioux Chief Big Snake delivers a speech in praise of Karl May."

From 1926 this column appeared regularly in the Nazi daily *Berliner Arbeiter-Zeitung*, edited by Gregor Strasser. All Nazi newspapers ran a similar "spotlight" on articles and editorials from the progressive German press.

Gerhart Hauptmann, Thomas Mann, Arthur Schnitzler, Franz Werfel and Alfred Döblin. The latter, always a champion of beautifully designed books in Germany, counted Rainer Maria Rilke and Stefan Zweig among its authors.

Both firms offered encouragement to young writers. Insel began publishing volumes of poetry by Johannes R. Becher in 1916, and Samuel Fischer printed the first manuscripts by Carl Zuckmayer, Walter Mehring, and Thomas Mann's children Klaus and Erika.

Two companies founded just before the First World War pioneered Expressionist literature and continued after 1920 to open new doors for young poets. These were Kurt Wolff, based in Leipzig and Munich, and Gustav Kiepenheuer in Potsdam. The brochures in Kurt Wolff's series *Der jüngste Tag* offered a platform to the latest German writing, and the same publisher brought out the plays of Carl Sternheim and the poetry of Franz Werfel. The firm recruited its most important author in 1911, in the person of Heinrich Mann: by 1932 Wolff had printed 155,000 copies of *Der Untertan* (The Patrioteer).

Gustav Kiepenheuer always made a point of maintaining a "literary team" in his office. Ludwig Rubiner joined his staff in 1910, and later, in the twenties, came Hermann Kesten, Walter Landauer and Fritz Landshoff to swell the ranks. Kiepenheuer was a close personal friend of Georg Kaiser, whose complete works he began publishing in 1919 alongside the first plays by Bertolt Brecht and Ernst Toller, novels by Joseph Roth and early short stories by Anna Seghers.

Ernst Rowohlt founded his company in Berlin in 1919. He already had experience of running his own publishing house in 1910/11 and as manager of Hyperion from 1913, and his own enterprise was soon to become one of Germany's top literary publishers. Like Kiepenheuer, Rowohlt and his chief editor Paul Mayer, himself a gifted

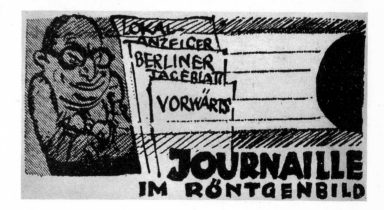

poet, were tireless in their search and encouragement for talent. They published Arnolt Bronnen and Kurt Tucholsky, Reinhard Goering's plays, journalistic features and reviews by Alfred Polgar and the novels of Robert Musil. Hans Fallada was one of the most successful house authors from 1929.

The art publishers Paul and Bruno Cassirer, supported by Max Tau, who was their chief editor for many years, made their contribution with fine illustrated volumes. They published beautiful collectors' editions of classical texts, works by Else Lasker-Schüler, essays and reviews by Carl Einstein and important monographs on the contemporary fine arts, a field which was also serviced by Klinckhardt & Biermann in Leipzig.

Berlin was the heart of the publishing world. In spite of the major companies based in Leipzig and Munich, book production in the Weimar Republic focussed on the capital. In 1927, for example, the Berlin Commercial Register listed 1,200 publishers of books. It would be impossible to describe even the major companies in rough outline.

Apart from the progressive bourgeois firms mentioned above, there were a number of left-wing publishers who played a part on the German publishing scene. Herzfelde's company Malik forged its political and avant-garde reputation in 1921 with the first cycle of prints by George Grosz, *Das Gesicht der herrschenden Klasse* (The Face of the Ruling Class), which ran into an edition of 12,000. That same year Malik printed the first novel by Upton Sinclair. The cover showed a photomontage by John Heartfield.

These publications set the literary and artistic tone, and in the years which followed Herzfelde published socialist fiction from Germany, the Soviet Union and the United States. One of Malik's principal accomplishments were the multi-volume editions of Upton Sinclair, Maxim Gorki and Ilya Ehrenburg. There were also new Soviet works and offerings by young German-language writers such as F. C. Weiskopf and Ludwig Turek.

There have been many imitations of John Heartfield's masterful and quite novel book design, which fused together binding, dust cover and endpapers, but the quality of a Heartfield original has rarely been repeated. Kurt Tu-

cholsky summed it up beautifully: "If I wasn't Tucholsky, I'd like to be a Malik book cover."[80]

Die Schmiede was a publishing venture set up in Berlin in 1921, and writer Rudolf Leonhard was a member of its editorial staff. The company reached a great many readers with its series *Twentieth-Century Novels*, 18 titles which appeared from 1924 to 1927 including Henri Barbusse's *Le Feu* and the first German translation, albeit abridged, of Marcel Proust's *A la Recherche du Temps Perdu*. The 14 volumes in the series *Society's Outsiders: Modern Crimes* included *Der Fall des Generalstabschefs Redl* (The Case of Chief-of-Staff Redl) by Egon Erwin Kisch and *Haarmann. Die Geschichte eines Werwolfs* (Haarmann: The Tale of a Werewolf) by Theodor Lessing, alongside with others.

The Neuer Deutscher Verlag in Berlin was one of the most important left-wing publishing companies. It was founded in 1925 by Willi Münzenberg on behalf of the KPD. Apart from political texts, it brought out works by Soviet and socialist German writers in editions of 10,000 to 25,000 copies. John Heartfield was one of its designers.

ARNOLD ULITZ, lebt in Breslau, wo er 1888 geboren wurde. Er wurde bekannt durch seine großen Romane „Ararat" und „Bastard". Soeben erschien als neustes Werk „Aufruhr der Kinder", eine Waisenhausgeschichte.

BERT BRECHT stammt aus Augsburg. Als 17 jähriger schrieb er „Trommeln in der Nacht". Er schuf den modernen Song und trat auch als Regisseur der jungen Generation hervor.

ERICH MARIA REMARQUE wurde 1898 in Osnabrück geboren. Als er aus dem Kriege heimgekehrt war, wurde er Volksschullehrer, dann Kaufmann und Redakteur. Sein Buch „Im Westen nichts Neues" überschritt in 12 Wochen das 500. Tausend.

WALTHER HASENCLEVER kam 1919 durch sein expressionistisches Drama „Der Sohn" in die Spitzengruppe der deutschen Dramatiker. Auch als Lyriker und Lustspieldichter hat er bedeutende Erfolge. Er stammt aus Aachen, wo er 1899 geboren wurde

CARL ZUCKMAYER ist der Schöpfer des neuen deutschen Volksstückes. Er wurde 1896 in Nackenheim am Rhein geboren. 1925 erhielt er den Kleistpreis für seinen „Fröhlichen Weinberg".

DIE JUNGEN AUTOREN
DES
PROPYLÄEN-VERLAGES

Alle Bücher des Propyläen-Verlages sind in jeder guten Buchhandlung zu haben! Einen ausführlichen Prospekt über die Werke dieser und anderer moderner Dichter erhalten Sie auf Wunsch bei Ihrem Buchhändler oder vom

PROPYLÄEN-VERLAG / BERLIN SW 68

LION FEUCHTWANGER ist der meistübersetzte junge deutsche Dichter. Seine Romane haben Welterfolg. Er wurde 1884 in München geboren und ist neuerdings auch als Dramatiker stark hervorgetreten.

LEONHARD FRANK 1882 in Würzburg geboren, arbeitete sich als Autodidakt aus kleinsten Anfängen empor. Er erhielt den Fontanepreis 1911 für sein Erstlingswerk „Die Räuberbande". Seine schöne Novelle „Karl und Anna" ging dramatisiert über viele Bühnen.

The Propyläen-Verlag was a literary offshoot of the big Ullstein publishing company. This advertisement from the magazine *Die literarische Welt* of May 1929 reveals a reliable sense of literary quality in the choice of young authors given contracts by the enterprise.

Left:
Fiction for mass consumption in the Weimar Republic. There were dozens of series like the *Wiking-Bücher*, of which 74 titles in all were published in Leipzig (advertisement 1919). The militant war book *Wir von der Infanterie* (We Infantry Men) came out in 1929 and sold over 60,000 copies by 1933.

In 1929 he illustrated an anthology by Tucholsky called—like the patriotic anthem—*Deutschland, Deutschland über alles*, which sparked off a political scandal: Heartfield had satirized the German Generals of the First World War in a photomontage entitled *Tiere sehen dich an* (Animal Gallery).

Two firms which would merit more detailed analysis were Erich Reiss, who published the eye-witness reports by Egon Erwin Kisch, and the Verlag für Literatur und Politik, based in Berlin and Vienna, which printed the first Complete Works of both Lenin, and Marx and Engels, in German. Neither of these projects was actually com-

133

pleted, as the company was wound up by the Nazis in 1933 along with other left-wing enterprises.

Book clubs were an important offshoot of the publishing business in the Weimar Republic. A wide range of well-produced books from international classics to specialist reading and light fiction was offered to members once a month at cheap prices. The Book-Lovers' Association, founded in 1919, was the first venture of this kind to be set up after the war.

Once inflation was over similar associations mushroomed, two of which deserve special mention. Many factory and office workers subscribed to the Büchergilde Gutenberg, founded in 1924. Titles by Martin Andersen Nexö, Jack London and B. Traven appeared here, tastefully bound in the distinctive oblong format. Willi Münzenberg addressed a similar readership with the Universum-Bücherei which he launched in 1926. The catalogue listed Kisch, Tucholsky and Bredel, but apart from publishing books the enterprise organized various cultural activities. One highlight was the annual festival which the Universum-Bücherei held at the Sportpalast in Berlin.

Weimar's publishers bequeathed to posterity some considerable accomplishments in the field of book design. An international exhibition of book art had already taken place in Leipzig in 1914. From the artist's point of view, the rapid advances in book printing after the war encouraged new type faces, a new typography and a new relationship between text and illustrations. Leipzig became a centre of book art. Hugo Steiner-Prag, a lecturer at the Academy of Graphic Arts and Book Design (a unique institution in Germany), and Julius Rodenberg, Head of the Artistic Prints Department at Germany's copyright library, the Deutsche Bücherei, were both pioneers in their own sphere, and they managed to place their two establishments in the service of their cause. Leipzig's printers combined the most efficient methods and the best quality in Germany, with Poeschel & Trepte and Haag Drugulin leading the field. This was the birthplace in 1924 of the Association of German Book Artists, which united printers producing collectors' editions on hand presses (such as Harry Graf Kessler's Cranach-Presse of Weimar and the Bremer Presse in Munich) printers using modern technol-

Publisher Gustav Kiepenheuer (photo 1928) gave tremendous encouragement to contemporary literature and music. His company published the works of writers such as Georg Kaiser, Ernst Toller, Bertolt Brecht and Anna Seghers.

Bruno Cassirer (photo 1930) and his brother Paul were leading art publishers in the Weimar Republic.

ogies, typecasters (Klingspor of Offenbach were the biggest firm), publishers and book illustrators of different artistic profile.

The first International Exhibition of Book Art in Leipzig was held in 1927, attracting displays from 21 countries in Europe and further afield to the Fine Arts Museum. Professor Hugo Steiner-Prag was Director of the exhibition, while Gerhart Hauptmann, Max Liebermann and historian Adolf von Harnack agreed to act as patrons. Liebermann wrote in the catalogue: "The ideal of any book art exhibition would be to display books whose external design blends in a harmonious whole with their inner substance."[81]

Artistic ideas were being realized increasingly by means of mechanical reproduction. Leipzig's printers were joined by companies such as Jakob Hegner of Hellerau near Dresden and Otto von Holten of Berlin in their quest for new aesthetic standards.

The first competition to find the year's most beautiful books was announced in 1930. A jury chaired by Hugo Steiner-Prag selected the fifty finest specimens from among the output of 1929. The awards went to 40 publishers in all, some of them still using manual methods for

the true bibliophile, and others producing mass editions by technological means. Insel took the laurels with four awards, and prizes for editions of over 10,000 went to S. Fischer for Walter Mehring's *Gedichte, Lieder und Chansons* (Poems, Songs and Chansons), the Büchergilde Gutenberg for B. Traven's *Die Brücke im Dschungel* (Bridge in the Jungle) and Malik for Ernst Ottwalt's *Ruhe und Ordnung* (Law and Order).

The competition became an annual event and was held for the third time in 1932. But a year later, in Nazi Germany, its continuation was out of the question.

"It's me, Marie from the Haller Revue. . ."— Show biz

The song was a hit in 1928 and was sung one evening after the next for seven months on the boards of Berlin's Admiralspalast:

> "Ich bin die Marie von der Haller-Revue,
> im Tanzen bin ich ein Genie.
> Von mir stehn Artikel bei Mosse und Scherl,
> man hält mich sogar für ein Tiller-Girl!
> Ich bin die Marie von der Haller-Revue,
> Sie sehn meine Fotografie
> In der B.Z. Drunter steht fett:
> Marie von der Haller-Revue."

> (It's me, Marie from the Haller Revue,
> My dancing's an absolute wow!
> Mosse and Scherl have done features on me,
> Some people even think I'm in the Tiller Show.
> It's me, Marie from the Haller Revue,
> You've seen my photo in the B.Z.,
> with a caption in bold:
> Marie from the Haller Revue.)

The "golden" aura of the twenties, the nostalgia and mystique which sometimes still cloud our gaze today, can be traced primarily to this: the glamorous world of the songs, the variety, the exotic dancing and the operetta, in short, the fairy tales of show business.

Richard Tauber sang *Dein ist mein ganzes Herz* (My Heart Belongs to You), Juan Llossas rasped erotic tangos on his fiddle, Shimmy and Charleston set the rhythm: those were the days! Or were they?

The pleasure industry expanded enormously after 1918, operating to the highest standards and enjoying prosperity in spite of the harsh post-war period, inflation and crisis. Until about 1924 entertainment was addressed principally to a small public with plenty of purchasing power which was able to indulge its appetite for amusement without restriction. The process began with a boom in vulgarity. In December 1918 the law which required everything to be submitted to police censorship in advance was revoked, and the door stood wide open for erotic entertainment. The cities, and above all Berlin, were overrun by light cabaret, striptease, bars and dives of every sort. Most of their clients were wartime profiteers, speculators, officers and landowners.

The feverish atmosphere is vividly described in a newspaper report of 1920: "There we find them, the gentlemen who turn up anywhere they can splash a bit of money around. Obese old men, the economic opportunists, the playboys with the hard cash who radiate as much of an interest in pure art as the compère radiates an interest in providing it. But we are about to start. The room darkens, a magic beam of light searches out the stage, the curtains part, and the priestess of pure joy floats in, followed by two handmaidens, all of them scantily clad in veils of silk with everything on view. Contact has been made, the audience aroused, the ladies are not modest in their movements. Nobody resents the expense of the ticket. And outside there are people perishing from hunger."[82] The morbid world of those years until 1923 is captured in the incomparable drawings of George Grosz. Another contemporary witness was Friedrich Hollaender: "'Cocaine, nude dancing on broken glass?' whisper dark shadows behind coatsleeves on the night streets. The rat catchers. And behind them, pattering after the pipes, come the rats. For when a tongue loses the desire to speak, cocaine will generously help it to babble. Naked female flesh titillates eyes that have lost their desire to see with the seven veils of Salome.

"'Sa-lo-meee, your lips are sweet death!' wailed the orchestras. 'Berlin, you are dancing with Death!' screamed the hoardings. Dives where smoky figures muttered secrets and clients dozed in the half light shot up out of the asphalt like toadstools. 'Kakadu' and 'Weisse Maus', 'Silhouette' and 'Toppkeller'. Down the side streets 'Eldorado' and 'Club Lila' for fashionable gentlemen in evening dress, 'Die Grotte' and 'Entrenous' for the fair sex in coarse tweed. They writhed like creeping plants to new dance rhythms in the blue light of the bars."[83]

New dances were churned out non-stop. The songsheet publishers were the driving force, and of course the pleasure-ground bands always wanted something new to offer the public.

In 1918 it was the Foxtrot and the Tango, in 1919 the One-Step and Boston which ruled the dance floors. In 1920 came the Shuffle and the Scottish Espagnol, in 1921 the Shimmy invaded Germany, followed by the Two-Step and the Cakewalk in 1922, the Fishwalk in 1924 and the Charleston, the symbol of the twenties, in 1925. That, in turn, gave way to the Black Bottom in 1926. Interestingly enough, the legend that this rapid succession of new dances was due to "the dynamic age" was destroyed in an analysis published as early as 1922. "The never-ending stream of fabulous names is created without effort. Countless notes are scribbled hurriedly onto paper. And —a few months later all the whole glorious affair had subsided for ever into the abyss. But naturally, none of these warnings will bear much fruit, as the people who determine these things (the musical community) regard dancing itself as pure business. And for a flourishing business one needs advertisements, a big ballyhoo and a dose of self-deception. So presumably people will go on for years hearing about new 'American' dances and being foolish enough to dance them for a few weeks because they have been in the papers."[84]

The popular melodies and music-hall songs of pre-war years developed alongside the dances after 1918 to become what is now generally known as a "hit". The word itself, simple, catchy and apt, was coined in early 1919. These new songs were the basis for a new industry. Publishers and record companies hired lyric writers and composers, and the commercialization was soon complete. Many of these products have long since fallen into obscurity, but some really did make their mark. A few of them even captured the atmosphere of the social situation, like *Hiawatha*, the popular Foxtrot dating from December 1918, in which the verses reflect the thirst for life after the war, while the chorus holds up a ghostly mirror to the bloodbaths out on the streets:

"Jeder tanzt, auch wenn er's nicht versteht;
denn es sind ja alle noch verdreht.
Alles schiebt und scherbelt spät und früh,
schlottert mit die Knie:
Kinder, Mutter, Vater. Es ist ein Theater!
Licht aus, Messer raus!
Haut ihn, dass die Fetzen fliegen!
Strasse frei, Fenster zu, runter vom Balkon!"

(Everyone's dancing, even if they don't know how,
as everyone is still pretty mixed up.
Everyone's heaving and reeling all night long
and shaking at the knees:
children, mothers, fathers, what a performance!
Chorus: Light out, knives out!
Bash him into little pieces!
Clear the street, shut the window, down from the balcony!)

A successful Shuffle in 1920 played on the double meaning of the German title: the word for Shuffle was the same as the word for dealing on the black market, and so when the public sang:

"Max, du hast das Schieben raus, Schieben raus, Schieben raus.
Alles schreit hurra: Schieber-Max ist da!"

(Max, you've got the hang of shuffling,
We all shout hurrah: Max the shuffler's here!)

they were casting a nudge and wink at the racketeers. As inflation took hold in 1922, even its victims were heard singing along to a popular polka:

The war profiteer and the young girl forced into prostitution: George Grosz's drawing *Frühlings Erwachen* (Spring Awakening) was a bitter paraphrase of the play Wedekind wrote in 1891. Adolescent relationships were no longer relevant in post-war Germany: money needed earning in order to survive. The work was included in a folder of Grosz prints, *Ecce Homo*, published by Malik in 1922.

"Wir versaufen unsrer Oma ihr klein Häuschen,
und die erste und die zweite Hypothek!"

(Granny's little house is going to pay for the booze,
just like the first and second mortgage.)

Until 1924/25, when radio and electric recording were able to reproduce hit songs by the million, the only channels for dissemination were the dance hall, sheet music and a comparatively small number of mechanical gramophones. Every new technological medium designed to increase the popularity of the songs and the profits of their producers was therefore welcomed all the more warmly. A Foxtrot in January 1924 took the wireless as its theme:

"Die schöne Adrienne,
tschingderassa-sassa-sassa-Radio,
hat eine Hochantenne,
tschingderassa-sassa-sassa-Radio."

(The lovely Adrienne
chingderassa-sassa-sassa radio,
has a roof aerial,
chingderassa-sassa-sassa radio.)

In the summer of 1925 the hit merchants praised the new, improved gramophone disc:

"Ich hab zuhaus ein Gramm, ein Gramm, ein Grammophon,
das spielt jetzt laut mit neu, mit neu, mit neuem Ton!"

(At home I have a gramophone,
Now it's loud and sings with a new tone.)

And the advent of sound film was turned into a hit in 1929:

"Mein Bruder macht im Tonfilm die Geräusche,
das hat er schon als Kind so gut gekonnt.
Er macht es so, dass ich mich selber täusche.
Es gibt nichts, was mein Bruder nicht vertont.
Er macht das Waldesrauschen, er macht den Wogenfall,
Er macht das Küssetauschen und den Revolverknall. . ."

(My brother does the sound effects for sound films.
It's something he was good at as a boy.
The way he does it I can't tell the difference,
and there's no sound that my brother cannot do.
He does the rustling forests, he does the crashing waves,
He does the sweethearts kissing and the pistol shots. . .)

The hit songs and dances reached their zenith from 1925 onwards, when the sleazy delights of expensive bars were no longer the exclusive reserve of a minority. After all those war-torn, hungry, cold and inflationary years, this new appetite was a mass phenomenon. It meant going out, throwing parties, having a good time and keeping up with all the latest fashions. But anyone who could not afford all this, in spite of the much-vaunted economic

stabilization, was quite likely to have a radio and dance to the latest hits at home.

About 2,600 of these songs were published in Germany between 1924 and 1932. Compared with mass production today, the figure seems small, but it was almost five times as much as in previous decades.

Fashion changed dramatically, too. Secretaries and shop girls had their hair bobbed and acquired various chic accessories (striking make-up, ladies' cigarette-holders), but the natural look and casual fashion were also in. Skirts lost their stiffness and also some of their length, legs and busts were exposed during the day in the offices, not to mention the plunging necklines and backless creations which were worn of an evening. Women's trousers invaded Germany, and anyone who could afford tails to dinner wore them, including the fair sex.

The prudish stuffiness of Wilhelminian Germany yielded to a freer lifestyle, especially where the role of women was concerned. The fashion industry made as much money out of the constant stream of dances as did the music business, as each time the ladies needed a new Shimmy blouse, a Charleston dress or a Black Bottom smock.

There was more freedom for erotic expression. The songs set an example:

"Wenn die Elisabeth nicht so schöne Beine hätt',
hätt' sie viel mehr Freud an dem neuen langen Kleid. . ."

(If Elisabeth's legs weren't so lovely
she would take more pleasure in her new long dress. . .)

"Was machst Du mit dem Knie, lieber Hans,
mit dem Knie, lieber Hans, beim Tanz?"

(What are you doing with your knee, Hans dear,
with your knee, Hans dear, as you dance?)

"Am schönsten sind die Mädchen, wenn sie baden gehn,
dann kann man ihre wunderschönen Waden sehn."

(Girls look prettiest when they're bathing,
because you can see their fantastic calves.)

Or even more outspoken:

"Ich möcht' mit dir, mein Schatz, nur einmal sündigen,
dann kannst du mir, mein Schatz, die Freundschaft kündigen.
Hab ich nur eine Nacht bei dir im Rausch verbracht,
dann hast du selig mich für alle Zeit gemacht!"

(I only want to sin once with you, my love,
and then, my love, you may finish our friendship.
When I have spent a single night of ecstasy with you,
you will have made me blissful for ever!)

Sheer nonsense always went down well; the meaning lay in their lack of any:

"Ich lass mir meinen Körper schwarz bepinseln
und fahre auf die Fidschi-Inseln. . ."

(I'm going to get my body painted black
and take a trip to the Fiji Islands. . .)

"Mein Papagei frisst keine hartgekochten Eier,
er ist ein selten dummes Vieh.
Er ist der schönste aller Papageier,
nur harte Eier, die frisst er nie!"

(My parrot won't eat hard-boiled eggs,
he really is a very stupid bird.
He's the most beautiful parrot in the world,
but he won't touch hard-boiled eggs.)

"Ich fahr mit meiner Klara
in die Sahara zu den wilden Tieren.
Denn mir wird immer klarer:
Ich muss die Klara unbedingt verlieren. . ."

(I am taking my Clara
to the wild beasts of the Sahara.
For one thing's growing clearer,
I simply must lose my Clara. . .)

The Chocolate Kiddies, a variety troupe from the United States, visited Germany in 1926 and brought original American jazz live for the first time to the German stage. Members of the company pose on the roofs of Berlin for the publicity photos.

And of course the songs extolled every new dance:

"Black Bottom, den liebt jeder,
Black Bottom, den schiebt jeder.
Der letzte Clou, Black Bottom, bist ja nur du!"

(Everybody loves Black Bottom,
Everybody does Black Bottom.
You alone, Black Bottom, you're the tops.)

"Schau doch nicht immer nach dem Tangogeiger hin,
was ist schon dran an Argentinien?"

(Don't keep eyeing the tango fiddler,
what's so special about Argentina?)

"Ich tanz Charleston, du tanzt Charleston, er tanzt Charleston.
Wir tanzen alle Charleston. Und was tun Sie?"

(I'm dancing Charleston, you're dancing Charleston, he's dancing Charleston.
We're all dancing Charleston, and how about you?)

Until 1929 most new hits owed their popularity to the leading dance bands who played in the big hotels and recorded discs: Marek Weber, Jack Hylton, Ilja Lifschikoff, Béla Dajos or Efim Schachmeister. But with the advent of sound film a new breed, the singing star, was born. Lilian Harvey, Willy Fritsch and Hilde Hildebrand, the cinema-goers' darlings, replaced the orchestral chorus with a visual rendering of their new hits.

The top songwriters were Walter Kollo, Jean Gilbert, Theo Mackeben, Werner Richard Heymann, Ralph Benatzky and Franz Grothe.

The Shimmy in 1921 heralded the adoption of American popular music. Jazz made a strong impact, having "gone respectable" in the United States in 1918.

The arrival of jazz in Germany was fraught with grotesque misunderstandings until well into the mid-twenties. Hardly any of the country's light musicians had ever heard the original thing, but they all wanted to jump on the sensational new bandwagon. The "Yazz-Bands" mushroomed in Berlin, Munich, Cologne and other cities from around 1920 onwards.

"Dance musicians blushed as they burned their old scores, found themselves red tailcoats, blacked their faces, pulled on yellow socks and blue shoes, bought themselves toy trumpets, cow bells, guitars and cap guns, and cheerfully sought engagements by the hundred as authentic Yazz-Bands. No pub could afford to be without one. And the public romped about by the thousands, dancing and sweating. There was something pricelessly funny about the whole business, for up until now no one in Germany had ever seen a real American jazz formation. Nice, solid people in Berlin set up Yazz-Band orchestras either to earn more money or because their employers told them to. And they produced more or less rhythmical noises on a handful of sorry utensils."[85]

When the first American jazz records did arrive on the German market in 1921, and when an American jazz show, the Chocolate Kiddies, toured several German cities in 1926 with the real sound, composers and performers were quick to incorporate this jazz idiom into the German entertainment scene, borrowing melody and harmony as well as the rhythm and instrumentation. A number of groups combining strings with jazz wind instruments were created in imitation of the Paul Whiteman Orchestra, who gave the first concert of Gershwin's *Rhapsody in Blue* in New York in 1925. They invented exotic names for themselves, like the Billy Bartholomeus Delphian Jazzband, or Sam Baskini and his Radio Jazz Orchestra.

But there was still only one band playing true jazz music, and that was the Weintraub Syncopators with Friedrich Hollaender at the piano. Later he gave his account of how it all started: "Everyone was screaming 'Yass! Yass!', as though someone had forgotten to turn the tap off. They meant jazz. Everyone wanted it and no one could play it. People ran around buying the new records from America, carted them home, tipped them on the plate like fried eggs and let them roll, ten times, twenty times. But the kind of guys whose senses were more acute began practising. It sounded terrible at first. Once you've heard Whiteman's *Rhapsody in Blue*, you feel like throwing your

Hermann Haller's revues at the Admiralspalast in Berlin were a watchword of twenties entertainment. Haller's theatre, with its lavish equipment, its Tiller Girls—imports from London in ever-changing costumes—and slots for popular stars, played to a full house for years. The illustration shows a scene from *Wann und Wo* (When and Where) in 1927.

Ad for Haller Variety Theatre in 1929.

Nobody could excel James Klein's shows at the Komische Oper near Friedrichstrasse Station when it came to undressing young women. The box office was soon ringing up the profits. Scene from the revue *Die Sünden der Welt* (Worldly Sins), 1927.

trumpet to the daisies. But five smart kids kept at it. They rehearsed the new sound in the laundry room. Stubborn and obsessed. They would rather have died than not manage to get hold of those foreign foghorns called saxophones. Finally they made it. They struck up for the first time to a younger generation in a sideroom of the Nation Club. The Weintraub Syncopators."[86]

Another American import which took Germany by storm was the variety show. It originated in 19th-century French vaudeville and was adopted in New York around 1910 in the form of the burlesque and the extravaganza. The first chorus girls in identical clothing, the symbols of the twenties review, were the Ziegfeld Follies, who formed in 1918.

Berlin's three "Kings of Review" led the way with their theatres near the station at Friedrichstrasse in the heart of

the capital. Their shows were magnetic, pulling in the spectators by the tens of thousands, and it was not long before they were imitated in other towns from Munich up to Hamburg.

James Klein began it all in the old Komische Oper. His first show, *Europa spricht davon* (The Talk of Europe) opened on 16 September 1922 with 21 acts. The talk of Europe, or rather Germany, was basically the display of nudity. Klein's variety hall was dominated until 1929 by naked girls, exotic settings, and sensuality, as the titles suggested: *Die Welt ohne Schleier* (The World without Its Veil), 1923, *Berlin ohne Hemd* (Berlin without Its Shirt), 1926, *Zieh dich aus* (Take Them off), 1928, or *Häuer der Liebe* (Fangs of Love), 1928. The artistic standards might have been low, but Klein's audiences poured into the Komische Oper from all over Germany.

Next door to that was the Admiralspalast, which Hermann Haller took over in 1923. The "Admiral of Review"

Edith Schollver Dolores Twins Hella Kürty Original-Lawrence-Tiller-Girls Kurt Lilien

presented his spectaculars there until 1929. There was more taste and style to the décor, music and dancing than in the neighbouring building. Haller made sure of that by hiring the right people: composers like Walter Kollo, designers like Emil Pirchan, solo performers like Trude Hesterberg and Paul Morgan. A Haller show ran uninterrupted for a full season, from August to March, and played to a full house night after night. The biggest attraction were the Tiller Girls, 24 ballet dancers from London engaged permanently by Haller in 1924 who dominated the acts with their faultless legs, their perfectly synchronized dancing and their magnificent costumes. German dancers joined the Tillers, but there were so many poor copies that they were soon obliged to call themselves the Original Tiller Girls.

It was only a few steps further to Erik Charell and the Grosses Schauspielhaus. Charell took over the building,

Black singer and dancer Josephine Baker, then living in Paris, enchanted the Berlin audiences with her frequent guest appearances from 1926. This pose from her famous Banana Dance was taken at the Theater des Westens in 1928.

Autumn 1928 brought resounding success in Berlin, not only for Brecht's *Dreigroschenoper*, but also for Franz Lehár's operetta *Friederike*. The photo shows the composer with Richard Tauber as Goethe and Käthe Dorsch as his early love Friederike Brion, October 1928.

Right:
"I'm off to the Sahara with my Clara", 1927, was one of the biggest nonsense hits of the twenties.

Friedrich Hollaender was one of the most successful composers writing for cabaret and sound film. His songs for *Der blaue Engel* won him worldwide acclaim. For a time he was leader of the Weintraub Syncopators, one of the few German bands playing real jazz. The caricature, dated 1930, depicts Hollaender at the piano in his Tingel-Tangel Cabaret.

the former Schumann Circus by the Schiffbauerdamm, in 1924, after Max Reinhardt had failed to revive the ancient theatre with his monumental productions. His first show opened on 18 October. It comprised 21 acts and was called *An alle!* (For Everyone!).

The spectacular on the gigantic stage verged on the fantastic. Charell's team, which included Reinhardt's stage designer Ernst Stern, composer Ralph Benatzky and stars like Claire Waldoff, Wilhelm Bendow and Curt Bois, vouched for quality entertainment. Charell's ballet corps was made up of German dancers, but took the name Jackson Girls to compete with Haller's Tiller Girls. After three successful years in variety Charell switched to operetta in 1928. His Schauspielhaus was the venue for a new blend, operetta review, which combined the two most popular forms of live entertainment. He broke all box-office records with a production called *Im weissen Rössl* (At the White Horse), which had its première in 1920. Charell wrote the words and Benatzky the music for this concoction of tearjerking operetta with bouncing peacock feathers and chorus-line legs which was soon snapped up by almost every theatre in Germany.

Up until that point operetta had been dominated by one man, the composer Franz Lehár. He wrote the stirring music for *The Count of Luxembourg* (1910), *The Land of Smiles* (1923), *Paganini* (1925), *The Tsarevich* (1927) and *Friederike* (1928), which owed much of their success to Richard Tauber, the mellifluous tenor with the tremendous public following. Stars such as Fritzi Massary, Lizzi Waldmüller and Gitta Alpar also triumphed in operettas by Walter Kollo, Emmerich Kalman and Fred Raymond. They were every bit as popular as well-known opera singers like Maria Cebotari or Helge Rosvaenge.

Not that operetta was always politically harmless. The spectre of militarism often reared its ugly head—to rapturous applause! Provincial theatres in particular kept Walter Kollo's ''patriotic war operettas''—*Immer feste druff!* (Let 'Em Have It!), 1915, *Die Gulaschkanone* (Soldier's Grub), 1916, and *Blaue Jungs* (Navy Blue), 1917—in their repertoires well into the twenties. When the Rotter brothers, Berlin's theatrical entrepreneurs, switched from farce to operetta in 1929, these attitudes were cheerfully revived. Their production of the operetta *Hotel Stadt Lemberg* (Lemberg Hotel), 1931, invoked the same old jingo-

istic values and was not even above a few anti-Semitic jokes. Not long afterwards the Rotter brothers were forced to leave Germany: they were Jews.

Another crowd-puller was the music hall. Thousands took their seats night after night in Berlin's Wintergarten or Scala, and in the other big cities like Leipzig, Hamburg and Cologne. Top-class acrobats such as the juggler Enrico Rastelli or the Three Codonas, the only act in the world at that time to perform a triple salto on the flying trapeze, were billed alongside popular singers, such as the audience sweetheart Otto Reutter with his catchy numbers or the irrepressible Claire Waldoff and her Berlin ditties, famous clowns such as Charlie Rivel and Grock, and the latest hits, splendidly sung by the Comedian Harmonists sextet.

But while we are on the subject of mass entertainment we must make a slight detour into the world of sport. The mixture of athletic skill and fairground, contest and comedy, was once again based on the American model. Boxing was the big new attraction. Max Schmeling, who took the European heavyweight title in 1927 and the world championship in 1930, and Paul Samson-Körner were the favourites, and the people flocked to see them. The world of art was by no means immune to the fascination. Samson-Körner knew Brecht and Carola Neher, while Schmeling married film star Anny Ondra and became a Romeo of the record business with his hit:

"Das Herz eines Boxers muss alles vergessen, sonst schlägt ihn der nächste knockout. . ."

(A boxer's heart must forget everything, or else he'll be knocked out next fight. . .)

The racing-car drivers were just as popular with their exciting tussles at the Nürburg Ring and the Berlin Avus. Half a million spectators packed the Avus in 1926 to watch Rudolf Caracciola snatch the biggest prize in Germany from Hans Stuck and Manfred von Brauchitsch in his eight-cylinder Mercedes. Events like this were festive occasions, and so were evenings at the cycle tracks during the Six-Day Races. Whenever they were held in Berlin at the Sportpalast famous names of stage and screen boosted publicity by their presence, and thousands whistled along to the tune of the lively *Sportpalast Waltz.*

There was less of a fanfare for riverside regattas and football, where the sport itself was more important and only real talent convinced the crowds. It was talent which helped the legendary goalkeeper Heiner Stuhlfaut of Nuremberg or Hertha BSC Berlin's forward "Hanne" Sobeck to fame.

Sport in the twenties was a combination of spectacular highlights to amuse the public and a new mass interest in physical exercise, with a very large workers' sports movement.

Throughout the show business world, art was closely intertwined with commercial acumen, and the theatres and record companies filled their coffers on "pure entertainment". But there was one genre which blossomed during the Weimar Republic without trying to observe the laws of profit, and which never closed its eyes and ears to the world "outside", and that was literary and political cabaret.

Germany's two best-loved sportsmen in the late twenties were racing driver Rudolf Carracciola (seen here at the Nürburg Ring in 1929) and boxer Max Schmeling. Sculptor Rudolf Belling's bronze figure of Schmeling took pride of place at the Sport in Culture Exhibition in Berlin in May/June 1930.

The *Brettl*, as it was originally known, first appeared in Germany in the late 19th century as a form of floor show. A Munich troupe called the *Elf Scharfrichter* (Eleven Executioners) struck out in a new, satirical direction in 1901, and from 1918 onwards the genre acquired greater literary polish and political bite. The writers and performers who banded together immediately after the war constituted a new chapter in the history of German art forms which lasted until 1933.

Schall und Rauch opened in December 1919 in the cellar of the Grosses Schauspielhaus in Berlin at the instigation of Max Reinhardt. The name itself held an obvious appeal. There had already been one attempt to set up a cabaret using this title in 1901/1902. It means "noise and smoke", and implies the hollow futility which underlies pomp and circumstance. As such, it aptly expressed the company's political aim, which was to expose militarism and war. The texts were written by satirists Kurt Tucholsky, Walter Mehring, Klabund and Joachim Ringelnatz; Friedrich Hollaender and Werner Richard composed the chansons; Blandine Ebinger, Gussy Holl and Paul Graetz were among the leading performers. It was here in 1920 that Rosa Valetti first sang Tucholsky's *Rote Melodie* (Red Melody), with music by Hollaender, warning the Generals "never dare try it again":

"General! General!
Wag es nicht noch einmal!"

Attacks like this intermingled with softer, gentle love songs and with a new kind of poetry designed for the genre which vividly captured the spirit of the times for the stage. Walter Mehring was its major exponent.

Most of the political cabaret companies were unable to survive for long, partly because there was no money in this field of entertainment, and partly because their members often argued about formal or political issues and departed to found new groups.

Schall und Rauch closed its doors again in 1921, a fate that was shared by Rosa Valetti's *Cabaret Grössenwahn* (1921–1922), and Trude Hesterberg's *Wilde Bühne* (1921–1924). One important post-war venture was the *Retorte* in Leipzig, which ran from 1921 to 1923. Erich Weinert and Hans Reimann were both members of the company before they left for Berlin.

The capital became the centre of political satire, just as it was the focus for so many other types of entertainment. Many new companies were set up between 1924 and 1930, but among the better known were Kurt Robitschek's *Kabarett der Komiker*, the longest-running political cabaret, which was founded in 1924 and survived after 1933, albeit under a new, Nazi management, Werner Finck's *Katakombe*, founded in 1929, Friedrich Hollaender's *Tingel-Tangel*, founded in 1930, and *Larifari*, a troupe with no permanent house of its own.

Satirical cabaret was graced by some outstanding performers, such as the mixed-up folk comedian Karl Valentin, who always received an enthusiastic welcome when

he appeared with Liesl Karlstadt, or the Viennese aristocrat Roda Roda, whose readings placed the royal personages of the Catholic Austrian Empire in a humorous light. There was an unprecedented literary quality to the chatter of compères like Fritz Grünbaum, Werner Finck and Willi Schaeffers. Erich Weinert, Ernst Busch and Hanns Eisler made a fine art out of presenting the problems of class struggle to a cabaret audience. And here was always an opportunity for budding writers to test their talents and gather some audience experience. The young Bertolt Brecht, for example, came to Trude Hesterberg's *Wilde Bühne* in 1924 to perform his ballads.

In 1925 Rudolf Nelson, Friedrich Hollaender and Marcellus Schiffer began experimenting with their own brand: the cabaret review. Hollaender: "Take the big Metropol Review Theatre and make it small. Take the thousand lovely legs and leave them to one side. You don't need the four intoxicants—the décor, the belly buttons, the orchestra or the ostrich feathers. Turn the five or six political sideswipes into seven or eight of same. Expand, trim down. Pump up a little here, deflate a little there."[87]

It was Nelson who introduced Josephine Baker, a cult figure in the Germany of the twenties, to a Berlin audience at one of his reviews in 1925. She was a singer and dancer who lived in Paris and who became the symbol of jazz, Charleston, modern dances and the new vitality. A German publisher actually brought out her *Memoirs* in 1928, when she was just twenty-six!

But Baker was an exception in cabaret review. In fact, she did not really fit in at all amid the racy lampooning of events and attitudes in the German Republic. Occasionally one of these shows would prove a box-office success, especially when stars like Marlene Dietrich, Hubert von Meyerinck and Curt Bois were on the bill, and be transferred from their habitual venues with 100 to 200 seats to a major theatre. In this way the Hollaender and Spoliansky review *Bei uns um die Gedächtniskirche 'rum* (All around the Gedächtniskirche) was able to reach a much wider audience than usual in 1927.

Two main ingredients contributed to the new flavour of political cabaret in the Weimar Republic. The first was the songs. The lyric-writers and composers had chosen their genre deliberately. They knew exactly how cabaret functioned and took the specific features of this milieu into account. Gifted partnerships such as Tucholsky and Hollaender, Mehring and Spoliansky, Brecht and Eisler, Schiffer and Nelson produced some excellent works which are still valued today as classics. They range from the direct assault of the political song, such as Tucholsky/Heymann *Der Trommler* (The Drummer), or Tucholsky/Eisler *Der Graben* (The Trench), via sensitive ballads which captured the mood of the times, like Mehring/Hollaender *Die Linden lang. Galopp! Galopp!* (Galloping, Galloping Down the Linden), or Schiffer/Spoliansky *Es liegt in der Luft eine Sachlichkeit* (There's an Objectivity in the Air) to hilarious numbers like Hollaender's chanson *Zersägen einer lebenden Dame* (Sawing a Live Lady in Two).

The second new element was the "diseuse", a generation of women who played a big innovatory role in political cabaret.

Their personalities varied in the extreme: Blandine Ebinger was playfully childlike, Trude Hesterberg brashly forthright, Kate Kühl pugnaciously determined, Annemarie Hase more enigmatic, and Margo Lion sensuality itself. These "ladies of the old school", as they are sometimes known today, captured the sense of their words and music with the utmost precision and injected their whole character into the songs that were written specifically for them.

The Nazis regarded jazz, review, hit songs and satirical cabaret, and most of the people who had anything to do with them, as particularly despicable manifestations of "Jewish cultural Bolshevism". The evening before Hitler attempted his putsch in 1923, SA men in Munich had beaten up the young composer Peter Kreuder on the stage of the *Bonbonnière* cabaret because of the bitter attacks in the songs which he had written and was accompanying on the piano. From 1928 onwards, committed cabaret in Berlin had to contend with kerfuffle and disruption by the SA almost as an everyday occurrence. It hardly came as a surprise, therefore, when the entertainments were "resolutely recalled to German positions" after 30 January 1933.

"No decoration without function"— New Objectivity and Functionalism

"Our generation was born in the last decade of the 19th century and was conscripted by an era in which human history made a fresh start . . . At the age of five I witnessed Edison's phonograph, at eight my first trams, at ten my first cinema, then the airship, the aeroplane, the radio. Emo-

In 1929 *Das neue Berlin* reproduced Otto Nagel's painting of a pub in the working-class Wedding district of Berlin along with the artist's commentary. Every one of these nine portraits tells a typical human story: the old worker at Borsig's mill, the prostitute, the amateur philosopher-cum-inventor-cum-choirleader who has been unemployed for years, the provincial petty bourgeois turned proletarian. The result is an impressive cross-section of the class most deeply affected by the world economic crisis as it began to hit Germany.

tions are being fitted with instruments to make them bigger and smaller. Progressive European and American technology is at pains to equip our generation."[88]

Lasar Markovich Lissitzky (El Lissitzky) was forty-two when he wrote those words in 1932. This brilliant Soviet painter, architect, typographer and designer had studied Architecture at the Polytechnic in Darmstadt from 1911 to 1914 and from 1921 onwards he spent several periods in Germany, where a number of his typographical works were printed. He also designed the Soviet Pavilions for big international exhibitions in Cologne, Leipzig and Dresden. His own first personal exhibitions were in Hanover and Dresden.

El Lissitzky's words are a testimony to the pathos and enthusiasm which pervaded many artists' attitudes to

Herrmann der Philosoph, baut seit 6 Jahren am Perpetuum mobile — seit vielen Jahren ohne Arbeit — führt jetzt eine Hofsänger-kolonne

Schulze, der nur das Un-politische liest

Willi der Pole, spielt Geige und singt mit Vorliebe das „Edelweiß" auf polnisch

Zottel vom „Strich"-Nettel-beckplatz — holte von Richard die Zigaretten. Seit einiger Zeit verschollen

Otto Nagel Wedding-Kneipe

Richard der Wirt

Vater, ehemaliger Provinz-gastwirt. Hat 3 Söhne im Krieg verloren. Wächter bei Wach- und Schließgesell-schaft — jetzt Zeitungs-händler

Weber, Invalide

Herrmann W., seit 27 Jahren bei Borsig

Heini der Boxer, von Be-ruf Klempner

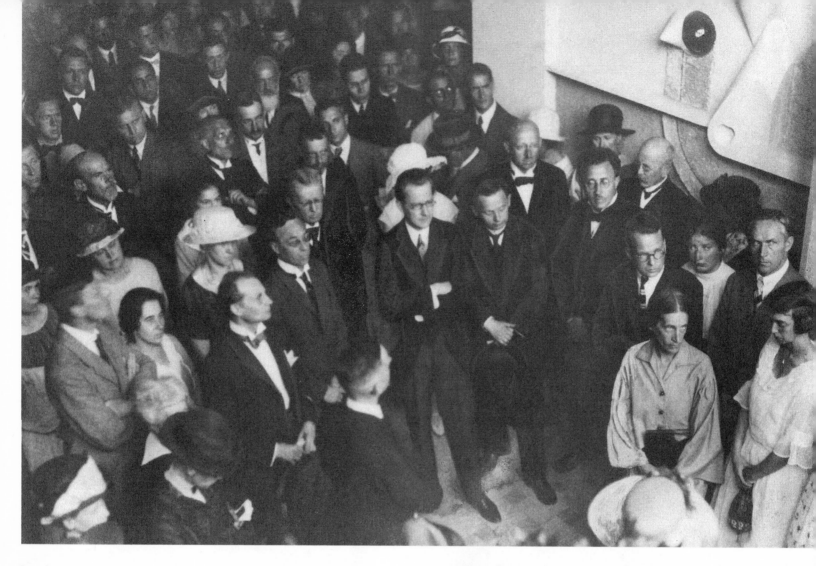

Prominent arts personalities gathered for the opening of the Bauhaus Exhibition at Weimar in October 1923. Dr Edwin Redslob, keeper of the arts in the Reich, is at the centre of the picture, with Vassily Kandinsky to the left in dark glasses.

Laszlo Moholy-Nagy takes photographs of dancer Gret Palucca during her visit to the Dessau Bauhaus in autumn 1929.

Right:
The *Denkmal der Märzgefallenen*, a monument to the workers killed during the Kapp Putsch in March 1920, was designed by Walter Gropius and cast in late 1920 using the new techniques of concrete construction. It stood in Weimar Cemetery in honour of the workers' self-defence units of Gotha, Ohrdruf, Suhl and Sömmerda in surrounding Thuringia, who joined in a fierce struggle to put down the rebellious armed forces.

technology. They also indicate the international character of these developments.

Lissitzky's blend of painting and architecture, Constructivism and functionality was typical of this new generation of artists who, once the storm of pamphlets and manifestos and the cries of Expressionist protest against war had died down by about 1922, responded to the growing urbanization of lifestyles by seeking to combine traditional forms of artistic expression with new materials and techniques drawn from the world of production. Architecture and the applied arts—the construction of modern buildings and functional furnishings—played an important part in this. It is hardly surprising that an avant-garde publication in 1922 should predict "Architecture is the new form!"

At the same time there was a search to define the new social function of art. In this respect El Lissitzky was an historical era ahead of his colleagues in Germany when he commented in 1925: "We want art again, the new art of architecture. We believe that in our country the ground plan for art is new, as the ground plan of our society is new."[89]

That, however, did not apply to the Weimar Republic. Few Functionalist ideas were able to develop beyond an initial impact. Besides, any artists who decided to work in the progressive spirit were vehemently attacked from the outset by conservative and reactionary opponents. Just as the nationalistic magazine *Fridericus* got away with calling Heinrich Zille a "painter of lavatories and pregnancies" in 1924, so the provincial government under von Stade was able to order the removal of Heinrich Vogeler's frescoes from Barkenhoff in Worpswede in 1927. From 1930 onwards these assaults on the visual arts escalated fast.

Although reputable architects such as Taut and Gropius devised some far-sighted schemes for housing communities—which were badly needed in view of the appalling housing shortage after 1918—these were only realized to a modest extent as the Republic only made very limited finance available. The social contradictions which inevitably resulted from entrusting the public purse of an old system with carrying out new ideas were more evident here than in other branches of the arts.

There had been a notable shift towards Verism in the fine arts even during the Expressionist phase. Diether Schmidt has summed up the process accurately: "The 'Spartacist' compositions of Dix and Beckmann, Grosz, Heartfield and Schlichter already herald the advent of Verism. One might even say that Verism was born of Expressionism and Dadaism when it acquired a revolutionary

political content, and that this revolutionary content was potentially so explosive that sooner or later it would have to burst out of its narrow formal shell of slogans and concepts so as to make direct contact with a reality which was undergoing turbulent change and rapidly sharpening contradictions."[90]

"Tendentious Art" of this kind, with its committed content, soon became the progressive stream of Verism, an important phenomenon in painting and graphic art during the twenties. It emerged in very disparate forms, in the etchings of Käthe Kollwitz, the woodcuts of Conrad Felixmüller and Karl Rössing, the big triptychon by Otto Dix and smaller paintings by Curt Querner, the sharp pen of George Grosz and the pencil of Hans Baluschek. But what they all had in common is a new approach to how their art should function, as Käthe Kollwitz formulated in 1922: "The international Trade Union Federation has asked me to make a poster opposing war. I am delighted with this commission. People will probably claim thousands of times over that it is not pure art . . . For as long as I go on working I want to make an impact with my art."[91]

This was a programme of action: making an impact meant taking sides, changing things. It was no mere chance that a group of Communist artists called the *Rote Gruppe* joined the KPD in 1924. The organizers were Grosz, Schlichter and Heartfield, and its members included Otto Nagel and Eric Johansson. Otto Dix wrote: "For me, anyway, what is new about this painting is that the subject matter is broader . . . That is why I have always attached such great importance to the question of whether I can move as close as possible to the thing I can see. What means more to me than How! The How has to develop out of the What."[92]

The Association of Revolutionary German Fine Artists (ARBKD, or "Asso"), was founded in Berlin in January 1928 and in Dresden in the summer of the same year. The Statutes defined its aims: "Unlike those artists' associations which are only based on various styles and the slogan *l'art pour l'art*, the ARBKD intends to promote the class struggle and will correspond in style and content to the needs of the workers."[93] There were soon 16 branches of the "Asso" in Germany, with 800 members,

making it an important artistic force in the intensifying political conflict from 1929 onwards.

Close links with the Soviet Union were only natural. Otto Nagel and Eric Johansson organized the first German art exhibition in Moscow, Saratov and Leningrad in 1924. This collection of Expressionist and Verist works alongside specimens of the new "Tendentious Art" caused Anatoli Lunacharski to remark: "This exhibition will not pass unnoticed. Not only has it been set up under the flag of International Workers' Aid; I am talking about the content of the exhibition itself . . . In their quest for an intellectual record of revolution, for the creation of revolutionary art . . . German artists have a weapon which strikes at the enemy's heart."[94]

The Heartfield Exhibition in Moscow in 1931 and the Kollwitz Exhibition which was shown in Moscow, Leningrad and Kharkov in 1932 were further showpieces of revolutionary German art. By the same token, Soviet artists appeared regularly at Berlin exhibitions, such as the Juryless Exhibition, from 1923. One-man displays in Dresden, Hanover and other cities were devoted above all to the Constructivists.

The precise registration of a social reality built on class contradictions, the commitment to the proletarian cause, executed with masterly artistic skill—typical features of revolutionary German art in general—were beautifully expressed by Heinrich Zille in praise of Otto Nagel: "N. Berlin. O. Nagel lives there and has known it since he was a boy. A factory worker, frail, not educated in art school using plaster heads and models selected by the state— the misery he saw and still sees made him a painter and he indicts. Everything dark, dull, grey—even the wooden picture frame grey, poor. And yet, I saw some cheerful colour, the red grease colouring the lips of the little, stunted, sixteen-year-old street prostitute.—Red?"[95]

This brand of Verism inherited Expressionism's activism, combining it in a new manner with social reality, but another brand of Verist painting gained considerable influence in Germany for a spell and became quite the fashion from around 1923: New Objectivity (*Neue Sachlichkeit*). The term was invented by art historian Gustav Friedrich Hartlaub. In 1925 Franz Roh called this recent art

"magic realism" and drew up the following table of comparisons between Expressionism and New Objectivity in painting:

Ecstatic objects	Sober objects
Represses subject	Illuminates subject
Stimulates	Penetrates deeper
Dissipated	Rather strict, purist
Dynamic	Static
Warm	Cool to cold
Admits indications of labour (fragmentary)	Erases all traces of labour (pure objectification)
Expressive deformation of subjects	Harmonious cleansing of subjects[96]

The spectator seemed to be confronted by an impartial, objective, sober depiction of reality beyond human control. Nature, people, things and settings seemed to have been placed into a test tube, a vacuum. Not a single trace of activism remained. This New Objectivity ended as helplessness, or even pessimism.

The artists chose their methods accordingly. There was a rediscovery of Classicism which is found in Alexander Kanoldt or Georg Schrimpf. Time appears to stand still, and there is utter stasis in the industrial landscapes devoid of human life painted by Carl Grossberg and Franz Radziwill, or in the portraits by Anton Räderscheidt and Carlo Mense. Ernst Thoms, the Hanover painter, summed up the creed: "We painted from the outside inwards."[97] The apparent objectivity was matched by a clearly visible detachment from reality.

This art owed its tremendous impact in part to developments in the post-inflationary period. "Objectivity" and "New Objectivity" were catchwords which were intended to express the rapid inroads which technology was making on life and the increasing socialization of production. The paintings of Kanoldt, Schad and Räderscheidt reflected these new attitudes.

The first national exhibition of New Objectivity, which opened at the Städtische Kunsthalle in Mannheim in 1925, was a great success. Hartlaub organized the display of 124 paintings by 32 artists, which had toured almost all German cities by 1927.

By around 1930 New Objectivity was on the wane. The crisis now looming called for quite different artistic methods.

There were dubious honours for New Objectivity during the early years of Nazi rule. The paintings were displayed until 1936 under the proud new nationalistic label of "New German Romanticism", but then they, too, were discarded as "degenerate".

So far we have considered identifiable currents within the fine arts in Germany—Verism, Tendentious Art, New Objectivity—but the picture would not be complete without mentioning a number of outstanding individuals. Neither Max Beckmann in Frankfurt am Main nor Emil Nolde in the north of the country can be allocated to one single group, as their work was marked by some variety. The same applies to Oskar Kokoschka, who spent most of the years from 1924 to 1931 on protracted foreign journeys. Leading exponents of older schools also continued to paint well into the twenties and their opinions counted on the Weimar arts scene. Max Liebermann and Lovis Corinth (d. 1925) never renounced Impressionism, while Max Pechstein and Erich Heckel remained dyed-in-the-wool Expressionists for all their stylistic shifts.

Ernst Barlach of Güstrow has a place all of his own. He was a deeply religious artist and was exposed long before 1933 to particularly venomous attacks from the right. The reason for this was that Barlach designed a number of memorials to the victims of the First World War which were diametrically opposed in inspiration to the glorification of war inherent in the Nazi creed. The paramilitary Stahlhelm, which itself was founded in Magdeburg, launched a campaign against his wooden memorial for Magdeburg Cathedral. When Barlach produced the draft for his Hamburg memorial in the winter of 1930, military hysteria had reached a peak with a ban on the American film version of Remarque's *All Quiet on the Western Front*. The *Berliner Tageblatt* reported on 24 December 1930: "There is a thread of the blackest cultural reaction which leads from the ban imposed on a film which gives a fairly realistic picture of war in all its horror straight to the suspicion and insult heaped on a monument which does not yet exist. The onslaught on Barlach's artistic outline is

being led by the German National newspaper *Hamburger Nachrichten*, which outstrips even the National Socialists in its level of opinion. The spokesman for these elements . . . has spotted an 'association with the Hamitic type' in Barlach's design. There is no need to formulate the covert implications of such so-called 'artistic' criticism in words, as they come over loud and clear of their own accord from this travesty of thought."

Barlach's memorials were removed immediately after 30 January 1933. But the first Nazi to assume a ministerial post in Germany was Wilhelm Frick, when he became Minister of Culture in Thuringia in 1930. One of his first moves on taking office was to "cleanse" Weimar's art collections in late September. Paintings by Klee and Kandinsky were banished—initially at least—into the depot, while murals by Oskar Schlemmer on the stairway of the former Bauhaus were covered up with whitewash. "The right has won the political battle in Germany," wrote Schlemmer with resignation.[98]

Klee, Kandinsky and Schlemmer had joined the Bauhaus as painters from 1919 onwards and had played a big part in the emergence of what is regarded today, under the blanket term of Functionalism, as one of the progressive traditions established in the Weimar Republic.

Its roots go back to about 1910, when Constructivism was born as an international art movement, at first in painting, in response to the growing socialization of material production. Kasimir Malevich in Russia, Piet Mondrian in Holland and France and Paul Klee in Germany were all searching for rudimentary compositional values. They discovered basic shapes such as the circle, square, cube and line in a new way and assigned them to primary colours.

Adornment was discarded for all time, for there was nothing superfluous in Constructivism. Chance was eliminated, and the aim was economic, rational design. This return to elementary principles was accompanied by a new definition of function. The Constructivists left the hermetic world of art behind them and entered the open domain of material life: "Activity which once lay outside of life . . . must be transferred into the field of reality and justify itself by solving practical tasks."[99]

In this sense Constructivism cannot be regarded as one artistic -ism among many; it was, rather, an all-embracing aesthetic approach which applied to painting and architecture as much as to handicrafts or film. Karin Hirdina calls it an "attempt to find and formulate elementary means of expression which would permit . . . a comprehensive synthesis of all structural disciplines. That is the core of the Constructivists' actual designs and of their model creations."[100]

In Germany it was mainly those fine artists associated with the Bauhaus and the German Craft League who applied the tools of Constructivism to the day-to-day human environment, achieving both a new approach to design and a new functionality derived from this social connexion. It is no coincidence that most of this activity focused on architecture. A fresh approach was overdue, not only because of the serious housing problem in Germany and the legacy of sunless tenements which had sprouted in the late 19th century, but also because technology was advancing so rapidly and posing the challenge of new materials and building methods (steel skeleton construction, cast concrete slabs, glass frontage).

When the Bauhaus, or State Building Centre, was founded in Weimar in April 1919, the manifesto declared its new aim: "The Bauhaus will seek . . . to reunite all artistic craft disciplines—sculpture, painting, decorative art, and handicraft—as inseparable components of a new architecture."[101] The title page of the manifesto showed Feininger's woodcut *Kathedrale des Sozialismus* (Cathedral of Socialism), an exuberant structure which seems just as Utopian as some of the aims formulated in this initial document, such as the call for "great structure", the large-scale total work of art.

The early years at the Weimar Bauhaus were marked by search and experiment on virgin territory. The objectives were both artistic and educational. The "masters" working under Director Walter Gropius were: Lyonel Feininger (until 1925), Johannes Itten (until 1923), Vassily Kandinsky (until 1933), Paul Klee (until 1931), Gerhard Marcks (until 1925), Adolf Meyer (until 1925) and Georg Muche (until 1927). They were joined in 1923 by Oskar Schlemmer (until 1929) and Laszlo Moholy-Nagy (until 1928).

49/50 Architect Erich Mendelsohn built the Einstein Tower in Potsdam during 1920/21 for the well-known scientific researcher. The bold design, which bears late traces of Expressionism, came to symbolize new-style architecture in the early twenties. Mendelsohn's sketch of 1920, and above it the building as it stands today.

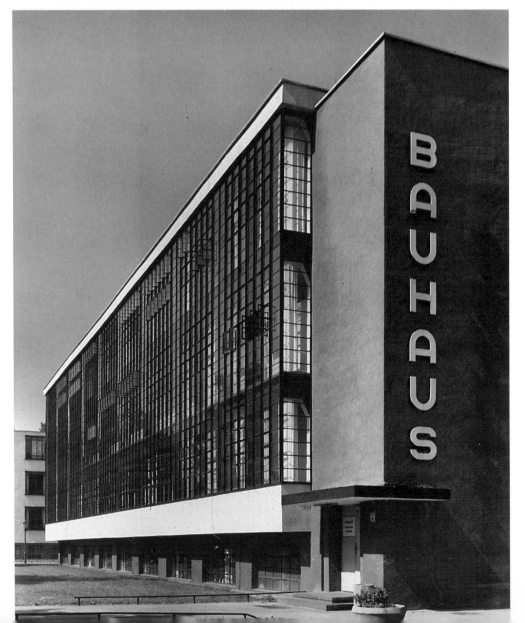

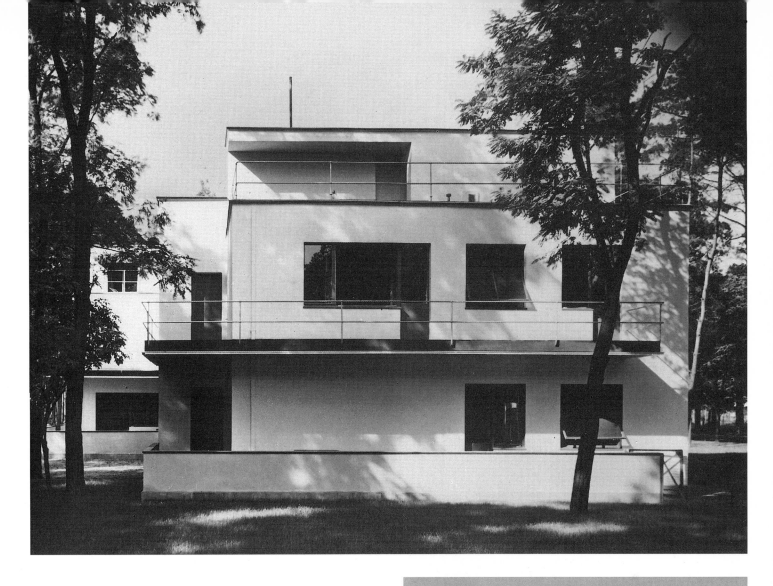

Left:
51 Members of the Bauhaus staff in the corridor between the workshops and the school on the day the building was opened. (Left to right: Vassily Kandinsky, his wife Nina, Georg Muche, Paul Klee and Walter Gropius.)

52 After the Bauhaus was forced to leave Weimar, it settled in Dessau in 1926, and this town became the centre of Functionalism in Germany. The building, designed by Walter Gropius, was ceremonially opened on 4 December. The centre was restored to its original condition in 1976.

53 Three twin households were built near the Centre in 1926 as accommodation for the staff. These were also designed by Gropius.

54 Household objects were designed in the Bauhaus workshops according to functional criteria, and then produced in conjunction with industry. Marcel Breuer designed this chair in 1927.

55　Erich Mendelsohn created boldly curving façades of glass and steel for new department stores which the Schocken chain built in Berlin, Chemnitz, Breslau and Stuttgart. The Kaufhaus Schocken in Stuttgart went up in 1926. It was restored to its original form in the fifties after severe war damage.

Right:
56　The Weissenhof Estate in Stuttgart, a model of functional architecture, was built for the Craft League exhibition in 1927. The latest technical and aesthetic standards were applied to both the terraced buildings in the background and the detached houses in front. This was an international project involving German, French and Dutch architects, including Le Corbusier, Stam, Gropius, Mendelsohn, Taut and Mies van der Rohe.

57　The Horseshoe Estate in Britz, in the south of Berlin, was one of a number of new, functional community projects aimed at meeting the mass demand for housing while offering something better, aesthetically and above all socially, than the conventional tenement. The estate was built in 1926/27 according to plans by Bruno Taut and Martin Wagner.

UPTON
SINCLAIR

LEIDWEG
DER
LIEBE

Left:
58 During the twenties John Heartfield set the tone for a new approach to book presentation, incorporating features of photomontage in his cover designs for the publishers Malik. His famous design for Upton Sinclair's novel *The Rose and the Forceps*, dates from 1930.

59 Bauhaus artists designed a number of Functionalist stage sets for productions at the Kroll-Oper. This was Oskar Schlemmer's creation for Arnold Schönberg's *Die glückliche Hand* (The Lucky Hand), 1930, produced by Arthur Maria Rabenalt under the musical directorship of Otto Klemperer. Theatre Institute, Cologne University

60 Bertolt Brecht and Kurt Weill owed their breakthrough on the stage of the Weimar Republic to *Die Dreigroschenoper* (Threepenny Opera). The première at the Theater am Schiffbauerdamm in Berlin on 31 August 1928 was followed by productions in many German towns until 1932. This sketch for the Berlin première is by Caspar Neher, a friend of Brecht's since their youth, who was one of Germany's major stage designers. The indistinct watercolour technique is typical of his sketches and the projections often used for his sets. Theatre Institute, Cologne University

Following page:
61 Munich comedian Karl Valentin was a favourite with the German cabaret audience. The portrait for the November 1929 programme of Berlin's *Kabarett der Komiker*, which appeared monthly under the name *Die Frechheit* (Cheek), was drawn by Walter Trier, one of the busiest press cartoonists and illustrators of the Weimar Republic, who is probably most famous for his illustrations to Erich Kästner's children's books.

By 1923 the institute had a clear common purpose: the complex design of daily environment. This included anything from the family house to entire estates, from furnishings to everyday utensils. According to the Principles of Bauhaus Production drawn up in 1926: "The Bauhaus seeks to serve developments in housing compatible with our age, from the simple household utensil to the finished house." The Utopian "Cathedral" was no longer the goal; the aim was to cater for real social needs. "The form of an object must be derived from its natural functions and limitations."

These principles could only be put into practice once the Bauhaus had moved to Dessau in 1925. The Weimar centre had been a thorn in the flesh of the right-wing in Thuringia from the outset, and in autumn 1924 the provincial government decided to slash the Bauhaus budget by 50 per cent. Continuing to work in Weimar was out of the question under those circumstances. The Council of Masters agreed to close the Weimar centre by 1 April 1925.

The town of Dessau offered the Bauhaus a new home and money to build an impressive new centre based on plans by Gropius. It was ceremonially opened on 4 December 1926 after taking just over a year to complete. This new Bauhaus with its glass and steel façade was a visual symbol of the new German architecture.

Work resumed on a larger scale. The classrooms and workshops accommodated up to 80 students who were trained as architects and designers. Contracts were signed with manufacturers such as Deutsche Werkstätten in Hellerau to enable the furniture and utensils designed and developed at the Bauhaus to enter industrial production. The centre had its own stage and also created new typefaces and styles of layout which were used for a series of Bauhaus books. But, most important of all, the new principles found architectural applications.

Few projects had been carried out during the Weimar period. They included the Versuchshaus Am Horn in 1923 and Auerbach's House in Jena, which was designed in a private office managed by Gropius alongside the Bauhaus and erected in 1924. Things changed in 1926. Dessau Town Council was willing to make resources available for Gropius and his team. Gropius had already outlined his ideas: "We want to create clear, organic structures which radiate, naked, an internal splendour free from deceits and playful fancies, which affirm our world of machines, wires and fast vehicles, which demonstrate their sense and purpose functionally, by their very own nature, through the tension between their components, and which reject all that is dispensable and merely disguises the absolute form of the construction."[102] There it is again, that technological pathos which we discovered above in El Lissitzky!

Six semi-detached houses for masters and a detached house for the director were built that same year not far from the Bauhaus, and the first building in Dessau to be constructed from a steel skeleton was also finished in 1926. The first big public building to be completed was the Employment Exchange (1927–1929). But the most important accomplishment of all was the estate in the Törten district of Dessau under construction from 1926 to 1929, which provided 316 homes. The estate consisted of two-storey terraced houses set out in rings around a four-storey highlight with annexed shops. The houses were composed according to a cubic principle. Sloping roofs were discarded and all the usual external adornment was dispensed with. The stark outlines of the windows offered a further structural division. But these external innovations were less important than the interior partitions. Each dwelling contained two semi-open-plan living rooms, a bedroom, kitchen, bathroom and toilet. Each house had its own laundry, which was shared by the two families who lived there, and behind each house was a garden. This was an enormous improvement on the jungle of tenements where most of the factory and office workers employed by Junkers who moved to Törten had lived previously.

During a conversation in 1983, over fifty years after he moved into the estate, one of the original residents, still in occupation at 5, Kleinring, recalled how much it had meant to him and his young wife and child to leave their dimly lit rear tenement (water and drain in the hallway, waterless toilet down one flight of stairs shared by four flats, and no children allowed to play in the dirty yard) for the new maisonette on the Gropius estate, which he had

helped to pay for by instalment as a member of a housing co-operative.

He also described the vociferous attacks on Gropius and the Bauhaus with which the Nazis and German Nationals in Dessau had greeted the ceremonial opening of the estate in 1929. The houses had been labelled as "Moroccan huts" and "Negro settlement", especially because "German roofs" were lacking.

Gropius himself had actually left the Bauhaus in April 1928 to devote his energies totally to his private architect's office in Berlin. He was replaced by the Swiss architect Hannes Meyer, whose motto for the Bauhaus was "cater for the people, not for luxury". Links with the building trade and with industry were strengthened. The Bauhaus absorbed some of the politics of the revolutionary labour movement and the students founded a branch of the KPD. This prompted the right wing to step up the attack, and Hannes Meyer was dismissed without notice in the summer of 1930 for "political reasons". He left for the Soviet Union with some of his pupils. He was succeeded as Director by Ludwig Mies van der Rohe. In the meantime, however, political supremacy had changed hands on Dessau Town Council and in the Provincial Parliament of Anhalt-Dessau. Reaction was on the march, and on 22 August 1932 the Council adopted a motion put by the NSDAP calling for closure of the Bauhaus. The Communists voted against and the Social Democrats abstained. The teaching staff were sacked and the building shut down on 1 October 1932.

Mies van der Rohe wanted to save the Bauhaus by running it as a private institute. Work resumed in November in an empty factory in the Berlin borough of Steglitz, but only eight months had passed before the Nazis closed the Bauhaus definitively in July 1933.

The ambitious Bauhaus experiment had lasted fourteen years, developing the concept of Functionalism in many fields in the course of its increasing commitment to socially relevant activities and managing in some cases to put these ideas into practice. Both the ideas and the practical results made a big impact on Germany. Radical change affected all aspects of building, from housing via public works to industrial plant. Architects such as Hans

Left:
Left:
This advertisement of 1928 is an example of the new typography used by publicity designers. It is a clear illustration of the geometric shapes borrowed from Constructivist art.

Walter Gropius turns his talents to cars: his design for the Adler Cabriolet in 1930.

The Workers' Press Pavilion designed for the Cologne Pressa Exhibition by architect Fritz Schumacher displayed newspapers, magazines and pamphlets published by the SPD and the trade unions.

One of the best-designed modern cinemas was Erich Mendelsohn's Universum-Lichtspiele on Berlin's Kurfürstendamm with 1,800 seats. The long structure with its semi-circular entrance and foyer combined functional and aesthetic considerations. The photo, taken shortly before it opened in 1929, shows the large complex of as yet untenanted shops and flats around it with plenty of space left for neon signs.

Poelzig, Erich Mendelsohn, Ludwig Hilberseimer, Peter Behrens, Bruno Taut and the Luckhardt brothers championed the new methods. As the cities grew, town planning issues carried more and more weight. It is to the credit of progressive planners such as Ernst May (Frankfurt am Main), Bruno Taut (Magdeburg) and Martin Wagner (Berlin), who were often obliged to wrestle tenaciously with conservative council majorities, that public finance was made available for housing construction and that leading architects of the new school were commissioned to design estates. A number of communities were born in this manner from 1926 onwards. In Berlin there

were the Gehag Estate in Britz (also known as the Horse-shoe Estate) whose architects were Taut and Wagner, the Woga Estate designed by Erich Mendelsohn, the Gagfah Estate in Zehlendorf designed by Hans Poelzig (all of them named after the initials of the respective housing co-operatives) and the Siemensstadt Estate. Other models of the new social community were the Bruchfeldstrasse in Frankfurt am Main and the Rundling Estate, a widely ac-claimed, circular development in the Lössnig district of Leipzig. Berlin offers a good example of the magnitude and limitations of this work. About 100,000 new dwellings were built there between 1925 and 1931, about one fifth of these in communities on completely new sites. How-ever, compared with the most urgent overall needs, this was only a fraction of the capital's real requirements. In an interview for the magazine *Das neue Berlin* which, like *Das neue Frankfurt*, reported on town planning, architec-ture and art in the city, Wagner, the venerable Council Spokesman for Building, admitted in March 1929 that about 200,000 homes were needed in the city to alleviate the worst need, and that this would mean constructing 70,000 dwellings per year. When asked whether he con-sidered this at all feasible, Wagner answered unambigu-ously: "No, I don't believe it is." Public resources were li-mited, while private entrepreneurs would not be able to rake in anything like the same profits from community housing projects as they could from a traditional tenement block. The social impact which these new communities actually made can be seen from the fact that about 80,000 people had received a home on one of the Berlin estates by the end of 1931, while almost two million people con-tinued to live in unacceptable conditions.

These estates really did cater for the people's needs, but at the same time Functionalist architects could not resist responding to the luxury needs of the grand bour-geoisie. Their own private villas (such as Mendelsohn's Haus am Rupenhorn in Grunewald, Berlin) and the many luxury homes which they designed for industrialists, bankers and businessmen demonstrate that, in spite of all the good intentions, the new architecture was not im-mune to the lure of capital. The illustrated accounts (Mosse even published a book on Mendelsohn's villa!)

show that there is no comparison between these spa-cious houses and the little dwellings in Törten or Britz. And yet as far as the basic principle of functional architec-ture is concerned, the same features dominate: clarity, linearity, frequent use of the cube, renunciation of orna-ment and useless trappings.

The proliferation of detached houses as a form of dwell-ing owed much to Bruno Taut and the Luckhardt brothers, culminating in the Craft League Exhibition in Stuttgart in 1927. Each year the association devoted its big show to a specific theme, and in 1927 it was the turn of the detached home. The Weissenhof Estate, an assembly of about 30 family houses and villas, was built especially for this exhi-bition as a model of functional architecture. The venture also demonstrated that the new trends bore international weight, for there were French and Dutch architects, in-cluding Le Corbusier and Mart Stam, on the team.

In the field of public facilities, it was the palatial new cin-emas which attracted the limelight. Berlin acquired the Universum-Lichtspiele, the Capitol and the Titania-Palast, and similar buildings designed according to functional demands, particularly inside, appeared in most cities. Here, too, the principles were clarity of line, a rejection of useless decoration, and novel techniques of indirect lighting.

The new design even infected the commercial and in-dustrial sectors. Mendelsohn built a number of depart-ment stores with imposing glass and steel façades for the Schocken chain while Poelzig created new offices in Frankfurt am Main for IG Farben, the most striking feature being the gigantic laboratory department with its novel glass roof and indirect interior lighting. Poelzig also de-signed the new radio headquarters in Berlin's Masuren-allee.

The Nazis did their utmost to express disparaging re-marks about these new structures even before they were completed. A book called *Die Architektur im Dritten Reich* (Architecture in the Third Reich) was published in Stuttgart in 1930, in which a certain Herr Straub argued: "They claim that 'modern architecture is able to interchange horizontal and vertical elements'. Surely that is an open declaration of bankruptcy on the part of a current which

ends in chaos. All the eternal laws of building which have been valid up until now are thereby stood on their head . . . It will be left to an organic development championed by the architects of the Third Reich to put a halt to the unhealthy exaggerations of an objectivity which has toppled over the brink and to restore this nonsense to true sense."[103]

We know now where this was to lead: to those "Germanic" estates with their steeply sloping roofs, and to the monumentalism of Albert Speer.

These developments broke off abruptly in 1933 and were continued outside Germany. Gropius, Mies van der Rohe and Mendelsohn headed the long list of eminent architects who chose to emigrate. In Dessau, however, the residents of the Törten Estate were compelled by the Nazis under threat of violence to carry out certain alterations to their homes. Only one building in the entire community has been preserved in its original form.

The German city centres were dominated by brightly lit office blocks and shop windows in the American style. New neon advertisements were installed to lure the customers, drawing attention to the latest fashions and electrical household gadgets on display beneath glaring frontage lights. In 1929 Berlin played host to an International Advertisement Conference, at which publicity experts from the United States and Europe gathered to discuss new advertising methods. The latest idea was suggestivity, and the magic recipe was the familiar brand symbol, the firm logo which would appear on everything from letter headings to press inserts. Big companies made use of typographical innovations for their publicity material. El Lissitzky designed printed material for the Hanoverian office supplies firm Pelikan, while Bauhaus artists produced the sales catalogues for Junkers in Dessau. The shapes so popular with the Constructivists—lines, cubes, circles—were frequently found on adverts from 1926. A series of advertisements by the prestige Berlin printers Otto von Holten used the slogans: asymmetry, function, standardization, contrast, dynamism, beauty.

The halls and pavilions designed by leading Functionalists came into their own at national and international exhibitions. Soviet influence was particularly strong in this field. It began with the International Art Exhibition in

Dresden in 1926. El Lissitzky had set up two rooms to demonstrate Constructivist art, displaying works by Mondrian, Léger, Picabia and others in a new manner. Their pictures radiated a more vital intensity set against walls divided into cassettes and capriciously painted in three colours. The viewer was unable to see everything at once, for the paintings appeared and disappeared behind metal screens as she or he walked. The room itself was alive. Lissitzky: "The objects in my room were not all going to bombard the viewer at once. If he is accustomed to being lulled into a certain passivity as he moves along the walls of pictures, our design is intended to make a man active."[104] Lissitzky applied this same activist inspiration to the Soviet Printing Exhibition in Moscow in 1927, after which the Soviet government entrusted him with his first big international task by appointing Lissitzky Director of the Soviet Pavilion for the Pressa Exhibition in Cologne in May 1928.

This was the most important exhibition of press and publicity which Europe had witnessed to date. Individual pavilions displayed the products of the big media companies (Erich Mendelsohn, for example, designed one for Mosse), and surveyed the party press. (There was an impressive pavilion for publications by the SPD and trade unions.) Foreign periodicals and newspapers were on show at national pavilions set up by various countries. Famous brand names took advantage of the publicity. The coffee bean roaster Haag and chocolate manufacturer Sarotti were among those who built their own advertisement pavilions.

The Soviet Pavilion, which had been designed by a team of 38 artists, contained 227 exhibits, a cross-section from the Soviet press. Visitors were greeted outside by a Constructivist flagstaff. Their gaze was captured in the foyer by a large photographic frieze by Lissitzky and Syenkin under variegated lighting, and then carried forth through the exhibition along transmission belts, optical and mechanical elements at one and the same time, which soared endlessly up into the unbroken space towards the core of the concept. The international press commented on the extraordinary impact which this display made. The Swiss newspaper *Morgen* wrote on 15 June 1928: "One excit-

ing, boldly constructed exhibition is amazing: the Soviet press. Not a single familiar form. Everything perceived and built in a new way. Dizzying, twisting spirals, straps reach for the ceiling, spherical lights flare and fade. One cannot fail to recognize in principle that there is a determination here to achieve a new form and that it is being applied with a rigour of iron."

Lissitzky also broke fresh ground with his contributions to the Soviet displays at the Craft League Exhibition of Film and Photography in Stuttgart in 1929, the International Hygiene Exhibition in Dresden in 1930 (during which the Museum of Hygiene built between 1928 and 1930 was ceremonially opened) and the International Fur Exhibition in Leipzig the same year. Meanwhile, German architects represented their country at international exhibitions in other European countries. Mies van der Rohe, for example, designed the German Pavilion for the World Exhibition in Barcelona in 1930. All these creations were dealt with in detail by the press and inevitably exerted an influence on commercial art, on window dressing, on national exhibitions and on the presentation of industrial products at the biannual Leipzig Trade Fair.

Functionalism in the twenties evolved against a lively background of discussion and experiment involving German and foreign designers alike. The process was not without its one-sided obsessions and its wild goose chases, but all in all those concerned took "function to mean social function . . . The purpose was accepted as a means to develop lifestyles and release energies."[105]

The Bauhaus, the Pressa Exhibition, and estates like the Gehag and Weissenhof were more than accomplishments in architecture and design, for they pointed to the future. Like the committed Tendentious Art that developed alongside it, Functionalism derived its significance from its relevance to actual social processes.

"Cut that sentimental gaping"— Theatre and opera with a social relevance

In 1922 Drei Masken Verlag in Munich published a flimsy edition of Brecht's play *Trommeln in der Nacht* (Drums in the Night). The preamble contained the following recommendations to the producer: "It is a good idea to hang up a few signs in the auditorium with sentences like EVERY MAN IS THE BEST OF HIS NATURE and CUT THAT SENTIMENTAL GAPING."

The première at the Kammerspiele in Munich (September 1922, producer Otto Falckenberg) complied with the playwright's wishes. Brecht's episodes from the November Revolution were played against a stylized setting that was often no more than a suggestion. Expressiveness gave way to sobriety, and operatic pathos was banished from the stage. Actor Rudolf Fernau recalls the original production of *Baal* in Leipzig, which took place a good year later, when he first met Brecht: "New Objectivity. After the seven trials of Expressionism was I now to be presented with an eighth stylistic trial? New Objectivity! I still had no idea what it might mean. Brecht had seen me as Tasso. 'That wasn't Tasso,' he said as he pronounced the sentence of death over me, 'that was an overheated steam engine. You must open all your valves and let off steam. Don't feed all the suggestion in, draw it out from your emotions until you are mentally lucid enough to stand outside the part. Expressionist ecstasy has a lot to answer for. We need New Objectivity up on the stage.' And in conclusion, 'Do you want to come to the cinema with me?'"[106]

It was not only the dramatists, but also the producers who put paid to Expressionist theatre. The conditions were ripe: the court theatres which once catered for the tastes of dukes and princes were now answerable to the state or municipal council and had attracted many capable, committed producers and managers, among them Erich Engel at the Staatstheater in Munich and Alwin Kronacher at the Altes Theater in Leipzig. There were also a number of progressive private theatres such as the Kammerspiele in Hamburg, directed by Erich Ziegel, and in Munich, directed by Otto Falckenberg. The "provinces" were most

In 1928 producer Leopold Jessner (front row, second from left) was on the Board of Examiners for young actors at the Staatliches Schauspielhaus on Berlin's Gendarmenmarkt. Other members were the actors Eduard von Winterstein (behind him on the right) and Ernst Deutsch (next to Jessner).

prolific, as one can judge from the many important premières of contemporary plays from about 1922 onwards which took place outside Berlin.

But Berlin was the indisputable centre, "the beloved capital of theatre", as Heinrich Mann called it. Thirty theatres opened their doors each evening, and they possessed a magic power which lured writers, actors and producers to the metropolis of the arts from all over the country. The two great magicians of the boards were Max Reinhardt and Leopold Jessner. Jessner and his fellow-producer Jürgen Fehling introduced a modern approach at the Staatliches Schauspielhaus on Gendarmenmarkt: "a repertoire from Sophocles to authors as yet undiscovered, seen through the eyes of our time, felt with the nerves of our time, and presented with the tools of our time!"[107] The stage was cleared of its clutter, and the new attitude to classical works was especially controversial. Hamlet in a shiny black raincoat, Shylock in the latest evening dress, Othello in a kind of crash helmet: the accessories used to bring the "age" to life through the mirror of an old text might have been superficial, but they went hand in hand with something more important, the discovery of modern-day issues in classical plays. Shakespeare, Schiller, Büchner were no longer to be declaimed à la Moissis, but offered to the audience as modern pieces with a relevance pinpointed by production technique and conveyed by new methods of acting. Excesses of facial and bodily expression gave way to an analytical projection of character, while artificial pathos was replaced by clear verbal articulation. Fritz Kortner was an outstanding actor in the Jessner mould. "Richard and Shylock. Kortner saw them both not through Shakespeare's eyes, but through his own, creating them anew from the spirit of our times, and this was his revolutionary feat, an act of reincarnation. Important figures from Kortner's gallery: Mortimer, Franz Moor, Gessler, Hamlet, Danton—none of them men of our day, yet the same

167

process of re-creation occurs in each one, so that we feel we can take immediate possession of them once more."[108]

Classical plays monopolized the repertoire, not only at Jessner's Schauspielhaus, but also at the two theatres under Max Reinhardt, the Deutsches Theater and the Kammerspiele next door. By this time Reinhardt's reputation as a "theatrical magician" was well established, so that he was frequently on lengthy tours between 1924 and 1929 and more likely to be found in Vienna or New York than Berlin. Heinz Hilpert and Erich Engel (who had arrived from Munich in 1925) took charge of productions during his absence. But whenever the master returned to Berlin, his plays were always a great experience. Under Reinhardt everything was subordinate to the individuality of the actor. While Jessner's production was primarily geared to the play and the ideas he was trying to convey, Reinhardt basically produced his actors: Helene Thimig, Elisabeth Bergner, Werner Krauss and Ernst Deutsch. "No other Berlin theatre enjoys this colourful wealth of players. Few companies are able to display their members so thankfully, to fill minor parts so fruitfully," wrote one critic. The actress Mathilde Danegger has recalled Reinhardt: "He was wonderful at rehearsals. He loved his actors. He always laughed if an actor did anything funny. He composed his productions right the way through. Reinhardt was a composer."[109]

Victor Barnowsky, who ran the Theater an der Königgrätzer Strasse, was another entrepreneur with ambitious standards, whereas the Rotter brothers staked their investments primarily on entertainment. When manager Oskar Kanehl, who was responsible for the repertoire at the Rotters' Lessing-Theater, shot himself in 1925, he left a letter for his employers recommending a fellow-student from his university days in Heidelberg as his successor. The man's name was Dr Joseph Goebbels. His first attempt to find a job in Berlin had already failed. In 1924 the *Berliner Tageblatt* had turned down his application for an editorial post. The Rotter brothers did not take him on either. His third attempt at conquering Berlin ended successfully two years later, this time in the brown shirt of a Nazi Gauleiter.

Fritz Kortner appeared at Jessner's Schauspielhaus in 1929. He is seen here with actor Veit Harlan (right) who took on the direction of the anti-Semitic film *Jud Süss* during the Nazi years.

Right:
The listings for May 1927 show that Max Reinhardt's Kammerspiele was running Klaus Mann's *Revue zu Vieren* (Foursome Revue). The author took to the boards in person along with his sister Erika and brother-in-law Gustaf Gründgens. There was no friction between them at the time. A few years later Erika Mann left Gründgens and went into exile with her brother. Klaus Mann published his *roman à clef Mephisto* in 1936. The central character, Hendrik Höfgen, bore unmistakable features of Gustaf Gründgens.

Two unusual talents on the German stage: Lotte Lenya was known internationally for her rendering of songs by Brecht and Weill, and the sensitive Peter Lorre won fame for his portrayal of a pathological child murderer in Fritz Lang's first sound film *M*. Both of them emigrated in 1933 and eventually made their names in the United States. The photo shows Lenya and Lorre in 1929 in Wedekind's *Frühlings Erwachen* (Spring Awakening), produced by Karlheinz Martin at the Volksbühne on the Bülowplatz.

The Berlin Volksbühne owed its broad influence to its organized membership. But although it had started out with the genuine aim of educating the masses, it became more and more reformist as the twenties went by, taking refuge from contemporary problems in non-committal productions and recruiting its members predominantly from the petty bourgeoisie. It was not, however, until 1927 that the internal row was forced out into the open and became a public talking point.

The period of stabilization inevitably affected the work of the theatres. Sponsors could now be found again to invest their money even in the more adventurous artistic undertakings. Playwright Marieluise Fleisser of Munich tells how her first work *Fegefeuer in Ingolstadt* (Purgatory in Ingolstadt) came to be staged in 1926: "There was this man in Berlin who could do magic. He had created some machinery from nothing, I mean from almost no money at all. He called it 'Junge Bühne', the young theatre, and this man only managed to do it because he knew the actors and the rich people. He ran round from one to the next, and they acted for him or gave him money. He used the money to buy a proper big theatre for one Sunday morning, the public poured in, and the press got a seat and started people talking about the actors and the author. They wrote about you, in Berlin that was worth its weight in gold."[110]

Moritz Seeler's Junge Bühne was only one among many outlets for playwrights and actors to try their luck. The new Contemporary Theatre went on trial in the morn-

ings or late at night, often meeting vehement resistance from the theatre owners themselves. Herbert Jhering reports how Moritz Seeler punched house manager Kanehl in the stalls because he tried to disrupt a performance of Arnolt Bronnen's play *Exzesse* (Excess) put on by the Junge Bühne at the Lessing-Theater.

Arnolt Bronnen was one of the young playwrights. He attracted public attention along with Brecht, Fleisser and Ferdinand Bruckner. In these new plays, life in the twenties was presented objectively, often with recourse to theatrical montage. Bronnen's *Anarchie in Sillian* (Anarchy in Sillian) was about the conflicts at a new electric power station, Fleisser's *Fegefeuer in Ingolstadt* portrayed a small town in Bavaria, Bruckner's *Verbrecher* (Criminals) attempted to offer a simultaneous account of life in a Berlin tenement as a microcosm of society in 1928.

Plays which attacked the notorious Paragraph 218, which made abortion illegal, were also successful. The most popular of these were Friedrich Wolf's *Cyankali* (Cyanide) and Hans J. Rehfisch's *Der Frauenarzt* (The Gynaecologist).

It was another millionaire patron who ultimately gave Berlin's third "great" producer a chance to continue his work in 1927. When actress Tilla Durieux asked her current husband, the industrialist Ludwig Katzenellenbogen, to support Erwin Piscator, he was only too glad to help. Piscator opened his first theatre on Nollendorfplatz on 3 September 1927 with Toller's *Hoppla, wir leben* (Whoops, We Are Alive). This was the beginning of an experiment in theatre which was to become one of the most far-reaching cultural ventures in the Weimar Republic.

After working with his Proletarian Theatre, Piscator had taken a job as producer at the Volksbühne in 1923. His

production of Schiller's *Die Räuber* (The Robbers) at Jessner's Schauspielhaus in 1926 was the most controversial stage event in Berlin. Piscator produced Schiller's early play as a sharp attack on militarism set in the First World War. The robbers were dressed in the faded grey of the Imperial army, the Bohemian Forest was lit-

tered with barbed wire and trenches, while Spiegelberg, wearing Trotski's mask, was promoted to the centre of the action, which ran simultaneously on two levels.

When Piscator staged Ehm Welk's *Gewitter über Gottland* (Storm over Gotland) at the Volksbühne in 1927, his political approach sparked off the row which had long been festering beneath the surface. Piscator left the Volksbühne to open his own theatre in the autumn of 1927. He set his sights high: at a political and technological renewal of the stage. "Whereas at most theatres politics permeate inwards from the periphery, at ours politics are the creative centre." And: "Burst the confined space beneath the proscenium arch, open it up into four-dimensional theatre with film as a living backdrop . . ., projection as a semi-solid backdrop. The stage itself will be movable both as a whole and in all its parts, however small."[111]

Erwin Piscator's theatre was based on the team principle. Playwrights, managers, backstage staff, actors, musicians and producers worked together closely. It was a meeting-place for Brecht and Heartfield, Weill and Eisler, Toller and Mehring. The very choice of plays betrayed the commitment that went into this political theatre. Toller's *Hoppla, wir leben* was followed by a stage version of Hašek's *Good Soldier Schweik*; Leo Lania's *Konjunktur* (Boom) branded the politics of the big oil companies; there were political plays by Franz Jung and Erich Mühsam. The cost of these expensive productions was so high that Piscator went bankrupt in June 1928. After the compulsory break of over a year he opened his second theatre in September 1929 with Mehring's *Der Kaufmann von Berlin* (The Merchant of Berlin), but the venture closed again before the year was out.

Piscator's brand of political theatre was an important innovation, and theatrical Functionalism in the very best sense, with its blend of art and technology, its novel structures and apparatus, and its use of film, music and projection. Nevertheless, most of his audience were bourgeois, and although they registered the technical novelties with interest they bitterly opposed his politics. This distorted relationship between the programme and the public created numerous obstacles and harassment against which Piscator was constantly obliged to defend himself. It was not until 1930 that his theatre underwent a genuine change in function with the formation of a collective. His plays were now presented to a working-class audience, and Piscator made the move from political theatre to revolutionary proletarian theatre. Commenting on the new quality of Contemporary Theatre thus achieved, Piscator wrote: "Formulating contemporary problems dramatically for the stage so that the spectator experiences their total dynamics calls for different laws of style, in fact those new dramatic methods which are the tools of political theatre and which can no longer be isolated from it. People can reject them and declare a conscious preference for the old theatre, but they cannot simply pass over them with a nod in the direction of a new age. Basically it is a good thing that this rift in the Contemporary Theatre movement has become such a yawning abyss and that so many fellow-travellers have fallen by the wayside."[112]

One person to voice unreserved acknowledgement for Piscator's idea of theatre was Bertolt Brecht. He drew on Piscator for his theory of epic theatre, which he was working on at about this time, and carried the producer's experiments further.

Towards the end of 1929 the Nazis launched their own theatre venture in Berlin, the NS-Volksbühne, renting a stage for four evenings a month. Significantly enough they opened at the Wallner-Theater with Schiller's *Die*

Karl Arnold's cartoon of the production *Hoppla, wir leben* summed up the plight of Erwin Piscator's Political Theatre: "A fine seat in the box and revolution on the stage. All I can say is: *'Vive la république!'*"

Left:
Erwin Piscator (second from left) rehearsing Toller's *Hoppla, wir leben* in August 1927 with Alexander Granach (left), Paul Graetz, Ernst Toller (right) and at the rear stage designer Traugott Müller.

Räuber. They countered Piscator's anti-war production of 1926—which the enemy never forgot!—with their "new national style", which was defined in the National Socialist theatre bulletin as "form of artistic expression rooted in the German soul". It made such a mediocre impact that the NS-Volksbühne was obliged to transfer to a much smaller theatre in the Klosterstrasse for its second production, the "national play" *Giftgas 506* (Poisonous Gas 506) by Karl Busch.

It stayed in its new home, somewhat obscured from view, until 1933. The great moment for Busch and his like-minded associates was not to come until Goebbels was in a position to order Berlin's leading theatres to toe the line and stage Nazi plays.

The years until 1932 especially in Berlin, saw the heyday, of the stage producer. People rarely mentioned Shakespeare or Schiller: they spoke instead of Jessner's *Hamlet* and Piscator's *Die Räuber*. But it was also a great epoch for actors. One might list at least 50 important names, from the great heroes (Heinrich George or Werner Krauss) via the intellectual type (Gustaf Gründgens, Fritz Kortner) to the great comedians and crowd favourites (Max Pallenberg, Felix Bressart, Paul Graetz). Among the women the spectrum was similar, from Helene Thimig and Käthe Dorsch via Elisabeth Bergner to Lucie Höflich and Adele Sandrock.

We have seen how stage plays after 1923 were influenced by the times. In the field of opera, meanwhile, the transformation was almost startling. The main reason for this was the new trends in music. Music drama could not be immune to the changes ushered in with the 20th century, the fascinating sound of perforated tonality in, for example, Gustav Mahler's work, which led ultimately to Arnold Schönberg's harmonic theory as it appeared in 1911, when tonality was renounced altogether. The Wagnerian constraints were to be thrown off at last. Ferruccio Busoni and, a little later, Igor Stravinsky influenced subsequent developments in Europe from Italy and France.

It was Alban Berg, the leading exponent of the Vienna School, who introduced these ideas to Germany. In 1922 he announced that he had completed an opera based on a work by Büchner. It was considered unstageable, and over three years passed by before Erich Kleiber managed to organize the première at the Berlin Staatsoper in December 1925.

Wozzeck was the ultimate challenge to opera as a genre, not only in the musical sense, with its absolute refusal to set up a harmonic totality, its stimulating polytonality, its "incredible wealth of dramatic music" (Reich), but also because of its social opposition. Berg had taken Büchner's fragmentary scenes about that "poor dog" Woyzeck and turned them into an epic, three-act libretto. It was nearly four years before another theatre ventured a production, but then Berg's opera gained triumphant acceptance with the unusually high account of 17 productions from 1929 to 1932.

Paul Hindemith's *Cardillac* was just as significant, although its musical structure was quite different. Fritz Busch staged the première in Dresden in 1926.

These pioneering attempts to renew the genre were, however, the exception until 1926, when Contemporary Opera assailed the German houses with a vengeance as young composers sought to convey those external phenomena of everyday life so dear to New Objectivity and so universally in fashion on the operatic stage. Anything which caught people's imagination was now fair game for opera: technology in *Maschinist Hopkins* (Machine-Minder Hopkins) by Max Brand, boxing in *Schwergewicht oder die Ehre der Nation* (Heavyweight: The Nation's Honour) by Ernst Krenek, the new ocean-liners in *Transatlantic* by George Antheil, cinema in *Achtung, Aufnahme!* (Action, Camera!) by Wilhelm Grosz, radio in *Malpopita* by Walter Goehr, modern luxury hotels in *Royal Palace* by Kurt Weill and the more tolerant attitude to love and marriage in *Neues vom Tage* (Today's News) by Paul Hindemith. The crowds thronged to see these Contemporary Operas just as they thronged to see paintings of New Objectivity. Yet Alban Berg recognized the dangers inherent in this purely external modernity: "Using the latest devices such as cinema, variety and jazz simply ensures that a work like this reflects its times. But I doubt if we can call that real progress. If we want to claim that opera has developed as an art form, we surely need to do more than merely incorporate the latest achievements and everything which happens to be popular at the moment."[113] The best example of this confusion between success and innovation was Ernst Krenek's *Jonny spielt auf* (Johnny Strikes up the Band), which made a sensational impact between 1927 and 1931. Having been announced as a "jazz opera" and staged for the first time in Leipzig in 1927, it was played at almost every opera house in Germany and even Europe.

The story of the black jazz violinist Johnny, who fights the white composer Max for the favours of singer Anita in a conventional eternal triangle, betrays an embarrassing similarity to that of Hollywood's Singing Fool in make-up, Al Jolson. Musically speaking Krenek dished up a potpourri of d'Albert, Puccini and Abraham. The fact that Johnny

Free dance blossomed in the Weimar years, fascinating a wide audience with its new forms and movements. Gret Palucca, performing one of her legendary leaps in 1926, was one of the leading lights of this new kind of expression.

Right:
This snapshot, taken at a party in Dresden to celebrate Mary Wigman's ten years in the profession in 1929, has brought together almost all the leading proponents of free dance in the twenties. Left to right (standing): Trude Engelhardt, Grete Wallmann, Vera Skoronel, Gret Palucca, Yvonne Georgi; (seated): Elisabeth Wigman, Mary Wigman, Berthe Trümpy, Hanya Holm. At the front: Harald Kreutzberg and Yella Schirmer.

plays the fiddle is typical of the basic blunder, as jazz had not yet discovered the instrument. Besides, it was not jazz which the audience saw and heard, but what masqueraded as jazz in German hotel foyers around 1927. "For all the cars and railway engines on the stage nothing of our times," wrote one of the few perceptive critics—Hanns Eisler.

One composer who did know how to absorb the musical impulse from jazz was Kurt Weill, who was deeply influenced by Igor Stravinsky and his *L'Histoire du Soldat* (1918). Weill had been a pupil of Busoni and was thus exposed to his new ideas at an early stage, especially the breakdown of a "total" composition into a series of separate musical numbers. Weill's collaboration with writers like Georg Kaiser and above all Bertolt Brecht led to the decisive renewal in opera during the Weimar Republic.

"Real innovations attack foundations," Brecht had observed. The foundations of opera lay in its existence as a bourgeois institution and its function in creating appetizing delights. Anyone who genuinely wanted to revolutionize this institution would first have to leave it. It was no accident that Brecht and Weill wrote the song play *Mahagonny* (1927) and the *Dreigroschenoper* (Threepenny Opera) (1928) for stage actors. Even if the tremendous success of the *Dreigroschenoper* was based on a misconception—the very people who were supposed to come under fire sat in the stalls and lapped it up!—something crucial had happened. These works dismantled the operatic institution and even denounced it by reducing its worth to threepence. Brecht's set served this purpose as much as Weill's music. The operatic pathos was exploited to expose patterns of bourgeois behaviour which had always been well disguised on the musical stage. Twisted,

deliberately misplaced chords highlighted all that was squalid as vividly as did the visual world of beggars, whores and thieves. The style of Weill's songs was completely new: the score had absorbed various elements of jazz as well as second-hand snippets from popular dances and hits. The music matched Brecht's text to a 't'. The *Dreigroschenoper* brought a new type of singing to the stage which critic Hans Heinz Stuckenschmidt characterized aptly as "gutter chorals".

The opera *Aufstieg und Fall der Stadt Mahagonny* (The Rise and Fall of the Town of Mahagonny) took almost three years to complete. The fruit of this labour was the theory of epic opera (an approach to the musical stage which pointed far into the future), and the most crucial practical accomplishment in operatic renewal in the period up until 1933. Weill: "If it is beyond the powers of opera to open up the Contemporary Theatre, then we shall have to prise it open."[114] That was the rigorous achievement of *Mahagonny*. Kurt Weill had already made various attempts at bursting the confines of this ponderous genre (one-act operas, chamber operas, plays with music, opera for schools, didactic plays), but this time he drew upon all the musical conventions of opera, from the overture via the aria and the ensemble to the grand finale, with the aim of redefining their function. Theodor W. Adorno summarized the intentions of Brecht and Weill accurately when he wrote: "The bourgeois world is shown at the moment of horror to be dead already, and it is completely demolished in the scandal which heralds its past."[115]

The Leipzig première on 9 March 1930 created an artistic and political furore. The audience divided into two clear camps. From that evening onwards, the Nazis denounced Weill in their newspapers.

Naturally there was still room for traditional opera in the Weimar Republic. In fact, it dominated the repertoire. The Italians from Verdi to Puccini were staged as frequently as Wagner. The neo-Wagnerian school flourished alongside the radical innovations of Berg and Weill and the Modernists' Contemporary Opera. It produced such works as Hans Pfitzner's *Palestrina*, the legend of the lonely genius, which saw its première in 1922, and new operas

Staats-Theater
Opernhaus

Berlin, Montag, den 14. Dezember 1925

14. Karten-Reservesatz.
(Außer Abonnement.)

Uraufführung:

Georg Büchners

Wozzeck

Oper in drei Akten (15 Szenen) von **Alban Berg.**
Musikalische Leitung: General-Musikdirektor Erich Kleiber.
In Szene gesetzt von Franz Ludwig Hörth.

Wozzeck	Leo Schützendorf
Tambourmajor	Fritz Soot
Andres	Gerhard Witting
Hauptmann	Waldemar Henke
Doktor	Martin Abendroth
1. Handwerksbursch	Ernst Osterkamp
2. Handwerksbursch	Alfred Borchardt
Der Narr	Marcel Noë
Marie	Sigrid Johanson
Margret	Jessyka Koettrik
Mariens Knabe	Ruth Iris Witting
Soldat	Leonhard Kern

Soldaten und Burschen, Mägde und Dirnen, Kinder.

Gesamtausstattung: P. Aravantinos.

Technische Einrichtung: Georg Linnebach.

Nach dem 2. Akt findet eine längere Pause statt.

Kein Vorspiel.

Den Besuchern der heutigen Vorstellung wird das neu erschienene Heft der „Blätter der Staatsoper" unentgeltlich verabfolgt.

Hans Pfitzner was the leading proponent of conservative, reactionary trends in German music before 1933. Quite logically he subsequently worked for the Nazis. The photo shows him at the Berlin Staatsoper conducting his opera *Das Christ-Elflein* (The Elfin Christ).

Left:
In 1930 conservative opponents of experiments at the Hessisches Landestheater in Darmstadt, which staged committed, modern interpretations of Classical opera, handed out this leaflet to theatregoers. The phoney business card pokes fun at producer Arthur Maria Rabenalt, stage designer Wilhelm Reinking and drama adviser Claire Eckstein.

The première of Alban Berg's *Wozzeck* was a major operatic event in the twenties, exerting decisive influence on attempts to renew the genre. Programme.

by Richard Strauss: Dresden introduced the public to *Die Frau ohne Schatten* (The Woman without a Shadow) in 1919, to *Intermezzo* in 1924, and to *Die ägyptische Helena* (The Egyptian Helen) in 1928.

Hans Pfitzner was notable for his reactionary adherence to tradition—in 1911 Busoni's *Arlecchino* prompted him to warn the world against the ''looming danger of Futurism''—and his extreme anti-Semitism. This blend made him an ideological champion of National Socialism,

and it came as no surprise when, after 1933, he stayed in Germany to work under the Nazis, who lavished great honours upon him. At seventy he was still arguing for ''Germanness in music'' in countries of Europe which had been occupied by the Nazis.

But operatic innovation was not confined to the works themselves. New approaches to production played just as important a part. Although most opera houses in Germany were still steeped in tradition, there were a number of exceptions which not only encouraged the new trends in opera, but also broke fresh ground in their theatrical and musical interpretations of classical works.

We have already mentioned the Dresden State Opera, where conductor Fritz Busch and director Josef Gielen carefully nurtured the works of Richard Strauss and offered premières to new operas such as Hindemith's *Cardillac* and Weill's *Protagonist*. The highly-esteemed conductor Gustav Brecher and director Walther Brügmann in Leipzig were equally committed. Three of Weill's operas were first staged here, and in 1930 Ernst Krenek was honoured with a festival week. Other champions of new operatic style included Paul Bekker in Kassel and director Arthur Maria Rabenalt at the Hessisches Landestheater in Darmstadt, which initiated a significant Handel renaissance during the Weimar Republic. But the most far-reaching support came from the Kroll-Oper in Berlin from 1927 to 1931.

In those days Berlin enjoyed an international reputation in the world of music. Franz Schreker, Paul Hindemith, Ferruccio Busoni and Arnold Schönberg taught at the Music College and the Prussian Academy of Arts. Wilhelm Furtwängler conducted the Berlin Philharmonic from 1922. Berlin was unique with its three opera houses, while Leo Blech, Erich Kleiber, Bruno Walter and Otto Klemperer held the baton in the concert halls.

In 1924 the Staatsoper acquired a second building when Kroll's Banqueting Halls by the entrance to the Tiergarten, opposite the Reichstag, were converted into a theatre. It opened as the Oper am Platz der Republik, but was renamed the Kroll-Oper in 1927 when it became an independent company. Otto Klemperer was appointed Director of Opera. This was the beginning of four years'

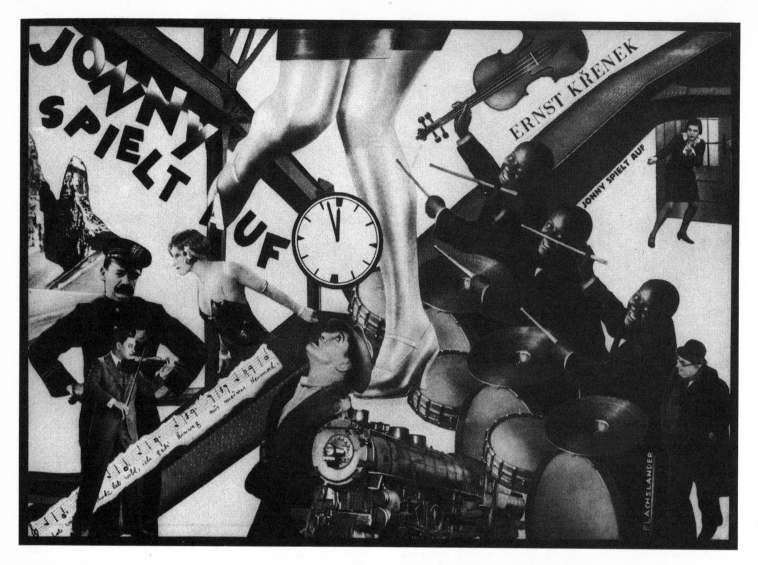

Ernst Krenek's "jazz opera" *Jonny spielt auf* (Johnny Strikes up the Band) was first staged in Leipzig in 1927, and over the next two years it was performed at almost every opera house in Germany. Flachsländer's photomontage for the Berlin Staatsoper production in 1928.

Kassel's operatic vanguard faced the photographer on 27 November 1926 to mark the première of Ernst Krenek's *Orpheus und Eurydike* (Orpheus and Eurydice) (libretto by Oskar Kokoschka): standing, left to right conductor Fritz Zulauf, Ernst Krenek, producer Paul Bekker, with Oskar Kokoschka seated.

August Sander's photographic portrait of Wilhelm Furtwängler, Chief Conductor of the Berlin Symphony Orchestra, in 1928. He was to stay in Nazi Germany where, like Gustaf Gründgens, he was crowned with laurels.

This Stravinsky Evening at Berlin's Kroll-Oper in November 1928 was open to members of the Volksbühne Society at discount prices. Otto Klemperer conducted and also produced *Oedipus Rex*. Klemperer was the second great German conductor, after Bruno Walter, who was compelled to leave in 1933.

work unprecedented in the history of Germany's musical theatre. 300,000 tickets a year were sold at reduced rates via the Volksbühne organization to people outside the well-heeled bourgeois elite that usually constituted the opera-going public.

There was a message to be gleaned in the opening production, Beethoven's *Fidelio*. Klemperer directed the production and conducted the orchestra. Ewald Dülberg designed a plain set with Constructivist elements. The performance was immediately attacked by the right wing, but all leading critics recognized its pioneering importance: "A blow for reform. It was purifying. It swept away the shoddiness and the routine gesticulation which have obscured the work of art from view for decades. A *Fidelio* without theatrical pathos, without bombastic sobs, with-out Philistine banality, without embarrassing naturalism. One felt one was hearing a new work. Its severe monumentality is shattering. A new era has dawned now that this reform has burst onto the operatic scene in Berlin."[116]

Klemperer's Mozart productions (*Don Giovanni* 1928, *Die Zauberflöte* 1929, *Die Hochzeit des Figaro* [The Marriage of Figaro] 1931) focused on the works themselves with a similar intensity. But the Kroll-Oper did not confine its commitment to presenting the classical repertoire with a fresh, contemporary appeal; it also tackled new works. The spectrum ranged from Stravinsky Recitals (*Oedipus Rex*, *L'Histoire du Soldat*, both in 1928) to Krenek's *Diktator* (The Dictator), 1928, Weill's *Jasager* (The One Who Said Yes), 1930, and Schönberg's *Erwartung* (Expectations) and *Glückliche Hand* (The Lucky Hand), 1930.

Conductor Alexander von Zemlinsky and chorus director Karl Rankl assisted Klemperer with the musical direction; Ernst Legal, Gustaf Gründgens and Arthur Maria Rabenalt, all men of the theatre, took a hand in the stage production. The sets, predominantly Functionalist, were designed by Ewald Dülberg, Teo Otto and the Bauhaus artists Oskar Schlemmer and Laszlo Moholy-Nagy. Looking back many years later, Ernst Bloch recalled: "Old works were performed as though they were new ones, and new ones betrayed a sense that contemporary relevance was not a matter of cheap topicality . . . One of Klemperer's essential traits, his conservative creativity, fused admirably at the Kroll-Oper with his other nature, his love of the future, his affinity with experiment as long as there were expertise about it."[117]

Together with Jessner and Piscator, Klemperer must be counted as one of the great triumvirate of theatrical experimenters in the Weimar Republic whose accomplishments were to stand the test of time.

The constant attacks on the Kroll-Oper enjoyed the protection of the Prussian state. The right-wing parties first brought a motion in the Provincial Parliament to close the opera house "for financial reasons" in January 1930. After several debates and a "committee of enquiry", the Prussian government decided on 6 March 1931 that the Kroll-Oper would be closed at the end of the season. The right-wing parties had all voted in favour, the SPD abstained, and only the Communist deputies opposed the resolution.

The curtain dropped at the Kroll-Oper for the last time on 3 July 1931. Nazi Fritz Stege had got his way. In May he had written an article about a production of Janáček's magnificent opera *Aus einem Totenhaus* (From the House of the Dead) in which he insisted: "Charitable thoughts about convicts, and that in a German opera house. The kind of 'art' the Kroll-Oper loves. It is high time that this theatre itself was turned into a mortuary!"[118]

Not even the massive campaign of international protest was able to save the Kroll. After the fire at the Reichstag the Nazis moved into the building with their parliament. It was here that they passed their dictatorial Enabling Act in March 1933.

From Brüning to Schleicher

**"Not a penny in yer pocket,
just yer docket from the dole"—
World economic crisis and
political confrontation**

10 May 1932 fell on a Tuesday. That morning friends and colleagues of Carl von Ossietzky gathered outside the gates of Tegel Prison in Berlin to escort the editor of the *Weltbühne*, who had been sentenced to eighteen months behind bars by the Reich Court in Leipzig for exposing illegal re-armament by the Reichswehr in a series of articles. The protests which met this verdict were in vain. Ossietzky had taken leave of his readers in an article called "Rechenschaft" (Called to Account), which appeared in the *Weltbühne* that same day: "Our sin is that we do not share a favourite German creed: we do not believe that military matters hold primacy in politics. This is what carved the wide rift between ourselves and our judges . . .

"The Generals have been ruling things for a few months now, and the result is a confusion that can hardly be disentangled, if not worse. Fascism has grown big and fat on it, and the way they conduct themselves with two Ministries represented by officers lend them an air of associate government. At first people used to say that the Generals were trying to teach Hitler the basics of legality, but the parasite has not attended his classes in vain. In fact, he has learnt enough to cast his painstaking mentors on the compost heap by thoroughly legal means."[119]

There had been drastic changes in the constellation of political forces in Germany during the four years from 1929 to 1932. Whereas the industrialists and financiers who held the real power in their hands, and their friends among the military, had tolerated the coalition politics of the cabinet led by Chancellor Hermann Müller during the final stage of stabilization and rejected the pressure from

the DNVP and NSDAP for revised power structures, this situation changed from the autumn of 1929.

Wall Street collapsed on 24 October, "Black Friday". The world economic crisis that had already been displaying mild symptoms now took rapid hold, quickly spreading from the United States of America to Europe, and Germany in particular. Although productive capacity had swollen tremendously in recent years, the country's financial reserves were poor, as reparation commitments and sizeable foreign capital investments in the wake of stabilization had made Germany strongly dependent on the international financial market. The collapse of the American banks and stock exchange struck the German economy on its Achilles' heel. The differences of opinion between the big monopolies on the subject of bourgeois democracy in the Republic (which the "traditional" branches of heavy industry, coal and steel, vehemently opposed and the "modern" manufacturers of chemicals and electrical goods, who owed their youthful existence to automation, supported) vanished into thin air. Something else, something more serious, was at stake: economic survival.

The Confederation of German Industry published its memo "Rise or Fall?" on 2 December 1929. It contained a clear manifesto for the erosion of democracy. The Weimar Republic was labelled a "welfare state", and the government's right to interfere in economic affairs was denied. The Reichstag was enjoined to "restrict itself": "The German economy must be freed of all uneconomic constraints." What this meant was elucidated in the next sentence: "The handicap imposed on production by taxes must be pegged back to the level which is indispensably necessary."[120] Consumer taxes, on the other hand, should be substantially raised, while wages and salaries should continue to fall. The Reichstag took ten days to carry out industry's demands. The industrialists were granted tax relief to the tune of almost a million and a half Reichsmarks, mostly due to cuts in Capital Gains Tax and Income Tax, while the incomes of working people were further reduced.

At the same time, the ruling monopoly circles began to step up their financial support for the Nazis. Seven-figure donations to the NSDAP coffers were no rarity from 1930 onwards. The Association of Mining Interests, for example, paid 1.7 million Reichsmarks a year, the heavy industrialists of Rheinland-Westphalen two million a year and Thyssen three million a year. These were princely sums, even though not all concerned were agreed as to the value of the Nazi party, and many a monopolist was wary of its "socialist" slogans.

Käthe Kollwitz used her lithograph *Hungernde Kinder* (Starving Children) of 1924 for several posters in support of the Artists' Winter Aid Campaign in 1929/30 in Leipzig, Berlin and elsewhere.

Left:
Friends and fellow-spirits accompanied Carl von Ossietzky to the gates of Tegel Prison in Berlin on 10 May 1932: front left Lion Feuchtwanger, in the middle Ossietzky, listening to a brief speech by Ernst Toller (with hat).

This pecuniary boost from Germany's big industry was the major factor enabling the fascists to launch their offensive. New NSDAP newspapers and magazines were founded all over the country, and it was no longer a problem to rent the most expensive halls. Brown-shirted speakers were driven from one mass meeting to the next in expensive Mercedes saloons. Hitler travelled his electoral route in a private aeroplane. Meanwhile the SA thugs stepped up their brutal attacks. The three basic elements of Nazi mass manipulation in the years of dictatorship after 1933 identified by the historian Kurt Pätzold—intimidation, ideology and corruption[121]—had already taken shape by 1930. The fascists made generous promises to every section of the population and donned a radical pose to prophesy that they would "smash our slavery to debt repayments", "exterminate world Jewry" and "destroy greedy capital". "Germany, awake!" was their echoing cry. In late 1931 Lion Feuchtwanger described the essence of fascist propaganda thus: "Anti-logical and anti-intellectual by nature and by ideology, National Socialism seeks to depose reason, glorifying instead emotion, instinct, in fact barbarism."[122]

But the seed fell on fertile soil. As a result of the world economic crisis, broad sections of the middle classes in town and countryside who had always been relatively passive in political matters were caught up in unemployment and poverty. This was where the Nazis recruited most of their support, especially as they corrupted many people with their brown uniforms and polished boots, the mark of every SA man and which made him believe in his own elevated "status". Even many agricultural workers and seasonal farm labourers in Germany's vast Eastern grain belt, who had hardly developed any class consciousness, followed Hitler like lambs to the slaughter. In the towns, the number of members and fellow-travellers grew among the swelling ranks of the unemployed.

For millions in Germany, the situation was becoming visibly more desperate. By the end of 1930 there were five million jobless. That Yuletide was celebrated under Emergency Laws as Hungry Christmas. By the end of 1932 there were seven and a half million people without work, two and a half million of whom had lost all further claim to even the most frugal assistance. Another four million were on short time. When Hanns Eisler put Brecht's poem *O Fallada, die du hangest!* (O Fallada, You Were Hanging!) to music in late 1931, the situation was no different from that in the harsh post-war winter of 1918/19, when the words were written. The inevitable perversion of the human soul is portrayed in shattering images. A horse recounts what happened to it when it collapsed from hunger and weakness in the middle of the street:

"Kaum war ich da nämlich zusammengebrochen
(Der Kutscher lief zum Telefon)
Da stürzten aus den Häusern schon
Hungrige Menschen, um ein Pfund Fleisch zu erben
Rissen mit Messern mir das Fleisch von den Knochen
Und ich lebte überhaupt noch
Und war gar nicht fertig mit dem Sterben.

Aber die kannte ich doch von früher, die Leute!
Sie brachten mir Säcke gegen die Fliegen doch . . .
Einst mir so freundlich und mir so feindlich heute!
Plötzlich waren sie wie ausgewechselt.
Ach, was war mit ihnen geschehen?''

(You see, as soon as I fell down—
My driver rushed to telephone—
Hungry people ran from their houses
To inherit a pound of flesh,
Tearing the meat from my bones with their knives,
And there I was still alive,
Hadn't even finished dying yet.
But I knew those people from before!
They used to give me sacks to keep the flies off . . .
They were once so nice to me
and today they were so nasty!
Suddenly they weren't the same at all.
Oh, what has happened to them?)

The working class was the only force which might have
been able to keep fascism at bay. The reason it did not
was that the labour movement was disastrously divided,
and the rift could not be healed even when the danger was
at its peak. The right-wing leadership of the SPD refused
to work with the Communists until the bitter end. The KPD
was the only political force in Germany from 1930 which
accurately assessed the real threat posed by the Nazis
and which mobilized the masses to oppose it.

In March 1930 the Reichstag voted in favour of a new
reparations schedule, the Young Plan. This was the result
of conferences in Paris and The Hague which the German
government had sought during 1929/30. Unlike the
Dawes Plan it placed an upper limit on the German repay-
ments, a total of 116,000 million gold Marks in 59 annual
instalments. Allied controls were to terminate and the
French were to withdraw their last remaining troops from
the Rheinland. Germany's chief negotiator, Schacht, who
was President of the Reichsbank, made no secret of the
fact that Germany wanted complete restoration of her
sovereignty. A move in support of this aim followed in
June 1930, when US President Herbert Hoover imposed

a one-year moratorium on reparations, after which, in fact, no more payments took place, as Germany stopped making them in late 1931. Differences within German imperialist groupings were still emerging openly during the debate about the Young Plan. In July 1929 Hugenberg and Hitler, the DNVP and NSDAP, petitioned for a referendum against the Plan, but this was defeated for lack of votes. During the campaign, however, the fascists whipped up an unprecedented level of hysteria.

A fortnight after the Young Plan came into force in German law, the government constituted by the biggest coalition in the Reichstag was brought down. It turned out to have been the last parliamentary government of the Weimar Republic. Events now followed in rapid succession. On 30 March 1930 President Hindenburg named Heinrich Brüning, parliamentary leader of the Centre Party, as Chancellor of the Reich. The first Presidential Cabinet, which was now appointed by the President of the Reich and no longer elected by parliamentary majority, took office. Brüning's erosion of democracy was reflected in his policy of Emergency Decrees, which continued to eat away at the country's social fabric. Brüning was the first Chancellor of the Weimar Republic to address the RDI, and accepted the evaluation of IG-Farben magnate Duisberg that his policies marked "the early beginnings of a U-turn after ten years of bad economic and financial policy".[123] And this at a time when broader sections of the population than ever before were facing destitution!

When the Reichstag failed to agree immediately to certain Emergency Laws on taxation and finance, Brüning dissolved parliament on Hindenburg's orders and announced fresh elections for September 1930. The political forces in Germany polarized further. Sizeable gangs of brown-shirted thugs went into action for the first time during this electoral campaign, and the Communists were their principal target. In August 1930 the KPD published its Manifesto on the National and Social Liberation of the German People, defining fascism not as a merely temporary danger, but as the vehicle for all those forces which wanted to eliminate the Republican constitution. The most urgent task was seen as preventing a fascist dictatorship and establishing a truly democratic system. This manifesto provided a preliminary basis for uniting all anti-fascist forces. Unfortunately it still sported the slogan: "Down with Fascism and Social Democracy!", so that while it addressed its appeal unambiguously to the right-wing SPD leadership, it did not remove the obstacles to forming a common cause with Social Democratic workers.

Advertising column with the KPD's election poster, and voting slip for the Presidential elections in 1932.

A special edition of the SPD newspaper _Vorwärts_ was issued for the first round of the Presidential elections in March 1932, fatefully calling on voters to smash Hitler by opting for Hindenburg.

Hoarding on the offices of Goebbels's newspaper _Der Angriff_ in Berlin before the Presidential elections of 6 November 1932.

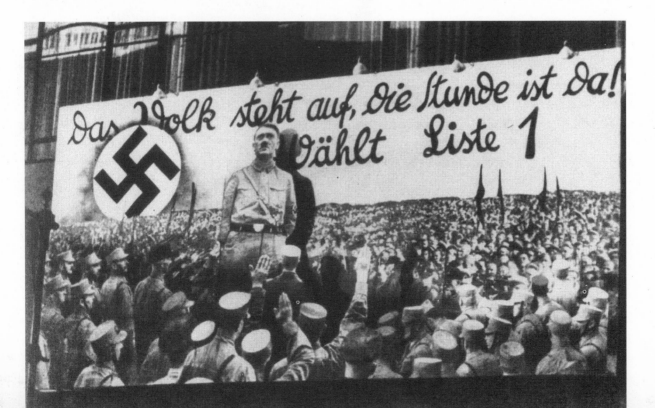

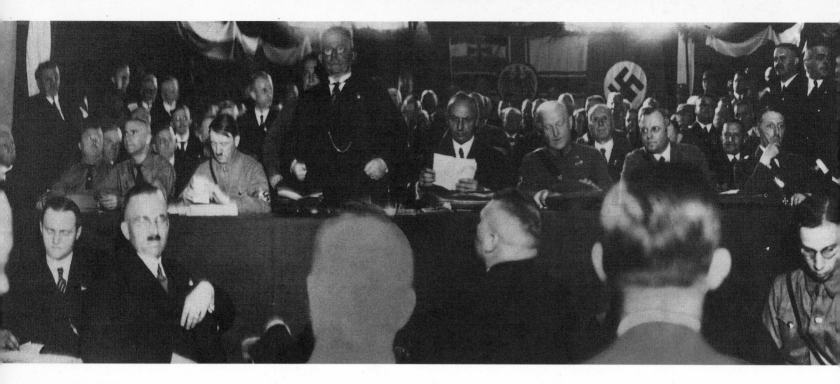

An alliance between the most reactionary representatives of the military, industry and finance and the Nazi party was forged on 11 and 12 October 1931 in Bad Harzburg. Following Alfred Hugenberg's speech are Adolf Hitler (on his left at the table), Thuringian Minister of Education Frick and (second from right) Stahlhelm commander Seldte.

Deposed Prussian royalty also made an alliance with the fascists. Prince August William of Prussia appeared in SA uniform at an SA rally in Brunswick in 1930.

Right:
KPD truck canvassing for the Presidential elections in November 1932.

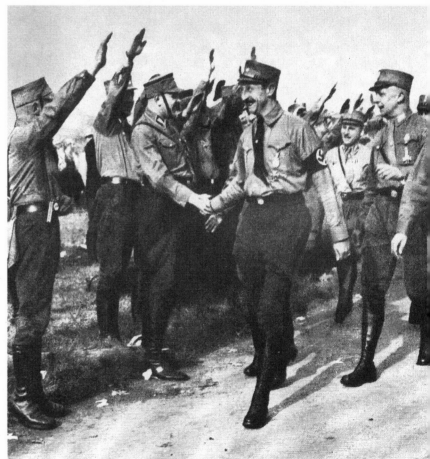

When the elections were held in September, the KPD emerged as the third party with 4.6 million votes. The SPD lost over half a million voters, but still came out on top with 8.6 million votes. The NSDAP attracted the most new voters and finished in second place with 6.4 million votes.

Centre politician Brüning thus led the new Reichstag with a minority Cabinet, but as the SPD delegates accepted him he was able to press ahead unhindered with his spate of emergency laws. Social problems continued to increase as a result. A second winter of crisis only aggravated the situation. The reactionary camp became more and more open in its demands that the Nazis should be brought to power.

Not even the constant flow of emergency decrees was able to put a stop to the crisis. Just how serious the position was could be seen from the number of big companies and banks which collapsed during the spring and summer of 1931. The monopolies now told Hindenburg exactly what they wanted: "It is our hope that the reins of government will be placed with the strongest patriotic party. Your Excellency, bring your historic life's mission to completion!"[124] Brüning gave the Reichstag a "holiday" from October 1931 until February 1932, and Germany was left without a parliament for five months of extreme tension. The anti-Republicans used this period to muster their strength for the final blow. The Harzburg Front, an attempt at a common platform uniting all right-wing forces from the NSDAP and DNVP, the Stahlhelm and other nationalistic paramilitary organizations, to representatives of the most powerful banks, monopolies and landowners, was formed in Bad Harzburg on 11 and 12 October 1931. The non-Nazi bourgeois parties began to feel helpless. Only the workers' parties responded to this all-out attack by the fascists. In December the Social Democrats formed their Iron Front, consisting of the SPD itself, trade unions, the paramilitary Reichsbanner and sympathetic sports associations. Pressure from below had achieved this summoning of party forces to oppose fascism, but even so it did not disguise the fact that the SPD leaders were still supporting Brüning and refusing point blank to co-oper-ate with the Communists. With Ernst Thälmann as Secretary, the KPD stepped up its mass campaign against the Nazis, and the party's political work received valuable assistance from the broad front of proletarian culture, which was joined by a number of bourgeois intellectuals.

Presidential elections were held in Germany in April 1932. The candidates of the three biggest parties were Hindenburg, Hitler and Thälmann. The SPD ran their campaign under the slogan: "Crush Hitler! Vote for Hindenburg!", the KPD, meanwhile, exorted the German people to choose Ernst Thälmann. Their slogan was: "A vote for Hindenburg is a vote for Hitler. A vote for Hitler is a vote for war!" But the anti-Communism of the nationalist and fascist forces, which was also inherent in SPD leadership, won the day. Hindenburg was elected with 19.4 million votes. Hitler rallied 13.4 million and 3.7 million were cast for Thälmann.

In May 1932 the Communist leadership set up the Antifaschistische Aktion, an organized grouping of factory and office workers and intellectuals of Communist, Social Democratic and Christian persuasions. The circular sent out by the KPD explained: "In the face of the strategy adopted by the bourgeoisie, the proletariat led by the KPD is also developing a big strategic plan with the purpose of engaging its class forces."[125] But although there were many initiatives at grass-roots level, the basic balance of forces remained unchanged.

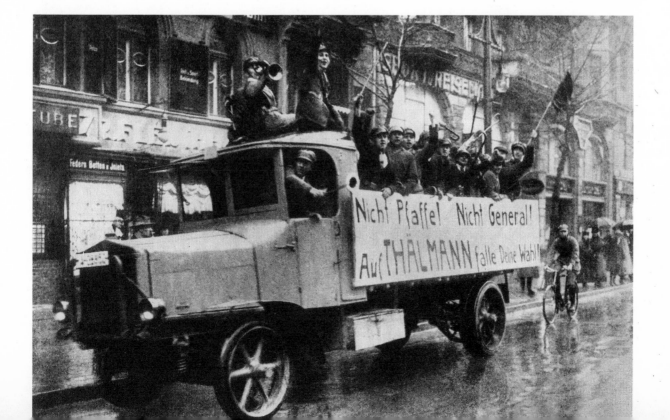

Brüning resigned as Chancellor on 30 May 1932, the day after Hindenburg informed him that he would not sign any more emergency laws. Franz von Papen, a politically unaffiliated Catholic of nationalistic inclinations who had never been a member of the Reichstag, was named in his place. He had many connections among army officers and monopoly directors. His Cabinet was a stepping-stone to the Hitler regime, and from the moment he took office he regarded his period in government as a "transition".

There were fresh elections to the Reichstag in late July 1932. The Nazis emerged as Germany's biggest party, with 13.7 million votes, which they owed to the deterioration in the economic situation and the unbridled demagogy which coloured their lavish electoral campaign. The SPD lost another half a million voters, leaving them in second place. The KPD remained in third position with an increase of 700,000 votes. Taken together, the KPD and SPD still had almost the same number of seats in the Reichstag as the Nazis: 222 to 230.

However, by comparison with the Presidential elections in April, it was clear that the Nazis had almost exhausted their potential for growing mass support. They only attracted an extra 300,000 voters.

The autumn of 1932 was marked by massive working-class protests against the Papen government. Ernst Thälmann declared: "We must unleash and foster the broadest based mass struggle against the Papen government, against the fascist bourgeois starvation assault. Economic strikes . . . backed by political mass strikes which have been specifically prepared for and timed, and ultimately general strike . . . —that is the only line of struggle which will enable us to prevent further fascist developments."[126]

There were 447 major strikes in Germany between mid-September and mid-October, demonstrating the proletariat's determination to resist. When the Papen government attempted to turn the screws on the population with yet another emergency decree "for economic revival", the KPD delegates at the Reichstag demanded its immediate repeal on 12 September 1932. Papen, who feared that the Communists might win their motion, responded by dissolving parliament again and calling new elections for 6 November. These resulted in a big drop in votes for the NSDAP (over two million) and the SPD (700,000), while the KPD's votes increased again. The Nazis now had 196 seats in the Reichstag, the SPD 121 and the KPD 100. This electoral blow plunged the fascists into a crisis. It spurred the financiers and monopolists into action realizing that their Harzburg policy was in jeopardy. In mid-November Hindenburg received a petition from the true rulers of Germany demanding that Germany should break at once with parliamentarism, that Hitler should be appointed Chancellor and that the Reichstag should be crippled by means of an Enabling Act. Papen was removed and on 17 November his entire Cabinet resigned. Over the next few days Hindenburg was locked in talks with the leaders of the major parties. On 19 November he received Adolf Hitler and, at the insistence of leading industrialists, offered him the position as Chancellor over a parliamentary majority government. Hitler would not accept the offer. He was already fairly sure of his strength and dictatorially demanded complete state power for the NSDAP. Hindenburg still refused. Without seeking to facilitate a fascist dictatorship, Papen attempted to overcome this critical moment in the governmental crisis by chipping in once more with a hazardous proposal. He recommended to Hindenburg that he should eliminate parliament and repeal the Constitution, which would have amounted to a military coup. The men of power, however, could not accept that risk, for they had not forgotten how the massive general strike by the German working-class had put an end to the Kapp Putsch. The threat of a political general strike still loomed too large in the light of the strike action that had been taken in the autumn of 1932.

The President therefore convened a provisional Cabinet with Armed Forces Minister Schleicher as Chancellor. The new government took office on 3 December 1932, openly professing that its aim was "to give German politics a breathing space of twelve weeks during which . . . negotiations can take place between those in whom power is invested and Hitler."[127]

1932 drew to a close. The fate of the Weimar Republic was finally sealed during the next two months.

"I lay this honour at the feet of my people"—Nobel Prize for Thomas Mann and literature in the Republic

In early December 1929 Thomas Mann broke his journey from Munich to take the most expensive suite in Berlin's Adlon Hotel. Accompanied by his wife, he was obliged to receive endless courtesy callers. This ambassador of the German intellect, as many an old enemy now pleased to style him, was on his way to Stockholm, where he was to be awarded the Nobel Prize for Literature on 10 December. Even Munich's nationalist rags had temporarily ceased their attacks on Thomas Mann when the Nobel Prize Committee announced its decision in November. They had never forgiven the author of those two great testimonies, *Friedrich und die grosse Koalition* (Frederick and the Grand Coalition) in 1915 and *Betrachtungen eines Unpolitischen* (Reflections of an Unpolitical Man) in 1918, for deserting the cause in 1922, after the assassination of Foreign Minister Walther Rathenau, and moving from the camp of the arch-conservative educated classes into democratic circles. He had selected no less an occasion than Gerhart Hauptmann's 60th birthday to inform the well-heeled audience at the homage in Berlin, where he was delivering the ceremonial address, of his Republican sympathies. The speech, *Von deutscher Republik* (On the German Republic), which finally healed the rift between the brothers Thomas and Heinrich Mann, was welcomed by Republicans, and particularly by the Social Democrats, as representing the political change of heart of a new Thomas Mann. From that moment onwards he was regarded as an intellectual spokesman for the German Republic, a status which was underlined by the honours heaped upon him: the Senate of Lübeck granted him an honorary professorship, while the Prussian Academy of Arts accepted him into its literary ranks. Thomas Mann himself bowed to this commitment and undertook constant lecture tours in Germany and abroad. But basically he remained just what he had always been, a stalwart exponent of the educated bourgeoisie, a champion of Germany's intellectual traditions, a citizen of European art, as he liked to call himself, and as such a vehement advocate of humanism. Thomas Mann was prompted to confess his allegiance to democracy and the Republic by the counter-revolutionary developments during the post-war crisis and the growing anti-humanism which prevailed among the nationalists and National Socialists. In Munich, where the Nazis were particularly vociferous in the early Weimar years, Thomas Mann was among those who, from the perspective of European liberalism, vigorously attacked the "mystical philistinism", the "inflated fatuousness" of Aryan radicalism, and the "mawkish educational barbarism"[128] of the National Socialist movement. In 1926 he gave a talk there called *München als Kulturzentrum* (Munich as a Cultural City), in which he was explicit about these sentiments for the first time. The Munich dailies eventually launched their fully-fledged campaign against him in 1928. Hübscher, the editor of the *Süddeutsche Monatshefte*, and his publisher Cossmann had written a pamphlet on Thomas Mann's *Betrachtungen eines Unpolitischen*, in which they included a personal letter from Mann to Hübscher written during an argument between the two. In this letter, Thomas Mann defended his idea of intellectual Europe. The press now accused him of distancing himself definitively from the German nation, exploiting in particular one passage in which he wrote: "I make no secret of the fact that I want nothing to do with people (professors at Munich University!) who reacted to Rathenau's murder by saying: 'Hooray, one less of them!', or that I think the bourgeois press in Munich is dreadful. And as I am writing to you on the same day as our good but misguided city is performing a nationalistic headstand in honour of those two silly pilots, I might as well admit straight away that I find this phenomenon worse than 'Jonny spielt auf'."[129]

The event to which Thomas Mann was referring here was the reception given to the airmen Hermann Köhl and Ehrenfried Günther Freiherr von Hünefeld, who had set off on the first German transatlantic flight in April 1928 aboard a Junkers plane. The success of this venture placed Munich in a state of patriotic intoxication. Germany, it was claimed, now ruled the air again, and this new accomplishment was exploited to belittle the pioneering

feat of the American Charles Lindbergh. The literary magazine *Das Tagebuch* offered Thomas Mann an opportunity to reply to the rebukes he had suffered, and the writer did so with the gentle, conciliatory diplomacy so typical of his nature: "It was a slovenly, infuriated comment about the turbulent, overdone reception in black, white and red which tipped the city on its head on the very day I was writing as Munich turned out to greet Hünefeld and companions after their ocean flight, a comment which I would naturally have put into different form had I intended it for the public ear. In no way, however, was it a criticism of the valiant airship crew, whose achievement certainly fills me with healthy respect, but was born rather of a fleeting indignation at the fashion for an excessive, uncivilized overrating of sporting records and its nationalistic exploitation, and indignation which I believe and know many a better German has experienced with me."[130]

When the Nazis subsequently made such tremendous gains at the Reichstag elections in 1930, Thomas Mann finally donned the cloak of commitment by warning that Nazi rule would entail devastating consequences for the cultural fabric of society in a speech which he gave at the Beethoven Hall in Berlin. In spite of all the heckling from the National Socialists, his *Deutsche Ansprache* (German Address) met with international acknowledgement, and for the first time the writer professed a clear-cut and carefully considered allegiance to Social Democracy.

For the time being, however, in the year of his Nobel Prize, the Nazis preferred to squeeze some advantage out of his honour. "There had been no lack of malicious attacks," wrote Viktor Mann, a brother of the distinguished novelist, in his memoirs. "But for the moment that no longer mattered, for this unpopular person had brought a Nobel Prize to Germany. It was almost as good as an international gold medal for the high jump! Germany leads the world in pilots and poets! No one can beat us!"[131] When Thomas Mann said in his speech at Stockholm: "I lay the honour which has been shown me at the feet of my people, to whom it will bring pleasure, for this people has not always been understood correctly or completely,"[132] he surely cannot have suspected that his homage to his intellectual fatherland was going to be treated like another sports trophy by his more mindless compatriots.

Who, after all, fought better for German honour and German glory than, for example, Germany's heavyweight boxing champion Max Schmeling, who in February 1929 had just returned from the United States, where he had knocked out Joe Monte, to be celebrated as a national hero? Or world record holder Hilde Schrader, who had taken one of ten German golds at the 1928 Amsterdam Olympics in the 200-m breaststroke? Along with the seven silver and thirteen bronze medals, these placed Germany in the rankings behind only the United States of America.

Athletic success was matched by technological prowess. Since August 1928 Germany had been the proud owner once more of two giant ocean liners, the "Europa" and the "Bremen", the most modern vessels, conceivable. In fact the "Bremen" won the hotly contested Blue Riband for the fastest transatlantic passage in July 1929. In May of that year Willi Neunhofer broke the world record for high-altitude flight. But whereas Germany had seemed to hold a season ticket for international literary awards before the First World War, nothing had happened on this front for 17 years. Things had gone painfully quiet after Theodor Mommsen's Nobel Prize for Literature in 1902, followed by Rudolf Eucken in 1908, Paul Heyse in 1910 and Gerhart Hauptmann in 1912. At last the spell seemed to have been broken. Intellectualism was now in there among all the other activities forging victories for Germany's national pride. The land of poets and philosophers had not been cast entirely into oblivion in this respect.

For Thomas Mann himself, however, this supreme honour was not an unsullied blessing. For one thing, the literary world was quite curtly arguing whether Heinrich Mann might not have been a better choice for the Nobel Prize and the representative role which accompanied it, and for another, Thomas Mann had been given the prize for a novel conceived almost thirty years earlier, *Buddenbrooks*. Thanks to the award, sales received a boost and the millionth copy was printed during 1929/30, which was an extremely rare occurrence in the Weimar book market if we discount the trash. In presenting the distinction, the panel made no mention of *Der Zauberberg* (The Magic

Marketing the Nobel Prize: "Thomas Mann Cigars" in 1931.

Above:
In 1929 Thomas Mann spent several days in Berlin's Adlon Hotel en route from Munich to Stockholm. Caption: "The page announces a visitor."

Mountain), a more recent work which had already sold an impressive 100,000 copies since publication in 1924 amid national and international acclaim. The bourgeois literary elite did not, therefore, attach enormous significance to this Nobel Prize. The honour was relegated to a private matter which the great man accepted in solitude, and that was the view which prevailed in contemporary histories. Klabund, whose 100-page volume *Deutsche Literaturgeschichte in einer Stunde* (German Literary History in One Hour) appeared in 1921, had written there: "One variation on Impressionism is Psychologism, as practised by Thomas Mann (Lübeck, born 1875) in his excellent novels and short stories *Die Buddenbrooks* and *Tod in Venedig* (Death in Venice). He analyzes the individual soul like a conscientious physician. His brother Heinrich Mann (Lübeck, born 1871) has lately been concerned with studying the mass soul. He has emerged as the novelist of democracy in: *Die kleine Stadt* (Small Town), *Die Armen* (The Poor), *Der Untertan*."[133] Indeed, it was only the conservative wing of literary studies who regarded their idol Thomas Mann with unreserved admiration. Fritz Strich of Munich wrote a book called *Dichtung und Zivilisation* (Literary Art and Civilization) in 1928, in which he paid tribute to *Der Zauberberg* as a signal warning that contemporary events could plunge bourgeois civilization into physical and mental turmoil: "Thomas Mann . . . once denied that the great, complete poet could exist today. These days, he said, the artist is just a painter and the poet just a writer. Bourgeois civilization can give birth to nothing else (. . .) By recognizing the destiny and mission of his day and adopting them honestly, courageously and elegantly in his work and in his humanity, he has done more for the advent of this new age than all those who believe they can already create it now, with frantic superficiality, by political or aesthetic means. He has done more for the German nation in the world than those who constantly shout about Germany because, as a specifically German man in this much-maligned age of European civilization, he has understood the German challenge and mission: to transform the mechanization of life by means of the German proficiency ethic into an intellectualization of life."[134]

If this is how Thomas Mann was patched together as an ambassador in the public eye, it is hardly surprising that most literary figures subsequently never even mentioned his Nobel Prize in their memoirs and autobiographies. The award had been made for a novel published as early as 1901 and its author, but it passed by the real literary movement of 1929, the Contemporary Novel, without any acknowledgement whatsoever.

A series of important books appeared in Germany during the year that Thomas Mann won the Nobel Prize. Erich Maria Remarque's anti-war novel *Im Westen nichts Neues* (All Quiet on the Western Front), which had been serialized in the *Vossische Zeitung*, was published on 31 January. The Ullstein publishing venture Propyläenverlag pulled out all the publicity stops, so that by the end of the year almost a million copies of the German-language original had been sold. Translations into more than twenty languages ensured its international success. Printers and bookbinders all over Germany seemed to be vying with one another all year to produce one edition after the other of *Buddenbrooks* and *Im Westen nichts Neues*.

In October S. Fischer published the first copies of Alfred Döblin's *Berlin Alexanderplatz*, a book which set the very highest standards for the Contemporary Novel both thematically and aesthetically. It is the tale of the petty bourgeois lumpenproletarian Franz Biberkopf who has done time for manslaughter and comes out of prison deter-mined to go straight into a Berlin that is beginning to reel under the effects of the world economic crisis. He experiences the city as a cruel, indifferent labyrinth of social and political conflicts and dangers. The city itself is Biberkopf's antagonist, and he is at its mercy. That is what makes this novel so astonishingly effective: Berlin with its tenements and pubs, its trams and city sounds, the hotch-potch of political slogans, advertisements and even the daily weather forecast emerges through this feverish muddle of impressions and influences as an autonomous "character", created with the aid of new narrative techniques such as documentary reporting, collage and montage combining snippets of authentic experience, fragments of speech, and metaphors drawn from local dialect. Along with *Ulysses* by the Irishman James Joyce and *Manhattan Transfer* by the American Dos Passos, this novel about the learning process to which Biberkopf is subjected and which "culminates in a 'true' understanding of the principle of force underlying society"[135] was to dominate international discussion about modern 20th-century novel-writing for many years to come. Alfred Döblin, who acquired a worldwide reputation as a result, thus became a leading symbol of the political Contemporary Novel.

Amid all these new titles which appeared in 1929 was a book by the young writer Werner Beumelburg, who had made a name for himself in 1922 with his war report

Im Westen nichts Neues

von Erich Maria Remarque hat
die Million überschritten! Als der
Propyläen-Verlag vor fünfzehn
Monaten Remarques Buch ver-

Neuauflage!

Soeben gelangt zur Ausgabe
das 851. bis 900.000 von

**THOMAS MANN
Buddenbrooks**

Roman. 736 Seiten

Ungekürzte Sonderausgabe in einem Band

2.85 RM in Ganzleinen

In der angekündigten Auflage von 900.000 Exemplaren der
Sonderausgabe sind die 185.000 Exemplare der normalen
Ausgabe nicht eingeschlossen, Gesamtauflage also

1.085.000 Exemplare

S. FISCHER VERLAG · BERLIN

Auslieferung: Leipzig C 1, Reclamstraße 42, für die Schweiz: Vereinssortiment Olten,
in Wien vorrätig bei R. Lechner & Sohn, in Budapest bei Béla Seadó, in Amsterdam bei Richard Sing
®

Notching a million in 1930: on 27 May the Propyläen-Verlag issued a
special four-page leaflet bearing the cover design from Remarque's
book to announce the millionth copy of the anti-war classic. On
26 September S. Fischer reported that the recent special edition of
Thomas Mann's family chronicle brought the total to over a million
since the novel appeared in 1901.

Left:
The anarchist revolutionary Max Hoelz came to symbolize the strug-
gle against class justice in the Weimar Republic. As leader of the
Red Guard in the Vogtland he was sentenced to life imprisonment in
1920 for faking evidence and producing false testimonies. An am-
nesty committee which included such names as Egon Erwin Kisch
worked tirelessly and ultimately secured his release in 1928. In 1929
Malik published Hoelz's book *Vom "Weissen Kreuz" zur roten Fahne*,
an account of his youth, political activities and prison life. Here we
see Max Hoelz arriving at the Schlesischer Bahnhof in Berlin after
his release, with Hugo Eberlein on the right and Wilhelm Florin on
the left.

Douaumont, an authentic and effective brand of national-
istic war literature. The new work was called *Sperrfeuer
um Deutschland* (Germany under Barrage), and it soon
became a bestseller. The publishers, Gerhard Stalling of
Oldenburg, had certainly learnt their lessons from the
successful publicity campaign which surrounded *Im
Westen nichts Neues*. Their advertisements carried en-
thusiastic praise by reviewers in the conservative nation-
alist and Nazi press. The "German war book" was born.
Sperrfeuer um Deutschland, complete with a Preface by
Field Marshal von Hindenburg, President of the Reich,

launched the nationalist counter-offensive against flour-
ishing anti-militarism in the field of war fiction: *Im Westen
nichts Neues*, Ludwig Renn's *Krieg* (War) which came out
in 1928, Arnold Zweig's *Der Streit um den Sergeanten
Grischa* (The Case of Sergeant Grischa) of 1927, Alfred
Polgar's *Hinterland*, Theodor Plivier's *Des Kaisers Kuli*
(The Kaiser's Coolie), Adam Scharrer's *Vaterlandslose Ge-
sellen* (Companions without a Country), the "first worker's
war diary", and Ernst Johannsen's *Vier von der Infanterie*
(Four Infantrymen), all of which appeared in 1929.

One of the most outstanding works by bourgeois writ-
ers to reach the bookshops in 1929 was Stefan Zweig's
biographical novel *Joseph Fouché*, another feather in the
cap of a man already well known for his essays and biog-
raphies. Another widely acclaimed writer of the times was
Joseph Roth, who had made his name with the novels
Hotel Savoy and *Die Rebellion* in 1924 and *Zipper und sein
Vater* (Zipper and His Father) in 1928. The next work to
appear was *Rechts und Links* (Right and Left), followed a
year later by his most popular novel *Hiob* (Job), before his
ultimate show-down with the Imperial Catholic Austrian
monarchy, the novel *Radetzkymarsch* (Radetzky March),
was published in 1932. Klabund, whose real name was
Alfred Henschke, wrote satirical pieces for *Simplizissi-
mus* and had already established a reputation with the
poetry anthology *Die Harfenjule* (The Harp Jule) and one
of the most frequently staged plays in the Weimar Repub-
lic, *Der Kreidekreis* (The Chalk Circle), which was pub-
lished in 1925 and based on a Chinese text. His contribu-
tion this year was *Rasputin*, a demonic novel. Hans Hen-
ny Jahnn scored a success with his novel *Perrudja*, in
which he adopted the most modern techniques to ex-
press his yearning for a better world, confronting modern
industrial society with a Utopian form of natural mysticism.

The poet and story-teller Rudolf Borchardt was widely
read and respected among bourgeois writers. He had
won fame with his anthologies *Deutsche Denkreden*
(German Tributes), 1925, *Ewiger Vorrat deutscher Poesie*
(Infinite Supplies of German Poetry), 1926, and *Deutsche
in der Landschaft* (Germans in Landscape), 1927. 1929
brought his *Pindarische Gedichte* (Pindaric Poems) and
the short stories *Der unwürdige Liebhaber* (The Un-

worthy Lover). Borchardt had been living in Italy since 1922. 1929 was a busy year for the book market, but one more title should be mentioned for the interest it aroused: a volume of recollections by Max Hoelz, probably the most fascinating personality among the radical left-wing revolutionaries of the Weimar Republic, called *Vom "Weissen Kreuz" zur roten Fahne* (From the "White Cross" to the Red Flag). In 1928 he had been released from prison, where he was serving a life sentence, after an international campaign to secure his amnesty.

The late twenties witnessed a spate of anthologies in the Weimar Republic. In contrast to the great Expressionist anthologies—Ludwig Rubiner's *Kameraden der Menschheit* (Comrades in Humanity) and Alfred Wolfenstein's *Die Erhebung* (The Uprising), both published in 1919, and Kurt Pinthus's *Menschheitsdämmerung* (The Twilight of Humanity) of 1920—which had presented a broad cross-section of young German poets, these later collections emphasized the polarization that was taking place in artistic and above all political terms. There was a big response, for example, when Malik published its anthology *30 neue Erzähler des neuen Russland* (30 New Story-Tellers of New Russia) in 1928. This collection of recent Russian prose had appeared by 1930 in two revised editions containing new authors each time, and it was a most effective tool in countering growing anti-Soviet propaganda in every field because of the way it demonstrated the breadth of creativity in Russia's young literature. Towards the end of 1932, Wieland Herzfelde picked up the threads of this success with another collection called *30 neue Erzähler des neuen Deutschland* (30 New Story-Tellers of New Germany), a contribution to anti-fascist unity which brought together writers from various camps. It was one of Malik's last publications in Germany.

In 1929 Herbert Günther edited an anthology entitled *Hier schreibt Berlin* (Berlin Writing), which included 50 well-known Berlin authors whose views ranged from conservative through liberal and democratic to socialist. The index of authors was small compared with the number of Berlin writers representing these views. Johannes R. Becher was the only socialist among them. But at that particular time it was an important defence of democratic literature, based in a city which Carl von Ossietzky had taken to calling Red Berlin. And yet it was here, too, that Adolf Hitler had staged his first public rally after Prussia lifted a ban on his speeches, filling the Sportpalast to bursting point on 16 November 1928. The Nazis had taken their first 13 seats in the City Assembly on 17 November 1929, although the Social Democrats and Communists were still heavily represented. Against this background the international workers' publishing house, Internationaler Arbeiterverlag, brought out a collection edited by Kurt Kläber and Johannes R. Becher. *Der Krieg* (War), the first "people's book of the great war", appeared in September 1929 in an edition of 20,000. The contributors included not only members of the League of Revolutionary Proletarian Writers (BPRS) and international opponents of war such as Sinclair, Barbusse and Rolland, but also writers who had never worked with the international workers' publishing house before, as they had free access to the most prestigious bourgeois companies. Among them were Leonhard Frank, Kurt Kersten, Ernst Glaeser, who had just made a name for himself with *Jahrgang 1902* (Born 1902), Kurt Tucholsky, Walter Hasenclever, Georg von der Vring, who had written the pacifist novel *Soldat Suhren* (Soldier Suhren), Remarque, Oskar Maria Graf, whose memoirs *Wir sind Gefangene* (We Are Prisoners) brought him both fame and hefty attacks from the nationalist camp in 1927, Erich Mühsam, Joachim Ringelnatz, and Bertolt Brecht. The book made a big impact during a time of escalating German re-armament and clandestine production of gas and tanks. Two writers had already paid the price for exposing this illegal arms manufacture, and had called down the reactionary wrath of the police and courts: Becher, who went on trial for high treason after his book *Levisite* (1926), and Peter Martin Lampel, whose play *Giftgas über Berlin* (Poisonous Gas over Berlin) had been banned in 1929. *Der Krieg* was a conscious attempt to boost left-wing calls for a united front in Germany by reaching out to a broad spectrum of writers. There were even contributions from Ernst Jünger and Franz Schauwecker, already regular authors of nationalist war literature, but whose texts contained detailed accounts of the horrors of war.

194

Emil Ludwig's biographies of great men from Goethe to Bismarck made him one of the most successful authors in the Weimar Republic. The photo shows him at his home in Moscia, near Ascona in Switzerland, in 1928.

Writer Arnolt Bronnen made his name in the early twenties with extreme left-wing plays such as *Vatermord* (Patricide), 1920, *Exzesse* (Excess), 1923, and *Anarchie in Sillian* , 1924. In 1930 he switched allegiance to the Nazis for several years, before rethinking his position in the early forties and joining the Austrian resistance. The photo shows him in 1931 after his marriage to Olga Schkarena, who had played a major part in the attacks on the Remarque film *All Quiet on the Western Front* the previous year.

The Literature Section at the Prussian Academy of Arts, founded in 1926, offers the most accurate insight into what might be regarded as the best German writing. Some of its distinguished members were in the limelight in the year that Thomas Mann, also one of their rank, won his Nobel Prize. Jakob Wassermann was as popular as ever and frequently described as the "fashionable middle-class author". *Das Gänsemännchen* (The Gooseboy), the novel he had written in 1915, had been a bestseller. He enjoyed even greater success with *Der Fall Maurizius* (The Maurizius Case) in 1928. This was a novel about a travesty of justice around the turn of the century which made a contemporary appeal at a time when writers and intellectuals were facing increasing persecution by the legal system. A screen version followed. That same year saw publication of his short story *Das Gold von Caxamalca* (The Gold of Caxamalca), a riveting account of the crimes committed by the Spanish conquistadors in subjugating the Incas of South America. Hugo von Hoffmannsthal, still rated as one of the greatest German

writers, was regarded in many senses as a model by Wassermann. Ricarda Huch, whose international reputation was sealed by her history of the Thirty Years' War in *Der grosse Krieg in Deutschland* (Germany's Great War), 1912/14, produced the second of her two volumes of essays in 1929 under the title *Im alten Reich. Lebensbilder deutscher Städte* (In the Old Reich: Portraits of German Towns). Hermann Bahr, the Naturalist playwright and comedy writer who had taken up the Expressionist cause in 1916, published no fewer than three books in 1929: his novel *Österreich in Ewigkeit* (Eternal Austria), the collection of stories *Labyrinth der Gegenwart* (Our Labyrinthian Times) and *Tagebuch 1929* (1929 Diary). Max Halbe, famous for the love drama *Jugend* (Youth), published his play *Präsidentenwahl* (Presidential Election). Bernhard Kellermann, who first attracted international attention in 1913 with his novel *Der Tunnel* (The Tunnel), delivered his views on militarism in 1920 in a novel called *Der neunte November* (November the Ninth). Towards the end of the Weimar Republic he was more concerned with the experiences he had gained on his international travels. In 1929 he published his Asian travelogue *Der Weg der Götter* (Path of the Gods), which was based on his journey to India and Tibet. The great literary democrat Heinrich Mann was appointed President of the Literary Academy in 1930. He was still regarded in Germany as a political essayist *par excellence*. During the year which brought a Nobel Prize for his brother, he published the novellas *Der Tyrann* (The Tyrant) and *Die Branzilla* and a play, *Bibi*. As the new President showed such commitment to salvaging Weimar democracy, three chauvinistically inclined conservatives, Wilhelm Schäfer, Erwin Guido Kolbenheyer and Emil Strauss, were prompted to resign from the Academy in 1931. One of Heinrich Mann's close allies was his predecessor as President, Walter von Molo, Chairman of the Association for the Protection of German Writers (SDS). Although his politics were also basically conservative and nationalist, he joined the ranks of committed bourgeois democrats during the latter years of the Weimar Republic and used his position in the SDS to make an active contribution, partly by co-founding the Emergency Association for German Writing. His novel

Die Scheidung (The Divorce) appeared in 1929. He had acquired his reputation as a writer, however, with a trilogy called *Der Roman meines Volkes* (The Novel of My People). The first volume, *Fridericus*, came out in 1918, reaching its 60th edition by 1920. It ran to three screen versions, in 1921, 1933 and 1937. This success heralded a wave of nationalism expressed in the glorification of Prussia. The second and third volumes, which swam in on this tide in 1922, were *Luise, Königin von Preussen* (Luise, Queen of Prussia) and *Das Volk wacht auf* (The Nation Awakes). The complete set was published in a single volume in 1924 in an edition of 585,000 copies.

One of the most prominent bourgeois writers of those years was Hermann Hesse, who finally withdrew from membership of the Literature Section in 1930 because he rejected the Weimar Republic on principle. The author of *Peter Camenzind* and the novella *Unterm Rad* (Under the Wheel), not to mention the famous anti-war essay of 1914 entitled *O Freunde, nicht diese Töne* (Don't Talk That Way, My Friends), brought out his novel *Der Steppenwolf*, in which he depicted the crisis currently facing the bourgeois writer, in 1927.

Emil Ludwig was one of the Weimar Republic's big success stories. He was widely read, not only in Germany, but also abroad. Almost all his works were translated into over 20 foreign languages. His numerous biographical novels about famous people were especially popular. They included his three volumes on Goethe, *Geschichte eines Menschen* (Story of a Mortal), which appeared in 1920, *Napoleon* (1925), *Bismarck* and *Wilhelm II* (1926), and *Lincoln* (1930). His output ranged from biographies of artists such as Rembrandt and Michelangelo to interviews with famous political figures of his own day. He also wrote plays about countless great men from Bismarck to the Pope. His first autobiography, *Geschenke des Lebens*

Robert Musil, drawn by Benedikt Dolbin, 1929.

A publicity leaflet by the publishers Williams & Co., Berlin, in November 1929 included an advert for Erich Kästner's *Emil und die Detektive* and quoted the following reader's letter: "Dear Mr Kästner, My Mummy gave me your address because I wanted to write to you. My sister and me have read Emil. It was a smashing book. Let me say again the book was very good. Best wishes Hans-Albrecht Löhr."

(Gifts of Life), was published in 1931. Beyond any doubt, Ludwig was a cultivated mind with a sophisticated style and mass appeal, well able to draw commercial advantage from his *Kunst der Biographie* (Art of Biography), as he entitled an essay in 1936 on the subject of his technique. Yet his presentation of history ascribed everything to the role of great men through the eyes of a liberal psychologism. At times Ludwig even went so far as to invent facts to suit his needs. As a result his books were always highly controversial.

The Austrian Robert Musil may not have run into such big editions, but he was renowned among the great names of German literature as a man of outstanding style and an engineer of the human psyche. He established an international reputation with his first, autobiographical work *Die Verwirrung des Zöglings Törless* (The Confusion of the Pupil Törless), which appeared in 1906. He published not only collections of novellas—*Vereinigungen* (Assemblies) in 1911 and *Drei Frauen* (Three Women) in 1924—but also biting subjective dramas of social analysis: *Die Schwärmer* (The Enthusiasts), 1921, and *Vinzenz und die Freundin bedeutender Männer* (Vinzenz and the Important Men's Girlfriend), 1923. These plays were so top-heavy with problems that they were never destined to make much impact on a stage. Musil ultimately expressed his literary creed in his great set of unfinished novels *Der Mann ohne Eigenschaften* (The Man without Qualities), of which the first volume, *Reise an den Rand des Möglichen* (Journey to the Boundaries of Possibility), appeared in 1930 and the second, *Ins Tausendjährige Reich* (Towards the Thousand-Year Reich), in 1932.

Gottfried Benn, who like Alfred Döblin was a Berlin doctor, was an Irrationalist poet who began publishing theoretical works in late 1929: *Über die Rolle des Schriftstellers in dieser Zeit* (The Writer's Role Today) in 1929, *Können die Dichter die Welt ändern* (Can Poets Change the World?) in 1930, *Eine Geburtstagsrede und ihre Folgen* (A Birthday Speech and Its Consequences) in 1931. Benn's esoteric philosophy, which drove him briefly into the arms of the Nazis as an advocate of nationalist renewal in 1933, was already evident in these works. He was admitted to the Literary Academy in 1932.

Two former Expressionists who continued to meet with widespread acclaim throughout the twenties were Kasimir Edschmid, who wrote travel stories, and in particular Franz Werfel. Werfel's claim to fame as a writer of prose dated back to the story *Nicht der Mörder, der Ermordete ist schuldig* (The Murdered Man is Guilty, Not the Murderer) in 1920, and in 1928 the novel *Der Abituriententag*

(Everyday Life of a Sixth-Former) restored him to the ranks of the most widely read authors, although some of this success was undoubtedly due to *Verdi,* the "novel of an opera", which had stolen the market in 1924. Another novel, *Barbara oder die Frömmigkeit* (Pious Barbara), followed in 1929 and became the subject of much critical debate.

One important feature of the Contemporary Novel in the late twenties was the writers' experience of inflation and the world economic crisis and the way which these affected the bourgeois lifestyle. Apart from Döblin's *Berlin Alexanderplatz,* the epitome of this trend, Hermann Kesser's novella *Strassenmann* (Man on the Street) in 1926 and Erich Kästner's novel *Fabian* in 1931 attracted considerable attention. Kästner tells the story of a moralist in satirical account of the intellectual milieu against a background of political conflict generated by the international economic crisis. One reason for the interest it aroused was that the author had reached the peak of his career as a poet of casual social criticism for popular consumption. His anthology of poems *Herz auf Taille* (Heart to Measure), which came out in 1928, had scored a tremendous success, while *Emil und die Detektive* (Emil and the Detectives) was a children's favourite.

Hans Fallada's chronicle of the crisis and its effects on the bourgeois middle classes was *Kleiner Mann—was nun?* (Little Man, What Now?), a novel which appeared in 1932 and was translated into over twenty languages. Fallada made his name with *Bauern, Bonzen und Bomben* (Barns, Bigwigs and Bombs), a novel published in 1930 about the previous year's peasant revolts in Holstein, which he had witnessed first-hand as a journalist for the *Neumünster Generalanzeiger.* Lion Feuchtwanger's novel *Erfolg* (Success), the "three-year history of a province" which came out in 1930, placed him on the list of Weimar's social chroniclers alongside Hans Fallada, Marieluise Fleisser, Oskar Maria Graf, Ödön von Horváth and Leonhard Frank.

Fascist literature was already more or less complete by this time. The front-liners of the nationalist movement met at the "German-Literature Festivals" and "Lippoldsberg Writers' Rallies" organized by Hans Grimm, author of *Volk ohne Raum* (Nation without Space), which had appeared in 1926 and since become compulsory reading for champions of German race and territory. One of the leading lights was Edwin Erich Dwinger, who wrote a trilogy called *Die deutsche Passion* (The German Passion): *Die Armee hinter Stacheldraht* (An Army behind Barbed Wire), 1929, *Zwischen Weiss und Rot* (Between White and Red), 1930, and *Wir rufen Deutschland* (Calling Germany), 1932. Among the rest were Josef Magnus Wehner with *Sieben vor Verdun* (Seven at Verdun), 1930, Werner Beumelburg with *Die Gruppe Bösemüller* (The Bösemüller Group), 1930, Franz Schauwecker with *Aufbruch der Nation* (A Nation Stirs), 1930, Richard Euringer, head of the fascist National Association of German Writers, with *Fliegerschule 4* (Flying School 4), 1929, and notably Ernst Jünger, whose diary of an assault troop leader, *In Stahlgewittern* (Storms of Steel), was serialized from 1920 and enjoyed great popularity. It was followed by essays like *Der Kampf als inneres Erlebnis* (The Inner Experience of Combat), 1922, and *Das abenteuerliche Herz* (The Adventurous Heart), 1929, and also a novel, *Die totale Mobilmachung* (Total Mobilization), 1931. Jünger's writing was not literature as such, but rather an accumulation of specialist reports by an army lieutenant distributed by military publishers which sold relatively quickly due to their literary quality and reached a wide readership as fascism took hold.

Apart from the extreme fascist ideology which occupied certain bastions of literature, the Weimar Republic also saw the publication of works by right-wing conservatives which were to be absorbed into the Nazi movement. Oswald Spengler opened fire in 1922 with his book *Der Untergang des Abendlandes* (Decline of the West), which was supplemented in 1924 by his *Neubau des Deutschen Reiches* (Rebuilding the German Empire). Other specimens of this kind were Arthur Moeller van den Bruck's *Das Dritte Reich* (The Third Reich), 1923, Edgar Jung's *Die Herrschaft der Minderwertigen* (The Rule of the Inferior Men), 1927, and Hans Freyer's *Revolution von rechts* (Revolution from the Right), 1927.

Liberal bourgeois literature appealed above all to the residents of Germany's cities, of which there were 45 in-

cluding Berlin and Hamburg with over a million inhabitants each. Out of the population of 63.2 million, 27 per cent were city-dwellers, 37 per cent lived in small towns and 36 per cent in rural communities with fewer than 2,000 inhabitants. Although there was a sizeable readership for Nazi literature in the cities, too, it was the "provinces" beyond, where nationalist and conservative voters prevailed, which provided the Nazis with a proper hinterland for their "cultural" offensive. This initiated the aim, at the party's Nuremberg Conference in 1929, of "winning the creators of intellectual wealth".[136] Alfred Rosenberg, author of *Der Mythos des 20. Jahrhunderts* (The 20th-Century Myth), published in 1930, set up an organization in 1927 called the National Socialist Society for German Culture, which changed its name in 1928 in favour of the less deceptive Fighting League for German Culture, and which sought to recruit intellectuals for the Nazis.

This places the work of the League of Revolutionary Proletarian Writers (BPRS) in a more significant light. It was founded in 1928, and its membership had grown to about 350 by 1930 and 500 by 1932. Johannes R. Becher, Ludwig Renn, Alexander Abusch, Kurt Kläber, Andor Gábor, Paul Körner-Schrader, Recha Rothschild and Berta Lask were among the founders, and over 20 branches were set up across Germany. The League not only contributed a great deal to the emergence of socialist literature in Germany, but also initiated a broad movement of working-class correspondents, which gave birth to many a new literary talent. The League's magazine, *Die Linkskurve*, offered practical and theoretical guidance and published much of this writing, which percolated via KPD newspapers and journals from the cities into the industrial conurbations and even into the rural communities. This broad movement of working-class culture functioned as a counterweight to the fascist offensive, and did much to obstruct the Nazi advance into the world of the arts during the final years of the Weimar Republic.

Hans von Wedderkop, editor of the exclusive literary magazine *Der Querschnitt*, responded in late 1929 to a pamphlet by Rudolf Borchardt called *Die Aufgaben der Zeit gegenüber der Literatur* (The Duties of Our Times to Literature) by taking stock of the contemporary German scene: "Borchardt scolds or, rather, warns us with pathos against the false image of the times, that image of the times which tempts the average writer to experiment. It is a strange thing about that image of the times. Hardly any of us see the same image of the times, and yet any one of us who is at all sensitive trembles whenever he finds that suddenly he has grasped one of its more pronounced features quite clearly, it does not matter where: in a crowd, alone, in a salon in the Tiergarten district or out on the Hasenheide . . . And yet it would be much too easy to reject it out of hand or approach it with distrust from the start, and it would be just as wrong as imagining that anything new can only be born in proletarian circles, a view which seems particularly ridiculous in a country like Germany, for Germany is the land of the centre, with as many proletarians among its upper strata as there are aristocrats of the mind lower down."[137]

Wedderkop's argument was typical of a large section of bourgeois intellectuals around 1930, when they still believed that they would be able to preserve their liberal stance between the parties. Attempting to describe the "image of the times" from somewhere in the middle was basically a way of avoiding the political decision that was now demanded. The essential error committed by intellectuals like Wedderkop was that, when they considered the working class, they were influenced by bourgeois clichés, rather than taking a serious look at the proletarian standpoint.

"Every chance for talent!"—
The fight for secular education

A lengthy debate on education and the arts preoccupied the Prussian Assembly during the last few days of January 1933. The right-wing parties had brought a motion demanding yet another ban on secular schools in Prussia. The main target of this attack were 20 or so Free Education experiments in and around Berlin. Some of these were autonomous community schools, while others consisted of special classes for talented pupils at a number of state elementary schools in Berlin. They had been set up by Social Democratic educationalists keen for reform, often working closely with Communist teachers and children's parents. Once more, a provincial parliament was the scene for a farcical education debate. In fact, there should not have been any need to discuss the issue of secular schooling, as it was guaranteed as a basic right in the Weimar Constitution of 1919, like the right of children from non-worshipping homes not to attend Religious Instruction. This right was only respected at 47 of Berlin's 589 elementary schools, which had been set up without R.I. lessons specifically for the children of "free thinkers", mostly politically active workers, with the intention of isolating them from the majority of Berlin schoolchildren. The schools of Berlin and a few other regions of the country where the working class was well organized, such as the Ruhr and Central Germany, were considered to be especially progressive. On the whole, education in the Weimar Republic was still under the influence of the old teachers and administrators who had served the Kaiser, and of the right-wing conservative parties, who by this time were making common cause with the Nazis.

Thus it was that in 1933 the Protestant League printed a fourth edition of its pamphlet *Der Kulturbolschewismus und die deutsche Jugend* (Cultural Bolshevism and German Youth). The author, Consistory Member Karl Foertsch of Stettin, had jumped on the bandwagon with hundreds of other politicians in this field and adopted the demagogic slogan "Fight cultural Bolshevism!", which was echoed in similar polemical articles, aimed at the education world, where the reforms advocated by individual Social Democrats and the KPD's campaign for a socialist school system were simply excommunicated. The concluding lines of this tract by Foertsch contained an attack on KPD arts and education policy which might have been written by Joseph Goebbels: "The state of cultural Bolshevism in Germany today presents the following picture: The C. C., or Central Committee, has gained a foothold in the German cultural arena, which was originally governed completely by the great cultural pivots of state and family, Church and school, art and science. (. . .) The all-out attack on the former cultural pivots, on the great cultural arena of the German nation has begun. If this all-out attack leads to victory, German culture will collapse and destruction will take over. Soviet Germany will then be born out of the ruins of the German Reich, and cultural Bolshevism will tower in completed form over the grave of the German species. Whether or not we come to this pass depends solely on whether the German nation will awaken at the eleventh hour and take up a resolute defensive struggle against cultural Bolshevism."[138]

During the debate in the Prussian Assembly the NSDAP deputy Meister invoked German and Christian values as the foundations of education and culture. He ended his speech by saying: "There is only one Lord God up above and only one German leader: Adolf Hitler."[139] With that provocative statement he simply dismissed a debate about the legal definition of state education which had been caught up for fourteen years in a constant tug-of-war between secular and religious schooling. By this time, however, the argument was really no longer relevant. KPD delegate Kerff told the Prussian house, in a speech addressed primarily to the Reichstag, that Weimar's politicians had wasted so much time on tactical compromises that they had paved the way for fascism to take over the education system. He described the pronounced militarization of schools as a particularly distressing symptom. And not only was the military parade flourishing, but fascist youth organizations were expanding their influence, especially in the elementary schools, as a result of propaganda and personal example. The Nazis were luring children into these organizations where murder and intimidation were drummed into them as tests

62 Kiepenheuer published a children's book by Brecht called *Die drei Soldaten* (The Three Soldiers) in 1931. The illustrations were by George Grosz. This book came as a sharp contrast to the new wave of chauvinistic war literature, ruthlessly exposing the horrors of war. "The book is intended when read aloud to provoke children to ask questions," Brecht wrote in his introduction. It was followed by Grosz's title drawing.

63 Georg Kaiser was the most-staged playwright of the twenties. This prolific writer penned over forty dramas from his home in Grünheide near Berlin. The photo shows him in his garden in 1930.

64 Ferdinand Bruckner (whose real name was Theodor Tagger) founded the Berlin Renaissance-Theater in 1923 and managed the house until 1930. He wrote some of the most successful plays of that period about contemporary issues, including such effective theatrical works as the socio-psychological dramas *Krankheit der Jugend* (Diseased Youth), 1926, and *Die Verbrecher* (The Criminals), 1928, as well as a historical play *Elisabeth von England* (Elizabeth of England), 1930. The photo was taken in 1931.

65 The poems and essays of Gottfried Benn, a doctor by profession, exemplified the powerlessness and isolation of bourgeois intellectuals. *Nach dem Nihilismus* (After Nihilism) appeared in 1932. The following year he offered his services to the Nazis, only to be dismissed as "degenerate" from 1937. He is seen here at his Berlin surgery in 1932.

66 *Der Mensch ist gut* (Man is Good) was a collection of novellas which brought fame to Leonhard Frank in 1917. His "Würzburg trilogy"—*Die Räuberbande* (The Gang), 1914, *Das Ochsenfurter Männerquartett* (The Ochsenfurt Male Quartet), 1927, and *Von drei Millionen drei* (Three out of Three Million), 1932—was a chronicle of the Weimar Republic. Some of his brilliant prose was adapted successfully for the stage, e.g. *Karl und Anna* from 1928 onwards. The photo dates from 1929.

67 Klabund (real name Alfred Henschke) died of tuberculosis at Davos in 1928 when he was only 38. He was a versatile writer who produced historical novels, plays, poetry and even a literary history, but it was above all his poems and chansons—*Die Harfenjule* (The Harp Jule), 1927, which captured the twenties spirit so aptly. This photo was taken in 1920.

68 Rudolf Schlichter painted Egon Erwin Kisch, the father of modern journalism, in 1927/28. The setting is an imaginary advertising column outside the Romanisches Café, and two of the posters draw attention to the two publishing houses which had edited collections of his writings: Erich Reiss and the Neuer Deutscher Verlag. Like George Grosz, Schlichter was one of the major political painters and cartoonists whose work became a chronicle of the years from 1918 to 1933. Städtische Kunsthalle Mannheim

69 Curt Querner, who came from Börnchen on the outskirts of Dresden, was a highly talented painter. As a young man he championed militant proletarian art. *Demonstration*, 1930, displays an intense social accuracy. The painting reflects the polarization of political forces in 1930 without any attempt at blatant propaganda. Staatliche Museen zu Berlin, Nationalgalerie/Otto-Nagel-Haus

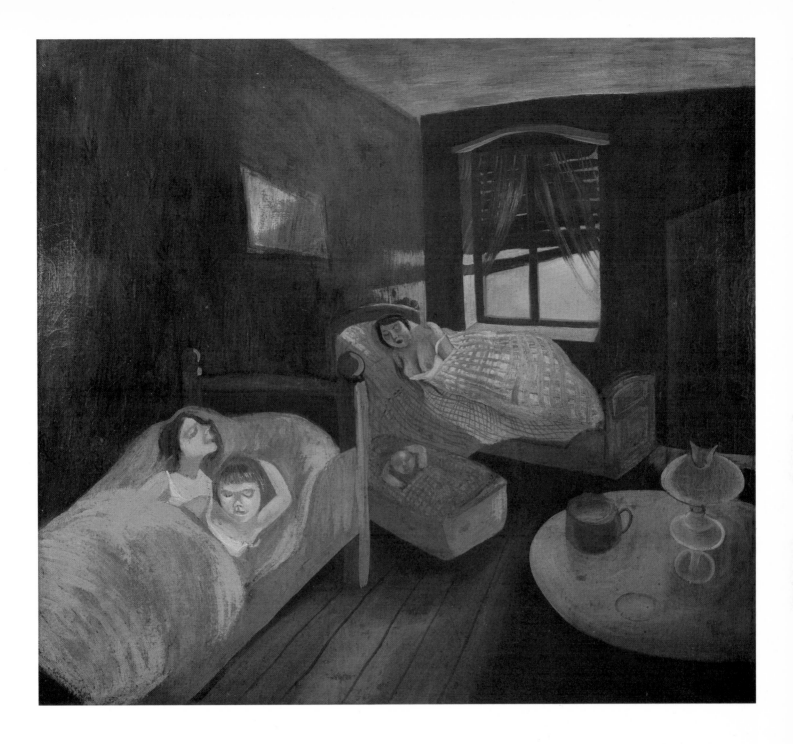

70 Hans Grundig's painting *Schlafkammer* (Bedroom) dates from 1928
The artist was a co-founder of the Dresden "Asso" in 1930. Staatliche
Museen zu Berlin, Nationalgalerie/Otto-Nagel-Haus

71 Walter Trier designed the cover for a travelogue by Thomas Mann's children Klaus and Erika published by Piper of Munich in 1929. It contained original illustrations by Henri Matisse and Rudolf Grossmann. There were 19 books by prominent authors in the series *Was nicht im Baedeker steht* (What Baedeker Doesn't Tell You). Hans von Wedderkop, the editor of *Querschnitt* wrote about Paris and London, Hans Reimann about Frankfurt am Main and Leipzig, Herbert Eulenberg about the Rhineland, and Eugen Szatmari about Berlin.

72 Ruth's cover for a collection of radio plays by Friedrich Wolf, which were published by the Deutsche Verlagsanstalt in Stuttgart in 1930, betrays the powerful influence of John Heartfield's photomontage covers for Malik. The face of millionaire Rockefeller, the protagonist in *John D. erobert die Welt* (John D. Conquers the World), suggestively dominates the design.

73 The *Arbeiter-Illustrierte-Zeitung (A-I-Z)* in its familiar copper gravure style offered more than a clear-cut political message: it also set trends for a new aesthetic category, montage of pictures and text. This title page, taken from No. 41, 1929, demonstrates the strong emotional appeal which lay-out can make in an illustrated magazine. From 1928 onwards *A-I-Z* published regular photomontages by John Heartfield commenting on topical politics.

74 In many smaller communities off the electoral campaign map, speeches by prominent party politicians were played to branch meetings by gramophone. This SPD election disc of 1928 contains a speech by Toni Sender, editor of the SPD women's magazine *Frauenwelt*, an SPD member of the Reichstag who belonged to the party's left-wing opposition grouped around Siegfried Aufhäuser and Max Seydewitz.

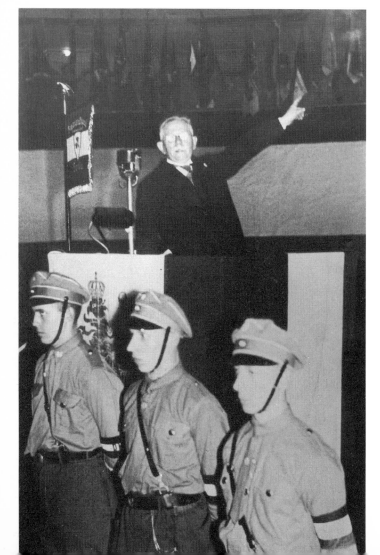

75 Wilhelm Külz of the German Democratic Party and Prussia's Minister of Culture Adolf Grimme (SPD), seen here leaving the Reichstag after the dissolution of Parliament in July 1930, were Weimar democrats. Grimme's progressive policies on education and the arts made him a hated opponent of the National Socialists, and he was "replaced" by solid Nazi Bernhard Rust immediately after the fascists seized power.

76 The political struggle in Germany polarized in 1930. Berlin's Sportpalast became the scene of enormous rallies staged by the leading parties. The photo shows Alfred Hugenberg, Chairman of the German National People's Party and co-founder of the Harzburg Front, during his speech on 7 March 1932.

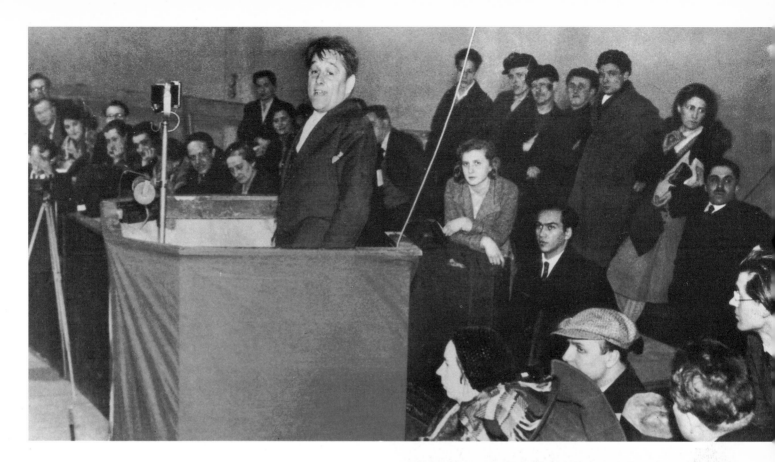

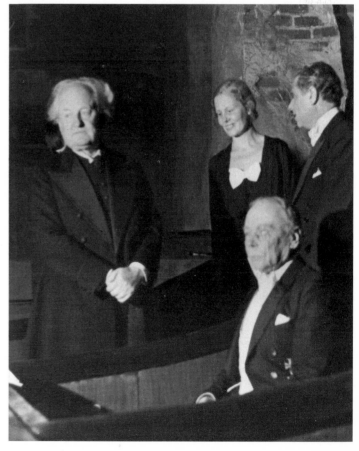

77 The KPD and International Workers' Aid had held a rally in the Sport-
palast only four days previously, when Willi Münzenberg spoke to 6,000
supporters.

78 Artists' Winter Aid was a campaign launched in Berlin in 1930 to help
the hungry and homeless. Max Reinhardt's company also gave a Benefit
performance. The photograph, taken in November 1930 at the Grosses
Schauspielhaus in Berlin, shows (left to right) playwright Gerhart Haupt-
mann, actress Helene Thimig (Reinhardt's wife) and Max Reinhardt. In
the box is one of the Republic's highest-ranking officers, Lieutenant-
General von Seeckt, Reichswehr commander and Chief of Army Com-
mand from 1920 to 1926. His memoirs, *Gedanken eines Soldaten*
(Thoughts of a Soldier), 1928, were a specimen of reactionary war litera-
ture.

Following page:
79 John Heartfield produced this famous poster for the Reichstag elec-
tions in May 1928.

of virile courage. The toys that the Hitler Youth played with were knives, knuckledusters, ropes and whips. The big dream was a pistol, like the ones carried by the SA men who served as role model. The fascist youth leaders used heroic myths, the romance of adventure, their idol of a *Führer* and an unconditional code of group honour and loyalty to trap many boys who yearned to become a "strong German" or "warrior hero", not least because of the kind of history they were fed on in class. Fascist children's books carried on where the teachers left off. One favourite was *Hitlerjunge Quex* (A Son of Hitler) by Aloys Schenzinger, which began to invade the bookshops in 1932. It was a book oozing with noble sentiments, in which a kindly SA man offers moral assistance to a boy still loath to oppose his Social Democratic father and join the Hitler Youth. His paternal friend from the Nazi militia naturally helps him to resolve this crisis of conscience. Shoulder to shoulder with his new companions he performs heroic feats, before the author deems him worthy to die for the "movement".

Reactionary ideas had long been reincarnated at high school. In 1921/22 German essays still had titles like "What qualities are shown to be typically German in the ancient sagas?" or "What comfort does history offer the German of today?", but by 1930/31 these had been replaced by "Native roots, tradition and history as the pillars of national spirit" and "Germany's right to land among the world's nations".[140] Fascist ideology was only one small step away from this blend of chauvinism, Teutonic pride and racialist aspirations to territory, which was by no means the exclusive domain of the National Socialists.

When the Weimar Republic met its death on 30 January 1933, the right to universal education laid down in the Constitution had still not been reflected in any government legislation on schools and training. Every draft law had been defeated. The government education authorities ended as they had begun in a morass of compromise.

In 1918 the Social Democrats had taken office with the firm intention of presenting the future Republic with a Marxist plan for education, that had sprung from efforts for reform since the turn of the century. In November of that year Adolf Hoffmann (USPD) and Konrad Haenisch (SPD) had removed the clergy's right to function as high school overseers in Prussia. In the Weimar Republic every child was going to attend the same kind of secular school with the same educational opportunities. There were many similarities between the aims of the Social Democrats and the ideas of progressive bourgeois educational reformers which had been taking shape since the turn of the century. The new education concept was promoted by a movement for the rights of children, with its slogan "Every chance for talent", and by supporters of Pestalozzi's demand for the development of child personality who had been working on the practical applications of this principle. Georg Kerschensteiner, for example, defended education for work as a healthy principle which prepared children for later life, while Gustav Wyneken argued that the formation of intellectual personality in young people equipped them to become aware and active citizens.

Konrad Haenisch declared exuberantly in January 1919: "Let it be no more a stigma for the minister's son to become a shoemaker than it will be out of the ordinary for a shoemaker's son to become a minister. That is what we mean when we talk about the social equality of manual and mental labour."[141] However, all that remained of a democratic education system which set out to achieve these demands was a legal stipulation of eight years' compulsory schooling and the introduction of a four-year primary school for all children aged 6 to 10. The Social Democrats' plans for a standard school type with a curriculum set by the government to educate all children in the Republican spirit foundered when the newly elected National Assembly started to draw up a Constitution. It proved impossible to win the most important, fundamental demand that Church and state power should be separated, as stipulated in the draft Constitution. The Centre Party was only prepared to consent to a signature of the Versailles Peace Treaty if this clause was removed, and under this pressure Ebert agreed to reformulate Article 146. It evaded the fundamental problem by the following wording: "The public education system shall be established organically. Secondary and tertiary education shall be based on a universal primary school. The structure shall be determined

by the diversity of vocations, and a child's admission to any school shall depend on his or her ability and inclination, not on the economic and social status or religion of the parents.

"Legal parents and guardians within a community may petition for the establishment of elementary schools in accordance with their religious or philosophical views insofar as this does not prejudice regular education . . ."[142] This compromise sealed the destiny of the education system and left the door open for the traditional class differences. The right-wing parties had hidden behind religion to ensure their own political influence on schooling in the Republic and to protect their monopoly on education. Apart from these religiously affiliated schools which the government financed, there were still private establishments, although they were rarely mentioned in public. These schools were well equipped with the best teaching materials, their staff were especially qualified and also better paid, and the classes were smaller. They enabled the children of the wealthier bourgeoisie to preserve their exclusive environment. In 1927 the composition of state schools was as follows: 28,570 Protestant schools, 15,216 Catholic schools, 121 Jewish schools and, by comparison, merely 8,413 of the community schools which had actually been defined in the Constitution as the initial building bricks in the education structure.[143] The secular schools were so few, and even dwindling in number, that they made no impact as an alternative to religious schooling. These rare experiments barely scratched at the surface of education in Weimar. Like the socialist republic, they never materialized. The bourgeoisie had rescued their educational privileges and with them the bourgeois spirit.

As the government had not produced standard legislation, provincial governments enjoyed an autonomous influence over their schools. The character of education depended on the current state of local politics. Every province had its own education authority, which also meant that there was no co-ordinated national approach to the curriculum. There was a whole gamut of text books of every political shading to cater for the tastes of each bourgeois party. Progressive educationalists defended their views

amid this chaos in a variety of organizations such as the German Teachers' Association or the League of Free German School Societies. The League of Resolute Education Reformers led by Paul Oestreich made a particular impact because it was the only body whose educational aims went beyond the slow attempts at piecemeal reform and traced the problems back to the basic issues of class conflict. The League worked closely with Communist politicians who had a special interest in education and who were defending the democratic rights guaranteed in the Constitution with the help of parents' committees, pupils' councils and Communist children's organizations. Edwin Hoernle, one of the KPD's best-qualified educationalists, wrote in one of his leaflets: "The battle for education should not be waged under the slogan: secular schools or Christian schools . . . Separating education from the Church is only one demand among several. Nor is it the 'will of the parent', that is, the individual parent, which should be decisive, but the will of the proletariat as a class as embodied in its class organizations."[144]

Progressive educationalists of Social Democratic or bourgeois persuasion who fought for democratic schools supported this campaign with a number of practical experiments. These later won the Weimar Republic a reputation for extremely liberal education policy, but in fact the reason why they deserve special attention is that they constituted the democratic remains of what had once been an ambitious project.

Wherever there was a strong labour movement in Germany, teachers and individual politicians had attempted to improve the educational opportunities offered by the state elementary schools by applying to local councils and provincial parliaments with a Social Democratic majority for permission to establish special classes for talented children. Gifted pupils who were unable to attend a grammar school or intermediary school after four years of primary education thus had a chance to spend the next four years acquiring a more substantial schooling which should help them on their way to a career in a practical field. In some areas special schools of this kind were opened, one aim being to preserve a political influence over the local youngsters for longer. In Berlin, the pro-

Kurt Löwenstein was one of an SPD group pressing for progressive education reforms, and Chairman of the "Reich Working Party of Children's Friends in Germany". This copy of his 1931 pamphlet was once in the library at the trade union centre, but the Nazis had it stamped "invalid" in March 1933 and withdrawn from the library as part of a "cleaning up" operation.

Edwin Hoernle, a co-founder of the KPD and member of the Reichstag from 1924 to 1933, was the Communists' major spokesman on education policy during the Weimar Republic. Photo taken 1932.

gressive Social Democrat Kurt Löwenstein combined this practice with the old Social Democratic idea of a School of Labour. He based his model of an integrated education system from the elementary school up to pre-university study on this principle of progressive education for work, and founded the Karl-Marx-Schule in Neukölln. It included a unique and interesting project for inviting young workers already earning their living to join classes which would prepare them for the pre-university examination, the *Abitur*, otherwise catered for by grammar schools exclusively.

This idea of education for work was an important factor in bourgeois experiments, too. In 1906, for example, Gustav Wyneken had founded his Free School Community in Wickersdorf near Saalfeld. It was a boarding school, where all matters relating to lessons and general education were decided independently by the teachers and pupils themselves. Like other ventures of its kind, Wickersdorf was co-educational, with girls and boys sitting together in the same class.

Lessons, which were known as "educational work", were built up according to a schedule of creative self-education for work geared to the various age groups. There was a considerable idealist strain to the concept, which stressed intellect and nature. The practical skills required by crafts and agriculture were fostered, but at the same time the community principles were predominantly elitist, as every member of the school was encouraged to feel destined for intellectual leadership. The Free School in Stuttgart set up by the anthroposophist Rudolf Steiner followed a similar course, and aimed to return children to their bourgeois families with a fresh intellectual spirit. There were other, far more practical enterprises with a more realistic, progressive tone to their ideology and politics, such as the Farm School on Scharfenberg Island near Berlin, a boarding school which consciously fostered gifted children and offered them the chance to choose freely between the natural sciences and the humanities. No marks were awarded. School-leavers were examined to establish the overall standard of their theoretical and practical maturity.

These "free school experiments", as they were bracketed together, were never more than attractive exceptions to the rule. Socially acceptable models could not be achieved by means of minor reforms. If the educational aims of the Weimar Republic sometimes showed signs of more tolerant liberalization, this was due primarily to modern industry and the demands of the economy, for now even workers were increasingly called upon to demonstrate specialist skills. As a result, the government subsidized evening classes and colleges of further education. Adult education offered most sons and daughters of the working class the opportunity to improve their qualifications. The Mayor of Nuremberg made no bones about this objective at the Reich Education Conference in 1920: "I think that we must be much clearer than we have been until now that we must integrate our entire educational policy into the great tasks facing Germany in its economic and moral reconstruction. This tells us that individual

ability alone cannot govern career choice, but that we must also consider the question of which skills we require . . . This factor is being completely overlooked . . . What we need today, if I may be so crude, are 50 per cent unskilled and semi-skilled workers. Our educational policy must be oriented towards creating these resources."[145]

"All Quiet on the Western Front"— Dr Goebbels's Great Battle

The witty headline "Huhu" which appeared in Joseph Goebbels's Berlin newspaper *Der Angriff* on 17 July 1930 drew attention to the following article: "The 'Committee to Fight Censorship' has sent an open letter to Minister Frick. Rumour has it that when Frick received this dispatch he began trembling with fright; he apparently feared in earnest that the National Socialist movement would never survive this dreadful blow. Oh, yes!

"This 'Committee to Fight Censorship' really exists. Only ridiculous ignoramuses have failed to note its existence until now. It is composed of a thousand pieces of headed notepaper, the same number of envelopes and a telephone number (Lützow 8430). And so that every citizen of this country will realize what a tremendous force has suddenly taken up arms against Frick, the names of the pompously intellectual organizations which are affiliated to this committee are printed on the notepaper. 17 net! They include: Academy of Arts, umbrella organization of film-makers, Company of German Stage Workers, Goethe League, Association of Berlin Theatre Critics, Association of People's Theatre Clubs, Association of Aesthetic Publishers, Association of German Radio Critics, Music Critics, Art Critics, etc."[146]

The Weimar Republic's dictatorial judiciary had already begun suppressing every breath of politically committed art with bans and court cases. The Committee to Fight Censorship, an ad hoc alliance of democratic intellectuals opposed to emergency legislation, was protesting in its letter about the ban on Friedrich Wolf's play *Cyankali* in Thuringia, after it had already been withdrawn from circulation in Berlin thanks to a furore provoked by rabble-rousers. Entering the provincial government in Thuringia had given the Nazis a terrific boost. Wilhelm Frick as the local Home and Education Minister was doing exactly what his *Führer* wanted, as he demonstrated with his notorious Decree "Against Negro Culture: For German Tradition" on 5 April 1930. By December 1930 he produced a list of books which was now used to "purge" the libraries—the same books as those which the Nazis were eventually to burn. Their local success in the field of culture encouraged the Nazis to present the Reichstag with a draft law to "protect the nation" in March 1930. Later, on 28 February 1933, this same document was declared an emergency law by the fascists. Although the Republican Reichstag rejected it in 1930, Weimar's reactionary judiciary had been operating one of this paper's most striking principles for a long time: "Whoever undertakes to distort or subvert German traditions and German culture, particularly German customs and morals, or to expose these to foreign influences, is guilty of cultural treason and . . . subject to imprisonment."[147] The editors of Communist and left-liberal newspapers and magazines were taken to court, daily newspapers were prohibited for weeks on end, writers were prosecuted and, more recently artists, too, at which point democratic concern broke out into fury. The trial against George Grosz and Wieland Herzfelde, which had begun in 1928 on account of a number of drawings in the folder *Gott mit uns* (God with Us), developed into a fully-fledged legal scandal. It was the best publicity that George Grosz could have hoped to experience for his anti-war prints, of which the crucified *Christus mit der Gasmaske* (Christ with Gas Mask) in particular prompted the charge of blasphemy, but above all the case revealed a great deal about the administration of justice in the Weimar state. What was so rare about these proceedings was that a democratic judge, the senior district judge Siegert, refused to accept the ruling of a superior judicial authority that was seeking to make an example of the case. There was a series of appeals, at which he kept pronouncing the accused innocent, but the Supreme Court of the Reich had not the slightest intention of giving way and blatantly perverted the course of justice. The trial was still not over in 1932. After 30 January 1933

the Nazis resolved the issue in their own manner. Grosz and Herzfelde had gone into exile, and the controversial prints were withdrawn, like any other progressive art, for the next "thousand" years. This was only one instance among many of the common cause which already bound the fascists and the reactionary judicial apparatus during the final years of the Weimar Republic.

Joseph Goebbels, the "conqueror of Berlin", recognized this concurrence of interests and thus rated his chances highly when he launched a huge militant propaganda campaign in December 1930 to demonstrate the power of the National Socialist movement in a big public display. The pretext was *All Quiet on the Western Front*, an American film based on Remarque's successful book that had been directed by Lewis Milestone for Universal Pictures. It was one of the first films to be dubbed, so that apart from running in the United States and Britain it had been released in France amid great acclaim. The German première was at one of Berlin's biggest cinemas, the Mozartsaal on Nollendorfplatz, on 4 December 1930. Laemmle, who produced the German version, had cut all the footage which showed particular cruelty on the part of German soldiers or officers, so as not to jeopardize the box-office success he anticipated in Germany. The first reviews which appeared in the liberal press therefore emphasized the impressive battlefield scenes as being the notable achievement of the film. Herbert Jhering commented in admiration "how this American adventure movie imposes its own discipline of remorseless battle images."[148] Like many others, he summed it up as an unambiguous anti-war picture, without any hint of the hostility to Germans which the conservative right wing had claimed for it before it was ever released in Germany. Their condemnation of the film was the result of anger that Remarque's book had met with such popularity, so that it was outlawed, not only by the Nazis, but also by more conservative nationalists. To detract from the novel's success they had written and published hundreds of nationalist works. In fact, the hysteria was so great that some publishing companies had even advertised in magazines for authors of true German war novels and promised them immediate big editions. Apart from that there were books

intended specifically as an antidote to *Im Westen nichts Neues*, some of them just as long as the original, such as Gottfried Nickl's *Im Westen nichts Neues und sein wahrer Sinn* (All Quiet on the Western Front and Its True Meaning), which was published by Leopold Stocker of Leipzig and Graz in 1929 and reprinted in an extended edition the following year. According to the publicity blurb: "This anti-Remarque brochure is irresistibly convincing. The scales fall from the reader's eyes! The brochure sells easily. Constant, growing sales . . . Anyone who reads Remarque's book is a potential customer. Review copies of the new edition are now being sent free of charge to 2,500 German newspapers, so that it will be drawn to the attention of the public at large."[149] Wilhelm Müller-Scheld's *'Im Westen nichts Neues' eine Täuschung* ('All Quiet on the Western Front' A Deception) also came out that year. Another response was Otto Strasser's long essay *Vom Sinne des Krieges* (The Sense of War), which was published in the Nazis' green-backed *NS-Briefe* series in 1930. A certain Dr Hermann Heisler attempted to mediate in 1929 between the militant advocates of war and the democratic pacifists. His book, published by a Christian society in Stuttgart, was called *Krieg oder Frieden* (War or Peace), with "marginal notes on Remarque's book". Max Joseph Wolff used the pseudonym Emil Marius Requark to publish a parody of militarism in 1929 entitled *Vor Troja nichts Neues* (All Quiet Outside Troy), which plagiarized entire passages from Remarque's novel. Remarque's brand of pacifism also found its opponents among left-wing liberals, who regarded it as dangerous escapism at a time when the Reichswehr was busy with its secret re-armament programme. Among them was Mynona, who delivered a direct personal attack on the successful author in 1929 in a tract called *Hat Erich Maria Remarque wirklich gelebt?* (Was Erich Maria Remarque a Real Person?).

The American film was thus caught up in a complicated exchange of fire which was only partly about Remarque and partly about the conflicting principles of democracy and militarism. The Nazi *Völkischer Beobachter* wrote on 6 December: "This screen product is quite simply an appeal to the lowest instincts a human being possesses, his

cowardice and egoism, his animal baseness. Not to mention the unbridled scorn poured on faithful soldiers of the front, conveyed to posterity in infamously distorted images.'' Joseph Goebbels and his entourage attended the 7 o'clock performance that day in the cinema on Nollendorfplatz. Goebbels, as he later insisted, had only come to establish the facts for himself. The Nazis staged a riot, with a chorus of whistles, stink bombs and assaults on members of the audience. A woman called Olga Schkarena, who married Arnolt Bronnen the following year, made a name for herself by letting loose white mice amid the excitement, much to the delight of her companions. The police stopped the showing and cleared the cinema. When the late performance began the square outside was already filled with Nazis. The riots inside began all over again, and the crowd, even non-Nazi ticket holders, were driven out with rubber truncheons. For the next few days the Nollendorfplatz resembled an army encampment. Underground trains would not stop at the station. The Police Commissioner, who had allowed the film to continue after talks with the Home Ministry and the head of the political police, placed several hundred officers on duty around the cinema to protect cinema-goers from Nazi attack. The hour had struck for Joseph Goebbels's great battle. On 8 December *Der Angriff* called for a big rally on Nollendorfplatz and summoned at least 100,000 Nazi supporters to take part in the demonstration. Although not quite that many turned up, the protest was no less thorough, and it was repeated in the days which followed. Although the police did attempt to break up the crowd and actually arrested 10 or 20 of the scandalmongers every now and then, an absurd response by comparison with the disruption and violence they were causing, they did not intervene to the extent that they usually did at Communist events. This helped the ''outraged German soul'' to have its way over this ''disgraceful film''. From 8 to 10 December Saxony, Thuringia, Brunswick, Bavaria and Württemberg all banned showings of the film and applied to the censors to withdraw its certificate. Their demands were reinforced by protests from the Ministry of Armed Forces, the nationalist Kyffhäuser League, the Reich Home Office and the conservative press, whose front

Nazi caricature of Remarque in the NSDAP's satirical weekly *Die Brennessel* of 20 April 1932. "The Face of Democracy" was a regular column from 1930 onwards which printed defamatory portraits of opponents. The comment on Remarque was: "Erich Maria Remarque came out of the War with nothing but a small pile of bullshit which the new Germany enabled him to convert easily into those millions on which he is now seeking to evade paying tax to his beloved homeland."

Right:
Carl Laemmle, head of production at the American Universal Film Corporation, in conversation with Erich Maria Remarque during preparations for shooting *All Quiet on the Western Front* in 1929.

pages were bursting with headlines about the riots in Berlin. Shamefully enough, Goebbels's part in instigating the campaign was played right down. He had been in almost permanent attendance in his luxury car. The right-wing newspapers poked a little fun at the violence, but added for the most part that there was no proof that any National Socialists were really involved. Their underlying tone was sympathetic to the rioters, for Goebbels's display suited

them perfectly. When the Berlin Police Commissioner banned all demonstrations in Berlin from 10 December, it was denied that the measure was aimed basically at the Nazis as there had never been more than 6,000 people gathered on Nollendorfplatz, but argued that although the demonstrators had been so few in number the peace had been disturbed, which was not a healthy state of affairs in a cosmopolitan city. The riots were a convenient excuse to prohibit Communist rallies which had already been announced to protest against war preparations in Germany.

The German National People's Party (whose Chairman Alfred Hugenberg made an appeal to Chancellor Hindenburg immediately after the film's première urging him to support the campaign for a ban) vociferously cheered by the Stahlhelm and the League of German Officers, also presented a motion to the Reichstag insisting that the government should ban the picture throughout Germany. But a Cabinet majority voted not to include the motion on the house agenda. Consultations would have led to an alliance between the government of the Reich and the Na-

tional Socialists, and that would have placed the German Republic in a macabre light abroad. A few supporters were recruited from the other parties, including General von Seeckt, who defied his German People's Party whip.

The film censors banned the film on 11 December for "threatening Germany's standing". Prussia was the only province to oppose this decision. As a result the Remarque affair assumed such dimensions in Berlin that it was debated in the Prussian parliament. On 12 December the *Neue Preussische Kreuz-Zeitung* reported: "Minister Severing and several members of the Prussian Cabinet accompanied by a large number of high-ranking officials in the Prussian Home Office and the Berlin Police Headquarters as well as police officers attended a special showing of the film *All Quiet on the Western Front* at the Mozartsaal on Thursday morning. The American version was shown.

"Among those present were the Prussian Prime Minister Braun, Prussian Home Minister Severing, Cultural Minister Grimme, Berlin Police Commissioner Grzesinski,

Police Commissioner Weiss, Colonel Heimannsberg who commands the Berlin police force along with about a hundred police officers, Permanent Secretary Badt from the Prussian Home Office, Permanent Secretary Weismann and many other civil servants from the Prussian Home Office, as well as several Members of Parliament. Our sources suggest that after viewing the film the Prussian Home Office is not of the opinion that even the American version is an incentive to hostility."[150]

The German Nationals in the Prussian Assembly therefore placed a vote of no confidence in Home Secretary Severing and Prime Minister Braun. The Nazi delegates did not say a word during the debate on 16 December. They sat back and relished the sight of their first great battle, which was aimed less at the film than at the Republic itself, as it developed into a government scandal, even if at first only the Prussian government was affected. On the evening of 16 December the *Deutsche Tageszeitung* gave the story front-page coverage: "There were turbulent scenes when the resolution was placed before the house. When DNVP delegate Schwecht spoke the Social Democrats gave way to gentle fury, which continued in the arguments of soc. del. Kuttner from the platform. This well-known valiant 'turncoat Spartacist' permitted himself the luxury of a very pompous speech about the honour of the German soldier, demonstrating at the same time, however, by extolling this malicious film, that he has no idea what he is talking about. Government party del. Nuschke naturally defended the film, whereas del. Schröder of the People's Party and Economy Party del. Hestermann sharply criticized it." There was a detailed account of Schwecht's speech on behalf of the party which put the motion, in the course of which the Speaker of the House frequently called the delegates to order and issued warnings, above all to protesting Communists. A brief excerpt from Schwecht's speech illustrates the similarities which already existed between Nazi propaganda and the arguments presented by the nationalist parties: "Although this film insults German values and has therefore quite rightly been banned, Messers Braun, Severing and Grzesinski are protecting this appalling film with rubber truncheons. It does not even occur to them

what a terrible crisis of conscience many a police constable must be experiencing by having to protect such a shameful creation which casts aspersion on his own honour. (Very true! from the right) Mr. Severing did not even have any objections to the American version, which includes a sentence about how dirty and repellent it is to die for one's country. This sentence, it might be noted, has much in common with that other sentence: 'I know no fatherland called Germany!' As far as the film is concerned, two philosophies are in collision: the spirit of the Reichsbanner and the spirit of the Stahlhelm."[151]

The vote of no confidence which the DNVP had asked for was due to take place the following day, but it was defeated. The Social Democrats, Communists and Democrats still held a majority in the Prussian Parliament. Nevertheless, the ban on the film included Prussia, at least until Alfred Hugenberg's Ufa studios produced their own version in 1931, which was not very different from the one shown at the Mozartsaal in early December. Business was business, after all. This alone proved what the Chairman of the DNVP had really been trying to achieve by blowing the Nazi trumpet. In 1931 he and Adolf Hitler were sitting at the same table, united in the Harzburg Front.

The National Socialists also received support from another quarter during the row of December 1930. The Austrian National Parliament debated *All Quiet on the Western Front* on 17 December. That same day the *Wiener Reichspost* wrote: "All of a sudden the Remarque film *All Quiet on the Western Front* has become the focus of public interest here in Austria, too. That is the more or less overnight result of propaganda by left-wing newspapers in favour of showing the film which Germany has banned in Austria. Today the National Parliament witnessed an at times rather lively debate on the issue of whether or not this film should also be banned in Austria. It was brought about by a question from the Homeland coalition deputies, which was granted emergency status thanks to votes from the Christian Social Party, the National League and the National Economy coalition."[152] Parliament pronounced its judgement on 23 December: "The Federal government . . . has voted unanimously to demonstrate

Even military trash tried to ride on the crest of the "anti-Remarque wave": an advert for "tales from the front" in the book trade bulletin *Börsenblatt* of 6 July 1929.

War books in 1929/30: Beumelburg jumped on the chauvinist bandwagon, indeed set new trends. Ludwig Renn's *Krieg* (War) was one of few humane anti-war books, apart from Remarque's remarkable novel, to be purchased in any great quantity.

national solidarity in the dispute about the Remarque film which has been banned in the German Reich and thus 'urgently advises' provincial governments to guard against public showings of the film."[153] In Vienna, where the Apollotheater and Schwedenkino went ahead and ran the film in early January 1931, provoking the Homelanders, Austria's Nazis, to stage similar riots to those in Berlin, the Austrian Home Secretary Winkler finally issued an emergency decree banning the film throughout Federal territory.

All that remained of the row about the Remarque film in Germany was a slim volume published by Rowohlt in April 1930 which was left untouched. The title was *Der Film 'Im Westen nichts Neues' in Bildern* (The Film 'All Quiet on the Western Front' in Pictures). Erich Maria Remarque's novel itself was burned publicly by National Socialists in Kaiserslautern on 26 March 1933, six weeks before the Nazis' dramatic book-burning ceremonies across Germany. The reason it had become such a political hot potato had less to do with its literary qualities than with the current social situation, for although another two years or more were to pass before the fascists seized power, the novel was incredibly effective in the way it painted a vivid picture of the horrors of war for its young readers in Germany. But the Weimar Republic was drifting along a course which held no future for anti-war feeling. German militarism had long been on the march. When the Nazis took over in 1933 they found not merely a well-equipped army, but one twice as large as the Treaty of Versailles permitted. The Generals who had led the First World War were still in charge. The vague hopes still cherished by Carl von Ossietzky in the *Weltbühne* as the year drew to a close were no more than an illusion: "1930 has been a year for pulling faces, and it has ended by shaking Germany's treacherously consolidated values to the core. Capitalism is raking in its profits with a frantic greed where there are hardly any profits left to rake, and is reliving a youthful ecstasy that has been artificially induced. The pseudo-democratic system has ceased to believe in its

own tomfoolery and is becoming submerged in an amateurish game of decree-making. And opposition to the party and trade union harmony-mongers is beginning to show among the masses. These primitive yet half unconscious stirrings are the guarantee that fascism will lose the match in the last round."[154] Even a man like Ossietzky was trapped by the same error as many other intellectuals, who had never taken the noisy Nazi oratory seriously enough and therefore underestimated the dangers.

"Onwards, never forgetting!" — The solidarity march of the proletarian arts

Six thousand Berlin workers came to the Sportpalast on 26 February 1932 to attend the first election rally for presidential candidate Ernst Thälmann. Walter Ulbricht, the KPD's District Secretary in Berlin, addressed the gathering. In the course of the evening entertainment was provided by the Workers' Music League and the Drummers' Corps from Wedding, the Greater Berlin Workers' Choir, Ernst Busch and Hanns Eisler, Li Weinert, Lotte Lenya, Lotte Loebinger, Leo Reuss, and the actors' troupe *Junge Schauspieler* with Helene Weigel.

Events like this were frequent from 1929 onwards, as the political conflict escalated. And this evening's programme was typical: art mingled with politics, intervening directly in the issues of the day.

This impressive movement with quite new aesthetic standards was primarily a fusion of the performing arts which aimed at a mass audience. It grew in the last few years of the Weimar Republic out of working-class music, proletarian song, agitprop, theatre and cinema, taking its cue from a speech given by Friedrich Wolf in 1928 called *Kunst ist Waffe!* (Art is a Weapon!). The amateur arts, whose adherents numbered tens of thousands, were brought into contact with progressive professionals, while the traditions of the working-class cultural movement were combined with the topical demands of political struggle. Added to this was the influence of young Soviet art, and the result was an artistic output which is regarded nowadays as one of the great legacies from the period.

Of all these cultural activities, it had long been the bands and choirs which attracted the greatest numbers of workers. The German League of Singing Workers (DAS), which was founded in 1908, claimed 440,000 members in 1929, 220,000 of whom regularly participated in over 5,000 choirs. Another 100,000 workers played instruments for clubs, mostly brass, the mandolin or the popular tin shawm. Many of the DAS choirs obtained a high level of musical standards, but for many years this had not been matched by their repertoire which, with the exception of a few very old labour movement songs, consisted almost exclusively of 19th-century texts and folk songs not much different from those performed by bourgeois choirs. The Social Democrats who controlled the DAS were not keen to change this state of affairs. In 1929 the Committee was still arguing about whether or not to allow the choirs to sing any political songs at all. It was left to composers such as Wladimir Vogel, Stefan Wolpe and Hanns Eisler, who originally emerged from the bourgeois musical avant-garde and were anxious to overcome their isolation by forging links with working-class music, to change things by providing new songs and choral works. Hanns Eisler began this revolution in 1928 with his *Vier Stücke für gemischten Chor* (Four Pieces for a Mixed Choir). Eisler and his fellow-composers found allies in the committed conductors of the best contemporary choirs: Hermann Scherchen, Karl Rankl, Jascha Horenstein. The singers, moreover, were stimulated by the more challenging musical structure of these new choral works. Pieces like Eisler's *Auf der Strasse zu singen* (For Singing on the Street), 1929, which urged the listener in its chorus to "take a closer look at this world" and scored the first mass success for the new choral literature, conflicted with the reformist policies of the DAS leadership, who responded in late 1930 by barring all "revolutionary singers and choirs" from the organization. These re-grouped in early 1931 to form the Battalion of Singing Workers in order to "convert the working-class movement of singers into a weapon that serves the revolutionary struggle".[155] The leading ensembles in the Battalion were three Berlin-based choirs, the Schubert-Chor, the Gemischter Chor Gross-Berlin and the Gemischter Chor Fichte Berlin.

Some of the best choirs in Düsseldorf, Leipzig, Cologne and other cities also joined the new organization.

Although the choirs made a considerable impact with their part singing, it did not achieve the same mass appeal as political songs destined to be sung in unison by the campaigning ranks. Here, too, Hanns Eisler set the tone from 1929. His aesthetic creed called for music to redefine its functions completely: "History teaches us that . . . the material can only be changed if the social functions of music are changed first to meet the requirements of history."[156]

Eisler's songs established a new proletarian style. The composer drew on folk and labour movement traditions and always observed one rule above all others: the tune and the words had to be simple, immediately accessible and singable. He combined excellent ideas for melodies with novel syncopation, clear accompanying harmonics and a gripping rhythm, that thumping march-like "Eisler bass" which carries on beating in the listener's head even after the song itself has come to an abrupt end. They work on the adrenaline in a way that nobody can resist. *Roter Wedding* (Red Wedding), *Kominternlied* (Comintern Song), *Stempellied* (Dole Song) and *Solidaritätslied* (Solidarity Song) all caught the mass imagination very fast, and were soon being sung at events and demonstrations across Germany.

Eisler found the ideal performer for his songs in Ernst Busch, whose clear, metallic voice with its northern diction was a key factor in promoting them. The bourgeois press aptly named him the "Tauber of the barricades". His voice really was as phenomenal as Tauber's and every bit as popular, except that he did not take his place in the land of smiles, but on the other side of the barricades, where he was unrivalled as the bard of the proletariat proclaiming the songs of his times. Whether he appeared before a crowd of 6,000 in the Sportpalast, 200 workers in the clubroom of a Berlin pub, or a middle-class evening audience at the cabaret *Larifari* or *Katakombe*, this "urgent musical summons", as poet Stephan Hermlin describes it, always "brought great hope into the room".[157]

The proletarian song developed hand in glove with German agitprop. This new fusion of theatre, choral reciting and singing originated in young Soviet Russia, where "on-the-spot" political education and campaigning, using popular artistic methods on improvised stages, the backs of lorries or even the shop floor soon caught on as the most important form of amateur dramatics.

German workers already had a long tradition of acting and reciting. A League of German Workers' Theatres (DAThB) had been founded in 1906, but like the choirs these, too, were faced in the late twenties with the question of a politically effective repertoire. In this case, however, the revolutionaries were relatively early in achieving an organizational breakthrough. The representatives of revolutionary drama societies won a majority at the 10th Congress in Berlin in April 1928. Arthur Pieck was elected President of the partially renamed ATBD, and the committee included Béla Balász and Gustav von Wangenheim. The workers' theatre movement was now led by a body which consistently organized the artistic apparatus to meet the political demands of the struggle, expanding its publishing venture and building up the magazine *Arbeiterbühne*. Agitprop took over as the major genre.

The final impetus had been given by a company on tour from the USSR. The Moscow *Blue Shirts* gave sixty guest performances in various German towns from October to December 1927, reaching an audience of more than 100,000. The enthusiastic reception which met them can only be compared with the response to Eisenstein's *Battleship Potemkin*. Wilhelm Pieck, who maintained close links with the workers' theatre movement all his life, wrote an article for the *Rote Fahne* about what Germany's worker actors could learn from the *Blue Shirts*: "Simplicity of performance and in the use of accessories, tight discipline, deep roots in the masses, the work of the party and political events."[158]

About 400 agitprop theatres were founded in Germany from 1927 to 1930, mostly in the cities and industrial conurbations. They rarely had a permanent home where the audience came to visit them. On the contrary: "Where do the agitprop companies go? Wherever the masses gather!" They played at rallies and meetings, outside the unemployment offices, in working-class districts, on streets and squares and in tenement yards. They played a partic-

ularly important part in the frequent election campaigns from 1929 onwards.

Agitprop used a range of methods. Sketches, often in the style of political cabaret, in which characters and situations were satirically overplayed, alternated with choral reciting, poetry and direct appeals to the public. Songs were an essential ingredient. Indeed, they were often the highlight of the scene, to the accompaniment of a single instrument (accordion, guitar, or a piano on the back of a lorry) or, if the company was bigger, a small orchestra. Some of the most effective campaign songs of the period were written specifically for an agitprop programme: the *Kominternlied* and *Roter Wedding* were examples. The amateurs were joined by outstanding writers, composers and stage professionals. Actor Maxim Vallentin founded an agitprop company in Berlin called "Das Rote Sprachrohr", and Hanns Eisler worked for them from 1929 as a composer, conductor and piano player. Erich Weinert and Slang (Fritz Hampel) appeared with Berlin's *Rote Raketen*, and they both wrote scripts for another Berlin troupe called *Roter Wedding*. Friedrich Wolf directed the *Spieltrupp Südwest* in Stuttgart, while Hans Hauska composed music for *Kolonne links* in Berlin.

Some of the more famous companies were: *Die Nieten* (Hamburg), *Links ran* (Hanover), *Rote Raketen* (Dresden) and the *Blaue Blusen* of Cologne, who took their name and their technique from the Moscow *Blue Shirts*.

Even the critic of the upper-crust *Dortmunder Generalanzeiger*, certainly no partisan observer, acknowledged the artistic standards and mass appeal of the best companies: "The well-known Communist agitprop and drama company *Kolonne links* of Berlin, whose popularity extends to people who do not share their politics, gave a guest performance of their political and satirical sketches on Saturday in the large hall at the Fredenbaum. The acting was uncommonly spirited and there was absolutely nothing ambiguous about the Communist propaganda behind it . . . The sketches were played remarkably for effect, primitive methods produced astonishing results, and the KPD may rest assured that one evening of *Kolonne links* is more effective than ten packed meetings!"[159]

Helmut Damerius, director of *Kolonne links*, which like most agitprop companies was closely allied to a proletarian organization, in this case International Workers' Aid, explained the secret of the troupe's success as follows: "Yes, work, rehearsals, rehearsals and more rehearsals. In my view and experience the work of an agitprop company lies in rehearsing. The performance shows whether this work has born fruit. There have been many weeks when we have rehearsed six times and once on Sundays."[160] He went on to report that in the course of a single year (February 1929 to February 1930) they had notched up 118 rehearsals and 86 performances to an audience of 65,000.

The reaction of Germany's rulers demonstrated how successful the movement had become. At a conference of German provincial Home Secretaries in March 1931 a resolution was adopted with regard to agitprop: "There is complete agreement on the need to counter the constant growth in incitement and political and cultural excesses with all available means."[161] The Ministers were not referring to the unbridled malice of National Socialist rags such as Goebbels's *Der Angriff*. The orders issued to the police were more specific: "Experience to date shows that it is the KPD's agitprop companies which are whipping up boundless hysteria against the state and religion . . . The Emergency Decrees fill a sensitive gap. According to § 1 of the Emergency Decrees any performance by agitprop companies can be prevented, as they will always infringe § 1, clauses 1 to 4. Until further notice, therefore, every appearance by the agitprop companies must be banned."[162]

So from mid-1931 the agitprop movement faced confrontation with the government and police of the Weimar Republic. The police files mounted with reports of bans, searches and arrests. But although there was less room for manoeuvre on this front of the proletarian cultural campaign, the fight was not yet over. The actors went on playing, often without prior announcement, and whenever police entered the room they changed the programme in a flash.

While agitprop was transforming amateur dramatics, the professional stage was also witnessing a movement now known as Collective Theatre. It consisted of experi-

ments outside the bourgeois theatre by playwrights and theatre workers who, from 1929 onwards, were seeking to redefine the functions of theatre in political struggle. The stage had not been left untouched by the growing crisis. There were many actors without work, and theatre managers were no longer including committed dramas in their repertoire. Over half of Berlin's theatres were forced to close down in 1930, and the remainder were playing the classics and certain box-office hits. There was hardly room for political plays, let alone committed concepts of theatre.

To find work where none was on offer, teams of writers, actors and producers came together in Berlin, Leipzig, Hamburg and Düsseldorf to set up a new type of theatre. They took on new political plays and began discussing and rehearsing on a non-commercial basis with a view to performing for working-class audiences. They made their own sets and costumes, which were reduced to bare essentials. Then they hired a stage and carried on performing for as long as they could sell tickets and pay their way. But what was new was not so much this response to unavoidable external conditions, but the choice of plays, the manner in which they were produced, and above all the way that the audience were involved in the work of the theatre.

It all began in the autumn of 1928 when the *Gruppe Junger Schauspieler* was founded in Berlin. One of the founders was Gerhard Bienert, who had met a young playwright called Peter Martin Lampel whose play *Revolte im Erziehungshaus* (Approved School Revolt) had been turned down by every theatre in Berlin. Bienert recruited some fellow-actors and producer Hans Deppe of the Deutsches Theater. The company gave their première at the Thalia-Theater in December 1928, and one critic called it ''the most stimulating production this winter''. Lampel's next play, *Giftgas über Berlin* (Poisonous Gas over Berlin), was a sharp, anti-militarist attack on the Reichswehr's plans to re-arm, written specifically for the company. The police banned the play after a single private performance, yet another instance of direct police censorship. The next production, Friedrich Wolf's *Cyankali*, was a long-running success. The company played it at the Lessing-Theater for over three months before touring Germany with it for several more months. ''The best thing that the young revolutionary theatre has come up with to date,'' wrote Herbert Jhering. The group's greatest triumph, and also its last production, was Brecht's didactic play *Die Mutter* (The Mother) with music by Hanns Eisler. The première was on 16 January 1932. Reinforced by Helene Weigel, Ernst Busch and Theo Lingen, the team staged a production which was nothing less than the birth of Bertolt Brecht's epic theatre. The stage adaptation of Maxim Gorki's famous novel was clearly relevant to the situation in Germany. The depiction of revolutionary processes in the Tsar's Russia of 1905 held immediate lessons for German workers in 1932. The innovations of epic theatre (the new acting methods, the separation of elements, the use of projection and title cards, Eisler's didactic songs and choruses which detached themselves from the action on stage and appealed directly to the audience) were aesthetically demanding, but they were understood by the workers in the stalls, who applauded enthusiastically, the best evidence that Brecht's and Eisler's concept of a theatre for the most progressive class using the most progressive means had emerged from its experimental phase. *Die Mutter* stayed at the Wallner-Theater for over a month before moving on to the Komödienhaus on Schiffbauerdamm and then the Lustspielhaus on Friedrichstrasse. Caspar Neher's set had been designed from the outset to be portable and practical.

Brecht's and Eisler's previous experiment, the didactic play *Die Massnahme* (The Measures Taken) had only been performed twice in Berlin as a result of the contrived and basically idealist text (which sparked off a controversy between the right and the left that has still not been resolved today). Besides, Eisler's marvellous music turned the play into a proletarian oratorio of Bach-like proportions. The première on 13 December 1930 at the Berlin Philharmonie brought together Berlin's best working-class choirs and Helene Weigel, Ernst Busch and Alexander Granach. There were nine more performances altogether before 1933 in other German towns, confirming the ''epoch-making nature of the music'', as Alfred Durus wrote in the *Rote Fahne*.

Organized ticket sales were a crucial factor in the survival of new, proletarian theatre collectives. The *Junge Volksbühne* was responsible for the lion's share. It was founded towards the end of 1930 and drew its support from theatre-goers who had left the Volksbühne in protest at its reformist approach to repertoire, as well as from sections of the working-class who had not previously established links with the theatre. A ticket for the *Gruppe Junger Schauspieler* or the *Piscator-Kollektiv* cost anything from 50 Pfennigs to 1.70 Reichsmarks, making it within the means of the proletarian people.

Erwin Piscator set up his collective in 1930. The new plays which he produced were theatrical interventions in German politics: Credé's *§ 218* championed the right of working women to decide for themselves whether they wanted to continue their pregnancies. Plivier's *Des Kaisers Kuli* was a sharp attack on militarism; Friedrich Wolf's play *Tai Yang erwacht* (Tai Yang Awakes) described the growing political awareness of a young proletarian woman. It was clear that Piscator himself had been through a dialectical process of development as a producer. He had shifted his focus from costly apparatus and complicated stage technology to the text and the actors. Indeed, he produced probably his best work in the years 1930/31 in the context of his proletarian collective, without pressure from bourgeois patrons and a bourgeois audience.

Piscator's last theatrical venture was wound up in March 1931, and in April he went to the Soviet Union to make films.

The third of Berlin's successful collectives was *Truppe 31*, led by Gustav von Wangenheim. It was founded in mid-1931 and its first public performance was a production of Wangenheim's own play *Die Mausefalle* (The Mousetrap) with music by Stefan Wolpe on 22 December 1931 at the Kleines Theater on Unter den Linden. Only eight performances had been planned, but the play ran for 250 instead. The tale of the insignificant clerk Fleissig—his name means "hard-working"—who descends deeper and deeper into the proletariat without ever relinquishing his social snobbery succinctly expressed a crucial political phenomenon in 1932. There were millions of Fleissigs, and it was among their ranks that the Nazis were recruiting most of their new members. The next play by Wangenheim, *Wo liegt der Hund begraben* (Where Is the Rub)

did not make quite the same impact, but nevertheless *Truppe 31* carried on performing without a break until 4 March 1933.

Prominent collectives outside the capital were the *Gruppe Junger Schauspieler* in Leipzig, the *Kollektiv Hamburger Schauspieler* and the *Truppe im Westen* under Willy Schürmann-Horster in Düsseldorf. Together they pioneered a revolutionary theatre for workers that evolved outside the bourgeois establishment.

Proletarian cinema was also obliged to seek channels outside the commercial studios in order to progress beyond portrayals of milieu to campaigning art. The Prometheus film *Kuhle Wampe* (made by Slatan Dudow, Bertolt Brecht, Ernst Ottwalt and Hanns Eisler) which was

Like Vladimir Mayakovsky in the USSR, Erich Weinert roused the German masses whenever he recited his own revolutionary poetry. Poster for an evening with Weinert in Berlin, 1931.

Hanns Eisler's jottings for his *Solidaritätslied*, 1931.

Four major cultural personalities who dedicated their art to the proletariat during the Weimar Republic. Left to right: Friedrich Wolf, Egon Erwin Kisch, Erwin Piscator and Erich Weinert in 1931.

Cover for Johannes R. Becher's poem *Der grosse Plan* (The Great Plan), 1931. It was an impressive choral work in free rhythms about the first Soviet Five-Year Plan which, apart from being published in book form, was performed by several proletarian ensembles.

The Dresden agitprop theatre *Rote Raketen* in 1930 protesting against yet another ban for the KPD newspaper *Rote Fahne*. The eventual aim was to silence the Communist press.

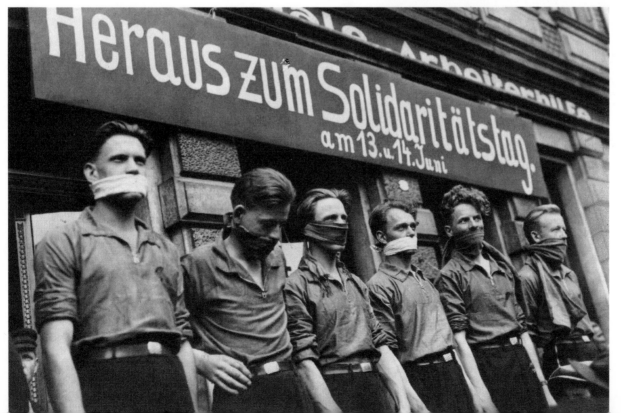

shot from August 1931 to February 1932 was the finest specimen of revolutionary German cinema prior to 1933, but at the same time it provoked yet another sorry example of political censorship in a Republic which Ossietzky was now calling "degenerate". It was banned several times, so that the first German showing was postponed from 18 March until 30 May 1932. Only then was an abridged version of the picture released under massive public pressure. Almost a million people saw it within the space of a few months, and so it was that Eisler's *Solidaritätslied* made its mark in the latter half of 1932 as the anthem of the proletariat. "Whose world is it?" the chorus asked. The film-makers still firmly believed that encroaching fascism would be defeated. The last record which Busch, Brecht and Eisler cut in July 1932 poured scorn on the Nazi movement: "It's a long way to the Third Reich.

How incredibly slow it is coming . . ." In fact it was only going to take another six months.

Members of the agitprop company *Die Rote Schmiede* in Halle were already being arrested in their homes at dead of night. The SA, Hitler's militia, had broken up a performance by a workers' choir in Cologne, and another unit in Frankfurt had thrown stink bombs at a performance of *Mahagonny* because their commander had confused the title with *Die Massnahme*. In addition, the police themselves were busy imposing countless prohibitions for "legal" reasons.

Some of the best revolutionary art in Germany emerged from the turbulent conflicts which bedevilled the final years of the Weimar Republic. Hanns Eisler commented in retrospect: "The truth is that songs can't destroy fascism, but they are necessary."[163]

1933

The Nazis take power

Schleicher's transitional Cabinet considered its first task in December 1932 to be negotiating with the trade unions in order to prevent the strike movement from spreading across Germany. They failed, as the working class had no respect whatsoever for Schleicher. He had, after all, been one of the ringleaders of the Prussian coup on 20 July 1932, when the SPD government had surrendered unconditionally to Papen, Schleicher and a handful of army officers. By the end of 1932 it was quite clear that there was no time to lose, as the mass campaign against fascism was growing stronger. On 4 January 1933 Papen met Hitler at the home of the Cologne banker Schröder, and the next few days brought several discussions between leaders of the NSDAP and heavy industrialists. Once Hitler agreed not to attempt any experiments or changes in economic matters, the company bosses gave their unreserved consent to Hitler's appointment as head of government. The appointment was duly arranged in the period around 10 January, and the fate of the Weimar Republic was sealed. Now the agreement simply had to be skilfully applied. Hindenburg entrusted his son Oskar and Franz von Papen with further negotiations. The crucial meeting on the formation of a government took place in Berlin on 22 January, attended by Hitler and Göring for the National Socialists and Papen, Permanent Secretary Meissner and Oskar von Hindenburg on behalf of the President. This resulted in an agreement on the composition of a new Cabinet. It could only be a matter of days before Schleicher's Cabinet resigned. As the NSDAP's prestige had been slightly dented, the Nazis plunged into a huge electoral campaign in the tiny province of Lippe, where voters went to the polls on 15 January.

The entire party leadership joined in and the resulting victory was celebrated all over the country as if the last word had now been spoken. In Berlin, meanwhile, they orga-

nized a provocative mass rally. On 22 January, while Hitler and Papen were negotiating about the future government, SA units paraded outside the KPD's headquarters at Karl-Liebknecht-Haus, heavily protected by the police of the Republic. Three days later, on 25 January, the Antifaschistische Aktion staged an impressive counter-demonstration, when 130,000 Communists, Social Democrats and unaffiliated sympathizers marched against fascism. There were similar demonstrations in Erfurt, Augsburg, Munich, Nuremberg, Dresden and other big towns during 20 to 25 January. The KPD declared: "At this grave moment, in view of the enormous danger that is looming... we are ready to respond to the threatening fascist blow with the weapon of political mass strike and general strike, shoulder to shoulder in a close fighting alliance with you all."[164] At the eleventh hour, the KPD repeated its offer to the SPD leadership to set up a united front, with an urgent appeal to put aside previous differences in favour of the joint action which was now indispensable. Ernst Thälmann

issued this invitation to the SPD Executive on 20 January and again on the morning of 30 January, but they rejected the idea of a general strike as "general nonsense", insisting that "parliamentary resistance" was the only possible form of struggle to adopt against a Hitler government. The last chance to stop the Nazis was cast to the winds because the SPD leadership were still placing their hopes in a parliament that for two years or more had done nothing but carry out orders from the President, and which had been dissolved and sent on holiday on the one occasion when it refused to play ball.

The Schleicher Cabinet resigned on 28 January. On 30 January 1933 Hindenburg confirmed Hitler as Chancellor of the Reich. Two days later, on 1 February, Hindenburg dismissed the Reichstag again and called fresh elections for 5 March 1933. The fascist movement had thus achieved what it had set out to do at least ten years earlier. But while they boasted jubilantly of their "power seizure", they had in fact been put where they were by industrialists

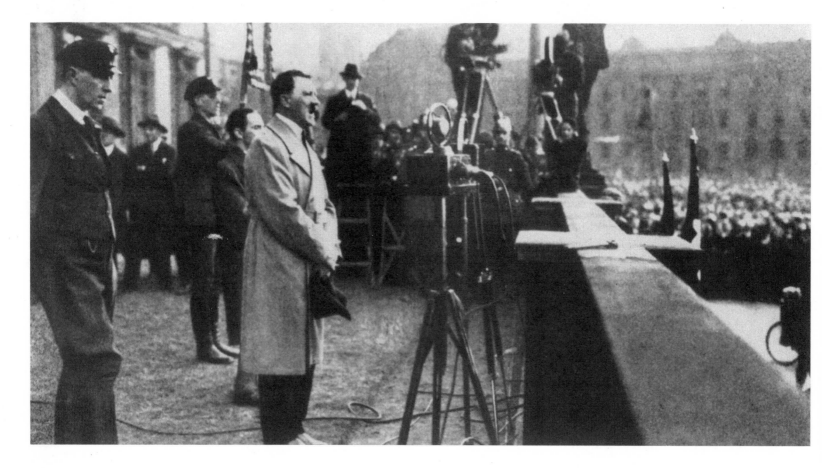

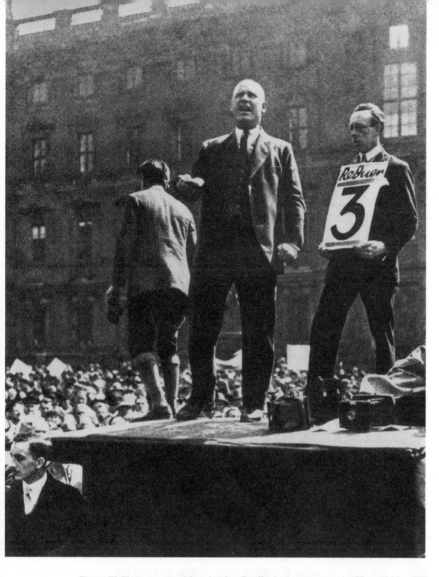

Ernst Thälmann speaking in the Berlin Lustgarten on 1 May 1930. The previous year Berlin Police Commissioner Zörgiebel (SPD) had ordered his units to fire ruthlessly on the demonstrating workers. Over 30 people died in the Bloody May of 1929 and the situation was aggravated even further.

Left:
NSDAP electioneering was demagogic and unrestrained in its incitement to hysteria. Adolf Hitler in the Berlin Lustgarten in March 1932 during the campaign for the Presidential elections.

and financiers who needed radical forces to ensure that their own interests were squarely met. Hitler and his Ministers went to see Hindenburg just after 11 a.m. on 30 January to receive their accreditation. At 1.40 p.m. the German public learnt that they now had a government led by the NSDAP. The first group photograph of Hitler's Cabinet was published that same afternoon. The gentlemen

all appeared in civilian clothes carrying their ministerial credentials: Adolf Hitler, Chancellor of the Reich, Hermann Göring, Minister without portfolio, Wilhelm Frick, Reich Home Secretary, Werner von Blomberg, Minister of the Armed Forces, Alfred Hugenberg, Minister of Economy and Agriculture and Franz von Papen, Vice-Chancellor. At first glance this picture did not look very different from any of former governments, but appearances were deceptive. Historian Kurt Pätzold comments: "This was no Cabinet shuffle to freshen up bankrupt policies. These were fascist politicians of various origins who had come together with the firm intention of setting up a new form of imperialist rule in the German Reich and burying the remains of something which had once been known as Weimar democracy, but which in recent years had disintegrated more and more into a sorry caricature of bourgeois parliamentarianism."[165]

There had been enough opportunity during those years to find out what might be expected of a government like this. Adolf Hitler had provided an elaborate account of Nazi aims in his book *Mein Kampf*: anti-Communism, anti-Semitism and dictatorship at home, coupled with the conquest of more "space to live" for the German people, not simply revenge for Versailles, but a struggle for world domination. There were many who had read the book without taking it seriously. Many had ignored the KPD's consistent warnings, or else waited too long before taking any notice. On the evening of 30 January a torchlit procession organized by the Nazis' Berlin Gauleiter Goebbels marched down Unter den Linden towards the Chancellery to cheer their new leaders. The SA, intoxicated with victory, bawled their songs: "When Jewish blood spurts over the knife we'll all be feeling twice as fine!" and "Smash the red scum to pulp! The SA are marching, clear the streets!"

The next morning Hitler went on the radio to announce the aims of his "Cabinet of National Uplift". His voice cracked as he screamed: "Give us four years, and you won't recognize Germany any more!" It did not take that long. The Reichstag was dissolved on 1 February. Göring banned all demonstrations in his capacity as Prussian Home Secretary, and the next day the measure was ex-

tended to cover all Germany. On 4 February Hindenburg issued a Decree for the Protection of the German People, which stipulated drastic restrictions on freedom of assembly, freedom of speech and freedom of the press. KPD and SPD newspapers were banned arbitrarily for days or weeks on end, which naturally helped the NSDAP in the new election campaign. Most liberal and democratic newspapers, however, were still being published, and there were big rallies against fascism. On 23 February the Prussian police broke up a KPD election meeting at the Berlin Sportpalast, and the same day Karl-Liebknecht-Haus and the Communist newspaper offices were occupied and boarded up. All this occurred without any legal basis. But the fascists needed an excuse to justify their treatment of political opponents.

The excuse was the fire at the Reichstag on 27 February 1933. The first flames leapt from the building at about half past nine in the evening. Hitler, Göring and Goebbels were on the spot at once. Hitler told a British correspondent standing next to him: "You are witnessing a great new era in German history. This fire is the beginning. It is a sign from God. Now no one will stop us destroying the Communists with an iron fist."[166] A precisely planned wave of arrests which affected all the Nazis' opponents, Communists, Social Democrats and trade unionists alike, was unleashed that same night. About 10,000 detainees were brought to the SA torture chambers. Hitler proclaimed: "The time has come for us to settle accounts and draw ice-cold conclusions . . . We shall pursue these men into every last corner and shall not rest until every bit of this poison has been extracted from the body of our nation."[167] Other members of Hitler's government displayed the same blatant cynicism in announcing their plans for repression. Home Secretary Frick: "It's not a bad thing if a few thousand Marxist officials come to harm."[168] And Hermann Göring: "As long as I can't see any Communists running around with their ears and noses cut off, I see no reason to get excited."[169] The morning after the fire, and a week before the next elections, Hindenburg issued the Decree for the Protection of Nation and State, which nullified every basic right in the Weimar Constitution. The KPD was forced underground,

"protective custody" was introduced and the first concentration camps were set up. By July 1935 there were already 45 camps where some 40,000 "protective detainees" were undergoing torment.

In spite of this harassment the KPD managed to win 81 seats in the Reichstag on 5 March, and the SPD took 120. The NSDAP came out on top with 288 seats. On 9 March the government declared the KPD mandates null and void and issued warrants for the arrest of the deputies. Ernst Thälmann had been in fascist hands since 3 March.

A total dictatorship was quickly established in Germany. On 12 March Hindenburg announced that the black, red and gold stripes of the Republican flag had been replaced by the black, white and red stripes and the

Dringender Appell!

Die Vernichtung
aller persönlichen und politischen Freiheit

in Deutschland steht unmittelbar bevor, wenn es nicht in letzter
Minute gelingt, unbeschadet von Prinzipiengegensätzen alle Kräfte
zusammenzufassen, die in der Ablehnung des Faschismus einig
sind. Die nächste Gelegenheit dazu ist der 31. Juli. Es gilt, diese
Gelegenheit zu nutzen und endlich einen Schritt zu tun zum

Aufbau einer einheitlichen Arbeiterfront,

die nicht nur für die parlamentarische, sondern auch für die weitere
Abwehr notwendig sein wird. Wir richten an jeden, der diese
Überzeugung mit uns teilt, den dringenden Appell, zu helfen, daß

ein Zusammengehen der SPD
und KPD für diesen Wahlkampf

zustande kommt, am besten in der Form gemeinsamer Kandidaten-
listen, mindestens jedoch in der Form von Listenverbindung. Ins-
besondere in den großen Arbeiterorganisationen, nicht nur in den
Parteien, kommt es darauf an, hierzu allen erdenklichen Einfluß
aufzubieten. Sorgen wir dafür, daß nicht Trägheit der Natur
und Feigheit des Herzens uns in die Barbarei versinken lassen!

Chi-yin Chen / Willi Eichler / Albert Einstein / Karl Emonts / Anton
Erkelenz / Hellmuth Falkenfeld / Kurt Großmann / E. J. Gumbel / Walter
Hammer / Theodor Hartwig / Vitus Heller / Kurt Hiller / Maria Hodann
Hanns-Erich Kaminski / Erich Kästner / Karl Kollwitz / Käthe Kollwitz
Arthur Kronfeld / E. Lanti / Otto Lehmann-Rußbüldt / Heinrich Mann
Pietro Nenni / Paul Oestreich / Franz Oppenheimer / Theodor Plivier
Freiherr von Schoenaich / August Siemsen / Minna Specht / Helene
Stöcker / Ernst Toller / Graf Emil Wedel / Erich Zeigner / Arnold Zweig

The International Socialist League initially used this poster in July 1932 to call for a united front of KPD and SPD. When it re-appeared before the Reichstag elections of 5 March 1933 it led to a "purge" of the Prussian Academy of Arts.

Left:
Once the Harzburg Front had been formed, if not before, the Weimar Republic was doomed. Cover page of the Nazis' "theoretical" journal in autumn 1931.

swastika as official emblems of state. On 21 March Hindenburg and Hitler opened their new parliament in the Garnisonskirche in Potsdam with a solemn handshake. On 23 March the Reichstag voted in favour of the Enabling Act which gave Hitler the absolute powers of a dictator. Only the SPD voted against, for the Communists were no longer present. The notorious secret police, the Gestapo,

was founded on 26 April, and soon established a foothold all over the country. The trade unions were banned on 2 May and the SPD on 22 June. A law was passed on 14 July banning the formation of new parties, which made the NSDAP the only party in the country. Six and a half months had passed since the fascists took power, and already Germany had changed beyond recognition. Fear, intimidation and fiery rhetoric had all played their part. A majority of Germans began to place their hopes in the *Führer*, their "leader". Hundreds of thousands had either left the country or would do so in the following years, many because of their political convictions, and untold numbers because they were Jews. The SA began their attacks on the Jews in March 1933, and from 1 April there was an organized boycott of Jewish shops. A law on the "restoration of the civil service" came into force on 7 April, removing "politically unreliable" and "non-Aryan" civil servants from their posts in national and local government, which covered everyone from town hall employees to health service doctors and musicians at the state opera house. It was only a preliminary to the mass destruction of human life which followed a few years later.

The Nazis were just as rigorous in pursuit of their cultural objectives. They systematically stamped out all the progressive works which they had constantly attacked during the latter years of the Weimar Republic, and put a stop to developments in the arts of a bourgeois democratic or revolutionary proletarian nature. Not only the works themselves were targets, but their creators, too. At the same time, anti-Semitism went on the rampage against the Jewish heritage, from the music of Felix Mendelssohn-Bartholdy to the poetry of Heinrich Heine.

During the Weimar Republic, cultural matters had come under the jurisdiction of provincial administrations. There had been a Reich Controller of the Arts, who played a co-ordinating role, but he was now dismissed. The Nazis, therefore, had to begin by setting up a national command centre for fascist cultural policy. This was the Reich Ministry of National Education and Propaganda, which was founded on 13 March 1933. Joseph Goebbels was put in charge. Three days after taking office he delivered a speech on the tasks of the press. If we replace the word

"press", just one of his spheres of responsibility, with the word "culture", we have a declaration of aims dated 16 March 1933: "The ideal as we see it would be to have a press so finely organized that it is like a piano in the hands of the government, on which the government can play; a press which holds enormous importance and significance as a tool of mass influence, which the government can use for its responsible work. I consider it my principal task to achieve that."[170] The Nazis soon came up with the word *Gleichschaltung*, which meant "switching into line", and that was the cue to proceed. They began quite naturally by focussing their attention on the media which made the greatest mass impact: the press and radio. These were completely "switched into line" in the course of March and April with the help of bans and enforced staff changes. Newspapers and magazines supporting the KPD and SPD had already been prohibited, and many editors and journalists on the best publications prior to 1933 had emigrated. Their successors received a new job designation of "German" etymology in October 1933. Of the three press giants, Scherl offered its services to the Nazis, Mosse went into liquidation in July 1933, and Ullstein fell victim to *Gleichschaltung* in November. Many newspapers, such as the *Vossische Zeitung* and the *Berliner Tageblatt*, simply ceased publication. The last issue of *Die Weltbühne* came out on 7 March. The Nazis took over the publication of some especially popular dailies after removing their editors. It is to the credit of Germany's journalists that hardly any prominent names agreed to work for the new regime. That was left to second-rate scribblers. A total of 3,298 newspapers and magazines were either banned or had ceased publishing by the end of 1934, which simply goes to illustrate the drastic impoverishment of what had once been a flourishing press world. The Nazis, however, were delighted: "To sum it up, a completely new press has been born in National Socialist Germany in the last six months which cannot be compared with the previous state of affairs either in spirit or in composition . . . The entire Marxist press has been extinguished once and for all, so much so that the new government can don its empty cloak. The *Welt am Abend* has resumed publication in Berlin under the aegis of National Socialism, the property of *Vorwärts* has been confiscated by the Prussian state . . . Of course, the government was often called upon to lend a hand in these developments, occasionally speeding things up by means of bans and demands relating to staffing, but by and large the development was, after all, organic."[171] To retain Goebbels's metaphor: the piano needed a considerable amount of retuning before it produced the required notes!

Hans Bredow, the Reich Commissioner of Radio, had handed in his resignation demonstratively on the evening of 30 January. A "political commissioner" was temporarily installed until Eugen Hadamowsky was appointed in July 1933, again with a new German etymology to his title. Hadamowsky had been responsible to Goebbels for radio matters in Berlin since 1931, and in July he also took over as Chairman of the Reich Radio Association. German radio programmes had, therefore, been "purged" since February, and even musical broadcasts were "pure". Jews were forced to leave the radio staff and recordings involving Jewish performers were no longer allowed on the air. Even jazz and contemporary music dating from the Weimar Republic was thrown out of the archives because it was "Jewish". Hadamowsky moved mountains. In July he contrived a "corruption scandal" over former pioneers of radio and leading administrators. The homes of Hans Bredow, Berlin producer Flesch, radio playwright Braun and others were subjected to searches. Goebbels urged his broadcasting chief: "Be ruthless about clearing up so that not even the smell remains in the broadcasting studios!"[172] Flesch and Braun were taken into "protective custody" on 8 August, and Bredow not long after. They were sent to the concentration camp at Oranienburg. In 1934 they found themselves in the dock for a "Radio Trial", as a result of which they were fined or sent to prison.

By that time, however, the Nazis had long been using radio as their major channel for propaganda. From May 1933 onwards the producers and directors of all German radio stations were summoned to Goebbels monthly to "discuss principal programming matters", which meant that they were told what to do. After the first of these meetings the Minister was able to comment with satisfac-

The last edition of the German book trade's *Börsenblatt* before Nazi dictatorship, dated 28 January 1933, had a complete front page devoted to six publications by Malik, symbolizing that culture in the Weimar Republic which, in a few days, would be dead and buried.

tion that "the new course at the radio, which recent changes in personnel have contributed towards achieving, has been particularly gratifying to note over the last month".[173]

One of the first measures taken in the world of cinema was a wide-ranging ban on films dating from the Weimar Republic, which was imposed in February 1933. It covered all pacifist and anti-militaristic works, from Pabst's *Kameradschaft* (Comradeship) to Milestone's *All Quiet on the Western Front*, all Soviet films, and not long afterwards almost all films whose directors or actors had emigrated. *Der blaue Engel* (The Blue Angel) of 1930 was as unwelcome in the Third Reich as Fritz Lang's *Testament des Dr. Mabuse* or *M*. The second measure, this time undertaken by Goebbels's Ministry, was to transform the weekly newsreel from an optional extra into a compulsory component of the cinema programme. The editing was carried out by the Film Department at the Ministry, and the Head of this Department was also in charge of the German Newsreel Office, which started making "documentary films" for propaganda purposes in 1933. Feature films were now all that remained to be "switched into line". Apart from the fact that Goebbels was later to play a personal part in producing "great" films, every single film project had to be submitted to the Ministry for prior scrutiny from 1934 onwards. During the first year of Nazi dictatorship, feature films adapted gradually to the "new" criteria. As far as the personalities were concerned, the "purge" went according to plan, but even Goebbels had to swallow some setbacks, as when both Fritz Lang and, not much later, Marlene Dietrich turned down his offers to make them the top director and top actress in the "new" German film industry. Lang emigrated the very night after his first interview; Dietrich was in Paris when the invitation came, and she firmly rejected the idea of returning to fascist Germany. Instead, Goebbels launched a new star, the Swedish actress Zarah Leander, who took the leading role in many Nazi pictures from 1935.

The theatre and music were affected less radically by the changes that occurred in 1933. Some leading names had been forced to leave Germany, mostly on grounds of race (Max Reinhardt, Leopold Jessner, Fritz Kortner, Elisabeth Bergner), but in the theatres and concert halls it was business as usual. Furtwängler conducted Beethoven, Kleiber conducted Wagner at the Staatsoper, Heinrich George played Götz von Berlichingen at the Schauspielhaus, and all as if nothing had happened. How many people noticed that certain Jewish musicians were no longer in

their chairs, or that new faces had appeared in the chorus or ballet? And yet there were some spectacular and unworthy public incidents. *Rigoletto* was due for performance at the Städtische Oper, Berlin, on 8 March 1933, and Fritz Busch, Director of the Dresden Opera House, had been announced as guest conductor. After the overture sixty SA men rushed onto the stage and declared that a certain Herr Striegler would be conducting the rest of the work in place of the "cultural Bolshevist" Busch. Busch was forced to leave the building, and the performance actually went ahead! A Bruno Walter concert was scheduled for the Berlin Philharmonie on 20 March. Walter had already been prevented by the Nazi Commissioner for Saxony from directing a concert at the Leipzig Gewandhaus on 18 March. Now Goebbels's Permanent Secretary Funk threatened him: "If you conduct in Berlin, everything in the hall will be smashed to smithereens!"[174] Walter stepped down, and Funk had to find a replacement for him within 24 hours. He found one, too: Richard Strauss. Bruno Walter later wrote in his memoirs: "The composer of *Heldenleben* (A Hero's Life) actually consented to conduct in the place of a colleague who had been removed by force."[175]

The theatres, opera houses and concert halls were obliged to draw predominantly on the classical repertoire. Works that had been written in the twenties were mostly banned, and there were hardly any new ones in the Nazi mould. But the fascsts did have one play to boast about in 1933: Hanns Johst's *Schlageter*. Over 50 German theatres staged the play, providing the audience with a chance to hear the notorious sentence which had become the sad incarnation of fascist cultural policy: "When I hear the word culture, I reach for my Browning."

Johst, who had made a promising start as an Expressionist poet, had been moving closer to the Nazis since the late twenties. As he was the most talented of the Nazi writers, it is hardly surprising that he was given a job in February 1933. He and Franz Ulbrich were installed as managers of the Staatsschauspielhaus in Berlin, where Jessner had once accomplished wonders as producer. He was replaced by Gustaf Gründgens in April 1934. Johst made a greater contribution in the field of literature,

The Nazis lampooned Heinrich Mann on their cover page in January 1933 for opening a synagogue by parodying the text of Friedrich Hollaender's hit, sung by Marlene Dietrich in the film *Der blaue Engel*.

the art which the Nazis chose in 1933 for the clearest international demonstration of their inhumanity. Weimar's best authors had never made any secret of their opposition to fascism. The Nazis hated them as much as they hated their friends in the world of journalism. The centre of what they called the "Jewish bog of literature" was Berlin, where a particularly tough Nazi from Hanover called Bernhard Rust was appointed Reich Commissioner and acting Prussian Cultural Minister immediately after 30 January. One of his first official acts, on 5 February 1933, was to re-introduce the cane in schools. The Prussian Academy of Arts and its Literature Section also fell under

his jurisdiction. The Honorary President of the Academy was Max Liebermann. Its members included arts personalities of stature such as Ernst Barlach, Käthe Kollwitz and Arnold Schönberg. The Nazis hated the Literature Section most of all because it enjoyed tremendous public respect. In early February Hanns Johst wrote an article for the journal of the Fighting League of German Culture defaming "these reactionary liberal writers, who should have hardly any more contact with the German concept of literature in an official capacity. We suggest dissolving this utterly obsolete group and making new appointments according to national, truly literary criteria."[176]

But an excuse was still needed, and it came sooner than expected. During the electoral campaign in February an appeal from the International Socialist League appeared on the Berlin advertising columns once more. It was an urgent call for a united front of KPD and SPD which had originally been made before the elections in July 1932, and it was signed by well-known personalities from the world of arts and science, from Albert Einstein to Arnold Zweig. Academy members Heinrich Mann and Käthe Kollwitz were also on the list.

Rust assured the readers of the *Deutsche Zeitung* on 15 February that he would put an end to this scandal. There was to be a plenary meeting of the Academy that evening. Käthe Kollwitz had announced her resignation in the afternoon and did not attend. Heinrich Mann was brought to the building at 9 p.m., and when he had been informed of the accusations against him he also resigned, simultaneously relinquishing the Chairmanship of the Literature Section. Berlin's Chief Architect Wagner declared his solidarity with Kollwitz and Mann and left the meeting under protest. The path was clear for the "purge" to continue.

On 13 March every member of the Literature Section received an ultimatum which read: "Are you still willing, in acknowledgement of the new historical situation, to place yourself at the disposal of the Prussian Academy of Arts? An answer in the affirmative rules out any public political activity against the government . . ."[177] Confronted with this coercion, Thomas Mann, Alfons Paquet, Ricarda Huch, Alfred Döblin and Jakob Wassermann announced their resignation. On 5 May composer Max von Schillings, the President of the Academy, informed other writers that it would no longer be acceptable for them to remain in the Literature Section. These were Franz Werfel, Bernhard Kellermann, Georg Kaiser, Leonhard Frank, Walter von Molo and René Schickele.

Most of the Section's 31 former regular members were already in exile when the provisional Chairman Gottfried Benn opened the next plenary on 5 May. 14 new members were elected, including almost every Nazi author who had made a name for himself, from Blunck and Kolbenheyer to Grimm and Beumelburg. Hanns Johst was naturally at the forefront, and in June he was promoted to become the new Chairman at the German Academy of Literature. Max Liebermann immediately resigned as Honorary President and left the Academy. The other sections fell into line in much the same way.

Other writers' organizations were either banned, as in the case of the League of Revolutionary Proletarian Writers, which carried on its activities underground until 1936, or purged, like the German PEN Club and the Association for the Protection of German Writers, which changed its name in July 1933 to the Reich Association of German Writers. Personal questions were resolved in this way. Most German writers of any standing had left the country. The Nazis celebrated as though they had won a victory. One of their demagogic arts journalists, Friedrich Hussong, who had been writing for Hugenberg newspapers since 1922, boasted: "Something wonderful has happened. They have gone. The people who once monopolized the audience have become inaudible. Those omnipresent personages who seemed to be the only people to exist—they have gone . . . Where are they now? Go to Prague! Look for them in Zurich! Search Paris! Or Lugano, or wherever else they have sought refuge from their bad conscience."[178]

Goebbels's Ministry issued its first "blacklists" in March 1933 for a "purge" of libraries and bookshops. These lists of "subversive writing" contained 131 names from Schalom Asch to Stefan Zweig. Almost all the progressive German literature of the 20th century was named, and from the end of March it was to be removed

systematically. The German Students' Press and Propaganda Office took an active part in this process, announcing on 6 April 1933: "In view of the shameless horror stories being propagated by Judaism abroad (a reference to the first emigrants' reports of life in Germany under the Nazis), Germany's students are planning a four-week all-round campaign against the subversive Jewish spirit to promote nationally conscious thought and action in German writing. The campaign will begin on 12 April, when twelve Theses Against Un-German Ideas will be pinned to public boards, and it will end on 10 May with public rallies in all German university towns."[179] A few days later the *Deutsche Kultur-Wacht* was more explicit: "On 10 May 1933, subversive writing will be commended to the flames at all universities."[180]

The "dress rehearsal" for burning the books came on 6 May, when fascist students and SA units raided the Institute of Sexology in Berlin. The Institute, which had been founded in 1918 by Magnus Hirschfeld and run on a Prussian government endowment, enjoyed an international reputation as a leading research establishment in this young science. Lorries drew up outside the building at 9.30 a.m. About 100 students wearing Nazi uniform jumped out, broke down doors and windows and stormed into the Institute. A brass band commissioned for the event began to play march music against the general noise. Furniture and fittings were ripped out, while the priceless library was thrown book by book through the windows and loaded onto the lorries beneath. The staff were under strict guard for the entire duration of the exercise. When asked where Hirschfeld was, one colleague replied that the Professor was abroad recovering from malaria, to which the SA commander retorted: "Then let's hope he'll kick the bucket without us, then we won't have to bother stringing him up or beating the life out of him!"[181]

Over 10,000 books were stolen from the Institute and found their way onto the bonfire on 10 May 1933. That evening, in every university town across Germany, books were cast into the flames to the sound of cheers and nine ritual incantations. German academics delivered the speeches, and German students pushed the carts carrying thousands of copies of the best German and foreign literature past and present to the crackling pyre, where they threw them into the flames. For the German people it was a night of utter moral and intellectual humiliation, but not so for their fascist overlords, who proudly celebrated this inanity as the "new spirit". Four days after the book-burning, Goebbels addressed the annual meeting of the German book trade in Leipzig, which had now also been pulled into the right shape. His speech showed that the regime was feeling uncomfortable about the beginning of the international campaign of revelations, that burning the books had been intended as a signal, and that it had been a total failure in the light of the worldwide storm of protest. "You know as well as I do that although at home the government can shake off any suspicion that it is hostile to the arts, this suspicion is being nourished from abroad by unscrupulous elements who left Germany after things got too hot for them here. If we have had to remove people who do not reflect the new spirit of the age here and there from our cultural institutions, that was not due to hostility to the arts; on the contrary, all we intended was to purify German culture from all the slag which has crawled in over the last fourteen years and clung to it . . . When the students gathered in the university towns last week to commend the refuse of recent years to the flames, they were carrying out a strong, symbolic act. It was not for nothing that I told the students in Berlin: Anyone who has the courage to demolish must also have the strength to build . . . That will be your task, gentlemen. You should see your duty, not only in eradicating what has harmed us, but in breaking the ground for what promises to be of use in the future!"[182] Here he was, praising the bonfires, offering Johst in place of Zweig, Blunck instead of Mann, and not one of the 300 publishers and booksellers present had the courage to object! But in order to salvage the honour of the book trade it should be noted that by this point many of its finest names were already in exile and working to keep anti-fascist German literature alive, among them Wieland Herzfelde, Fritz Landshoff, Hermann Kesten and Walter Landauer. Yet hundreds stayed and allowed themselves to be "switched", and in every other field of culture the pattern was the same.

About 30 of Germany's leading writers composed the Literature Section of the Prussian Academy of Arts. This photo, taken in 1928, shows (left to right) Oskar Loerke, René Schickele, Ludwig Fulda, Max Halbe, Walter von Molo and Heinrich Mann. They were all "removed" in 1933.

Magnus Hirschfeld was Director of the Berlin Institute of Sexual Research. On 6 May 1933 the Institute was attacked by the SA and the library plundered in a dress rehearsal for the book burnings of 10 May. Photo 1932.

The process of *Gleichschaltung* was completed for the arts world on 22 September 1933 with the foundation of the Reich Chamber of Culture. It was divided into Chambers for Writing, the Press, the Radio, Film, Theatre, Music and Fine Arts, and henceforth membership of the appropriate Chamber was essential for anyone working in the cultural field.

Goebbels's piano of suppression took eight months to build. Now there was nobody to stop him playing and, as with any other piano player, his virtuosity improved with practice. Anyone who stayed in Germany and would not play according to the score was either excluded from the profession or taken into "protective custody". *Führer* Adolf

Writer Hanns Johst was President of the "German Academy of Writers" from autumn 1933 and the literary doyen of Nazi Germany. In 1931, in his play *Schlageter*, he wrote the notorious words: "When I hear the word culture, I reach for my Browning."

"14 Years of Jewish Republic" scoffed the title of this "account of the era of the system" which appeared in July 1933. Nazis ceremonially burning books, a crass symbol of inhuman fascism in the eyes of the world, are glorified on the cover. The author was Secretary of the PEN-Centre in Nazi Germany and produced a number of diatribes against the Weimar Republic.

Hitler, the Chancellor of the Reich, explained to the Cultural Conference at the NSDAP Party Congress in Nuremberg on 1 September 1933 what, in his view, new German art would mean: "That providence ordain our best humanity to accomplish the task posed to us today . . . in masterful fashion from our inner essence motivated in accordance with our blood . . . What is crucial is that we shall create a seed which will bring its creative spirit to bear for many aeons by giving conscious prominence to the racial substance on which our nation is built and by masterfully proclaiming its essence and the world view which accompanies it."[183]

That is an outstanding specimen of what Viktor Klemperer called *"lingua tertii imperii"*—the language of the Third Reich! And the fascist art produced in the period up until 1945 matched the rhetoric. In organizational terms the ground had already been prepared between February and July 1933, when virtually every individual or association which had meant anything in the Weimar Republic was "extinguished". Then, in summer 1933, the first fascist "critiques" of the "age of the system", as the period 1918 to 1933 was now officially known, began to appear.

The leading light was Johann von Leers, who penned two books: a two-volume work entitled *14 Jahre Judenrepublik* (14 Years of Jewish Republic) and a pamphlet called *Juden sehen dich an* (Jews' Gallery), which threw mud at leading Weimar intellectuals in the perfidious kind of style which the Nazis favoured under categories like "Lying Jews", "Arty Jews", etc. At the end of each personal entry readers found the comment "Non-hanged". Only a year before, some of the best artists and scientists, many with a reputation throughout Europe, had lived here in plenty, but now the mind had been perverted by fascism. It would not be long before Heinrich Heine's warning became grim reality: "Wherever books are burnt, human beings will eventually be burned, too."

The intellectual exodus

The arts in Germany were treated to one more highlight on 18 February 1933 which documented, although posthumously, the progressive developments which had taken place in the Weimar Republic. This was the première of the play *Der Silbersee* (The Silver Lake) by Georg Kaiser and Kurt Weill.

It was written in November/December 1932. Weill had moved from grandiose operatic schemes back to the "play with music", written for actors who also sang to the accompaniment of a small orchestra.

Der Silbersee was the swan song of the Weimar Republic, the story of unemployed young people caught up in the tussles between "great" politicians and ultimately left without hope, except for a single dream, a legend: "If you need to move on, the Silver Lake will carry you." But that hope was based on an illusion. Weill's songs were a poignant attack on life in Germany, and the *Ballade von Cäsars Tod* (Ballad of Caesar's Death) offered direct parallels between the dictator Caesar and Hitler, who by that time had almost achieved his goal: "No one should be led astray by the crazy idea that he's a cut above anyone else: Caesar chose to rule by the sword, and he died on a knife blade."

Kiepenheuer published the play in early January 1933. *Der Silbersee* was the last book they produced before 30 January. Not a single theatre in Berlin dared to stage it. As with *Mahagonny* three years previously, it was Gustav Brecher, the man in charge of opera in Leipzig, who ignored all the warnings and threats and went ahead with a production. There was to be a triple première in Leipzig, Magdeburg and Erfurt on 18 February. The Nazis had been at the helm for eighteen days when many of the artists, writers and critics who were still in Germany gathered for the last time, most of them in Leipzig. The performance ended amid Nazi rioting, as it did in Erfurt, and in Magdeburg, where Ernst Busch appeared in the leading role as a guest from Berlin. But the Nazis were not content with this. They released a statement to the press which put pressure on the managers. Undisguised threats of violence were made to those who had taken part. The *Völkischer Beobachter* wrote on 20 February: "The most shameful part is that Gustav Brecher, the doyen of music in Leipzig, was party to it all. Any man of sensitivity would have refrained from displays of this nature five days after the fiftieth anniversary of Richard Wagner's death, right in the middle of the commemorative events at the opera house with which he is unfortunately still entrusted! At the recent Commemorative Concert in the Gewandhaus Brecher took a long and careful look at our *Führer*, the leader of the German nation. I had occasion to observe this. Now he is going to find out exactly what he is made of and what strength he emanates!" The threat to Kurt Weill was just as personal: "Herr Weill, that was your last attempt at destruction! Now it has finished for ever!"[184]

The third performance of *Der Silbersee* in Leipzig came on the night the Reichstag caught fire. The play was banned at the end of February and none of the three theatres played it again. Almost 50 years later, one of the participants remembered the Leipzig première: "Anyone who was anyone in German theatre met there for the last time. And everyone knew it. One can hardly describe the atmosphere. It was the last day in the greatest decade of German culture this century."[185]

The lights had gone out on the Weimar Republic. What happened to the *Silbersee* team after that illustrates the di-

versity of individual destinies, and it is impossible to make generalizations about such things—with one exception: sooner or later they all found their way into exile.

Ernst Busch left Germany the day after the fire at the Reichstag. He went to Holland to make some records. From 1935 he lived in the Soviet Union, and until 1939 he fought in the Spanish Civil War, after which he was interned in France and survived imprisonment in Brandenburg in spite of severe injuries.

Kurt Weill and Lotte Lenya left their home in Kleinmachnow near Berlin on 21 March 1933 and travelled by car to Paris. In 1935 they moved on to the United States of America, where Weill became well-known as a stage composer.

Georg Kaiser stayed in Germany until 1938, although he was thrown out of the Academy. He lived a secluded existence in Grünheide near Berlin before emigrating rather belatedly, but not too late, to Switzerland in the autumn.

Detlef Sierck, the producer of the Leipzig première, was the only one to work for the Nazis for a period. He kept his job in Leipzig until 1936, then made films for the Ufa studios in 1937/38, including two pictures with Zarah Leander. At the end of 1938 Sierck emigrated, too. He went to the United States, where he made a career for himself in Hollywood from 1940 as a specialist in melodrama under the name of Douglas Sirk.

The most tragic fate was that of conductor Gustav Brecher. He left Leipzig in April 1933 and emigrated to Prague, then moved on to Holland in 1938. While he was waiting for his US entry visa he went to Ostend in Belgium, and when the Nazis invaded in 1940 he and his wife committed suicide.

Such were the different destinies which awaited a team of theatre professionals working together during the final phase of the Weimar Republic.

100,000 people left Nazi Germany in 1933 alone. By 1939 there were half a million emigrants, most of them Jews who fled for their lives as Hitler's genocidal aims became clearer. 20,000 politicians, scientists, artists and journalists went into self-imposed exile if we include those who are not recorded as famous in biographical ref-

Georg Kaiser corrected his proofs at Grünheide in December 1932, and Kiepenheuer produced *Der Silbersee* in book form in January 1933, the company's last title before Hitler became Chancellor. Caspar Neher designed the cover as well as the set for the Leipzig première, which took place on 18 February 1933 before the play was banned a few days later.

erence books. It was an intellectual exodus unparalleled in history, and it meant that genuine German culture between 1933 and 1945 was actually created outside the country. What had been the intellectual life of Germany prior to 1933 was scattered across the globe. Writers, politicians, composers and scientists who had been driven from their homeland lived and worked in over 50 different

countries, from Britain to China, from Mexico to the Soviet Union, and often in conditions of great hardship. Although their intellectual and political views were so heterogeneous, even in exile, the painful experience of banishment now bound them, and even though it varied in intensity, anti-fascist commitment was usually the governing factor in their life and work.

1931 was not yet over when Lion Feuchtwanger wrote the sentences which many intellectuals, and deep down he himself, still preferred not to believe: ''It is obvious what awaits intellectuals and artists if the Third Reich is visibly established: extermination. That is what most of them expect, and any among them who has the chance is already preparing to emigrate. If one mixes with intellectuals in Berlin, one gains the impression that the city is composed of nothing but future emigrants.''[186]

Fifteen months later Feuchtwanger's vision had become reality. He himself was giving lectures in the United States on 30 January, and he did not return to Germany. Few members of the arts community emigrated as soon as Hitler assumed power, as in the case of Alfred Neumann and Joseph Roth. Most of them stayed in Germany throughout February to see how things would develop. The majority found it hard to make the decision to leave. They were tied by too many bonds to German intellectual life, to the culture, language and the artistic machinery. Heinrich Mann was sixty-two when he left Berlin on 21 February. He later remembered: ''The building where I had foolishly had a flat refurnished was under constant surveillance. Luggage, a car or other signs of attempted flight would have delivered me straight into their hands. But I had nothing with me except for my umbrella. . . I walked to the stop to catch the good old anonymous tram. No indecent haste to climb into the Frankfurt train! Only Frankfurt, that was as far as my ticket took me, who could object . . .? My wife said she hoped we would be seeing each other again soon. When? Tomorrow? Maybe I won't come back until the day after. So that, it seems, is the Rubicon. Across the fateful river I have chosen lies exile.''[187]

When the Reichstag went up in smoke on 27 February many writers and artists ceased postponing their preparations for flight, especially when news of the arrests spread the next morning. Erich Mühsam, Carl von Ossietzky (who had been granted his amnesty in December 1932 and rejected all the urgent advice to emigrate at once) and Egon Erwin Kisch were among the first victims. Mühsam was beaten to death in Oranienburg concentration camp in 1934. Ossietzky died from the effects of ill-treatment in 1938 after spending the years until 1936 in a concentration camp. Kisch was released after three weeks in prison because of his Czech citizenship. He immediately wrote a series of articles for the *Arbeiter-Illustrierte-Zeitung*, which was now published in Prague. It subsequently appeared in several European countries and was one of the earliest authentic testimonies about the situation in Germany:

''The Reichstag burned in the evening and I was arrested in the morning. I had moved into my room in Motzstrasse exactly four weeks earlier, on the day when Hitler was put in charge of Germany by Hindenburg—Hindenburg, for whom the Social Democrats had been canvassing as President of the Reich in such a massive campaign only a few months ago! My doorbell rang at 5 o'clock in the morning on 28 February . . . I opened the door and a man leapt in. 'Police! Hands up! . . . Herr Kisch, we have orders to take you to police headquarters.'. . . Right, and so off we went to the I. A., the political police. The corridor was packed with people. The first person I recognized from a distance was the solicitor Dr Apfel, who defended Max Hoelz . . . And then I noticed others. Carl von Ossietzky, chief editor of the *Weltbühne*, novelists Ludwig Renn and Kurt Kläber, Hermann Duncker who published the socialist classics . . . and many, many more. At first I did not understand why so many of them looked distracted and pale, only later did I discover the havoc that the auxiliary police had wreaked when arresting them, and even later than that I learnt to my greater dismay, to my horror, and saw with my own eyes how the National Socialists treated defenceless prisoners in their barracks.''[188]

Ludwig Marcuse left Germany on the night of the fire: ''I went to the Anhalter Bahnhof, accompanied by Sascha and our maid Gertrud. Sascha stayed behind to rent the house, pack the suitcases, above all our 5,000 books, and

obtain a visa for France. The stations were already being watched. We behaved as though I was only travelling a few stations along the line and had not said a word to Gertrud. When the train pulled in the tears began to pour. She sobbed dangerously loud: 'We'll never see him again.' I had booked a first-class sleeper, assuming that the Harzburg Front was basically fairly capitalist and that it would not treat well-heeled people as badly as workers . . . The SA man who inspected my identity card touched his cap and only fingered the edge of the document. I had been very frightened; the era of hatred had begun."[189]

Persecuted Communists and Social Democrats found emigrating much more difficult than many a bourgeois traveller. Wieland Herzfelde reports:

"When I left Germany in March 1933 I had not been to my flat for several weeks. Since the Reichstag fire I had not even dared to lie low with comrades and friends, as I had done hitherto . . . Not only were my flat and offices occupied. Even collecting money from the bank would have meant voluntary surrender. On the train, at the ticket offices and on the platforms, young men in brown or black shirts were hanging around everywhere. My wife had bought my ticket—to Leipzig to begin with, to make it seem like a business trip . . . I hade no luggage. In fact, all I had were the clothes I stood up in and money to travel on to Salzburg. But this was no time for mourning lost possessions."[190]

Wieland Herzfelde was one of those newspaper workers and publishers of the Weimar Republic who continued the anti-fascist struggle from abroad as soon as they had emigrated by bringing out newspapers, magazines and books, so that while culture was being forcefully demolished inside Germany a "counter-attack" could be launched from outside the country, establishing Germany's true culture as a component of the anti-fascist front.

In the early years the main destinations were France, Czechoslovakia and the Soviet Union. Since March the most important organs of the working-class parties, the *Rote Fahne*, *Vorwärts*, and *A-I-Z*, had been published in Prague. That was also where Bruno Frei and Alexander Abusch set up the weekly *Gegen-Angriff*—or "counter-attack"—in April, while Hermann Budzislawski con-

tinued Ossietzky's work with *Die neue Weltbühne*. *Das Neue Tagebuch* and *Das Pariser Tageblatt*, heirs to their famous Berlin predecessors, appeared in Paris.

The first two major literary and political magazines to be based in exile began publication in autumn 1933. These were Klaus Mann's *Sammlung* with Querido in Amsterdam, and Wieland Herzfelde's *Neue Deutsche Blätter* in Prague. Former Weimar publishers played a substantial part in forming new book companies abroad. Fritz Lands-

Major anti-fascist newspapers and magazines were being published within the first year of exile. The name *Der Gegen-Angriff* was itself a declaration of intent.

Left:
John Heartfield's photomontage for the cover of A-I-Z, published in Prague, on 28 February 1935. The implication is that, just as Göring set fire to the Reichstag and blamed the Communists, so the Nazis would blame Moscow for the war they were preparing.

hoff set up Querido's German department in Amsterdam, Wieland Herzfelde continued managing Malik from Prague, and in Paris Willi Münzenberg founded Editions du Carrefour. "Today literature of any stature can only be anti-fascist," argued Herzfelde in an essay.

In the spring of 1933 Nazis like Hussong had made a mockery of the emigrants, but not long afterwards they turned the full weight of their hatred against those newspapers, magazines, books and pamphlets which appeared in exile and told the world the truth about fascist Germany. "The poisonous literary potions of this clique of uprooted emigrés are turning into a European danger," Goebbels confessed in anger.[191]

The anti-fascist movement scored its greatest international victory in 1933 when the Reichstag Fire trial, which was held at the Supreme Court in Leipzig from September to December, ended in defeat for the Nazis and acquittal for Georgi Dimitrov and the other Communists accused. One important factor in mobilizing European opinion and frightening the Nazis from making a show of their repressive judiciary was the *Braunbuch über Reichstagsbrand und Hitlerterror* (Brown Book on the Reichstag Fire and Hitler's Repression), compiled by German emigrés in Paris. About half a million copies in 20 languages appeared between August and December 1933. It was published by Willi Münzenberg at Editions du Carrefour, and for security reasons bore a false cover and the name of a fictitious company: Universum-Bücherei, Basle. The chief editors were Alexander Abusch, Otto Katz (André Simone), Albert Norden and Wilhelm Koenen, assisted by Bruno Frei, Bodo Uhse, Friedrich Wolf and Alfred Kantorowicz. The *Braunbuch* not only published evidence that the Nazis had started the fire themselves, but went further by collating the first detailed material on the crimes and outrageous cruelty that had already occurred in the first five months of Nazi rule in Germany. The copy deadline was 30 June 1933, and the Strasbourg printers delivered the book on 1 August. One of the editors recalls: "I can still see the corner room in a maison meublée in the Rue St. Honoré in Paris near the summery Tuileries, where most of the *Braunbuch* was written. The testimonies of hundreds of voluntary helpers in Germany and newly arrived refugees all accumulated here, naturally via intermediaries. We followed the German and international press closely, collected legally checked documents, read reports from illegal anti-fascist organizations . . . We updated every chapter until the last minute, sometimes even standing next to the printing presses in Strasbourg. It was a race with time."[192]

This eye-witness account shows that resistance to the Nazis was not only taking place beyond the borders, but that it was organized in Germany from the very day the regime took power. In 1933 it was almost exclusively the work of the working-class parties and organizations which had been forced underground, but later they were joined by bourgeois and Christian groups. Support for this illegal campaign came from abroad in the form of leaflets, newspapers and pamphlets smuggled across the frontier.

The account about the making of the *Braunbuch* illustrates something else, too: for the first few months the exiles were highly optimistic that the fascists would not rule Germany for long. "Hitler's voodoo", as Brecht called it from Denmark, would quickly pass away. This optimism obviously lent considerable momentum to the resistance campaign. But from 1934 onwards, as the Nazis consolidated their dictatorship, expanded the network of concentration camps and visibly won millions of supporters and fellow-travellers to their side, it became clear that the exile was going to last longer.

Two German Nobel Prize-winners, Albert Einstein and Thomas Mann, came to symbolize Hitler's emigrant opposition in the eyes of the world. Both left Germany at the height of their fame. Albert Einstein was fifty-four when he gave his last lecture in Berlin in October 1932 and moved to the United States to continue his research and—as he put it—"turn my back on fascism". The scientific genius behind the Theory of Relativity had played an active part in the pacifist and socialist movement during the Weimar Republic, and he continued his political activities in exile. He used his internationally respected name to ensure that a number of appeals and manifestos were taken seriously, and there were countless emigrés who owed their livelihoods to him. His correspondence with Sigmund Freud was published in Paris from 1933 under the title *Warum Krieg?* (Why War?), and the book was one of the most widely acclaimed emigré publications in the early years. In Germany, meanwhile, he was described by Leers thus: "Invented an extremely controversial 'Theory of Relativity'. Was much celebrated by the Jewish press and the unsuspecting German nation, repaid this with fabricated horror stories about Adolf Hitler abroad (Non-hanged)."[193]

Whereas Einstein was with the anti-fascist movement from the outset, Thomas Mann followed a more tortuous path to active commitment. He had already received a package containing a singed and charred copy of his novel *Buddenbrooks* at his Baltic refuge Nidden in summer 1932. Mann spent 30 January 1933 at his home in Munich, and on 10 February he addressed a festive audience at Munich University to mark the fiftieth anniversary of Wagner's death, reading from his famous essay *Leiden und Grösse Richard Wagners* (The Suffering and Greatness of Richard Wagner). On 11 February Thomas Mann set off on a tour of Holland, Belgium and France, delivering this lecture, before spending a week on holiday in Arosa, Switzerland. It was there that he heard the news of the fire at the Reichstag. His children Klaus and Erika, who were preparing to emigrate, telephoned their father from Munich and warned him: "It was advisable to use a discreet form of expression; it was quite possible, even probable, that our conversations were being listened to. We were careful, therefore, not to refer directly to the political situation, and spoke instead of the weather. It was dreadful in and around Munich, we said, and our parents would do well to stay away for a while longer. Unfortunately our father was loath to accept this kind of argument . . . In the end we said what we meant with desperate directness. 'Stay in Switzerland! You wouldn't be safe here!' This time he understood."[194] On 13 March Thomas Mann sent a letter from Arosa to a family friend. It is a moving account of how Germany's highest-ranking writer wrestled with the decision to turn his holiday into exile. After wondering whether the present excesses in Germany were merely of a transitory nature, he continued: "If this nightmare drags on, I for my part must stay away—I still do not know where, perhaps in Tyrol or else in Zurich. Besides, the question is whether there is going to be room for people like me in Germany, and whether I shall be able to breathe the air there."

In Thomas Mann's case, the question was soon answered. By April or May he had decided not to return. Doubtless the burning books were the last straw for this man of liberal beliefs, even though his own works were not on the list. After travels in Switzerland and France,

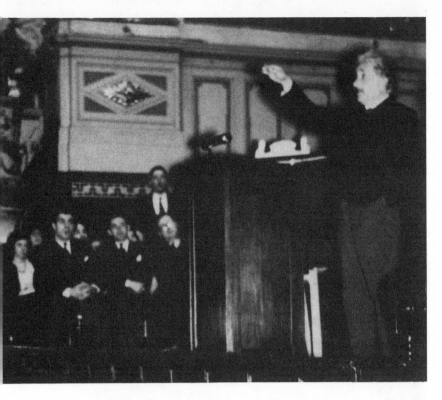

Farewell to Berlin: Albert Einstein's last public appearance was on 16 October 1932, when he gave a lecture in the Berlin Philharmonie in aid of impoverished students. He then accepted an invitation from the University of Pasadena (USA) and left Germany in order, as he stated unambiguously, "to turn my back on fascism".

Mann finally settled in Küsnacht near Zurich in October 1933. In the letter quoted above he predicted the effects: "I am far too good a German, and much too intimate with the cultural traditions and language of my country, for the idea of spending years, even the rest of my life in exile not to contain a very serious, fateful significance for me . . . At 57 such a loss of bourgeois existence to which one has grown accustomed and in which one was beginning to grow a little rigid cannot be a trivial matter. But I think my artistic pursuits have kept me supple enough to start afresh in a completely different context."[195]

For three years Thomas Mann devoted himself to his writing, partly at the insistence of his publishers, S. Fischer Verlag, who were still permitted to publish works by their star author in Germany and did not emigrate to Vienna until 1936. During this period he refrained from contact with the anti-fascist movement. It was not until November 1936 that he broke silence, notably in the

United States after 1938, and became the second symbol of German exile after Einstein.

Einstein was fifty-four when he left Germany, and Thomas Mann fifty-seven. They were both wealthy and never needed to renounce their former lifestyles when living abroad. But they were in the minority in this respect. Many emigrés suffered years of depressing and unworthy financial hardship, and for many of them this refugee existence became unbearable after a few years, especially when Hitler's army made its first lightning conquests and the prospect of an end to this barbarism disappeared into the distant future. So it was that many chose suicide. The list is a long one, and the names it bears must be counted among the victims of Nazi Germany, alongside those anti-fascists who were tortured to death in their own country. They included some of the best and most sensitive poets and philosophers of the Weimar Republic: the philosopher Theodor Lessing was murdered in Marienbad by two SA henchmen in August 1933; Kurt Tucholsky killed himself in Sweden in late 1935; Joseph Roth drank himself to death from sheer misery in Paris in 1939; the same year Ernst Toller hanged himself in a hotel room in New York. More tragedies were sparked off when France fell in 1940. Walter Hasenclever took poison at a concentration camp in Les Milles; art historian Carl Einstein drowned himself in the Pyrenees; Walter Benjamin took his own life at the Spanish frontier town of Port Bou after a border control had arrested him; novelist Ernst Weiss took poison when he caught sight of the Nazi troops marching into Paris through his hotel window.

Thomas Mann, by this time in the United States, wrote of the Weimar Republic in 1944: "Yes, it was strange, wonderful, a time worth living in and in every way a time worth retelling. The fact that it ended so badly, that a storm of blood, hatred and misery swallowed it all up, that a race entered the stage which regarded the concept of culture so dear to the times as a bourgeois obstacle on its path to revolution and pulled the revolver on it, that cannot dull the bright memories of what have now long since become the good old days. But we who are still living for the moment in this new, evil, yet by no means hopeless age, which deep down has not relinquished its quest for the

good, now understand more about the inner shortcomings of the cultural bliss we then experienced with its gentle worries and strenuous wit; it has confirmed doubts which many of us always secretly harboured about the solidity, the justification for our bliss.

"We have discovered that good cannot be consummated by what is aesthetically bold and attractive, that culture which 'is not interested in politics' and excludes social questions from its sphere of vision comes quite close to barbarism, and that a person of intellect shoulders greater responsibilities than problems of beauty. As we look back with you, this experience has made us richer and more mature."[196]

So what kind of a Republic had it been? Born as the worm-eaten Imperial Reich sank amid the ruins left by a world war and a post-war revolutionary crisis, it seemed to offer the arts great freedom, especially during the stabilization after 1924. There seemed no bounds to the artistic liberty inspired by the revolutionary transformations in Soviet Russia and by a fascination for American technology and mass culture. The market expanded, absorbing opinions and works of art of every political complexion.

High standards of bourgeois democratic art developed, but at the same time nationalism increased its arsenal of broadly effective works. Revolutionary proletarian culture blossomed.

As far as the overwhelming majority of intellectuals were concerned, it was true what Thomas Mann said in 1944: that "culture which 'is not interested in politics' comes quite close to barbarism". The Weimar Republic carried the seeds of its own destruction with it from the beginning because the relationship between intellect and power in its state structure had never been radically altered, because the old military and state apparatus was preserved, and because the interests of the imperialist monopolies remained basically the same as ever.

For more than a decade, most members of the artistic community did not pay any attention to the reactionary forces, let alone take them seriously. It was not until the alliance which set out to destroy the Republic had been firmly forged in late 1932 that many of them began to sense the impending disaster. This "stony path to under-

And thus did many cultural personalities set off abroad in 1933. With a harmless railway ticket for a town near the border in their pockets, a suitcase of bare necessities in the compartment, they took one last look as the train chugged out of the station at the artistic metropolis of the twenties, the scene of successes and failures which were now a thing of the past. Max Reinhardt at Berlin's Anhalter Bahnhof. He left the town as early as autumn 1932.

standing", as Feuchtwanger subtitled his novel *Goya*, was never trodden until it was too late.

This does not detract in any way from the stature of so many works of art to emerge from that era. They were created in a Republic which was never more than a stopgap, and which ultimately collapsed because the decisive questions of power and structure were never resolved.

Notes

1 *DZA Potsdam, Reichsamt des Inneren.* No. 12 328, F. 282. Quoted after: Hellmuth Weber, *Ludendorff und die Monopole.* Berlin, 1966, p. 52.

2 *Die Weimarer Republik. Ihre Geschichte in Texten, Bildern und Dokumenten.* Ed. by Friedrich A. Krummacher and Albert Wucher. Munich, Vienna, Basle, 1965, p. 27.

3 Hermann Herlinghaus, *Dokumente zur Vorgeschichte der Ufa.* Quoted after: Jerzy Toeplitz, *Geschichte des Films.* Vol. 1. Berlin, 1972, p. 140.

4 Hellmuth Weber, *Ludendorff und die Monopole.* Berlin, 1966, p. 132.

5 In: *Die Aktion.* Instalment 43/44 of 2 November 1918, column 558.

6 Stefan Zweig, *Die Welt von Gestern.* Frankfurt am Main, Hamburg, 1970, pp. 187–188.

7 Oskar Maria Graf, *Wir sind Gefangene.* Berlin, 1979, p. 290.

8 In: Bernhard Schwertfeger, *Das Weltkriegsende.* Potsdam, 1937, p. 91.

9 Bernhard Schwertfeger, "Die politischen und militärischen Verantwortlichkeiten im Verlauf der Offensive von 1918," in: *Das Werk des Untersuchungsausschusses der Deutschen Verfassungsgebenden Nationalversammlung und des Deutschen Reichstags 1919–1928.* Fourth series. Vol. 2. Berlin, 1925, p. 360.

10 Richard Dehmel, "Einzige Rettung," in: *Die Aktion.* Instalment 43/44 of 2 November 1918, column 557.

11 *Berlin 1917–1918. Berliner Parteiveteranen berichten über die Auswirkungen der Grossen Sozialistischen Oktoberrevolution auf die Berliner Arbeiterbewegung.* Berlin, 1957, p. 91.

12 *Illustrierte Geschichte der Novemberrevolution.* Berlin, 1968, p. 105.

13 *Die Rote Fahne. Ehemaliger Berliner Lokal-Anzeiger.* 9 November 1918.

14 Walter Oehme, *Damals in der Reichskanzlei.* Berlin, 1958, p. 112.

15 Franz Pfemfert, "Nationalversammlung ist Konterrevolution," in: *Die Aktion.* Instalment 45/46 of 30 November 1918, column 611–612.

16 *Plakat der Bremer Räterepublik.* III. in: Wolfgang Ruge, *Novemberrevolution.* Berlin, 1978, p. 138.

17 *Literaten an der Wand. Die Münchner Räterepublik und die Schriftsteller.* Ed. by Hansjörg Viesel. Frankfurt am Main, 1980, p. 767.

18 Hermann Sinsheimer, *Gelebt im Paradies.* Munich, 1953, p. 173.

19 "Stenographischer Bericht über die Sitzung der Berliner Stadtverordnetenversammlung am 15. Juli 1920," in: Hans Schulze, *5 Jahre Gross-Berlin. Ein wirtschaftshistorischer Rückblick und Beitrag zur Geschichte und Organisation der Reichshauptstadt.* Neustrelitz, 1927, pp. 52–54.

20 Walter Oehme, *Damals in der Reichskanzlei.* Berlin, 1958, p. 345.

21 Herbert Jhering, *Berliner Dramaturgie.* Berlin, 1947, pp. 10–11.

22 Carl Zuckmayer, *Als wär's ein Stück von mir.* Vienna, 1969, pp. 313–314.

23 Siegfried Melchinger, *Drama zwischen Shaw und Brecht.* Bremen, 1963, pp. 122–123.

24 Franz Marc, "Die 'Wilden' in Deutschland," in: *Der Blaue Reiter.* Munich, 1912. Quoted after: *Manifeste, Manifeste 1905–1933.* Ed. by Diether Schmidt. Dresden, 1965, p. 51.

25 Epilogue in: *Neue Jugend.* Instalment 7, 1916 (Herzfelde has bought the magazine, aimed at a school-age readership, and this issue was the first to carry his name as editor).

26 *Manifest der Novembristen* (draft). Quoted after: *Manifeste, Manifeste 1905–1933.* Ed. by Diether Schmidt. Dresden, 1965, pp. 156–157.

27 Jost Hermand, *Expressionismus.* Berlin, 1975, p. 9.

28 Alfred Kerr, *Mit Schleuder und Harfe. Theaterkritiken aus drei Jahrzehnten.* Berlin, 1981, p. 156.

29 Kasimir Edschmid, "Stand des Expressionismus," in: Edschmid, *Das beschämende Zimmer.* Leipzig, 1981, p. 197.

30 "Auch der frühere Kronprinz schreibt 'Erinnerungen'." Correspondent's Report. In: *Berliner Tageblatt.* 3 April 1919.

31 *1918. Erinnerungen von Veteranen der deutschen Gewerkschaftsbewegung an die Novemberrevolution.* Berlin, 1958, p. 331.

32 In: *Der Gegner.* Instalment 10–12. January-March, 1920, pp. 52–53.

33 "Flugblatt. Die 'Grüne Leiche'." In: Johannes Baader, *Oberdada. Schriften, Manifeste, Flugblätter, Billets, Werke und Taten.* Ed. by Hanne Bergius, Norbert Miller and Karl Riha. Giessen/Lahn, 1977, p. 49.

34 Eberhard Roters, "Mouvement Dada," in: *Katalog, Tendenzen der Zwanziger Jahre. 15. Europäische Kunstausstellung Berlin (West).* 1977, pp. 3–6.

35 "Dadaistisches Manifest, Flugblatt 1918," in: *Dada-Almanach.* Ed. by Richard Huelsenbeck. Berlin, 1920, p. 36.

36 Alfred Kerr: Oskar Kokoschka, "Der brennende Dornbusch"—"Hiob". In: Kerr, *Mit Schleuder und Harfe.* Berlin, 1981, p. 159.

37 "Dadaistisches Manifest, Flugblatt 1918," in: *Dada-Almanach.* Ed. by Richard Huelsenbeck. Berlin, 1920, p. 37.

38 Walter Mehring, "Berlin Simultan," in: *Das politische Cabaret.* Dresden, 1920, p. 45.

39 Kurt Tucholsky, *Dada.* Quoted after: *Dada Berlin. Texte, Manifeste, Aktionen.* Ed. by Karl Riha and Hanne Bergius. Stuttgart, 1977, p. 126.

40 George Grosz and Wieland Herzfelde, *Die Kunst ist in Gefahr.* Berlin, 1925, pp. 22 and 24.

41 Victor Klages, "Ein Protest," in: *Der Marstall.* No. 1/2, 1920, pp. 46/47.

42 Willy Mann, *Berlin zur Zeit der Weimarer Republik.* Berlin, 1957, p. 61.

43 Hans Ostwald, *Kultur- und Sittengeschichte Berlins.* Berlin, no date, pp. 603–604.

44 "Die Aufführung des Spartakus-Aufstandes," in: *Leipziger Volkszeitung.* 2 August 1920.

45 Oskar Maria Graf, *Wunderbare Menschen.* Berlin, 1976, p. 82.

46 Erwin Piscator, *Das politische Theater.* Berlin, 1929, p. 35.

47 ibid., pp. 44–45.

48 Quoted after: Wolfgang Ruge, *Deutschland von 1917 bis 1933*. Berlin, 1974, p. 249.

49 Quoted after: Günter F. Hallgarten, *Hitler, Reichswehr und Industrie*. Frankfurt am Main, 1955, p. 65.

50 Kurt Tucholsky, *Auswahl 1924 bis 1925*. Berlin, 1970, p. 283.

51 Ivan M. Fainger, *Die Entwicklung des deutschen Monopolkapitals*. Berlin, 1959, p. 23.

52 Egon Erwin Kisch, "Das giftige Königreich am Rhein," in: *Die Rote Fahne*. Berlin, 4 September 1927.

53 Wolfgang Ruge, *Deutschland . . .*, loc. cit., p. 287.

54 Kurt Tucholsky, *Auswahl 1924 . . .*, loc. cit., p. 388.

55 *Kunst und Technik*. Ed. by Leo Kestenberg. Berlin, 1930, p. 5.

56 *Gegen das Kinounwesen*. Stuttgart, 1919, p. 6.

57 ibid., p. 11.

58 *Die Weltbühne*. 11 March 1920.

59 This stands at the head of a section of Lotte H. Eisner's book: *Die dämonische Leinwand*. Wiesbaden, 1954 (first German edition).

60 Siegfried Kracauer, "Wiedersehen mit alten Filmen," in: *Basler Nationalzeitung*. 2 May 1939.

61 ibid.

62 Lotte H. Eisner, *Die dämonische Leinwand*, loc. cit., p. 323.

63 *Die Filmwoche*. Berlin, 10 January 1927.

64 *Frankfurter Zeitung*. 3 May 1927.

65 Jerzy Toeplitz, *Geschichte des Films*. Vol. 1. Berlin, 1972, p. 427.

66 *Die Rote Fahne*. Berlin, 1 January 1930.

67 *Der Film*. Berlin, 27 October 1930.

68 *Nachtausgabe*. Berlin, 1 April 1930.

69 Maurice Maeterlink, *Die vierte Dimension*. Stuttgart, 1929, pp. 142/143.

70 *Im Banne des Mikrofons*. Berlin, 1931, p. 244.

71 *Drei Jahre Berliner Rundfunkdarbietungen*. Berlin, 1927, p. 154.

72 *Die Funk-Stunde. Ein Jahrbuch*. Berlin, 1926, p. 211.

73 *Vortragsabend der Reichs-Rundfunkgesellschaft*. Berlin, 1928, p. 14.

74 Richard Woldt, "Der Arbeiterfunk der Deutschen Welle," in: Hans Bredow, *Aus meinem Archiv*. Heidelberg, 1950, p. 135.

75 *Die Weltbühne*. Berlin, 28 June 1921.

76 *A-I-Z*. Berlin, No. 41/1931.

77 "Gespräch mit Joseph Roth," in: *Het Volk*. Amsterdam, 31 May 1939.

78 *Die Weltbühne*. Berlin, 23 January 1928.

79 *Die Weltbühne*. Berlin, 2 June 1931.

80 Wieland Herzfelde, *John Heartfield*. Dresden, 1971, p. 113.

81 Quoted after: *Weltgalerie des schönen Buches*. Leipzig, 1982, p. 31.

82 Felix Langer, "Nackttanz," in: *Berliner Tageblatt*. 29 March 1920.

83 Friedrich Hollaender, *Von Kopf bis Fuss*. Berlin, 1967, p. 68.

84 Heinz Pollak, *Die Revolution des Gesellschaftstanzes*. Dresden, 1922, p. 71 f.

85 ibid.

86 Friedrich Hollaender, *Von Kopf bis Fuss*, loc. cit., p. 96.

87 Quoted after: Heinrich Greul, *Chansons der zwanziger Jahre*. Zurich, 1962, p. 108.

88 Sophie Lissitzky-Küppers, *El Lissitzky*. Dresden, 1976, p. 330.

89 ibid., p. 62.

90 *Manifeste, Manifeste*. Ed. by Diether Schmidt. Dresden, 1965, p. 26.

91 ibid., p. 277.

92 *Berliner Nachtausgabe*. 3 December 1927.

93 *Manifeste . . .*, loc. cit., p. 381.

94 Anatoli Lunacharski, *Die Revolution und die Kunst*. Dresden, 1962, p. 102.

95 *Manifeste . . .*, loc. cit., p. 321.

96 Franz Roh, *Nach-Expressionismus*. Leipzig, 1925, p. 119. These are extracts from his comparison.

97 Cf. Roland März's valuable introduction to the folder: *Malerei der Neuen Sachlichkeit*. Leipzig, 1984, p. 7 f.

98 *Wie sie einander sahen*. Munich, 1957, p. 214.

99 Jan Tschichold, "Typographische Mitteilungen," in: *elementare typographie*. Leipzig, 1925, p. 212.

100 Karin Hirdina, *Pathos der Sachlichkeit*. Berlin, 1981, p. 32.

101 *Manifeste . . .*, loc. cit., p. 231.

102 ibid., p. 302.

103 Karl W. Straub, *Die Architektur im Dritten Reich*. Stuttgart, 1931, p. 14.

104 Sophie Lissitzky-Küppers, *El Lissitzky*, loc. cit., p. 366.

105 Karin Hirdina, *Pathos der Sachlichkeit*, loc. cit., p. 206.

106 Rudolf Fernau, *Als Lied beganns*. Frankfurt am Main, 1972, p. 104.

107 *Berliner Tageblatt*. 6 April 1927.

108 *Fritz Kortner*. Ed. by Heinz Ludwig. Berlin, 1929, p. 50.

109 *100 Jahre Deutsches Theater*. Berlin, 1983, p. 90.

110 Marieluise Fleisser, *Ausgewählte Werke*. Berlin, 1979, p. 802.

111 Erwin Piscator, *Theater, Film, Politik*. Berlin, 1980, pp. 30/31.

112 ibid., p. 91.

113 *Blätter der Staatsoper Berlin*. October 1927, p. 12.

114 *Anbruch*. Vienna, 1/1929, p. 24.

115 *Der Scheinwerfer*. Essen, 14/1930, p. 113.

116 "Heinrich Strobel," in: *Thüringer Allgemeine Zeitung*. Erfurt, 25 November 1927.

117 In: *Experiment Krolloper*. Ed. by Hans Curjel. Munich, 1975, p. 8.

118 *Der Berliner Westen*. 30 May 1931.

119 *Die Weltbühne*. Berlin, 10 May 1932.

120 *Veröffentlichungen des RDI*. 49/1929, p. 11.

121 Kurt Pätzold, "Die faschistische Manipulation des deutschen Volkes," in: *Künstler und Künste im antifaschistischen Kampf 1933 bis 1945*. Berlin, 1983, p. 25.

122 *Wie kämpfen wir gegen ein Drittes Reich?* Berlin, 1931, p. 11.

123 Quoted after: Wolfgang Ruge, *Deutschland 1917 bis 1933*. Berlin, 1982, p. 361.

124 Quoted after: Lothar Berthold, *Das Programm der KPD zur nationalen und sozialen Befreiung des deutschen Volkes*. Berlin, 1956, p. 189.

125 *Die Antifaschistische Aktion*. Berlin, 1965, p. 65.

126 *Die Internationale*. Berlin, 6/1932, p. 287.

127 *Deutsche Allgemeine Zeitung*. Berlin, 6 December 1932.

128 Thomas Mann, *Deutsche Ansprache. Ein Appell an die Vernunft*. Berlin, 1930, p. 114.

129 Thomas Mann, "Konflikt in München," in: *Das Tagebuch*. Instalment 30 of 28 July 1928, p. 1318.

130 ibid., p. 1319.

131 Viktor Mann, *Wir waren fünf. Bildnis der Familie Mann*. Berlin, 1961, p. 337.

132 Thomas Mann, . . .

133 Klabund, *Deutsche Literaturgeschichte in einer Stunde*. Leipzig, 1921, p. 89.

134 Fritz Strich, *Dichtung und Zivilisation*. Munich, 1928, pp. 177–178.

135 Hartmut Böhme, "Zwischen Antibürgerlichkeit und Sozialismus: Alfred Döblin," in: *Sozialgeschichte der deutschen Literatur von 1918 bis zur Gegenwart*. Frankfurt am Main, 1981, p. 336.

136 Quoted after: *Geschichte der deutschen Literatur, 1917 bis 1945*. Vol. 10 of *Ge-*

schichte der deutschen Literatur von den Anfängen bis zur Gegenwart. Berlin, 1973, p.243.

137 H. von Wedderkop, "Literaturbetrieb," in: Der Querschnitt. Instalment 12, 1929, p.874.

138 Karl Foertsch, Der Kulturbolschewismus und die deutsche Jugend. 4th edition. Berlin, 1933, pp.6-7.

139 "Schulkampf im Landtag," in: Vossische Zeitung. 20 January 1933.

140 Quoted after: Elke Peters, Nationalsozialistisch-völkische Bildungspolitik in der Weimarer Republik. Weinheim, Basle, Vienna, 1972, pp.155-156/159.

141 Konrad Haenisch, Sozialdemokratische Kulturpolitik. Quoted after: Katalog: Theater in der Weimarer Republik. Berlin, 1977, p.563.

142 Artikel 146 der Verfassung der Weimarer Republik. Quoted after: Walter Ladé, Die Schule in der Reichsverfassung. Berlin, 1929, p.15.

143 Quoted after: Katalog: Theater in der Weimarer Republik. Berlin, 1977, p.551.

144 Edwin Hoernle, Schulpolitische und pädagogische Schriften. Berlin, 1958, p.563.

145 Quoted after: Katalog: Theater in der Weimarer Republik. Berlin, 1977, p.563.

146 Bar Kochba, "Huhu," in: Der Angriff. 17 July 1930.

147 Quoted after: Geschichte der deutschen Literatur, loc.cit., p.244.

148 Herbert Jhering, "'Im Westen nichts Neues' als Film," in: Berliner Börsen-Courier. 5 December 1930.

149 "Verlagsannonce," in: Börsenblatt für den deutschen Buchhandel. 10 July 1930.

150 "Severing sieht auch in der Uniform keine Hetze. Sondervorführung der amerikanischen Fassung im Mozartsaal," in: Preussische Kreuz-Zeitung. 12 December 1930.

151 "Sturm im Landtag. Kampf um den Hetzfilm," in: Deutsche Tageszeitung. 16 December 1930.

152 "Für die Untersagung des Films 'Im Westen nichts Neues'," in: Reichspost. Vienna, 17 December 1930.

153 "Nationale Solidarität im Remarquefilm," in: ibid., 24 December 1930.

154 Carl von Ossietzky, "Alle gegen Alle," in: Die Weltbühne. Instalment 53 of 30 December 1930.

155 Kampfmusik. Berlin, 5/1931, p.8.

156 Hanns Eisler, Musik und Politik. Schriften 1924–1928. Leipzig, 1973, p.162.

157 Hans Bunge, Fragen Sie mehr über Brecht. Munich, 1970, p.344.

158 Die Rote Fahne. Berlin, 12 October 1927.

159 Dortmunder Generalanzeiger. 17 November 1930.

160 Arbeiterbühne. Berlin, 3/1930. Quoted after: Helmut Damerius, Über zehn Meere zum Mittelpunkt der Welt. Berlin, 1977, p.71.

161 Quoted after: Arbeiterbühne und Film. Berlin, 4/1931, p.21.

162 Quoted after: Die Rote Fahne. Berlin, 29 April 1931.

163 Quoted after: Jürgen Schebera, Hanns Eisler im USA-Exil. Berlin, 1978, p.166.

164 Flugblatt. January 1932. Quoted after: Zur Geschichte der KPD. Berlin, 1955, p.352.

165 Kurt Pätzold, "Adolf Hitler," in: Sturz ins Dritte Reich. Leipzig, 1983, p.81.

166 Quoted after: Gerhart Hass, "Hermann Göring," in: ibid., p.104.

167 Quoted after: Braunbuch über Reichstagsbrand und Hitlerterror. Paris, 1933, p.130.

168 ibid., p.198.

169 ibid., p.183.

170 "Reichsminister Goebbels über die Aufgabe der Presse," in: Zeitungs-Verlag. Berlin, 18 March 1933. Quoted after: Joseph Wulf, Presse und Film im Dritten Reich. Frankfurt am Main, 1983, p.64.

171 Friedrich Zimmermann, "Einheitspresse," in: Münchner Neueste Nachrichten. 19 August 1933.

172 Tremonia. Düsseldorf, 3 August 1933. Quoted after: Joseph Wulf, Presse und Film im Dritten Reich, loc.cit., p.294.

173 Deutsche Allgemeine Zeitung. Berlin, 6 March 1933.

174 Quoted after: Joseph Wulf, Musik im Dritten Reich. Frankfurt am Main, 1983, p.23.

175 Bruno Walter, Thema und Variationen. Frankfurt am Main, 1950, p.419.

176 Deutsche Kultur-Wacht. 4/1932 of 15 February.

177 Quoted after: In jenen Tagen. Leipzig, 1983, p.219.

178 Friedrich Hussong, "Die Diaspora des Geistes," in: Der Tag. Berlin, 19 March 1933.

179 Quoted after: In jenen Tagen, loc.cit., p.267.

180 Deutsche Kultur-Wacht. 9/1933, p.6.

181 Braunbuch über Reichstagsbrand und Hitlerterror, loc.cit., p.153.

182 Börsenblatt für den deutschen Buchhandel. Leipzig, 1933, p.354.

183 Berliner Lokal-Anzeiger. 2 September 1933.

184 Deutsche Bühnenkorrespondenz. 4/5 1933, p.6.

185 Begleitheft zur Schallplatte 'Silverlake'. Nonesuch Records No.79003. Los Angeles, 1981.

186 Wie kämpfen wir gegen ein Drittes Reich? Berlin, 1931, p.11.

187 Heinrich Mann, Ein Zeitalter wird besichtigt. Berlin, 1973, p.344.

188 Egon Erwin Kisch, "In den Kasematten von Spandau," in: A-I-Z. Prague, 25 March 1933.

189 Ludwig Marcuse, Mein 20. Jahrhundert. Munich, 1960, p.133.

190 Wieland Herzfelde, "Als ich Deutschland verliess," in: Der Malik-Verlag 1916 bis 1947. Berlin, 1967, p.43.

191 Quoted after: F.C.Weiskopf, Unter fremden Himmeln. Berlin, 1948, p.48.

192 Alexander Abusch, Epilogue to the reprinted edition of Braunbuch über Reichstagsbrand und Hitlerterror. Frankfurt am Main, 1973, without pagination.

193 Johann von Leers, Juden sehen dich an. Berlin, 1933, p.28.

194 Klaus Mann, Der Wendepunkt. Berlin, 1974, p.371.

195 Thomas Mann, "Brief an Lavinia Mazuchetti," Arosa, 13 March 1933, in: Briefe 1881–1936. Berlin, 1968, p.365.

196 Thomas Mann, "Brief an Max Osborn," Pacific Palisades, 15 October 1944, in: Briefe 1937–1947. Berlin, 1965, p.423.

Synchronology

Year	Politics	Science & Economics	Literature, Theatre, Music	Art, Architecture, Film
1918	**March:** Peace Treaty of Brest-Litovsk **29 Oct.:** Sailors mutiny in Kiel **3 Nov.:** November Revolution begins **9 Nov.:** The Kaiser abdicates Republic proclaimed Government by Councils of People's Deputies **Dec.:** Reich Congress of Workers' and Soldiers' Councils **Dec.:** KPD founded **Nov.:** Armistice signed at Compiègne	Max Planck wins Nobel Prize for quantum theory Fritz Haber develops his industrial ammonia process	**Nov.:** Council of Intellectual Workers founded **Nov.:** Club Dada founded in Berlin Heinrich Mann *Der Untertan*	**Dec.:** *Novembergruppe* set up in Berlin Karl Schmidt-Rottluff, woodcut cycle *Ist euch nicht Kristus erschienen* (Did not Christ Appear to Ye)
1919	**Jan.:** General strike in Berlin; street fighting; Liebknecht and Luxemburg murdered **Jan.:** *Räterepublik* in Bremen **6 Feb.:** Constituent National Assembly in Weimar, Friedrich Ebert elected President **March:** Comintern founded in Moscow **March:** Hungarian *Räterepublik* **April:** Bavarian *Räterepublik* **29 June:** Versailles Peace Treaty signed **11 August:** Weimar Constitution enters force	**Feb.:** Reich Confederation of Industry (RDI) founded First all-metal aeroplanes for civilian use produced by Junkers in Dessau Rapid expansion of telephone network, especially in cities Universities founded in Hamburg and Cologne	**Sep.:** Ernst Toller's *Die Wandlung* at Tribüne theatre, Berlin (prod. Karlheinz Martin) **Oct.:** Leopold Jessner takes over as manager of Preussisches Staatstheater **Nov.:** Max Reinhardt opens his theatre in converted Grosses Schauspielhaus, Berlin Kurt Schwitters' *Anna Blume* Magazine *Der Dada* (Heartfield, Herzfelde, Grosz, Hausmann, Huelsenbeck)	**Jan.:** Workers' Art Council set up **Feb.:** *Gruppe 1919* founded in Dresden with Otto Dix **12 April:** Bauhaus opens in Weimar, Walter Gropius as Director Twentieth Century Gallery established in Berlin's Crown Prince Palace Hans Poelzig remodels Zirkus Schumann into the Grosses Schauspielhaus in Berlin
1920	**Feb.:** Hitler's National Socialist German Workers' Party (NSDAP) founded in Hofbräuhaus, Munich **March:** Kapp Putsch founders due to general strike, Red Ruhr Army puts down the coup in the Ruhr area **June:** Reichstag elections	**April:** First meeting of Reich Confederation of German Industry in Berlin **Oct.:** Hugo Stinnes founds the Rhine Elbe Union of companies Increasing concentration of capital in Germany	**Jan.:** Ferruccio Busoni takes over Master Class in Composition at Prussian Academy of Arts **Jan.:** First jazz records on sale in Germany **Oct.:** Erwin Piscator opens his Proletarian Theatre Ernst Jünger *In Stahlgewittern*	Max Liebermann becomes President of Prussian Academy of Arts Erich Mendelsohn builds Einstein Tower in Potsdam **June:** International Dada Fair in Berlin *Das Kabinett des Dr. Caligari* (Dir.: Robert Wiene) Otto Dix *Kriegskrüppel*

Year	Politics	Science & Economics	Literature, Theatre, Music	Art, Architecture, Film
1921	Workers take arms in Mansfeld **May:** United States and Germany sign peace treaty **July:** Adolf Hitler becomes Chairman of the NSDAP **Aug.:** International Workers' Aid (IAH) founded, chairman Willi Münzenberg **Dec.:** KPD and USPD merge	**May:** First trade treaty signed between Germany and Soviet Russia **June:** Friedrich Bergius demonstrates high-pressure hydrogenation of coal in Stuttgart **July:** Mittelland Canal opens Spiralling inflation	**May:** Erich Weinert appears in literary cabaret *Die Retorte*, Leipzig **July:** First Music Festival in Donaueschingen **Sep.:** Trude Hesterberg opens *Wilde Bühne* in Berlin **Nov.:** Konstantin Stanislavsky visits Berlin with Moscow Arts Theatre	**Oct.:** Grosz, Nagel, Kollwitz and other arts personalities organize IAH aid to Russia **Nov.:** Alexander Archipenko's Art School opens in Berlin *Der müde Tod* (Dir.: Fritz Lang) Käthe Kollwitz *Gedenkblatt für Liebknecht* (Commemorating Liebknecht) George Grosz *Das Gesicht der herrschenden Klasse*
1922	**April:** Rapallo Treaty **June:** Foreign Minister Walther Rathenau assassinated **Oct.:** Benito Mussolini marches on Rome, Fascist government in Italy **July:** Reichstag in Berlin passes Emergency Laws "to protect the Republic" **Nov.:** Chancellor Joseph Wirth resigns, replaced by Wilhelm Cuno *Deutschlandlied* becomes national anthem	AEG electricals company set up Triergon sound films patented in Berlin Germany's first lung operation using Ferdinand Sauerbruch's low-pressure method	**Sep.:** Munich *Trommeln in der Nacht*, Brecht wins Kleist Prize for his play **Oct.:** Thomas Mann *Von deutscher Republik* Oswald Spengler *Der Untergang des Abendlandes*	**1 May:** Walter Gropius's Monument to Those who Fell in March unveiled in Weimar Vassily Kandinsky joins Bauhaus **Sep.:** First sound film shown in Berlin, the process is a flop **Oct.:** Berlin stages Soviet Russia's first art exhibition abroad Käthe Kollwitz's *War Cycle* George Grosz *Ecce Homo* *Dr. Mabuse der Spieler* (Dir.: Fritz Lang)
1923	**Jan.:** Allies occupy Rhineland **Aug.:** Gustav Stresemann becomes Chancellor **Oct.:** First Enabling Act comes into force (decreed by government without consulting Parliament) **Oct.:** Hamburg Revolt **8 Nov.:** Hitler's Munich Putsch, thwarted next morning **30 Nov.:** Wilhelm Marx becomes Chancellor, Gustav Stresemann Foreign Minister	**Oct.:** First public radio broadcast from Vox-Haus Berlin **17 Nov.:** Rentenmark issued to end inflation Hjalmar Schacht becomes President of the Reichsbank **Dec.:** Decree on Countering the German Economic Crisis prolongs working day to 12 hours Hermann Oberth develops liquid-fuel rocket Institute of Social Research founded in Frankfurt am Main	**Jan.:** Dada magazine *Merz* in Hanover (Kurt Schwitters) **April:** Alexander Tairov visits Berlin with Moscow Studio Theatre **May:** Georg Kaiser's *Nebeneinander* (Side by Side) at Berlin's Lustspielhaus (Dir.: Berthold Viertel) Möller van den Bruck *Das dritte Reich* Johannes R. Becher *Maschinenrhythmen* Joachim Ringelnatz *Kuddel Daddeldu* Rainer Maria Rilke *Sonette an Orpheus*	**Aug.:** Bauhaus Week in Weimar and Jena **Nov.:** Charlie Chaplin's first full-length film *The Kid* in Germany **Oct.:** Funkstunde Berlin broadcasts first public concert of light music Georg Muche's Versuchshaus Am Horn in Weimar Otto Dix completes his *Schützengraben* (Trenches) Cycle George Grosz *Abrechnung folgt* (Accounts Will Be Settled) *Die Strasse* (Dir.: Karl Grune)
1924	**April:** Association of Red Front Fighters (Rotfront) founded **May:** Reichstag elections **1 Sep.:** Dawes Plan comes into force	**July:** Radio subscribers in Germany number 100,000 **Aug.:** Rentenmark replaced by Reichsmark Hugo Eckener first to cross Atlantic in a Zeppelin	**Jan.:** Kroll-Oper opens as Berlin's third opera house **Nov.:** First issue of *Arbeiter-Illustrierte-Zeitung (A-I-Z)* **Nov.:** Erwin Piscator *Revue Roter Rummel*	Ernst May takes over Town Planning at the Frankfurt Institute Cologne Cathedral fitted with the world's biggest bell

Year	Politics	Science & Economics	Literature, Theatre, Music	Art, Architecture, Film
	Adolf Hitler writes *Mein Kampf* during a reduced prison sentence **Dec.:** Reichstag elections	**Dec.:** First Berlin Radio Exhibition	**Dec.:** Kurt Robitschek opens *Kabarett der Komiker* Thomas Mann *Der Zauberberg*	*Der letzte Mann* (Dir.: F. W. Murnau) *Die Nibelungen* (Dir.: Fritz Lang)
1925	**Jan.:** Hans Luther becomes Chancellor **Feb.:** President Friedrich Ebert dies **April:** Paul von Hindenburg becomes President **Sep.:** SPD's Heidelberg Programme **Oct.:** Locarno Conference closes with Locarno Treaties **Nov.:** Ernst Thälmann elected Chairman of KPD	**May:** German Museum opens in Munich **May:** Reich Radio Association founded **Dec.:** IG Farben founded First electrical disc recordings on sale Bosch/Bergius develop their process for the industrial production of petrol First phototelegrams demonstrated in Berlin	**April:** The Charleston comes to Germany with the Chocolate Kiddies **Sep.:** Klabund's *Der Kreidekreis* in Hanover and Frankfurt am Main **Dec.:** Alban Berg's *Wozzeck* at Berlin Staatsoper Lion Feuchtwanger *Jud Süss* Franz Kafka *Der Prozess* (The Trial)	New Objectivity exhibitions in ten German cities Bruno Taut designs his first estate: Britz Horseshoe, Berlin Weimar Bauhaus closed on 14 October, Dessau offers Walter Gropius the chance to continue Prometheus-Film founded in Berlin by IAH Grosz/Herzfelde *Die Kunst ist in Gefahr* *Die freudlose Gasse* (Dir.: G. W. Pabst)
1926	**April:** Germany and Soviet Union sign neutrality agreement **May:** Chancellor Hans Luther resigns, succeeded by Wilhelm Marx **June:** Successful referendum on no compensation for deposed royalty **Sep.:** Germany joins League of Nations	Marxist Workers' School (MASCH) set up in Berlin Big steel company Vereinigte Stahlwerke founded Airline Deutsche Lufthansa AG founded **Feb.:** First Green Week Exhibition in Berlin **Oct.:** Conference of German and English industrialists in Ramsay ("Economic Locarno") Berlin Radio Tower opened **Dec.:** Adolf Hitler addresses Rhine industrialists	Literary Section opens at Prussian Academy of Arts, President: Walter von Molo Arnold Schönberg takes Master Class in Composition **Feb.:** Friedrich Hollaender's first revue in Berlin **Nov.:** Paul Hindemith's *Cardillac* at Dresden Staatsoper Johannes R. Becher *Levisite* Hans Grimm *Volk ohne Raum*	**April:** Sergei Eisenstein's *Battleship Potemkin* finally shown in Berlin after several bans **June:** Mies van der Rohe's Monument to the Revolution unveiled in Berlin **4 Dec.:** New Bauhaus Centre opens in Dessau Carl Einstein *Die Kunst des 20. Jahrhunderts* (20th-Century Art) *Berlin—Symphonie einer Grossstadt* (Dir.: Walter Ruttmann) *Metropolis* (Dir.: Fritz Lang)
1927	**April:** Emergency Law makes 10-hour working day compulsory **May:** State of Emergency "to protect the Republic" extended for two years **May:** SPD Congress in Cologne champions "organized capitalism" **Aug.:** Sacco and Vanzetti executed in USA **Aug.:** Emil Kirdorf represents coal and steel industry at NSDAP Congress	Nürburg Ring Race Track opens Laws passed regulating unemployment pay and employment exchange Ramon tests anti-tetanus vaccine American Charles Lindbergh makes first solo non-stop flight across Atlantic in single-engine aeroplane	**Feb.:** Ernst Krenek's *Jonny spielt auf* at Leipzig Opera House **July:** German Festival of Chamber Music moves from Donaueschingen to Baden-Baden Musical *Mahagonny* by Bertolt Brecht and Kurt Weill provokes scandal **Sep.:** Piscator's first theatre opens with Ernst Toller's *Hoppla, wir leben* Revue *Rund um die Gedächtniskirche* in Berlin **Oct.:** Moscow's *Blue Shirt* agitprop company tours Germany	Weissenhof Estate opened at Craft League Exhibition in Stuttgart Bruno Taut expounds Functionalist approach to family house Provincial government orders revolutionary murals to be removed from Barkenhoff Children's Home in Worpswede (former home of artist Heinrich Vogeler) El Lissitzky designs Abstract Room in Hanover's Provincial Museum European Exhibition of Decorative Arts in Leipzig

Year	Politics	Science & Economics	Literature, Theatre, Music	Art, Architecture, Film
			Nov.: Otto Klemperer becomes Director of Kroll-Oper Bertolt Brecht *Hauspostille* (Die Hauspostille: A Manual of Piety)	Paul von Hindenburg and Erich Ludendorff unveil Tannenberg Monument in Hohenstein Alfred Hugenberg becomes Chairman of Ufa Board
1928	**May:** Reichstag elections Seats: SPD 153, Nationals 73, KPD 54, NSDAP 12 **May:** Hermann Müller becomes Chancellor **July:** Amnesty for political prisoners (Max Hoelz freed on 18 July) **Aug.:** Kellogg Pact signed in Paris **Oct.:** People's referendum to halt battleship production fails Alfred Hugenberg becomes Chairman of German National People's Party Joseph Goebbels *Kampf um Berlin* (The Battle for Berlin)	Deutsche Bank Annual Report: "The boom is yielding to regressive trends" **Dec.:** 2.8 million jobless Ocean vessels "Europa" and "Bremen" launched in Hamburg and Bremen Opel and Valier's Rocket Car reaches 238 k.p.h. on test drive Hermann Köhl and Ehrenfried Hünefeld first Germans to fly across Atlantic in aeroplane "Graf Zeppelin" airship starts passenger service Germany-USA	**June:** Piscator's first theatre closes **31 Aug.:** Brecht/Weill's *Die Dreigroschenoper* at Berlin Schiffbauerdamm **Oct.:** Association of Revolutionary Proletarian German Writers (BPRS) **Dec.:** Peter Martin Lampel *Revolte im Erziehungshaus* by *Gruppe Junge Schauspieler* Anna Seghers *Aufstand der Fischer* Ludwig Renn *Krieg* Friedrich Wolf *Kunst ist Waffe*	**Jan.:** Association of Revolutionary German Fine Artists (ARBDK/"Asso") founded in Berlin and Dresden Heinrich Zille's 70th birthday **Feb.:** Hannes Mayer becomes Bauhaus Director El Lissitzky designs Soviet Pavilion for Pressa Exhibition in Cologne Technical Town Exhibition in Dresden Blasphemy trial against George Grosz and Wieland Herzfelde after *Christus mit der Gasmaske*
1929	**Feb.:** Alfred Rosenberg founds Fighting League of German Culture in Munich **March:** International Anti-Fascist Congress in Berlin (Chaired by Henri Barbusse) Bloody May in Berlin (33 dead) **Aug.:** Hague Conference on reparations adopts Young Plan **Oct.:** Petition for referendum on Young Plan fails KPD founds Association of Labour Culture (IfA) as umbrella organization for proletarian cultural work Sklarek brothers corruption scandal	**May:** First experimental TV transmission in Berlin **May:** Opel sold to General Motors **June:** General Electric buys 25 per cent of AEG shares **24 Oct.:** Black Friday on Wall Street provokes world economic crisis **Dec.:** RDI memo "Rise or Fall" Kodak patents 16 mm colour reversal film First German talkies Albert Einstein works on his unified field theory	**March:** Marieluise Fleisser *Pioniere in Ingolstadt* (Pioneers in Ingolstadt) at the Theater am Schiffbauerdamm **April:** Max Brand's *Maschinist Hopkins* at Duisburg Opera House **June:** Paul Hindemith's *Neues vom Tage* at Kroll-Oper **July:** Kurt Weill and Paul Hindemith compose Brecht's *Lindberghflug* for Baden-Baden **Sep./Oct.:** Piscator's second theatre stages Walter Mehring's *Der Kaufmann von Berlin* Werner Finck opens the *Katakombe* Cabaret Franz Lehár *Das Land des Lächelns* (Land of Smiles) Erich Maria Remarque *Im Westen nichts Neues* Alfred Döblin *Berlin Alexanderplatz* Erich Kästner *Emil und die Detektive* Thomas Mann awarded Nobel Prize for Literature	Breslau: Craft League Exhibition on the living and working environment Berlin exhibition to mark Paul Klee's 50th birthday **May:** Foundation stone laid for new Berlin Radio Centre in Masurenallee Mies van der Rohe designs German Pavilion for World Exhibition in Barcelona Ernst Barlach completes his *Magdeburger Mal* August Sander *Antlitz der Zeit* (Profile of the Times), a collection of photos

Year	Politics	Science & Economics	Literature, Theatre, Music	Art, Architecture, Film
1930	**Jan.:** Wilhelm Frick in Thuringia first Nazi to take ministerial post in a provincial government **Feb.:** Horst Wessel shot dead during street fighting in Berlin **March:** Chancellor Hermann Müller resigns, succeeded by Heinrich Brüning **March:** Young Plan comes into force **June:** Allies pull out of Rhineland **June:** KPD resolution to "Smash the fascists wherever you find them!" **June/July:** Strike by 13,000 Mansfeld copper workers **July:** Brüning Cabinet issues new Emergency Decrees **Aug.:** KPD's Programme on the National and Social Liberation of the German People **Sep.:** Reichstag elections Seats: SPD 143, NSDAP 107, KPD 77, Nationals 41 Alfred Rosenberg *Der Mythos des 20. Jahrhunderts*	**March:** 3.5 million unemployed Reich Association of Agricultural Co-operatives founded, named after Raiffeisen Max Horkheimer and Theodor W. Adorno found the Frankfurt School of Critical Theory Max Planck becomes President of the Kaiser Wilhelm Society for the Promotion of Science Walter Reppe develops acetylene chemistry Hugo Junkers builds first heavy oil aeroplane engine Junkers' designer Schmidt produces jet engine Hungry Christmas in Germany State of Emergency from 25 Dec.	**March:** Brecht/Weill's *Aufstieg und Fall der Stadt Mahagonny* at Leipzig Opera House **June:** New Music Festival moves from Baden-Baden to Berlin **Sep.:** Ernst Toller's *Feuer aus den Kesseln* at Theater am Schiffbauerdamm **Oct.:** Nazis throw stink bombs during *Mahagonny* at Frankfurt Opera House **Dec.:** Brecht/Eisler's *Die Massnahme* with workers' choirs at Berlin Philharmonie First competition for the Year's Finest Books, Hugo Steiner-Prag heads the jury Ludwig Renn *Nachkrieg* (Postwar) Lion Feuchtwanger *Erfolg* Robert Musil *Der Mann ohne Eigenschaften* Walter Hasenclever *Napoleon greift ein* (Napoleon Intervenes) Ernst Jünger *Die totale Mobilmachung*	Berlin Museums Centenary **Aug.:** Hannes Mayer dismissed as Director of Bauhaus, replaced by Mies van der Rohe **Nov.:** Wilhelm Frick orders works by Ernst Barlach, Paul Klee, Vassily Kandinsky et al. to be "removed" from Weimar **Dec.:** Nazi riots at showings of American film *All Quiet on the Western Front* in various towns force ban on film George Grosz *Das neue Gesicht der herrschenden Klasse* (The New Face of the Ruling Class) Otto Dix completes his *Krieg* (War) triptychon *Der blaue Engel* (Dir.: Joseph von Sternberg) *Westfront 1918* (Dir.: G. W. Pabst) *Die drei von der Tankstelle* (Dir.: Wilhelm Thiele)
1931	**Oct.:** Harzburg Front between NSDAP, DNVP, paramilitary Stahlhelm and heavy industry **Nov.:** Carl von Ossietzky sentenced to 18 months' prison for article in *Weltbühne* **Dec.:** Iron Front formed between Reichsbanner, trade unions and Social Democratic sports organizations	**Jan.:** 5 million unemployed Growing number of banks collapse (Darmstädter Nationalbank, Dresdner Bank, Bank für Handel und Industrie) **Sep.:** Gustav Krupp becomes RDI Chairman	**May:** New Music Festival in Munich with works by Carl Orff, Werner Egk and Wolfgang Fortner **July:** Prussian government votes to close Kroll-Oper, opposed by KPD Gustav von Wangenheim's *Die Mausefalle* in Berlin (*Gruppe Junge Schauspieler*) Deutsche Bücherei in Leipzig starts publishing *Deutsche Nationalbibliographie* Heinrich Mann becomes President of Literature Section of Prussian Academy of Arts	**April/May:** Photomontage Exhibition in Berlin Museum of Decorative Arts Hans Poelzig builds IG Farben offices at Frankfurt am Main Otto Nagel *Wedding-Familie* (Family from Wedding) *Die Dreigroschenoper* (Dir.: G. W. Pabst) Bertolt Brecht and Kurt Weill take film company Nero to court before reaching settlement *Berlin Alexanderplatz* (Dir.: Piel Jutzi) *Der Kongress tanzt* (Dir.: Erik Charell)

Year	Politics	Science & Economics	Literature, Theatre, Music	Art, Architecture, Film
1932	**Jan.:** Adolf Hitler addresses Düsseldorf Industrial Club **April:** Presidential elections (2nd round). KPD slogan: "A vote for Hindenburg is a vote for Hitler. A vote for Hitler is a vote for war!" SPD slogan: "Smash Hitler! Vote for Hindenburg!" Votes (in millions): Hindenburg 19.4 Hitler 13.4 Thälmann 3.7 **April:** Provincial elections. Considerable losses for bourgeois parties whose voters desert for Hitler **15 May:** KPD calls for united anti-fascist front **1 June:** Franz von Papen becomes Chancellor (Barons' Cabinet) **10 July:** Anti-fascist conference in Berlin: "We are anti-fascists by deed." **July:** Reichstag elections. Seats: NSDAP 230, SPD 133, KPD 89, Nationals 37 **Aug.:** Hermann Göring President of Reichstag **6 Nov.:** New Reichstag elections. Seats: NSDAP 196, SPD 121, KPD 100, Nationals 52 **17 Nov.:** Franz von Papen resigns **3 Dec.:** Kurt von Schleicher forms Cabinet	**Jan.:** 6 million unemployed **Sep.:** Presidential Decree "to revive the economy" orders more wage cuts **Oct.:** 7.5 million unemployed, 4 million on short week About 2.5 million jobless disqualified from all forms of benefit German industrial capacity operating at 25 per cent National income down to 25,700 million Marks (1929: 44,500 million) **July:** Lausanne Conference decides to end payments of German reparations and demands once-off compensation of 3,000 million gold Marks **Dec.:** Industrial output at 58 per cent of 1928 level Werner Heisenberg discovers the atom can be split Gerhard Domagk discovers therapeutic properties of sulphonamides Hermann Staudinger publishes his paper on the chemical structure of cellulose	**Jan.:** Brecht's *Die Mutter* in Berlin (*Gruppe Junge Schauspieler*) **June:** Paul Hindemith's Plön Music Festival **Oct.:** Police ban meeting of League for the Protection of German Writers (SDS) in Berlin to mark 30th anniversary of Emile Zola's death Centenary of Goethe's death celebrated across Germany. Thomas Mann addresses his Goethe Speech in Munich to young people in particular Else Lasker-Schüler wins Kleist Prize Herbert Eulenberg's *Thomas Münzer* in Leipzig Fritz von Unruh's *Zero* in Frankfurt am Main Walter Hasenclever's *Christoph Columbus* in Leipzig Anna Seghers *Die Gefährten* (The Companions) Hans Fallada *Kleiner Mann—was nun?* Malik anthology of modern German short stories *30 neue Erzähler des neuen Deutschland* Joachim Ringelnatz *Gedichte dreier Jahre* (Three Years' Poems) Edwin Erich Dwinger *Deutsche Passion* (German Passion) Hans and Lea Grundig open cabaret *Linkskurve* in Dresden with support from BPRS Paul Hindemith's *Philharmonisches Konzert* (Philharmonic Concerto) in Berlin conducted by Furtwängler	Nazi/National majority on Dessau Town Council order Bauhaus to close on 30 September Nazi majority on Essen Town Council enforces dismissal of all teachers at Folkwang School on 30 June **July:** Big Käthe Kollwitz exhibition in Wedding, Berlin **Oct.:** Mies van der Rohe continues running Bauhaus as private school in Steglitz, Berlin Cuts in provincial budgets lead to closure of state art colleges in Königsberg, Breslau and Kassel Slatan Dudow's *Kuhle Wampe* permitted to show after several bans Carl Hofer *Maskentanz* (Masked Ball) Hans Grundig *Demonstration mit Polizei* (Demonstration with Police) The box-office hit is *Peter Voss, der Millionendieb* (The Man Who Stole Millions) (Dir.: Hans Deppe) Oskar Schlemmer's painting *Die Bauhaustreppe* (Bauhaus Stairs) Rudolf Arnheim *Film als Kunst* (Film as Art)
1933	**22 Jan.:** Nazis demonstrate outside KPD's Liebknecht-Haus in Berlin **28 Jan.:** Kurt von Schleicher resigns **30 Jan.:** KPD's last-minute appeal for united front and general strike rejected by SPD leaders:	**24 March:** Official RDI Address to thank Adolf Hitler **April:** Metallurgy Research Society founded to develop new weapons **May:** National Motorway Plan launched	**18 Feb.:** Triple première for Georg Kaiser/Kurt Weill's *Der Silbersee* in Leipzig, Magdeburg and Erfurt. Banned in early March in all three towns after few performances **April:** Blacklists of banned writers and publishers	**30 Jan.:** SA disrupts Berlin branch meeting of Artists' Association **Feb./March:** Purge of Prussian Arts Academy. Max Liebermann resigns as Honorary President, many artists and writers follow suit or are barred

Politics

"The fight must take place within the framework of the Constitution!"

30 Jan.: Paul von Hindenburg asks Adolf Hitler to form a new government—Nazis celebrate their "seizure of power"

27 Feb.: Reichstag fire

28 Feb.: KPD banned

5 March: Last Reichstag elections in Germany. Seats: NSDAP 288, SPD 120, KPD 81—KPD mandates declared invalid and warrants issued for the deputies' arrest

20 March: First concentration camp opens in Dachau

24 March: Hitler's Enabling Act forces Parliament into complete acquiescence

22 June: SPD banned

14 July: Law against re-founding of parties—NSDAP only party in Germany

Science & Economics

Sep.: IG Farben memo on capacity to produce unlimited quantities of industrial fuel

Oct.: Deutsche Bank submits Colonization Plan to Hitler

Dec.: Feder-Bosch Agreement spurs petrol production

Friedrich Krupp AG produces first air-cooled Diesel engines for road vehicles

Hundreds of well-known professors and lecturers, including Albert Einstein, lose their posts

Prominent scientists who leave Germany by 1939 total:
170 chemists
82 physicists
311 doctors
50 biologists
41 physiologists
107 economists

Literature, Theatre, Music

20 April: Newly formed Preussisches Staatstheater opens under Hanns Johst and Franz L. Ulbrich (from February 1934 Gustaf Gründgens) with Johst's play *Schlageter*. Quote from script: "Whenever I hear the word culture, I reach for my Browning." This unprecedented "intellectual exodus" from Germany also affected the arts. About 3,000 artists, writers, musicians, journalists and other cultural figures had emigrated by 1939. They included almost every prominent writer in the German language.

Art, Architecture, Film

April: Purge of Dresden Art Academy, Otto Dix loses his teaching post

11 April: Bauhaus finally closed down in Berlin as "hotbed of cultural Bolshevism"

First displays of "degenerate" art in Germany

Selected Bibliography

This selected bibliography has been drawn from some of the more comprehensive surveys of politics, economics, culture, literature and art in the Weimar Republic. Readers with a special interest in the subject might like to refer to the most detailed bibliography published to date: *From Weimar to Hitler. Germany 1918–1933. A Bibliography.* London, 1964. Another useful reference work is Bode, Ingrid: *Die Autobiographien zur deutschen Literatur, Kunst und Musik 1900–1965. Bibliographie und Nachweise der persönlichen Begegnungen und Charakteristiken.* Stuttgart, 1966. Much of the more recent secondary literature on the Weimar Republic is listed in John Willett's selected bibliography in: *The New Sobriety. Art and Politics in the Weimar Period 1917–1933.* London, 1979.

Politics

BERLIN, JÖRG: *Die deutsche Revolution 1918/19. Quellen und Dokumente.* Cologne, 1979.

BERTHOLD, LOTHAR, and HELMUT NEEF: *Militarismus und Opportunismus gegen die Novemberrevolution.* Berlin, 1978.

BOCK, HANS MANFRED: *Syndikalismus und Linkskommunismus von 1918–1923. Zur Geschichte und Soziologie der Freien Arbeiter-Union Deutschlands (Syndikalisten), der Allgemeinen Arbeiter-Union Deutschlands und der Kommunistischen Arbeiter-Partei Deutschlands.* Meisenheim am Glan, 1969.

BRACHER, KARL DIETRICH: *Die Auflösung der Weimarer Republik. Eine Studie zum Problem des Machtverfalls in der Demokratie.* Villingen, 1964.

Braunbuch über Reichstagsbrand und Hitlerterror. Basle, 1933. New impression, Berlin, 1980.

CARLEBACH, EMIL: *Hitler war kein Betriebsunfall. Hinter den Kulissen der Weimarer Republik.* Frankfurt am Main, 1983.

CRAIG, GORDON A.: *Geschichte Europas im 19. und 20. Jahrhundert. Vol. 2: Vom Ersten Weltkrieg bis zur Gegenwart (1914–1945).* Munich, 1979.

Das Ende der Parteien 1933. Darstellungen und Dokumente. Ed. by Erich Matthias and Rudolf Morsey. Düsseldorf, 1979.

Deutsche Demokraten. Die nichtproletarischen demokratischen Kräfte in der deutschen Geschichte 1830 bis 1945. Ed. by Dieter Fricke. Berlin, 1981.

ERDMANN, KARL DIETRICH: *Die Weimarer Republik.* Munich, 1981.

FÜLLBERTH, GEORG, and JÜRGEN HARRER: *Die deutsche Sozialdemokratie 1890–1933.* Darmstadt, Neuwied, 1974.

Geschichte der deutschen Arbeiterbewegung. Vol. 2: Vom Ausgang des 19. Jahrhunderts bis 1917. Vol. 3: 1917 bis 1923. Vol. 4: 1924 bis 1933. Berlin, 1966.

HABEDANK, HEINZ: *Der Feind steht rechts. Bürgerliche Linke im Kampf gegen den deutschen Militarismus (1925–1933).* Berlin, 1965.

HALLGARTEN, GEORG F. W.: *Hitler, Reichswehr und Industrie. Zur Geschichte der Jahre 1918–1933.* Frankfurt am Main, 1955.

HANNOVER, HEINRICH, and ELISABETH HANNOVER-DRÜCK: *Politische Justiz 1918–1933.* Frankfurt am Main, 1977.

HEIBER, HELMUT: *Die Republik von Weimar.* Munich, 1966.

Illustrierte Geschichte der deutschen Novemberrevolution. Group of authors under the leadership of Günter Hortzschansky. Berlin, 1978.

Klassenkampf, Tradition, Sozialismus. Grundriss. Berlin, 1974.

KOCH, HARALD: *Von der Weimarer Verfassung zur Hitlerdiktatur.* Dortmund, 1978.

NUSS, KARL: *Militär und Wiederaufrüstung in der Weimarer Republik.* Berlin, 1977.

OPITZ, REINHARD: *Der deutsche Sozialliberalismus 1917–1933.* Cologne, 1973.

PÄTZOLD, KURT: *Faschismus, Rassenwahn, Judenverfolgung. Eine Studie zur politischen Strategie und Taktik des faschistischen Imperialismus 1933–1935.* Berlin, 1975.

PETZOLD, JOACHIM: *Die Demagogie des Hitlerfaschismus. Zur politischen Funktion der Naziideologie auf dem Weg zur faschistischen Diktatur.* Berlin, 1982.

Reich und Republik. Deutschland 1917–1933. Ed. by Karlheinz Dederke. Stuttgart, 1975.

RUGE, WOLFGANG: *Deutschland 1917–1933.* Berlin, 1974.

RUGE, WOLFGANG: *Novemberrevolution. Die Volkserhebung gegen den deutschen Imperialismus und Militarismus 1918/19.* Berlin, 1978.

RUGE, WOLFGANG: *Weimar — Republik auf Zeit.* Berlin, 1969.

SCHREINER, ALBERT: *Zur Geschichte der deutschen Aussenpolitik 1891–1945.* Berlin, 1955.

SNYDER, LOUIS L.: *The Weimar Republic.* New York, 1966.

SONTHEIMER, KURT: *Antidemokratisches Denken in der Weimarer Republik. Die politischen Ideen des deutschen Nationalsozialismus zwischen 1918 und 1933.* Munich, 1964.

Sozialdemokratische Arbeiterbewegung und Weimarer Republik. Ed. by Wolfgang Kuthardt. 2 vols. Frankfurt am Main, 1978.

Sturz ins Dritte Reich. Ed. by Helmut Bock. Leipzig, 1983.

TORMIN, WALTER: *Zwischen Rätediktatur und sozialer Demokratie. Die Geschichte der Rätebewegung in der deutschen Revolution 1918/19.* Düsseldorf, 1954.

Traditionen deutscher Justiz. Grosse politische Prozesse der Weimarer Zeit. Ein Lesebuch zur Weimarer Republik. Ed. by Kurt Kreiler. Berlin (West), 1979.

WEBER, HELLMUTH: *Ludendorff und die Monopole.* Berlin, 1966.

Die Weimarer Republik. Ihre Geschichte in Texten, Bildern und Dokumenten. Ed. by Friedrich A. Krummacher and Albert Wucher. Munich, Vienna, Basle, 1965.

Die Zerstörung der Weimarer Republik. Ed. by Reinhard Kühnl and Gerd Hardach. Cologne, 1979.

Zur Geschichte der Kommunistischen Partei Deutschlands. Eine Auswahl von Dokumenten und Materialien aus den Jahren 1914 bis 1946. Berlin, 1955.

Economics and Science

FAINGAR, IVAN M.: *Die Entwicklung des deutschen Monopolkapitals.* Berlin, 1959.

FÜRST, ARTUR: *Das Weltreich der Technik. Entwicklung und Gegenwart.* Vol. 2. Berlin, 1924.

GOSSWEILER, KURT: *Grossbanken, Industriemonopole, Staat.* Berlin, 1975.

HARDACH, KARL: *Wirtschaftsgeschichte Deutschlands im 20. Jahrhundert.* Göttingen, 1976.

HENNING, F. W.: *Das industrialisierte Deutschland 1914 bis 1972.* Paderborn, 1974.

Industrielle Systeme und politische Entwicklung in der Weimarer Republik. Ed. by Hans Mommsen, Dietmar Petzina and Bernd Weisbrod. Kronberg (Taunus), Düsseldorf, 1979.

KUCZYNSKI, JÜRGEN: *Darstellung und Lage der Arbeiter in Deutschland von 1917/18 bis 1932/33.* Berlin, 1966.

Monopole und Staat in Deutschland 1917–1945. Berlin, 1973.

Die Staats- und Wirtschaftskrise des Deutschen Reiches 1919/33. Ed. by Werner Conze and Hans Raupach. Stuttgart, 1967.

VARGA, EUGEN: *Die Krise des Kapitalismus und ihre Folgen.* Frankfurt am Main, 1969.

WEIHER, SIEGFRIED: *Berlins Weg zu Elektropolis.* Berlin (West), Munich, 1974.

Comprehensive presentations on the history of art and civilization

Dichter, Maler und Cafés. Ed. by Ludwig Kunz. Zurich, 1973.

EVERETT, SUSANNE: *Lost Berlin.* London, Chicago, 1979.

FÜHR, CHRISTOPH: *Zur Schulpolitik in der Weimarer Republik.* Weinheim, 1972.

GAY, PETER: *Weimar Culture.* New York, 1968. In German: *Die Republik der Aussenseiter. Geist und Kultur in der Weimarer Zeit: 1918–1933.* Frankfurt am Main, 1970.

Geschichte der Körperkultur in Deutschland. Vol. 3: *Die Körperkultur in Deutschland 1917–1945.* Ed. by Wolfgang Eichel et al. Berlin, 1969.

GLATZER, DIETER and RUTH: *Berliner Leben 1914–1918. Eine historische Reportage aus Erinnerungen und Berichten.* Berlin, 1983.

GRIMM, REINHOLD, and JOST HERMAND: *Die sogenannten zwanziger Jahre.* Bad Homburg, Berlin (West), Zurich, 1970.

HASS, HERMANN: *Sitte und Kultur in Nachkriegsdeutschland.* Hamburg, 1932.

HAUSER, ARNOLD: *Sozialgeschichte der Kunst und Literatur.* Munich, 1967.

HERMAND, JOST, and FRANK TROMMLER: *Die Kultur der Weimarer Republik.* Frankfurt am Main, Vienna, 1976.

Im Namen des Volkes! Rote Hilfe gegen Polizeiterror und Klassenjustiz. Arbeiterkorrespondenz. Gefängnisbriefe. Gerichtsreportagen. Kurzgeschichten. Gedichte. Zeichnungen. Bilder und Dokumente aus den Jahren 1919–1933. Berlin, 1976.

KIAULEHN, WALTER: *Berlin. Schicksal einer Weltstadt.* Munich, 1968.

KOSZYK, KURT: *Deutsche Presse 1914–1945.* Berlin (West), 1972.

KREUZER, HELMUT: *Die Boheme. Analyse und Dokumentation der intellektuellen Subkultur vom 19. Jahrhundert bis zur Gegenwart.* Stuttgart, 1971.

KUCZYNSKI, JÜRGEN: *Geschichte des Alltags des deutschen Volkes. Studien.* Vol. 4: *1871–1918.* Vol. 5: *1918–1945.* Berlin, 1982.

KURUCZ, JENOE: *Struktur und Funktion der Intelligenz während der Weimarer Republik.* Cologne, Berlin, 1967.

LANGE, ANNEMARIE: *Das Wilhelminische Berlin. Zwischen Jahrhundertwende und Novemberrevolution.* Berlin (West), 1967.

LAQUEUR, WALTER: *Weimar: A Cultural History 1918–1933.* London, 1974. In German: *Weimar: Die Kultur der Republik.* Berlin (West), Frankfurt am Main, Vienna, 1976.

MENDELSOHN, PETER DE: *Zeitungsstadt Berlin.* Berlin, 1959.

OSTWALD, HANNS: *Sittengeschichte der Inflation.* Berlin, 1931.

Das proletarische Kind. Zur Schulpolitik und Pädagogik der KPD in den Jahren der Weimarer Republik. Berlin, 1974.

ROH, FRANZ: *German Art in the Twentieth Century.* New York, 1968.

Theater in der Weimarer Republik. Ed. by Kunstamt Kreuzberg und Institut für Theaterwissenschaft der Universität Köln. Berlin (West), 1977.

THIEL, ERIKA: *Künstler und Mode.* Berlin, 1979.

Wem gehört die Welt. Kunst und Gesellschaft in der Weimarer Republik. Ed. by Neue Gesellschaft für Bildende Kunst. Catalogue. Berlin (West), 1977.

WERNER, BRUNO E.: *Die zwanziger Jahre.* Munich, 1962.

WILLETT, JOHN: *The New Sobriety. Art and Politics in the Weimar Period 1917–1933.* London, 1979. In German: *Explosion der Mitte. Kunst + Politik 1917–1933.* Munich, 1981.

WILLETT, JOHN: *The Weimar Years.* London, 1983.

Die Zeit ohne Eigenschaften. Ed. by Leonhard Reinisch. Stuttgart, 1961.

Literature, Theatre, Music

Angewandte Musik der 20er Jahre. Exemplarische Versuche gesellschaftsbezogener Arbeit für Theater, Film, Radio, Massenveranstaltungen. Ed. by Dietrich Stern. Berlin (West), 1977.

ALBRECHT, FRIEDRICH: *Deutsche Schriftsteller in der Entscheidung. Wege zur Arbeiterklasse 1918–1933.* Berlin, Weimar, 1975.

BABLET, DENIS: *Les Révolutions scéniques du XXᵉ siècle.* Paris, 1976.

Berlin als Musikstadt. Die Jahre 1910–1960. Freiburg i. Br., Berne, Munich, 1962.

BOLLENBECK, GEORG, BERNHARD ZIMMERMANN, OTTO F. RIEWOLT, and KNUT HICKETHIER: *Deutsche Literaturgeschichte. Zwanzigstes Jahrhundert.* Düsseldorf, 1981.

Brechts Modell der Lehrstücke. Ed. by Reiner Steinweg. Frankfurt am Main, 1976.

DREWS, RICHARD, and ALFRED KANTOROWICZ: *Verboten und verbrannt. Deutsche Dichter — 12 Jahre unterdrückt.* Berlin, Munich, 1947.

Die deutsche Literatur der Weimarer Republik. Ed. by Wolfgang Rothe. Stuttgart, 1974.

FÄHNDERS, WALTER, and MARTIN RECTOR: *Linksradikalismus und Literatur. Untersuchungen zur Geschichte der sozialistischen Literatur in der Weimarer Republik.* 2 vols. Reinbek near Hamburg, 1974.

FUHR, WERNER: *Proletarische Musik in Deutschland 1928–1933.* Göppingen, 1977.

Geschichte der deutschen Literatur von den Anfängen bis zur Gegenwart. Vol. 10: *1917 bis 1945.* Berlin, 1973.

GOLLBACH, MICHAEL: *Die Wiederkehr des Weltkrieges in der Literatur. Zu den Frontromanen der späten zwanziger Jahre.* Kronberg (Taunus), 1978.

HINCK, WALTER: *Das moderne Drama in Deutschland. Vom expressionistischen zum dokumentarischen Theater.* Göttingen, 1973.

HÖSCH, RUDOLF: *Kabarett von gestern nach zeitgenössischen Berichten, Kritiken und Erinnerungen.* Vol. 1: *1900–1933.* Berlin, 1967.

HOFFMANN, LUDWIG, and DANIEL HOFFMANN-OSTWALD: *Deutsches Arbeitertheater 1918–1944.* 2 vols. Berlin, 1972.

HOUBEN, HEINRICH HERBERT: *Der ewige Zensor. Längs- und Querschnitte durch die Geschichte der Buch- und Theaterzensur.* Kronberg (Taunus), 1978.

In jenen Tagen . . . Schriftsteller zwischen Reichstagsbrand und Bücherverbrennung. A documentation, arranged by Friedemann Berger, Vera Hauschild and Roland Links under collaboration of Sigrid Bock. Leipzig, Weimar, 1983.

KÄHLER, HERMANN: *Von Hofmannsthal bis Benjamin. Ein Streifzug durch die Essayistik der zwanziger Jahre.* Berlin, Weimar, 1982.

KÄNDLER, KLAUS: *Drama und Klassenkampf. Beziehungen zwischen Epochenproblematik und dramatischem Konflikt in der sozialistischen Dramatik der Weimarer Republik.* Berlin, Weimar, 1970.

KEMPER, HANS-GEORG: *Vom Expressionismus zum Dadaismus. Eine Einführung in die dadaistische Literatur.* Kronberg (Taunus), 1974.

KETELSEN, UWE: *Völkisch-nationale und nationalsozialistische Literatur in Deutschland 1890–1945.* Stuttgart, 1976.

KLATT, GUDRUN: *Arbeiterklasse und Theater, Agitprop—Tradition—Theater im Exil—Sozialistisches Theater.* Berlin, 1975.

KLEIN, ALFRED: *Im Auftrag ihrer Klasse. Weg und Leistung der deutschen Arbeiterschriftsteller 1918 bis 1933.* Berlin, Weimar, 1975.

KLEIN, ALFRED: *Wirklichkeitsbesessene Dichtung. Zur Geschichte der deutschen sozialistischen Literatur.* Leipzig, 1977.

KNELLESSEN, FRIEDRICH W.: *Agitation auf der Bühne. Das proletarische Theater in der Weimarer Republik.* Emsdetten, 1970.

KOESTER, ECKART: *Literatur und Weltkriegsideologie. Positionen und Begründungszusammenhänge des publizistischen Engagements deutscher Schriftsteller im Ersten Weltkrieg.* Kronberg (Taunus), 1977.

KOLINSKY, EVA: *Engagierter Expressionismus. Politik und Literatur zwischen Weltkrieg und Weimarer Republik.* Stuttgart, 1970.

KOTHES, FRANZ-PETER: *Die theatralische Revue in Berlin und Wien 1900–1938. Typen, Inhalte, Funktionen.* Wilhelmshaven, 1977.

KRON, FRIEDHELM: *Schriftsteller und Schriftstellerverbände. Schriftstellerberuf und Interessenpolitik 1842–1973.* Stuttgart, 1978.

LAMMEL, INGE: *Das Arbeiterlied.* Leipzig, 1975.

LETHEN, HELMUT: *Neue Sachlichkeit 1924 bis 1932. Studien zur Literatur des "Weissen Sozialismus".* Stuttgart, 1975.

Das literarische Leben in der Weimarer Republik. Ed. by Kaith Bullivant. Königstein (Taunus), 1978.

MARTENS, WOLFGANG: *Lyrik kommerziell. Das Kartell lyrischer Autoren 1902–1933.* Munich, 1975.

MELCHINGER, SIEGFRIED: *Geschichte des politischen Theaters.* Frankfurt am Main, 1974.

MENNEMEIER, FRANZ NORBERT: *Modernes deutsches Drama. Kritiken und Charakteristiken.* Vol. 1: *1910–1933.* Munich, 1979.

NÖSSIG, MANFRED, JOHANNA ROSENBERG and BÄRBEL SCHRADER: *Literaturdebatten in der Weimarer Republik. Zur Entwicklung des marxistischen literaturtheoretischen Denkens 1918–1933.* Berlin, Weimar, 1980.

OTTO, REINER, and WALTER RÖSLER: *Kabarettgeschichte. Abriss des deutschsprachigen Kabaretts.* Berlin, 1977.

PISCATOR, ERWIN: *Das Politische Theater. Schriften.* Vol. 1. Berlin, 1968.

PHILIPP, ECKHARD: *Dadaismus. Einführung in den literarischen Dadaismus und die Wortkunst des 'Sturm'-Kreises.* Munich, 1980.

PÖRTNER, PAUL: *Literatur-Revolution 1910–1925. Dokumente. Manifeste. Programme.* Vol. 1: *Zur Ästhetik und Poetik.* Darmstadt, Neuwied, Berlin (West), 1960. Vol. 2: *Zur Begriffsbestimmung der Ismen.* Neuwied, Berlin (West), 1961.

PRÜMM, KARL: *Die Literatur des soldatischen Nationalismus der zwanziger Jahre (1918–1933). Gruppenideologie und Epochenproblematik.* 2 vols. Kronberg (Taunus), 1974.

Revolution und Literatur. Zum Verhältnis von Erbe, Literatur und Revolution. Ed. by Werner Mittenzwei and Reinhard Weisbach. Leipzig, 1971.

RIHA, KARL: *Moritat, Bänkelsong, Protestballade. Zur Geschichte des engagierten Liedes in Deutschland.* Königstein (Taunus), 1979.

RÖSLER, WALTER: *Das Chanson im deutschen Kabarett 1901–1933.* Berlin, 1980.

RÜHLE, GÜNTHER: *Theater für die Republik.* Frankfurt am Main, 1967.

SCHLENSTEDT, SILVIA: *Wegscheiden—Deutsche Literatur im Entscheidungsfeld der Revolution 1917 und 1918.* Berlin, 1976.

SERKE, JÜRGEN: *Die verbrannten Dichter.* Weinheim, Basle, 1977.

SLODERDIJK, PETER: *Literatur und Lebenserfahrung. Autobiographien der zwanziger Jahre.* Munich, 1978.

Sozialgeschichte der deutschen Literatur von 1918 bis zur Gegenwart. Group of authors. Frankfurt am Main, 1981.

STROTHMANN, DIETRICH: *Nationalsozialistische Literaturpolitik. Ein Beitrag zur Publizistik im Dritten Reich.* Bonn, 1963.

Theater der Kollektive. Proletarisch-revolutionäres Berufstheater in Deutschland 1928–1933. Stücke, Dokumente, Studien. Ed. by Ludwig Hoffmann and Klaus Pfützner. 2 vols. Berlin, 1970.

TROMMLER, FRANK: *Sozialistische Literatur in Deutschland. Ein historischer Überblick.* Stuttgart, 1976.

VIESEL, HANSJÖRG: *Literaten an der Wand. Die Münchner Räterepublik und die Schriftsteller.* Frankfurt am Main, 1980.

WEBER, RICHARD: *Proletarisches Theater der revolutionären Arbeiterbewegung 1918 bis 1925.* Cologne, 1976.

Wer schreibt, handelt. Strategien und Verfahren literarischer Arbeit vor und nach 1933. Group of authors. Berlin, Weimar, 1983.

Zur Tradition der deutschen sozialistischen Literatur. Eine Auswahl von Dokumenten, 1926–1949. Berlin, Weimar, 1979.

Art, Architecture, Film, Radio

ADES, DAWN: *Photomontage.* London, 1976.

BANN, STUART: *The Tradition of Constructivism.* New York, 1974.

BENEVOLO, LEONHARD: *Geschichte der Architektur des 19. und 20. Jahrhunderts.* 2 vols. Munich, 1964.

BENJAMIN, WALTER: *Das Kunstwerk im Zeitalter der technischen Reproduzierbarkeit.* Frankfurt am Main, 1963.

BRAUN, ALFRED: *Achtung. Achtung. Hier ist Berlin! Aus der Geschichte des deutschen Rundfunks in Berlin 1923–1932.* Berlin (West), 1968.

Bühne und bildende Kunst im 20. Jahrhundert. Ed. by Henning Rischbieter. Velber near Hanover, 1968.

Dada Berlin. Texte, Manifeste, Aktionen. Ed. by Karl Riha and Hanne Bergius. Stuttgart, 1977.

Da Dada da war ist Dada da. Texte und Dokumente. Ed. by Karl Riha. Munich, 1980.

Dada. Monographie einer Bewegung. Ed. by Willy Verkauf, Marcel Janco and Hans Bollinger. Teufen, 1965.

Film und Realität in der Weimarer Republik. Ed. by Helmut Korte. Munich, 1978.

Film und revolutionäre Arbeiterbewegung in Deutschland 1918–1932. Dokumente und Materialien zur Entwicklung der Filmpolitik der revolutionären Arbeiterbewegung und zu den Anfängen der sozialistischen Filmkunst in Deutschland. Ed. by Gertraud Kühn, Karl Tümmler and Walter Wimmer. 2 vols. Berlin, 1978.

GROHMANN, WILLI: *Bildende Kunst und Architektur zwischen den beiden Kriegen.* Berlin (West), 1953.

HAMANN, RICHARD, and JOST HERMAND: *Expressionismus.* Berlin, 1975.

HERMAND, JOST: *Stile, Ismen, Etiketten. Zur Periodisierung der modernen Kunst.* Wiesbaden, 1978.

HIEPE, RICHARD: *Die Fotomontage. Geschichte und Wesen einer Kunstform.* Ingolstadt, no date.

HIRDINA, KARIN: *Pathos der Sachlichkeit. Tendenzen materialistischer Ästhetik in den zwanziger Jahren.* Berlin, 1981.

HOFMANN, WERNER: *Plastik des 20. Jahrhunderts.* Frankfurt am Main, 1958.

HÜTT, WOLFGANG: *Deutsche Malerei und Grafik im 20. Jahrhundert.* Berlin, 1969.

HUSE, NORBERT: *"Neues Bauen" 1918 bis 1933. Moderne Architektur in der Weimarer Republik.* Munich, 1975.

In letzter Stunde 1933–1945. Künstlerschriften II. Ed. by Diether Schmidt. Dresden, 1964.

JOHN HEARTFIELD: *Der Schnitt entlang der Zeit. Selbstzeugnisse, Erinnerungen, Interpretationen. Eine Dokumentation.* Ed. by Roland März. Dresden, 1981.

Kino-Debatte. Texte zum Verhältnis von Literatur und Film 1909–1929. Ed. by Anton Kaes. Tübingen, 1978.

KRACAUER, SIEGFRIED: *Das Ornament der Masse.* Frankfurt am Main, 1977.

KRACAUER, SIEGFRIED: *Von Caligari zu Hitler. Eine psychologische Geschichte des deutschen Films. Schriften.* Vol. 2. Frankfurt am Main, 1979.

KRÖLL, F.: *Das Bauhaus 1919–1933.* Düsseldorf, 1974.

Kunst und Technik. Ed. by Leo Kestenberg. Berlin, 1930.

LANG, LOTHAR: *Das Bauhaus 1919–1933. Idee und Wirklichkeit.* Berlin, 1965.

LÜDECKE, WILLI: *Der Film in Agitation und Propaganda der revolutionären deutschen Arbeiterbewegung, 1919–1933.* Berlin (West), 1973.

MAENZ, PAUL: *Art Deco. 1920–1940. Formen zwischen zwei Kriegen.* Cologne, 1974.

Manifeste, Manifeste 1905–1933. Künstlerschriften I. Ed. by Diether Schmidt, Dresden, 1965.

MUCHE, GEORG: *Blickpunkt: Sturm. Dada. Bauhaus. Gegenwart.* Munich, 1961.

MÜLLER-WULKOW, WALTER: *Architektur der zwanziger Jahre in Deutschland.* Königstein (Taunus), 1975.

Neue Sachlichkeit und Realismus. Kunst zwischen den Kriegen. Museum des 20. Jahrhunderts. Catalogue. Vienna, 1977.

NEUMANN, ECKHARD: *Functional Graphic Design in the 20's.* New York, 1967.

NEUMANN, THOMAS: *Sozialgeschichte der Fotografie.* Neuwied, 1966.

OESTERREICHER-MOLLOW, MARIANNE: *Surrealismus und Dadaismus. Provokative Destruktion, der Weg nach innen und die Verschärfung der Problematik einer Vermittlung Kunst und Leben.* Freiburg i. Br., Basle, Vienna, 1978.

PILZ, GEORG: *Geschichte der europäischen Karikatur.* Berlin, 1976.

RADEMACHER, HELMUT: *Das deutsche Plakat. Von seinen Anfängen bis zur Gegenwart.* Dresden, 1965.

Realismus und Sachlichkeit. Aspekte deutscher Kunst 1919–1933. Staatliche Museen zu Berlin. Catalogue. Berlin, 1974.

Revolution und Realismus. Revolutionäre Kunst in Deutschland. Staatliche Museen zu Berlin. Catalogue. Berlin, 1978.

ROH, FRANZ: *Geschichte der deutschen Kunst von 1900 bis zur Gegenwart.* Munich, 1958.

RUBIN, WILLIAM S.: *Dada and Surrealism.* New York, 1968. In German: *Dada und Surrealismus.* Stuttgart, 1972.

SCHMALENBACH, FRITZ: *Die Malerei der "Neuen Sachlichkeit".* Berlin (West), 1975.

SCHMIED, WIELAND: *Neue Sachlichkeit und Magischer Realismus in Deutschland 1918–1933.* Hanover, 1969.

SIEPMANN, ECKHARD: *Montage: John Heartfield. Vom Club Dada zur Arbeiter-Illustrierten Zeitung.* Berlin (West), 1977.

SOPPE, AUGUST: *Der Streit um das Hörspiel 1924/25. Entstehungsbedingungen eines Genres.* Berlin (West), 1978.

STENEBERG, EBERHARD: *Russische Kunst Berlin 1919–1932.* Berlin (West), 1969.

Tendenzen der Zwanziger Jahre. 15. Europäische Kunstausstellung Berlin 1977. Catalogue. Berlin (West), 1977.

TOEPLITZ, JERZY: *Geschichte des Films.* Vol. 1: *1895–1928.* Vol. 2: *1928–1933.* Berlin, 1979. Vol. 3: *1934–1939.* Berlin, 1980. Vol. 4: *1939–1945.* Berlin, 1983.

TRAUB, HANS: *Die Ufa. Ein Beitrag zur Entwicklungsgeschichte des deutschen Filmschaffens.* Berlin, 1943.

Über die Schönheit hässlicher Bilder. Dichter und Schriftsteller über Maler und Malerei (1880–1933). Ed. by Wolfgang Tenzler. Berlin, 1982.

VOGT, PAUL: *Geschichte der deutschen Malerei im 20. Jahrhundert.* Cologne, 1972.

WESCHER, HERTA: *Die Collage. Geschichte eines künstlerischen Ausdrucksmittels.* Cologne, 1968.

WINGLER, HANS M.: *Das Bauhaus 1919–1933.* Weimar, Dessau, Berlin, Bramsche, 1962.

ZGLINICKI, FRIEDRICH VON: *Der Weg des Films.* Hildesheim, New York, 1979.

Sources of Illustrations

Figures in Roman type refer to text pages; figures in *italics* refer to numbers of illustrations.

ADN/Zentralbild, Berlin 15, 20, 21(2), 29, 53 top left, 93 bottom, 114 top, 114 bottom left, 115, 123 top, 123 bottom right, 129 top, 131 top, 134 left, 142 top, 148 top, 167, 168, 170, 171, 177, 178, 182, 186 top, 191 top, 192, 195(2), 215 right, 239(2), 247, 248; *3, 26, 28, 31, 41, 63–67, 75–77*

Akademie der Künste der DDR, Hanns-Eisler-Archiv, Berlin 226 top right

Beyer, Klaus G., Weimar *49, 52, 54*

Bildarchiv Preussischer Kulturbesitz, Berlin (West) *9, 18, 45*

Fotokinoverlag Leipzig 179 left

Grambow, Axel, Berlin 14 bottom, 26 left, 57; *4, 69, 70, 79*

Hänse, Ingrid, Leipzig 137; *37, 62*

Kunstmuseum Bern *5*

Kunstmuseum Dusseldorf *48*

Kunstmuseum Hannover *27*

Kunstsammlung Nordrhein-Westfalen, Dusseldorf *1, 47*

Museen der Stadt Köln, Cologne *46*

Petri, Joachim, Mölkau near Leipzig 27, 215 left, 233

Saarland-Museum, Saarbrücken *17*

Sächsische Landesbibliothek, Deutsche Fotothek, Dresden 53 top right, 53 bottom right, 94, 148 bottom, 149, 163 bottom, 175, 228 bottom left, 227(2); *32, 33, 53, 55–57*

Staatliches Filmarchiv der DDR, Berlin *10, 40*

Städtische Kunsthalle, Mannheim *68*

Tate Gallery, London *22*

Todtenberg, Harry, Leipzig 82 bottom

Ullstein Bilderarchiv, Berlin (West) 140

Verlag der Kunst, Dresden 25

Von der Heydt-Museum, Wuppertal *23*

© 1986 by Cosmopress, Geneva, for ill. no. 5

All other illustrations were taken from contemporary sources of the years 1918–1935 (books, magazines, newspapers) which the Deutsche Bücherei Leipzig supplied. The reproductions were accomplished by Viola Boden, Leipzig.

Index of Personal Names